LINCOLN CHRISTIAN COLLEGE AND SEMINARY

W9-CCL-673

LINCOLN CHRISTIAN COLLEGE AND SEMINARY

How the Other Half Worships

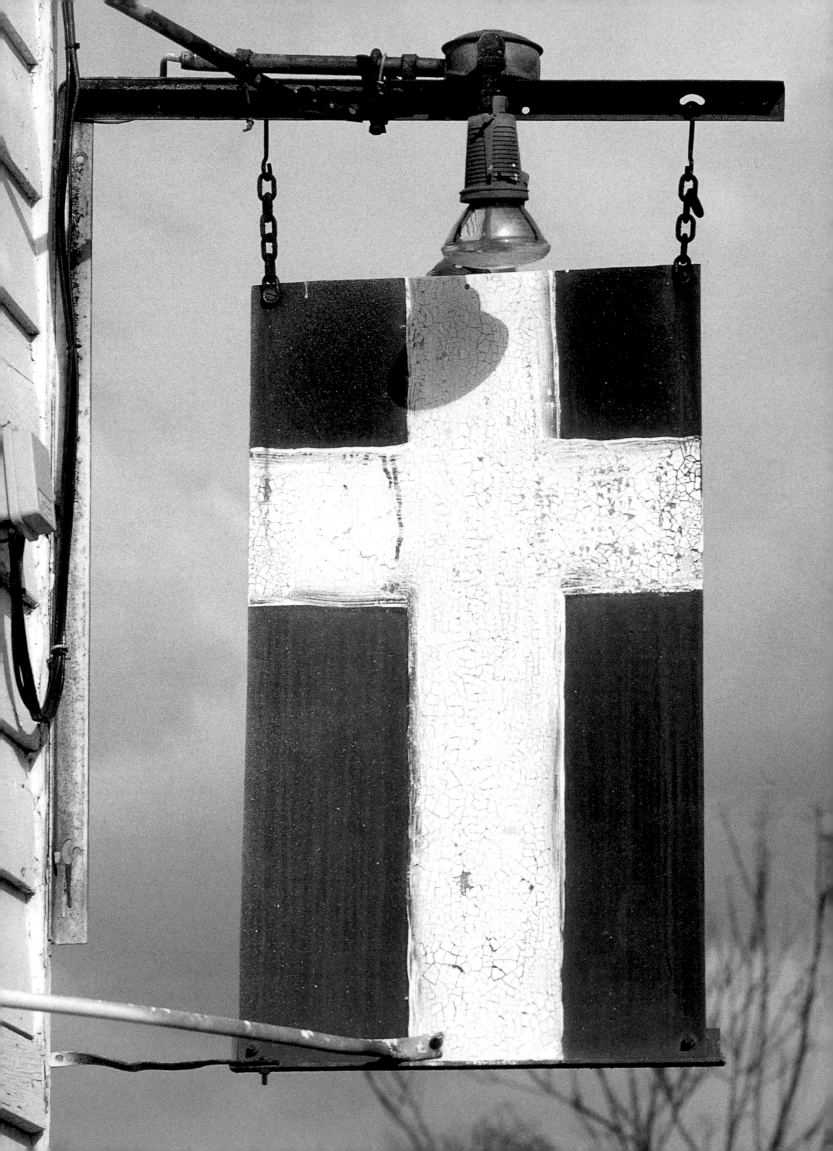

How the Other Half
Worships

Camilo José Vergara

Rutgers University Press

New Brunswick, New Jersey, and London

frontispiece:
**Sign designed for durability
by metalworker Columbus Perkins,
for Antioch Independent Church of God in Christ,
South Nineteenth Street, Newark, 2003**

**Contact paper on window at
Fellowship Greater Jehovah Baptist Church,
Germantown Avenue, Philadelphia, 2003**

Library of Congress Cataloging-in-Publication Data

Vergara, Camilo J.
 How the other half worships / Camilo José Vergara.
 p. cm.
 Includes bibliographical references.
 ISBN-13: 978–0–8135–3682–8 (hardcover : alk. paper)
 1. City churches—United States. 2. United States—Religious life
and customs. 3. Church buildings—United States. 4. United
States—Religion. I. Title.
 BV637.V47 2005
 277.3'009173'2—dc22

 2005002523

A British Cataloging-in-Publication record for this book is available
from the British Library.

Copyright © 2005 by Camilo José Vergara
All rights reserved
No part of this book may be reproduced or utilized in any form or by
any means, electronic or mechanical, or by any information storage
and retrieval system, without written permission from the publisher.
Please contact Rutgers University Press, 100 Joyce Kilmer Avenue,
Piscataway, NJ 08854–8099. The only exception to this prohibition
is "fair use" as defined by U.S. copyright law.

Manufactured in China

CONTENTS

How the Other Half Worships has its roots in the late 1970s, when I began photographing the built environment of poor, minority communities in cities across the United States. Churches were such a prevalent feature of the urban landscape that I quickly understood them to be crucial to my project, and a separate study of them began to develop. The subject of this study inevitably grew beyond the church buildings themselves to include socioeconomic conditions and religious practices that shape these churches and give them meaning. I wanted to know, for example, why Christian churches were so pervasive in destitute neighborhoods, and how the local residents thought about fellowshipping, living virtuously, the afterlife, and ways of communicating with the divine—that is, their answers to basic questions about human existence.

Compiling a comprehensive history of popular religion might occupy a team of researchers for a lifetime. My contribution, on the other hand, deals with the everyday experience of Christianity and is primarily visual and documentary in nature. How the Other Half Worships aims to look at significant phenomena in the realms of the poor that, nevertheless, have remained largely overlooked. My role is that of a relentless recorder of things seen and heard.

My original intent was to write about the evolving architecture of religious buildings in America's poorest ghettos. But as my work progressed, the book grew into an account of African American and Latino migrants and immigrants, often semiliterate hustlers who had left the tutelage of the established churches in their places of origin and had brought their own individual visions and beliefs to large cities in the North, Midwest, and West. When I asked pastors if they had reinvented or modified Christianity, they denied having done so, insisting that what they preached came from God and was "aligned with the Scriptures."

As I look back, I find that I have surveyed and photographed thousands of churches in more than twenty-one cities. By returning many times over the past thirty years to document the same buildings, I was able to show how ordi-

nary structures assume, modify, and shed a religious character, how traditional churches—if they fail to adapt to new congregations—are demolished, and how new buildings are designed and built from the ground up as churches. I explore how religious leaders create, over time, an environment that inspires devotion, and I seek the reasons that dictate their choices of objects, texts, and imagery.

My interest was aroused by the sheer number and variety of churches, the vitality of their services, the poignancy of formally dressed church members emerging from decayed buildings and walking through empty lots, and much else. In poor neighborhoods, houses of worship are plentiful and each, of necessity, has a unique identity. But certain phenomena recur. For example, the churches speak to resilience, for often they are the last survivors on an old commercial block. Former stores (storefront churches) are ideal structures in which to start houses of worship: they are cheap to buy or rent; they have adequate floor space; and they are located near parking lots. The same is true of churches in former garages, factories, warehouses, domestic dwellings, or public institutions. Although traces of a building's secular origins often endure, its religious purpose is proclaimed through the addition of symbols and architectural motifs associated with traditional sanctuaries to the façade and interior.

In ghetto areas I have encountered four main types of houses of worship:

1. Traditional houses of worship, some still representing the original denomination, others changing as congregations move away (synagogues, for example, are quite often recycled as Christian churches).
2. Storefront churches, which are ubiquitous. These ephemeral churches—for they open and close like flowers in spring—rarely achieve the symmetry, simple forms, and elegant proportions associated with America's rural and small-town churches. Storefront churches are a vital new territory. They change hands often, have small congregations, and are usually open only part of the day on Sunday, and for a few hours on weekday evenings for prayer and Bible study.
3. Megachurches are less common and more recent, and they attract thousands of members not exclusively from the neighborhood, but often from an entire metropolitan

Window, Echoes of Revelation N:D Church Romans 10:13, Mack Avenue, Detroit, 2002

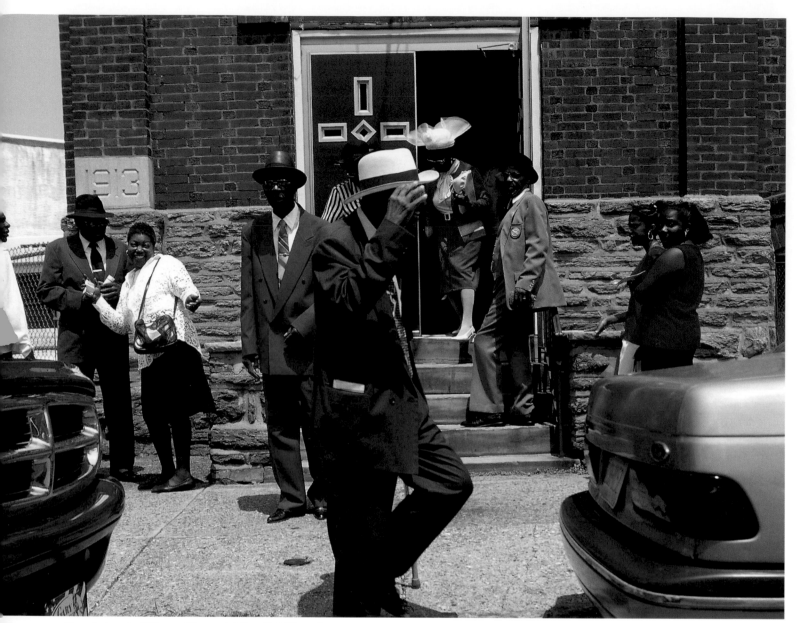

**People leaving Moore Memorial Baptist Church
after Sunday service, Dauphin Street, Philadelphia, 2003**

area. These institutions support schools, choirs, counseling and health services, missions, bookstores, restaurants, and funeral homes.

4. Churches designed by architects for medium-sized congregations. These houses of worship are built over time as the funds become available; as a consequence, the plans go through many revisions, often lack coordination, and produce surprising results.

Nontraditional churches created by visionary pastors in a dialogue with God and the devil are the most visually interesting. I admire the imagery that people devise as a legacy from their small-town upbringings in the southern United States, Mexico, Puerto Rico, Africa, or the West Indies. In these unexpected cultural transplants, I have seen rich undercurrents survive in the big city. A church's name, for example, will make its way from Alabama to South Central Los Angeles. Colors, clothing, and rituals popular in small Caribbean islands are revived in Brooklyn. It is these pastors' voices that linger in my ears, their slow cadences calling me to earlier times and faraway places, places where God and the Scriptures made the world real. Here prayer is wish fulfillment, miracles follow natural laws, and the impossible happens without violating everyday reason. Pastors of these churches are crusaders whose missions cannot be served by traditional religious iconography, and whose budgets force them to use inexpensive materials. Occupying their own idiosyncratic turf, these houses of worship exemplify urban folk architecture but, over time, they tend to lose their naïve character, becoming more "church-like" as the congregation's religious zeal cools.

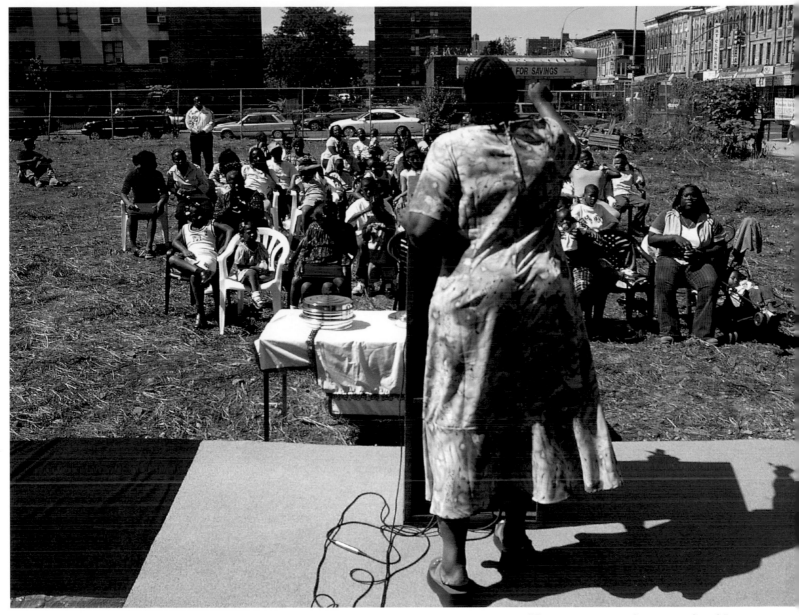

"Satan, you are no longer my Lord,"
a woman preacher tells an outdoor service
of New Creation Ministry, Sutter Avenue, Brooklyn, 2003

Congregations share many practical concerns. Chief among these are keeping the flock together and growing in number, raising the necessary funds for the upkeep of the church, making converted buildings look more like houses of worship, and accommodating the needs of a largely female membership. Recently started congregations often lack a building of their own and rent space in other churches, or in the halls of hotels and motels.

I searched for common threads in a sea of diversity. Latino churches with predominantly Caribbean congregations have different styles of worship from those practiced by Mexican congregants. Haitian churches with members of African descent are as distinct from African American churches as they are from traditionally Catholic ones. Ethnicity, when combined with a shared national origin, gives a common style to religious practices.

I did not find it useful to organize this study according to religious denominations because most congregations I visited controlled their own fates. For instance, even though they are loosely affiliated to an established religious denomination, each Baptist and Holiness church has its own unique interpretation of the Scriptures. Some centrally controlled groups such as Episcopalians, Catholics, Lutherans, and The House of Prayer for All People give their individual houses of worship strong identities. Yet even among these denominations there are wide ranges of styles of worship. Among Catholics, for example, there are traditionalists that still celebrate the mass in Latin and Afrocentric churches whose services as emotionally expressive as those of evangelical Protestants.

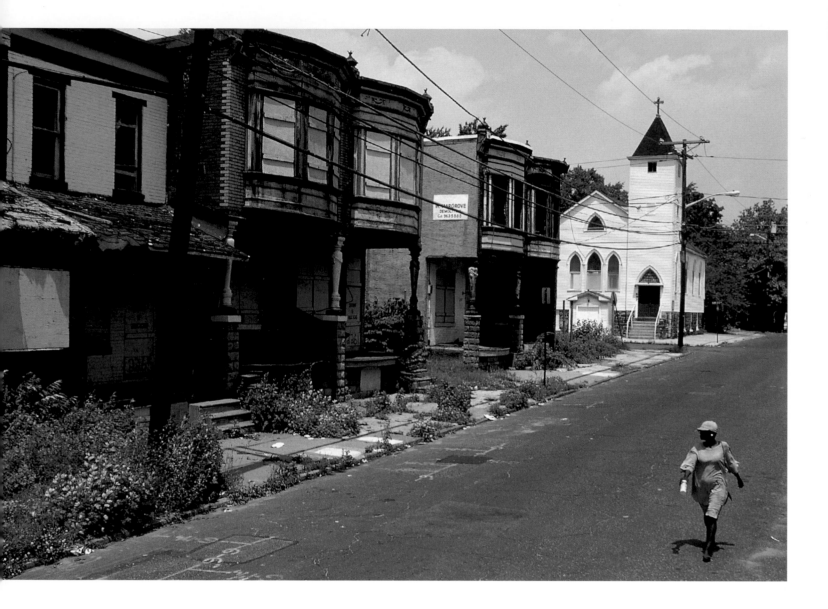

Saint Mathew of the Highway Church of Christ of the Apostolic Faith, formerly Saint Michael's Ukrainian Catholic Church, Florence Street, Camden, New Jersey, 2004. The white frame church is a traditional image, but its setting is not. It looks like Saint Mathew landed on another planet.

Methodology

This book is a survey of houses of worship, the beliefs they express and the rituals performed in them. I give much attention to the material culture of urban folk religion, the devotional objects chosen, the way spaces are arranged, and the manner in which buildings are created or retrofitted for worship. To understand decorations, objects, texts, and physical structures, I asked church leaders why and how they were acquired and under what conditions they had changed over time. I collected flyers and newspapers offered to the public, and took down the names and telephone numbers of contacts from bulletin boards. I observed parking lots and church vehicles. Finally, I copied texts chosen for worship, listened to hundreds of sermons, and wrote thousands of pages of notes.

How the Other Half Worships grew in breadth as I visited more churches of various denominations. It grew in depth as I interviewed more people and returned to ask additional questions or to seek clarification from those I had already interviewed. In the religious practices and beliefs so typical of the ghetto poor, I had a large research topic although, at the start, I didn't know which specific issues would be central to congregations. My questions were originally inspired by the building and the members, that is, they were based on the physical structure, the ethnic and racial makeup of the people, and the objects and texts they selected for public display. If a church had the word "deliverance" in its name, I assumed its officials to be experts on the subject, so I asked them to explain its meaning. At a different church that advertised a "Soul Saving Revival," a subject of the interview was the need for a revival and how to choose the best pastor to preach one. I also asked about the advantages of pitching a tent to hold a revival. If changes had been made to the building, I probed the reasons for these changes while sharing before and after photographs with the respondent.

I imagined myself to be a conduit for the churchgoers' religious opinions. What were they saying, doing, and, even, what would they like to be doing? For example, I asked: How should Jesus be represented? Should He be represented at all? What is the importance of the Bible? What is a "full gospel church"? What does a bishop do? How do you get to be one? What is a Spiritual church? Why do so many church names start with the word "greater"?

There were always new buildings, decorations, and instructional materials to investigate. The pastors' words and texts, included in pamphlets and embedded in walls and façades, led me to many topics that encompassed their conceptions of God, the Bible, faith, and salvation. Issues such as the need for steeples became more important as I noticed their addition to storefront churches in different cities. There were jobs to understand, such as guarding the vehicles belonging to the congregation during services. And numerous calls and expressions of gratitude for the Holy Spirit prompted me to add more commentary on the subject.

Naturally, most of my church visits took place on Sunday since most churches are closed during the week. I frequently asked for permission to photograph during services and would later give some of these pictures to the pastor. Often I had to choose between taking notes or photographing; photography usually took precedence. During my visits I interviewed deacons, pastors' wives, and congregants. Since the pastor was busy preparing for the service, I often arranged for a phone interview with him or her at a later date.

After a brief greeting, church officials would often be the first to ask questions. Our discussions frequently shifted from architecture and other physical aspects of religion to the church founder's life story, or to the current pastor's vision, or even to the condition of my own soul. Several pastors asked me to write their biographies. Pastor J. C. Tubbs, of Compton, proposed that I start a business with him.

Most pastors are dismissive of "graven images," yet they often use illustrations to make biblical texts more poignant. When I asked about this, they denied that such images had any significance. I observed the intensity and repetition of their religious expressions, and the color, size, and lettering used to convey ideas. I asked why certain symbols such as the cross and the Bible were featured prominently. In the photographs I present church interiors as depositories of folk art, and I asked officials about the origins and meanings of paintings, statues, portraits, and signs. As I kept going back and forth from the images to the interviews, reformulating questions and adding entries, this study acquired a life of its own.

Before every field trip I examined the photographs I had already taken, reviewed the notes I had collected in the city, and used them as a guide to select themes that

needed to be further expanded. Some churches were selected because the photographs were old and I wanted to observe changes that had occurred to the buildings. Others were selected because I needed to record stories I had heard and had not been able to document during my previous visit. Still others were chosen because they advertised miracles or faith healing, and I wanted to know more about these rituals.

Individual cities have specialties. Metropolitan Chicago, for example, is a good place to observe Catholic churches that have been adapted to black congregations, and to study varieties of Holiness and Spiritual styles of worship. Los Angeles is full of public representations of Mexican and Central American religiosity; it is common here for African American churches to switch or adapt to a Latino membership. Brooklyn is the nation's best place to document West Indian styles of worship.

Churches in ghettos are, for the most part, driven by a religious agenda that largely ignores national and international events. For example, references to militarism and current wars are limited to notions of "The army of the Lord," and to the singing of religious hymns with lines like "I am a Holy Ghost soldier." During the time I was researching this book, there were numerous headlines in the mainstream press about the ordination of an gay Episcopal bishop; yet this controversy was never brought up during my visits and interviews. Same-sex marriages, however, were interpreted as a sign of moral decay and were often condemned as an abomination against God. Other front-page items that were frequently mentioned in services included the September 11 terrorist attacks (interpreted as a warning from God) and Mel Gibson's film *The Passion of the Christ*.

On many occasions I received divergent opinions from members of the same church on the meaning of symbols or practices. I understand how the desire to get a handle on a topic or to generalize, or the need to prove a thesis or to be socially useful has often made scholars mistrustful of the inconsistencies, emotions, and secrecy associated with religion. I wrote down what people said and how they said it, including the emphases they put on words. In poor communities beliefs are expressed differently than they are in liberal, academic settings. Even though church officials know that "worldly people" do not share their beliefs, they consider their truths to be absolute, based on the authority of the Scriptures. Others are free to accept them and be saved or reject them and be damned.

I have frequently attended services during which wives were told that they must obey their husbands, who are the heads of households, because that is what is written in the Bible. The word "mankind" was often used, never "humankind." The word "sons" denoted the concept of children, and the word "men" was meant to include women. There is no difference in the language used by male or female pastors. The capitalization of pronouns such as "He" or "Him" in reference to God, Christ, Jesus, or the Holy Ghost is a sign of respect and an acknowledgment of the power of the divinity. I did not encounter expressions of hate or dislike for male or female homosexuals, yet there was agreement among church officials that such sexual preferences were an "abomination." Older pastors who were raised in the South interpreted a white person to be of Anglo Saxon origin; in their view, other European Americans, such as Italians or Jews, make up a separate category. Racial perceptions are changing, as even Roman Catholic places of worship display brown and African images of Christ. Approximately half of the church officials interviewed believed that Jesus was black, while the remainder were divided between those who believed that race was not important (yet often selected a white Christ for their sanctuaries), and those who felt that Christ could not be represented at all, because He is a spirit.

If I had wanted to write a book that was logical, consistent, and politically correct from beginning to end, I would have to have chosen a different topic! *How the Other Half Worships* is the beginning of what I hope will one day be a well-developed and rich interpretation of Christianity in the inner city.

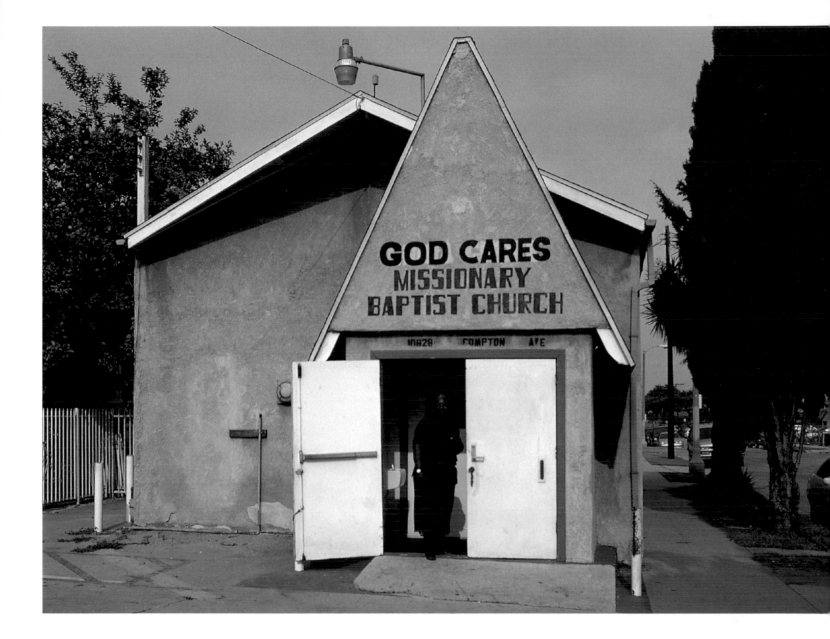

**God Cares Missionary Baptist Church,
South Compton Avenue, Los Angeles, 2002**

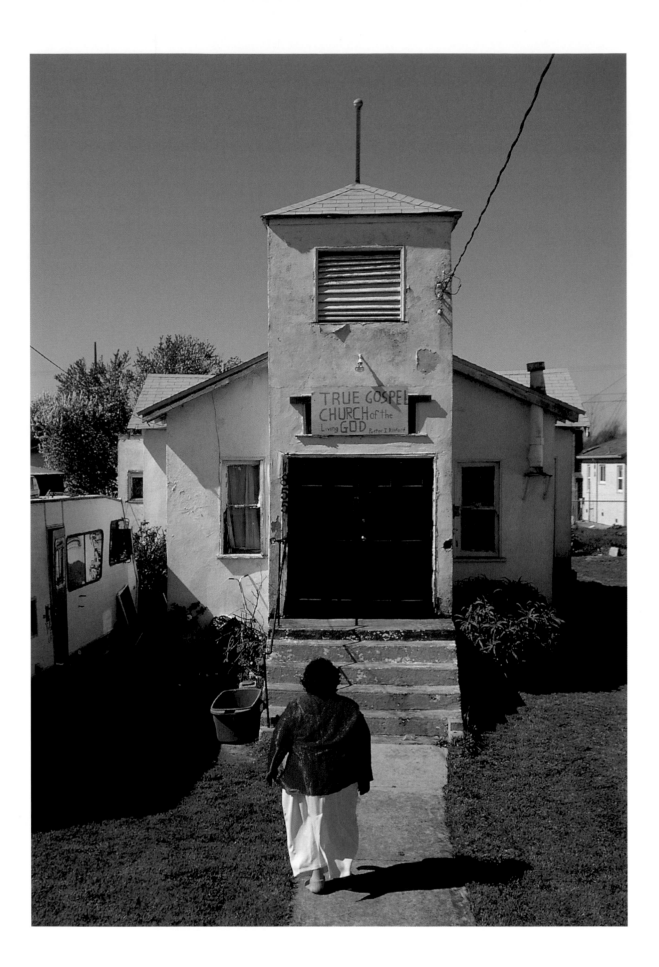

Pastor Inez Ashford walking toward her house of worship,
the True Gospel Church of the Living God, Third Avenue,
North Richmond, California, 2004

How the Other Half Worships

1 Religion, Transcendence, and Denial among America's Urban Poor

The title *How the Other Half Worships* was inspired by Jacob Riis's extraordinary, influential book of photographs, *How the Other Half Lives* (1890). Riis's photographs constituted an indictment against the system that allowed the squalid living conditions in the slums of New York City to exist. His book stirred up a passionate response. In *How the Other Half Worships,* quotes from congregation members describe their beliefs and practices in connection with their physical surroundings. And while Riis focused on the Lower East Side of Manhattan, I have surveyed ghetto churches in cities located in ten states across the country.

It has been drummed into the minds of all Americans that ours is the richest country in the world. Indeed, it is hard not to be impressed by the standard of living in the nation's affluent suburban and urban neighborhoods. Yet, visiting our largest ghettos means seeing decay and desolation stretching for miles, often along once prosperous avenues, and it is just as difficult not to feel disheartened by such an unequal distribution of wealth. Direct experience of the ghetto is overwhelming, and it becomes even more disturbing when we realize that the vast majority of the residents are Latinos and African Americans.

The following section contains entries that strongly support the perception of ghettos as violent, poor, segregated, and ignored by public officials and politicians. But it also presents the views of church members who regard their neighborhoods as improving, and who take offense at this negative vocabulary.

Is This the Ghetto?

Many houses of worship in ghettos are located in former little downtown areas that were built in the late nineteenth and early twentieth centuries. Composed of theaters, banks, garages, and stores, these commercial districts often formed the core of neighborhoods that would later fall apart when jobs disappeared and commerce moved to shopping malls. The buildings left behind were cheap to rent and, in the case of movie theaters, well set up to

accommodate a congregation. Pastors frequently declare that the ghetto is a ripe place for a mission, and they argue that God sends them there to preach to those who are lost.

Pastor M. Scriven, of the General Assembly Church of the Apostolic Doctrine in North Philadelphia, is not concerned about the location of his church. He sees the crime and violence that exist in this neighborhood, one of the most deprived communities in the country, not as a reason to flee or to be there, but as a reflection of "the times we live in." In his church on North Broad Street, Pastor Scriven and his congregation "find peace in the midst of the storm."

Church members from the wider metropolitan region often find it difficult to connect to a community they see for only a few hours, once a week, when they come to worship. Surrounded by large parking lots and secured by guards, these religious institutions are islands in their communities. Typically, their leaders resent the use of the term *ghetto* when it is applied to their churches and neighborhoods. They feel it is insulting, and it makes both them and their congregations seem "ghetto" in the sense of "minority," "poor," and "decayed."

You don't want to go to the worst neighborhood, but God chooses it because there is work to do.
Pastor Sarah Daniels, Whole Truth Gospel Church of Faith, Eleventh Avenue, Gary, Indiana

If you are not needed, why are you starting a church in the middle of the storm? God wanted Pastor W. A. Smith to be in the middle of gangbangers. When we are doing service, we can always hear the sirens and the fire trucks. There are a lot of people that go hungry. We feed the people who come here on Saturday.
Elder Michael Diggins, Light of the World C.O.G.I.C., Rosencrans Avenue, Compton, California

The purpose of my church is to show those in my community that there is hope and that hope is in Christ Jesus. Life can wear you down. My purpose is to build self-esteem, to repair all the breaches, all the disappointments that life has left to the people. It just happens that I am in an area called the ghetto—a poor, impoverished area of torn-down houses, trash in the streets, people standing out on the corners in

Contact paper at front entrance of First Corinthians Baptist Church, Eighteenth Street, Newark, 2003

front of the liquor stores, where prostitution is high because women prostitute themselves to buy drugs. If you see some Caucasians down here, it is because they got hooked up on drugs, and they know they [drugs] are readily available here.

Pastor Kennard Pettaway, Wings as Eagles Church,
Marcus Street, Detroit

Gary is a ghetto; the whole city is a ghetto. The city has been going through hell; it is rundown and messed up. The new mayor is trying to revive it.

Melvin Jones, member,
Progressive Missionary Baptist Church,
Carolina Street, Gary

The definition of the ghetto is this area. It is a poor area; financially deprived people live here; you have crime, a lot of theft, a lot of break-ins. People around here are uneducated; the higher level people don't live here. If you are anywhere in the city of Detroit, you are in a ghetto; some areas are better than others.

Pastor Victor Beauchamp, Bibleway Pentecostal Assembly of
the Apostolic Faith, West Warren Avenue, Detroit

They need to be honest: anything across South Central Avenue is considered the ghetto. Somebody has to be there to save the people. It does not matter where God's work is being done.

Deacon Mitchell, New Jerusalem, Primitive Baptist Church,
Fir Avenue, Watts, Los Angeles

The ghetto is defined by poverty, by the condition of the houses people live in, by the economic condition of the neighborhood. There is not enough money, not enough food and clothing. The ghetto manifests itself in anger, disappointment, illicit sex, drugs, and alcohol. The ghetto fence is still there because we don't have the finances to move to where we want to move. The church is responsible for changing the mentality of the people from no expectations to great expectations.

Pastor Lillie Lu Grant, New Nazareth Great Expectations
Deliverance Center, Martin Luther King Jr. Drive, Milwaukee

I use the words ghetto or inner city interchangeably. The ghetto is where the lepers are; you can't be afraid to touch the lepers. I allude to the gangs and to the drug addicts, and to the decent people written off as failures.

Elder John G. Stevens, Community House of Prayer,
South Orange Avenue, Newark

I may live in the ghetto, but the ghetto does not live in me. Jesus grew up in the ghetto. It was so rough where He grew up that one asked the question: Can anything good come out of Nazareth? Gospel according to Saint John.

J. C. Tubbs, Living Rock Community Baptist Church,
Compton Boulevard, Compton, California

They consider this area the empowerment zone; they consider it economically challenged, and that is the same as ghetto.

Cornell Williams, Hicks Memorial C.O.G.I.C.,
Mack Avenue, Detroit

It is a neighborhood church. The city is not picking the area back up like they are doing in other neighborhoods. Anything that is deteriorating would be considered the ghetto. Any place where the white man has moved out, they consider the ghetto.

Edwin, usher, Rhema International Church of the Apostolic
Faith, Mack Avenue, Detroit

This is Watts. This is how our black community is, churches all over. It is more poor class of folks in Watts; we have the projects, we have welfare.

George, church caretaker, East Ninety-seventh Street,
Los Angeles

This is a neighborhood church, call it an inner-city church. We care as much about our neighborhood as anybody else, but the money is not here. It has a lot to do with the politicians and the decision makers. A lot of crime and a lot of drugs are brought to the neighborhood. This is our home, and if you don't convert us to spirit nothing is going to change—things are going to get worse. We are here to strengthen people's spiritual being and to worship almighty God. Everything for the African Americans that has been positive has been done through neighborhood churches.

Minister Curry, New Life Missionary Baptist Church,
Van Dyke Avenue, Detroit

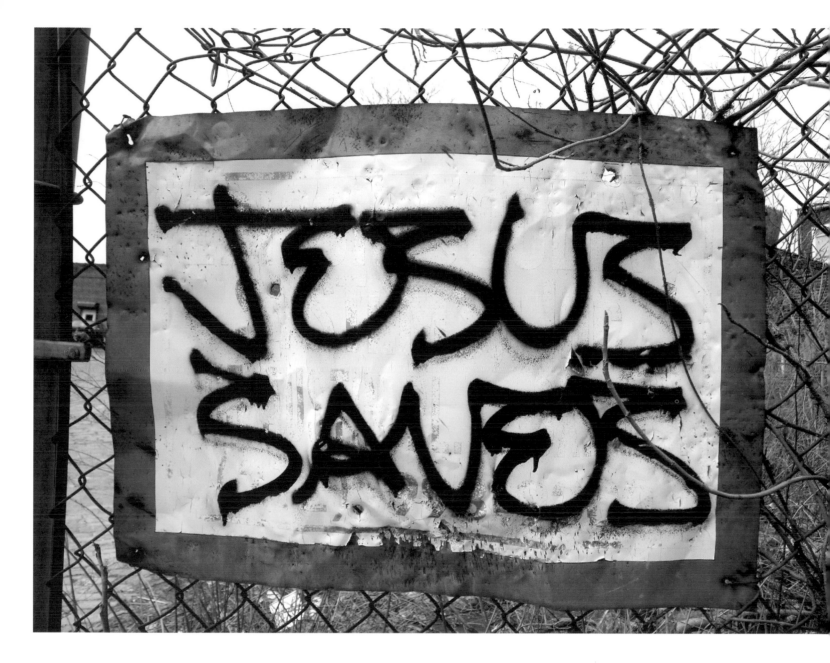

Sign, Austin Place, Bronx, 2005

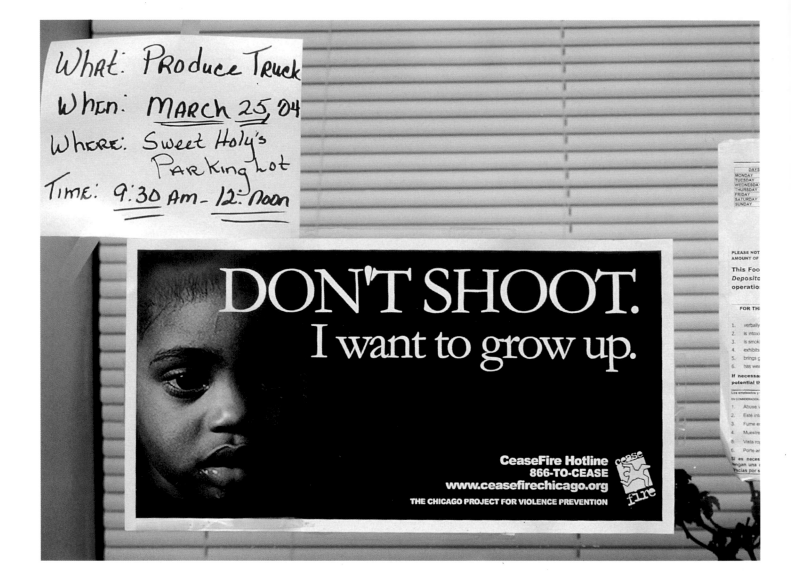

Signs offering free food and pleading for a cease-fire, window of
Sweet Holy Spirit Church, West 103rd Street, Chicago, 2004

When we first came here twenty years ago, this was what we considered the ghetto. There were addicts, drunks, and prostitutes in the parking lot across the street from the church; they'd be lying on the street and on the parking lot. My husband said, "This is a good place for a mission." Now you have new businesses, all the buildings and the streets have been repaired, new buildings have been built, and few old buildings are left. Today you don't see so many drunks and addict people. I would not consider it a ghetto anymore. Now I would say it is a middle-class neighborhood; that is the next step from the ghetto.

Geraldine Brown, wife of the former pastor of
Good Shepherd Church of Christ, Disciples of Christ, Inc.,
Springfield Avenue, Newark

My church is not in the ghetto. The ghetto is considered Watts, Compton, and around Wall Street, in skid row. That is where the poor and the black people are. You have high and low. The churches that are in the west side of Los Angeles are not considered ghetto churches.

Pastor Raymond Branch, Heavenly Rainbow Baptist Church,
South Western Avenue, Los Angeles

If you build a two-million-dollar church in the ghetto, the church is in the ghetto, but is not a ghetto church.

Pastor Victor Beauchamp, Bibleway Pentecostal Assembly of
the Apostolic Faith, West Warren Avenue, Detroit

You wouldn't call it the ghetto. They don't call it the ghetto anymore; they usually say poor area or bad area, but not the ghetto.

First Lady Barbara Griffin, New Testament Baptist Church,
Mack Avenue, Detroit

The ghetto is a frame of mind. If I live here and if I have a frame of mind of the ghetto, the ghetto follows me.

Pastor Jodie Holmes, Echoes of Revelation N: D Church
Romans 10:13, Mack Avenue, Detroit

This area of East New York, Brooklyn, is considered an urban area. The word ghetto is very inappropriate, very derogatory. These people see God, and they work hard. From the community you come from, you can't come here and call this place a ghetto. Sure, teenagers and rappers call it ghetto,

but who do they represent? You are not going to sell many copies of this book if you call it "Ghetto Churches."

Eddie, usher, Greater Temple of Praise, The House of Judah,
Snediker Avenue, Brooklyn

We don't call this neighborhood a ghetto. I don't see nothing wrong with the people and the buildings. You have not seen anybody that is dirty and looking bad out there, and I have been in Bedford-Stuyvesant forty-two years.

Betty Dasher, Mother of the Church, Fire Baptized Holiness
Church, Fulton Street, Brooklyn

Hell, we are in no ghetto. We own our house; we own our apartment; we don't allow drug addicts around here. We live like humans.

Helen Saunders, retired nurse, Saint Augustine R. C. Church,
Franklin Avenue, South Bronx

This is no ghetto; this is the most beautiful area in the country because I am here, because I am a man of God, because Jesus is right here with me. Wherever He is at is beautiful. I don't know no ghettos. I don't deal with ghettos; this is the truth with me.

Fred Marshall, street preacher, Martin Luther King Jr. Drive,
Jersey City, New Jersey

Rich Churches, Poor Churches

During interviews, I frequently asked members how churches in ghetto areas differed from those that were part of the mainstream. Their answers addressed the following questions: Are your congregants poor? How are poor members treated in affluent churches? Is the God of the rich and the God of the poor the same God? Do affluent people need God as much as those who are destitute? Some even asked: Are rich people happy?

While some pastors believe that prosperity is a sign of being favored by God, none denied that the Lord tests people, as He did with Job, making them "wait for their miracle." Pastors advised members to be patient and to search for everlasting prosperity—wealth that comes from God and that nobody can take away from you.

I was surprised to encounter pastors who denied that their members were poor. Officials of larger churches

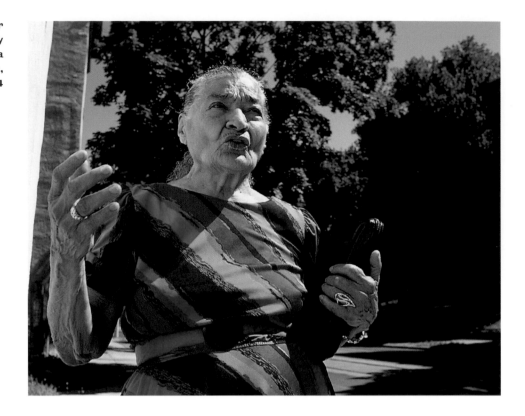

Carlota Guzman, waiting for Pastor Huertas to open church for Sunday services, Iglesia Pentecostal Jehova Jireh, Inc., Germantown Avenue, Philadelphia, 2004

(more than one hundred members) often told me that the bulk of their families drove to services from the suburbs or from other better-off neighborhoods, adding that many had stable jobs. Pastor Walter Washington of Greater New Light Baptist Church, for example, stated in a letter that even though they are located in South Central Los Angeles his membership consisted of "Entrepreneurs, Health Professionals, NASA Engineers, Design Engineers, Educators, as well as other professionals." He advised me not to "judge a book by its cover."

Most officials I interviewed did not consider the difference between rich and poor Christian congregations to be significant since they worship the same God. Pastor White, of Greater New Jerusalem Baptist Church in South Central Los Angeles, explained, "If you want to have peace, you need Jesus; it doesn't matter if you are rich or poor." When I asked if Matthew 11:28, "Come unto me, all ye that labor and are heavy laden, and I will give you rest," a very popular verse in ghetto areas, would have greater appeal for the poor, Pastor Lillie L. Grant, of Great Expectations Deliverance Center in Milwaukee, told me, "You can have millions of dollars and still be burdened; those who don't have Jesus are the ones that have burdens." About half of

the officials I interviewed denied that wealthy offerings made any difference to God, saying that people should give God the best they have. In their opinion, God is just as pleased with a few straws from the poor as with the gold and diamonds of the rich.

Christianity offers poor people a future they can look forward to, as well as a way to shape their identities and to cope with suffering. Among those who ministered to poor congregations, many felt that the only real wealth came from being a son or a daughter of God. Pastor L. Summers, of Robbins, Illinois, told me: "Jesus is my father, and He is rich."

Several noted that Jesus was Himself poor. A member at the Church of God in North Philadelphia told me that Jesus was born "in a stable and not a Beverly Hills mansion." Pastor Rodriguez of Iglesia de Dios la Senda Divina in North Newark believes that because they are humble, poor people are more receptive to the word of God and, therefore, are more likely to go to heaven. He explained that, according to the Bible, when God came to the world, "the needy, the poor, and the sick followed Him." In their opinion, we are here to please God, and it is better to have one's name written in the book of life than to have a business, a fine home, a fancy car, and sev-

eral women. The rich lack peace; they are unhappy and depressed.

A commonly held view is that when things are going well people tend to ignore God. On a Sunday in June 2004, while traveling along Germantown Avenue in Philadelphia, I came across Carlota Guzman, a Puerto Rican woman waiting for Pastor J. Huertas to open the Iglesia Pentecostal Jehova Jireh. She spends all of her time caring for her semiparalyzed and angry daughter, but on Sundays she leaves her daughter home alone and spends a few hours at her church. When I asked her the difference between the God of the poor and the God of the rich, she told me, "The God that resides in heaven and the universe is the same, the only thing is that we [the poor] look for Him in a different way. Even though there are good-hearted rich people, they help with what they have left over. Some smoke and drink and say that they believe in God; others dance, fight, and treat other people badly. Poor folks give out of themselves. The God we believe in is one that makes us live in peace with everybody and help our fellow humans in all that they need. I don't do favors only for my people, but for everybody. I pray for people that are lost and lack bread to eat, so that the Lord gives it to them." I left Carlota waiting for her church to open.

Pastor Edward Young of the Mount Zion Holiness Church of Christ in Camden feels certain that "the presence of the Lord comes to the poor." He asked, "What do affluent people gain from going to church? Does going to church make them closer to God? Are their riches their fiat?" I told him I didn't know the answers to any of these questions.

Pastor Geneva King Fulton of Mount Calvary Bibleway Church of God in Christ, in Philadelphia, told her congregation that she feels uncomfortable with rich people because they are "all about money. A rich person is one that has a lot of earthly stuff; they worry about how to keep it. Money is the root of all evil." Dena, at All Nations Healing Ministry in South Central Los Angeles, sang, "People look at me and say, say, say, there goes Ms. Nobody going down." She was not worried because she "didn't need shoes" to get to heaven.

More often, however, religious leaders promise their faithful abundant life on earth and the certainty of residing in paradise in the afterlife. Another version, most popular

among Spiritual churches, makes the believer a king, a queen, or a princess in this world while promising everlasting life as one with the divinity. When I asked Elder Winston D. Thomson of Ebenezer House of Prayer in Chicago the reason for this upbeat message amid such bleak surroundings, he explained, "In the black community a lot of people feel defeated and downtrodden; they need to go home with hope to last them for a week. In the black church you have to extend the positive."

Because of their apparent success, larger and wealthier churches often feel favored by God. Many pastors of small congregations, however, believe that the success of megachurches is due to their interest in social status and material things, as well as to their having compromised the truth. As a member testified at Springfield Avenue in Newark, "I give thanks for Mount Carmel Holiness Church. This is not a big cathedral downtown. It is a nice, clean place."

We all have a need of God. You may have more economic needs, but you still need to pray for guidance to have a happier life. A lot of rich people commit suicide. If your needs are greater, you seek God in a greater way. Often people who have the resources don't pray that much; they are self-sufficient. Poor people tend to pray more.
 Pastor Joe L. Parker, Wayside Baptist Church,
 Broadway, Brooklyn

I know how to get my prosperity. Because I am in partnership with God, I am in an everlasting prosperity. You come to church, and there are people who don't come to church that are more prosperous than you. I am going to church on Sunday; I am going to church on Tuesday; yet those who aren't going as much have more prosperity than me. We are complaining because we don't get results today. I assure you that you will get results. So you may not get results from God now, but don't complain and be a Jeremiah. Stop fretting. Stop complaining. We want our prosperity from God because then nobody can take it away from us. Say Father, there is a roof over my head; I thank you. Father, there is water in the tap; I thank you. I can walk; I thank you. Mind your own business; everything is between you and God. Don't worry about what nobody has. The only prosperity is the one that comes from God; true prosperity comes from the soul. In

some way or another, the Lord will provide. God is the source of all substance.

 Rev. Marva M. Edmonds, minister, Truth Center of Divine
 Awareness, Inc., Ralph Avenue, Brooklyn

The big and the small churches don't communicate. Big churches figure that small ones have nothing to offer, but the small churches give the best sermons.

 Bishop Andrew Davis, Go Tell It on the Mountain Full Gospel
 Church, Inc., South San Pedro Street, Los Angeles

The apostles met in homes. They didn't establish cathedrals.

 Pastor Glenn Bowden, Full Christian Fellowship Center,
 Los Angeles

The big man with the big churches has a tendency to squash the little people. The owner of a big church doesn't want to give a chance to the little pastor. The little pastor gets disturbed and establishes a storefront church.

 Pastor Raymond Branch, Heavenly Rainbow Baptist Church,
 South Western Avenue, Los Angeles

In a big church, they walk right by you; in a little church, they ask you, How are you doing? It's like family.

 George, church caretaker, Watts, Los Angeles

When my members get sick, they see me; when they die, I preach at their funeral; when they get married, I marry them. I like small churches where people are able to talk to their pastor.

 Pastor William Elliott, Zion Baptist Church,
 Broadway, Camden, New Jersey

The church is like the ocean, and each building I would liken to a ship. There are all kinds of ships that sail the ocean in harmony. There are ocean liners that convey people through the seaways; there are battle ships to defend the seas; there are cargo ships and tugboats. The ocean liners and the battleships need the tugboats. Some tugboats dream of being ocean liners; others are content to be tugboats. All of these ships have one thing in common. They are running in the water. The water is the word of God.

 Pastor Edwin L. Williams, South West Institutional Baptist
 Church, South Broadway, Los Angeles

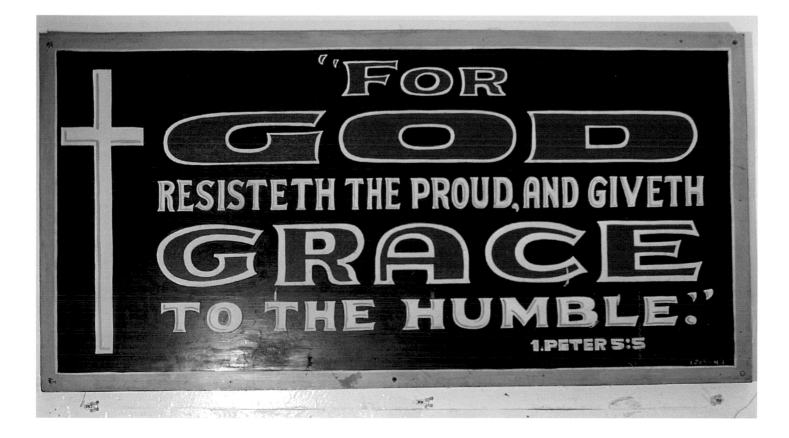

Sign made by John B. Downey for Emmanuel Baptist Rescue Mission,
Fifth Street, Los Angeles, 2003

Houses of worship are very diverse. The best way to capture this diversity is to present several case studies. My aim here is to include profiles of houses of worship representing major denominations and ethnicities, as well as sizes of congregations. Each story contains a sketch of the congregation's history, a short biography of the pastor or founder, and the church's viewpoints on the key issues they had to confront. I describe some of the important phases in their institutional lives, such as the building of a new temple or a schism that tore apart the membership. These profiles demonstrate each church's independence and distinct personality.

In a few downtown blocks of Los Angeles, one can experience extreme misery and degradation. I have observed hundreds of evangelists of every color and sex coming to reclaim the "lost" living on skid row streets and in shelters. Bringing with them salvation, food, and clothes, under the bright sun of Los Angeles, they create an intense and uniquely American blend of despair and hope.

Saint Martin's Spiritual Baptist Church, Brooklyn

Rev. Kenneth Paris prayed aloud, "I came to you, for I have nothing. Sanctify me. Please Lord, please Lord, please Lord." The tall pastor, of Saint Martin's Spiritual Baptist Church on Utica Avenue in Brooklyn, lay on his belly on the church floor because, he said, "you have to show yourself lower than God." He was praying in a soft, clear voice, confessing his problems and proclaiming the good things that God had done for him—giving him air to breathe, life, health. He later said, "When you are in the presence of God, you feel relaxed; you feel like you are in paradise."

On a tray placed in front of him was a vase containing red carnations and, surrounding this, a lighted candle, a jar of honey, and a bottle of oil. This assortment of objects, I was told, is called the bonding center.

The heat was intense. To cool him off, a woman from the congregation dipped a carnation in a glass of cold

Contact paper decorating window of
Heavenly Rainbow Baptist Church,
South Western Avenue, Los Angeles, 2002

water and let drops fall on his head. Another woman wiped the sweat off his face with a piece of cloth. Reverend Paris continued, "Sanctify me. Please Lord. Please Lord. Keep the promise." He lapsed into a language that I took for Creole. Lucille, a church member, explained to me that he was speaking in an unknown tongue, and "when you speak unknown, you speak directly to God." There was also drumming, the ringing of hand bells, and the sound of rattles. On that Sunday in August, the congregation consisted of twenty-four people of African descent, mostly women and children. Three of the women wore red-checked dresses and bright matching kerchiefs; the others wore blue or yellow dresses. They sang from a book of West Indian hymns. The flags of Granada, Saint Vincent, Barbados, Trinidad, and Antigua hung from the ceiling.

The church interior was a feast of saturated colors. The walls of the small, narrow room were white except for a blue band painted at the base. The congregants, wearing deep-hued clothing and performing exotic rituals, seemed remote from the provincial Roman Catholic churches of my own Chilean childhood. Yet there was something in the sounds, the traditional objects, and the cultivation of mystery that connected them to my early religious experiences. As an observer, accustomed to keeping my distance, I nevertheless was overwhelmed by an intense feeling of the sacred. In this humble space, after more than three decades, the power of religion caught me by surprise.

The pastor made the rounds of the room, holding the vase with the candle surrounded by carnations. He passed it to each adult member, who lifted it three times and then shook the pastor's hand. When my turn came, I was offered only a handshake. The pastor spoon-fed a few of the women from the jar. A woman asked me to come up front and talk; speechless, I had to decline.

At the back of the church stood a man wearing a red kerchief on his head and a black cassock tied with a red rope. He held a shepherd's rod in his left hand. He was the Shepherd Lord, symbol of Jesus leading the flock. Next to him stood a child, approximately nine years old, eyes open wide. The child was very sick, I was told. He could not sleep and would run at night; he was, perhaps, possessed by the devil. On a later visit to Saint Martin's, the Shepherd Lord walked over to me, shook my hand firmly and kept

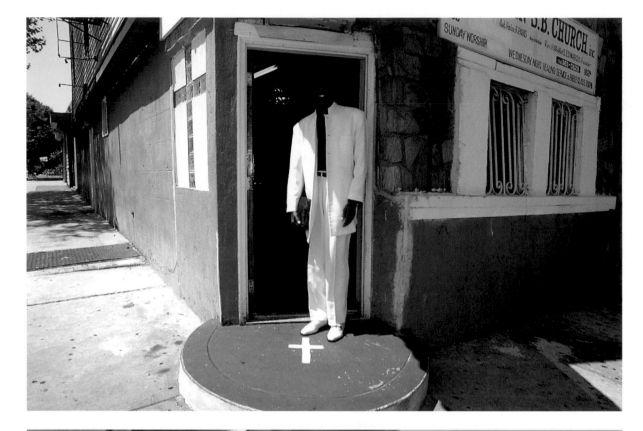

Assistant Pastor Kenneth Paris, Saint Martin's Spiritual Baptist Church, Utica Avenue, Brooklyn, 2002

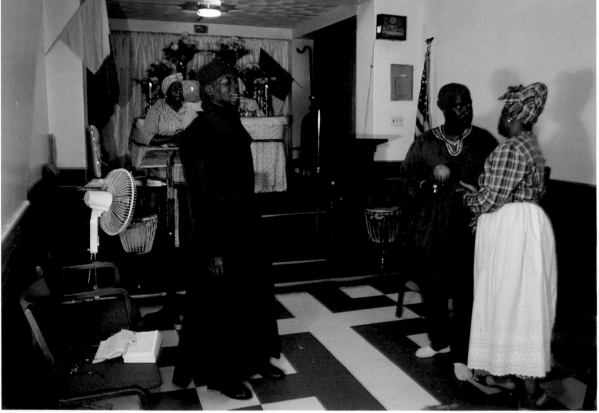

Sunday service at Saint Martin's Spiritual Baptist Church, Utica Avenue, Brooklyn, 2002. The Shepherd Lord is standing at the center.

shaking it for about five minutes, saying, "Even though I don't know where you came from, Jesus made you."

At Saint Martin's Church, I believe that there was a greater source of hope, sustenance, and fortitude than we can normally find inside ourselves, or receive from friends and relatives. As I left the church, Pastor Paris, sitting on a wicker chair, rocked back and forth, saying, "Bless the Lord. Bless the Lord. Thank you, Lord. Thank you, Lord Jesus Almighty."

Two years later, in autumn, 2004, I attended a Sunday service at Saint Martin's that lasted for more than three hours. During the first two hours, spontaneous expressions of religious feeling came together as if perfectly choreographed. Everybody moved and made music and sound, several by singing, some by tapping the floor with their feet or a book with their hands, others by clapping, one by humming the melody, another by limping back and forth from foot to foot, and yet another by playing a large African drum. One woman moved her arms as if she were slowly swimming. Some gently slapped a side of their head, or held a hand against their face as if soothing a toothache. At one time or another, most members danced. From time to time, a woman energetically shook a hand bell. Above all of the sounds, I clearly heard these words: "Preserve me from all evil. I am begging you for strength, Jesus. Teach us what to do and what to say, O Lord. Bless us, O Lord. I need a friend in you, Jesus, so that the breadbasket will not be empty. And, Our Father who art in heaven...." Then the congregants sang "Stand Up and Tell Me if You Love My Jesus."

During the final portion of the service, three male officials spoke to approximately a dozen women and one child. Bishop Paul spoke first, saying, "One of the reasons why men suffer, one of the reasons why women bring their children in pain is because of disobedience. I have seen some of you writing the obituary of this church. I have seen some of you killing this church. Dig a hole, dig a hole, and have the obituary ready. We are faltering. There can only be one head and the body. Humble yourself under the mighty hand of God." Pastor Paris spoke last, saying, "If a child cannot grow, the child is suffering from malnutrition. We only come here one Sunday of the week; we come here to hear the Word of God. I hope to God we come to a mutual understanding. You have to have one mind, the mind of God."

Saint Mary's Roman Catholic Church, Bridgeport, Connecticut

Saint Mary's Church with its golden crown flashes like a kitschy jewel over the empty lots and rusted factories of Bridgeport, Connecticut. "This was a hopeless neighborhood," says Father Mateo Bernelli, a priest from Turin, Italy. "It had Father Panic Village, a housing project where shootings were a daily occurrence. The original congregation of Irish and Italian families continued to come to Saint Mary's, even after they moved to the suburbs, but they eventually died off. As the city lost most of its once thriving industrial base, the parishioners became mostly Puerto Ricans, and today they are a diverse group of Latinos. Today a small new neighborhood surrounds Saint Mary's. The church was the force that pushed to have the projects demolished."

The old Saint Mary's church had been a long, narrow traditional structure that had fallen into disrepair. The new, round suburban structure, built in 1988 on the site of the old Saint Mary's, allows everybody to see the priest, encouraging participation in the mass. "Above the entrance, we put the Virgin of Guadalupe, 'The Patroness of the Americas,' with Juan Diego kneeling by her side," says Father Bernelli. On one side of Our Lady of Guadalupe is an image of Mary, the mother of Jesus, at the foot of the cross, and on the other, Mary as part of a nativity scene with the Magi. Father Bernelli chose the three kings instead of shepherds because the Day of the Kings (Epiphany) in early January is a great celebration for Puerto Ricans.

"Saint Mary's is a modern church, but the art is traditional," says Father Bernelli. Before rebuilding he visited many other churches, and he was most impressed with the Holy Rosary Church in Ansonia, Connecticut, with its circular plan. Paul Antonazzi, the son of the architect of Holy Rosary, was the architect for Saint Mary's. Although he is pleased with the result, he distances himself from the church, saying, "I don't include it in my portfolio; it is not typical of what we do." Father Bernelli gave Antonazzi very clear instructions on how to make his vision work. He brought in Italian artisans to do the mosaics, and he installed the stained-glass windows from the old structure.

The church is attractive and loud, a little coliseum rising out of perfectly manicured green grass, decorated with colorful mosaics. It is an unexpected sight in this decayed

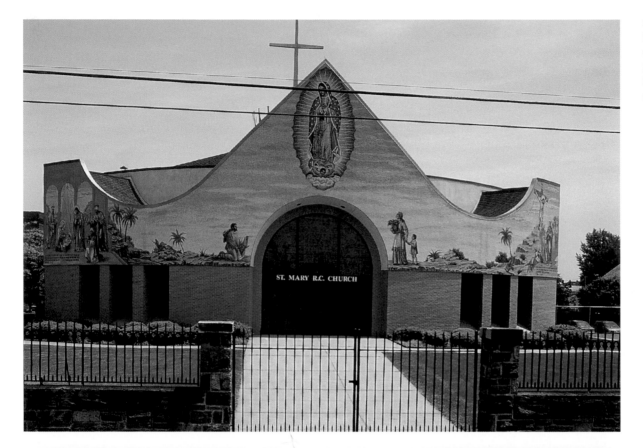

Saint Mary's Roman Catholic Church, Pembroke Street, Bridgeport, Connecticut, 2001

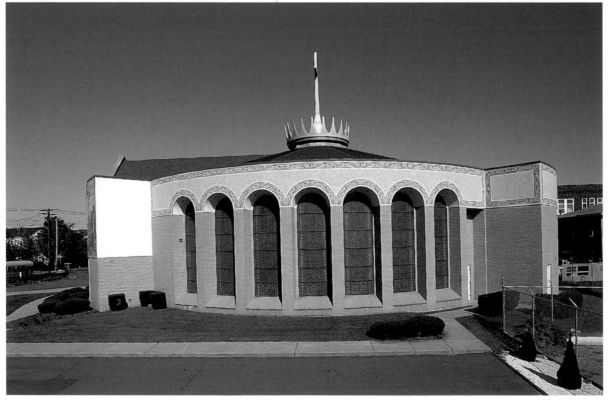

Side view of Saint Mary's Roman Catholic Church, Pembroke Street, Bridgeport, Connecticut, 2002

industrial city. A golden crown, that of Mary, Queen of Heaven, sits on the roof, a full sixteen feet in circumference. It offers a surprising example of vernacular design that can be appreciated even from the Connecticut Turnpike.

Building the new church was a huge undertaking. A poor parish of approximately four hundred families built this 3-million-dollar church in an urban setting without help from the diocese. Father Bernelli organized raffles, festivals, food fairs, and special collections to raise the money. For Saint Mary's inauguration, Father Bernelli organized a parade in which the various Latino nationalities were represented, carrying their flags, and pigeons were released. Now Father Bernelli plans to add a campanile.

Tabernacle of Faith Church of God in Christ, Hoover Street, Los Angeles, 1996

"Hoover Street Dreams": Los Angeles

Until he died of cancer, in 2002, at the age of fifty-five, Bishop Richard Boone pursued his vision for twenty-one years on the 6500 block of Hoover Street in South Central Los Angeles. I interviewed his daughter, Carol. Bishop, as he was called, "was different," she said. "He was born the seventh son of a Texas family, and God used him more than anybody else in that family." She described his birthplace, Karnak, Texas, as a "hick town with few employment possibilities." This led him as a teenager to move with his older sister to Los Angeles. He worked at Felix Chevrolet as a Subaru mechanic until "God told him, off the job." This is how it happened. One day, as he was driving in South Central, he heard a voice instruct him to turn onto Hoover Street, where he encountered a minister, Harvey Brown. He joined Brown's small church, Tabernacle of Faith, and when Brown died a few months later, Bishop replaced him.

"This part of South Central used to be a hard territory," his daughter reported. "Bishop Boone got to know the gang leaders and the members from Gage to Florence avenues. He wanted to get the gangbangers and the prostitutes saved." Bishop acted on matters that grabbed his attention. For example, there was a nightclub a few blocks south, on Hoover Street. People would say, "Don't let that man of God touch this building, or something will change." And it did change; Bishop took over the nightclub, made it into a new Tabernacle of Faith Church, and converted his former church building into a Latino ministry. The façade of this church bore the inscription, "Luke 4: 17–20." Bishop must have chosen that biblical passage for its apt verse: "The

God Tabernacle of Faith Church of God in Christ, Hoover Street, Los Angeles, 1997

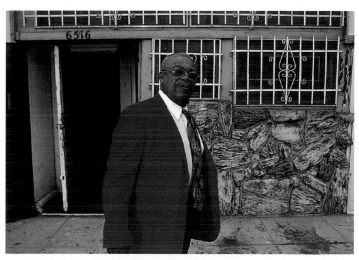

Pastor Claude Boone in front of True God's Tabernacle of Faith, Hoover Street, Los Angeles, 2002

spirit of the Lord is upon me, because he had anointed me to preach good news to the poor."

Everyone knew that Bishop liked the color green. Carol explained, "He liked green so much that he wore green suits, and green tee shirts under his suits, and he painted his church and school green and white." He told her that green meant prosperity. He also had open Bibles painted on the façade, along with an inscribed command, "Speak The Word." To allow drivers along Hoover Street to see his buildings at night, he lit them up. God also asked Bishop to create a church in Leigh, Texas. "There was no leadership there; there was nobody that was real," claimed Carol. "The local pastors were sleeping around and taking people's money for themselves, so the Lord turned to my father to represent him in a good way." Bishop painted the Texas church white and green, just like the one on Hoover Street. He trained a minister to run it and often returned to supervise its progress.

I also spoke with Bishop's brother, the minister Claude Boone. "He wanted to get things done," Claude said of Bishop. "He would start out with an idea, and he would change the idea, and he would keep developing it until it looked like a church. He meant business." Claude described his brother as "a strange fellow," adding, "anyone doing the work of God is strange. They are serious. They don't joke. What they mostly do is what God tells them to do. I have seen God do great work through Bishop, like healing people from cancer. He laid hands on them, and the cancer was gone." Raymond, an associate of Bishop, reported that the minister treated stalled cars the same way; he laid hands on them "and the cars would start running."

I was left with the impression that Bishop, because of his obsession with changing people and things, was a somewhat meddlesome, difficult person. But Claude insisted that his brother was just busy, not a busybody, and that he was relaxed enough to play with little children.

Carol told me that her father "was supposed to die of cancer twenty years ago. The doctor told him that there was no hope and gave him a year to live. An uncle who was saved prayed with him. One night, Jesus performed an operation on him, granting him twenty years to do what he wanted him to do. His wife felt a shaking in the bedroom and something moving under the covers. They [Jesus and his heavenly helpers] were working on him and, when they finished, they left by the window. When Bishop went back

to the doctor, he found a scar and no sign of the cancer."

Tabernacle of Faith is a church with a varied congregation of about one hundred people. In the neighborhood, the Latino population is growing rapidly, and blacks are moving out to the surrounding areas. Many African American churches are closing or becoming Latino churches. In this context, Bishop asked Nestor, a young assistant pastor, to paint a multiracial Jesus on the church's lobby wall. The mural represents a large figure of Jesus, seated frontally, with blue eyes, golden hair, a delicate feminine mouth, and a multitoned complexion (see photo on page 99). Pastor Claude explained that this figure is the color of brass, like Christ in the Book of Revelation: "If you have a black God, a Spanish God, or a Japanese God, you are in trouble. God is all—white, black, and Latino, male and female. The church is mixed wherever we go." To one outside observer, Nestor's figure has a sixties look reminiscent of artist Peter Max's work, and it seems strange as it rises above the linoleum tiles, too big in relation to the usher's table behind which He seems to sit.

The death of Nestor and of Bishop Boone soon afterward, followed closely by that of his wife, left the church in disarray. A power struggle ensued. One of the factions, headed by Claude, set up a church in the original building and has since become a Latino ministry. The second faction, which stayed with Raymond, holds services in the main sanctuary and is now looking for a pastor. Bishop's vision of an inclusive, prosperous church complex seems to be falling apart as the two branches eye each other with suspicion. The once clean, even elegant, green and white buildings, one with a sign in Spanish and the other in English, have changed. The original church now has a scrawled, homemade sign on the front and, instead of its Spanish name, it is called True God Tabernacle of Faith, the word "True" separating it from God Tabernacle of Faith, just up the street.

"My father," said Carol, "touched a lot of lives. He didn't have a big church like Los Angeles' Faithdome, or a big cathedral like Bishop Blake's West Angels Cathedral. What is the purpose of having a big church if you can't talk to the people? People could call Bishop at any hour of the day or night, and he would be available to them. A lot of people who were hurting came and found in him a father figure."

According to Claude, at the time of Bishop's death his

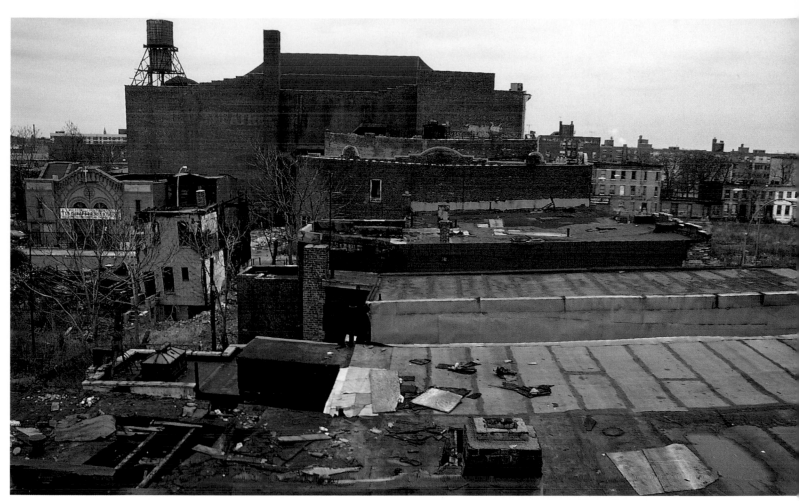

Panorama of East New York, Brooklyn,
from the Sutter Avenue stop of the L train.
Former synagogue Chevra Sphard of Perry Slaw
at left has already become a Latino church, 1978

dream had been to build "one big church to cover that whole block, and a rehab place across the street." Bishop was planning to have a movie made about his life. He had already found someone to write it for him, and he had selected the title: "Hoover Street Dreams."

La Sinagoga: Dancing Your Problems Away in East New York, Brooklyn

For more than two decades, the elevated Sutter Avenue Station on the L line has been a place of pilgrimage for me. I was first drawn there by the vista of ruins extending as far as the eye could see, a scene that could have passed for Berlin in 1945. By 1985, most of the ruins had been cleared, leaving a former synagogue—the Chevra Sphard of Perry Slaw (now La Sinagoga, a Christian church)—standing alone in open fields crossed by city streets. In the early 1990s, this part of East New York, once called "Little Pittsburgh," because of its thriving junkyards and metal shops, seemed on its way to becoming a reservation for the destitute. A large homeless shelter for families, called Help 1, was built east of the church, and a city shelter for singles was installed to the west, in P.S. 63, a former elementary school. In 2002, the construction of warehouses began.

For a generation La Sinagoga was one of the few occupied buildings on Snediker Avenue. It has a sign on its roof announcing the imminent coming of Christ. I wanted to know how people were affected by having their house of worship in such dismal surroundings, what took place inside the former synagogue, and to what extent its former decorations were left.

Today the sidewalks outside the church are overgrown with weeds and trash. In this section of Brooklyn, where the smell of dead animals is intense, people dump tires, mattresses, and used appliances at night. I saw Minister Jorge Lara park his car near the church. Unable to get out of the car without soiling his clothes because the sidewalk was overgrown with bushes and topped with garbage, he moved to a clear spot to exit. Later, Minister Lara told me, "I don't like the area," adding that, "once inside the church, people feel secure." In 1990, I saw a dead body being pulled out of a nearby abandoned building.

On Sundays, order appears amidst the chaos. People

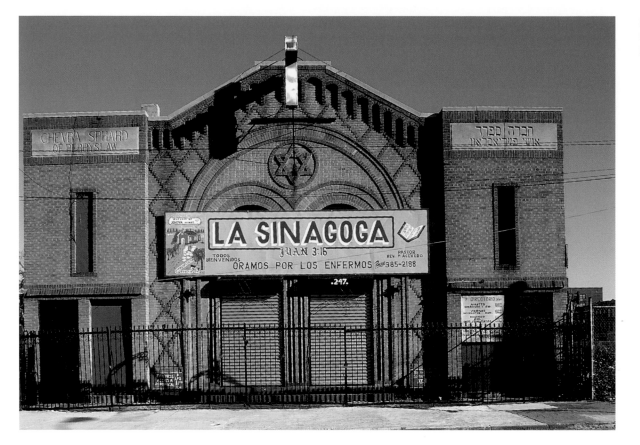

La Sinagoga,
Snediker Avenue,
Brooklyn, 1986

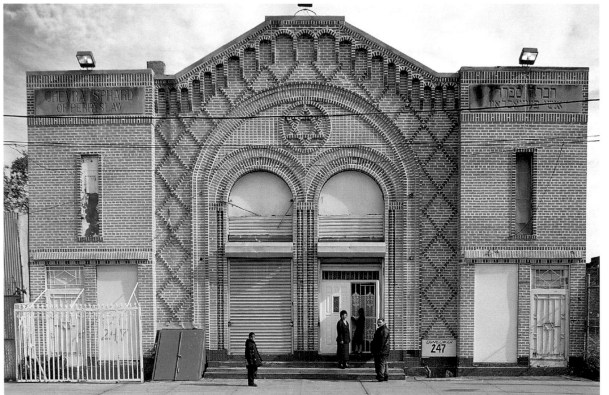

La Sinagoga,
Snediker Avenue,
Brooklyn, 2004

come to the church dressed in well-pressed business suits, white shirts that have been ironed, and with their hair well groomed. Women wear colorful dresses or suits. Children look well scrubbed, and their hair is carefully combed. Minister Rivera, also of the Sinagoga, contrasted the people who come here from all over the city to pray to God with those who unload their trash here. Eric, a teenager, said that seeing all that trash made him "feel that nobody cares." But Irma, a new member, dismissed the impact of the surroundings, saying, "I don't let myself be carried away by appearances."

The façade of the building retains the name of the former synagogue and several stars of David. The lobby has scores of tablets with Hebrew writing, and the year 1928 is inscribed on the top of the wall. The present congregation has added tablets in English next to the old ones. The pastor's wife, "La Pastora," told me that "they want to keep the Jewish character of the place. After all, Jesucristo was born a Jew, and he lived among Jews." Minister Lara explained that the first pastor of the church had "invited someone to translate the tablets and, upon hearing what they said, he told the congregation to leave things as they were."

I was struck by the absence of images in the sanctuary. "We don't worship no idols; we don't burn candles," said usher Felix Hernandez. Two small freestanding white columns on each side of the lectern held vases with artificial flowers, and four armchairs placed behind the columns provided seating for the six ministers. A drop ceiling had been installed. An overhead projector casts the words of hymns on a white screen for people to follow as they sing, and there are large drums and many rattles. Inside, I saw congregants in a prayerful posture: kneeling, bent forward, heads supported on their arms, with arms resting on a pew, a chair, or the low base of the altar itself. They prostrate themselves humbly in this manner, physically self-contained and totally absorbed in oration. At times they stretch out their arms in a gesture of praise. As Hernandez explained, the Bible says that we must pray "down."

The first time I attended service at the church at La Sinagoga, a tablet recorded that eighty-seven people had attended Sunday school there, and of those, seventy-two had brought their Bibles. Men shook hands, women embraced each other, and babies were kissed and hugged. The minister said, "We are in Your house, searching for You [the Lord]." He asked people to come up to the front

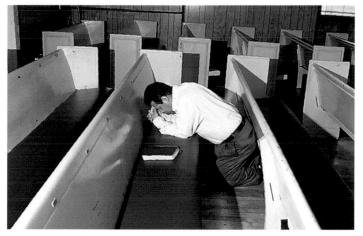

Man praying before Sunday service, La Sinagoga, Snediker Avenue, Brooklyn, 2004

and form a "chain of prayer." He added, "God wants a people that is always happy, no matter what happens to them."

The following week, new people were introduced, complete families were presented as models. People were told that Jehovah was going to take care that their unemployment check would not be discontinued, and that their Section 8 rent subsidy was going to be increased. Those looking for a job were going to find one. The practical issues were repairing the ceiling at a cost of three thousand dollars—because a more beautiful temple was needed for the work of God—and healing the sick. Laboy, an elderly man, was brought to the altar, and six ministers formed a circle around him. Pastor Paulino Gabriel said, "Tissues go back to where you belong. Kidneys start functioning; pancreas start functioning; lower intestines start functioning. Death, you have no part or luck over him; it is not the time yet, it is not the time yet.... I feel four strong devils that want to take him away.... In the name of Jesus, we declare health. Now it is for doctors to marvel, and for laboratories to be astonished. It is done. Hallelujah!" Pastor Gabriel spoke in tongues as the forces of Jehovah did battle with the devils. I was not able to transcribe the words he shouted.

At the end of the service I saw Mr. Laboy. He looked old, weak, and sad. The choir sang, "Because my complaint has changed into dance. He is my king. He is my king. And I will dance in His house."

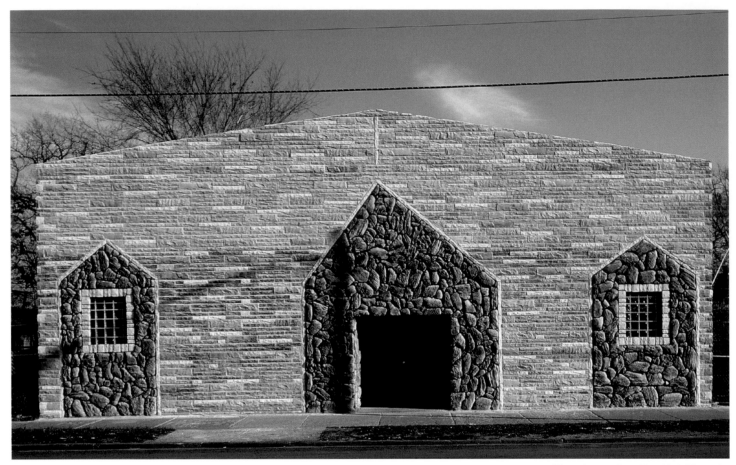

New Jerusalem Baptist Church,
South Halsted Street, Chicago, 1992

Losing New Jerusalem, Chicago

I could never drive past the New Jerusalem Missionary Baptist Church on Halsted Street in South Side Chicago without stopping. The skewed symmetry of the façade would make anyone do a double take: two barred, fortress-style windows and an off-center door, each surrounded by childlike house shapes made of rugged-looking perma-stone. A closer look reveals the one correctly aligned element of the structure, a thin white cross embedded in the siding, directly beneath the apex of the roofline.

My curiosity as to how this design came about led me to interview the church's former pastor, Wilford D. Collins. Born seventy-seven years ago on a farm outside Tuskegee, Alabama, Collins has now retired from both of his jobs, as pastor of the church and as a maintenance worker for the Chicago Housing Authority. I called on him at his current residence, a senior citizen apartment building. He explained the design of the church façade: "They did not put the remodeling in the right hands. It is crooked; it

leans to the north. They had a whole bunch of foreigners like you. They were not serious. They had no business doing construction. I asked one of them, 'Don't you think that it's crooked?' But he just shrugged and walked away."

The building, originally two storefronts, has been in use as a house of worship for forty-five years. Collins talked about his ten-year tenure there: "It was a regular church; it was a religious place to worship God. It was some goodly people; there was some beautiful atmosphere. It was a nice church when I had it. We had about three hundred people there doing the work of the Lord. That is what the church is all about. It was the best church and church people I ever had."

Despite his love for the church, Collins left of his own accord. "At the last draw, it was hell pastoring to these people," he told me. "I did not have a mind. I prayed for them.

At the spur of the moment, I decided to pass the church on to Rev. Michael Harrington in 2000. The Lord above told me to. The word came down: 'Give it up; give it up.'"

In 2001, Harrington changed the name of the church to New Jerusalem Church of the Harvest. It was then renamed, according to Harrington, First New Revelation M.B. Church after two deacons "ambushed it on November 14, 2001." Collins expanded on the story of this changeover: "The church is still in a bad way. Some other people have it now. They were working behind the scenes, these deacons. They were the destroyers. They took all the materials and threw them out on the street. They took everything but the pews. They took the organ. They were hell-raisers and wrongdoers. They are not really and truly honest people. They are children of the satanic group. You are hearing of crazy folks, foolish people. They are haters of God. They pretended that they were Christians, that they were lovers of God. Now they are reduced to having service for five or six people."

I asked Pastor Collins if he still conducted Sunday services anywhere. "We just went south on Halsted Street, seven or eight of us, to the Precious Memory Funeral Home LTD," he answered. The funeral home has a chapel where people can worship. I asked him why only seven or eight attended. His explanation was indirect but revealing, "During service we have to close the doors of the sanctuary so you can't see the dead. People are scared to death of spooks. Once upon a time my wife was shaky. We are more afraid of dead folks than of people living."

After Reverend Harrington was deposed by the deacons, he put his name on a list of people interested in purchasing Saint Leo, a Roman Catholic church on Seventy-eighth Street. Harrington believes that God wants him to have this church, and that the Catholics will give it to him. Reverend Collins's opinion is that Saint Leo "is a real good church, and someone still takes care of it. The Catholic Church wants to sell it to black people. They want to sell it to any people who have money." To obtain funds to purchase the building, Harrington relies on faith: "I know that God intervenes. We will put our mind to it and be prayerful. Besides, the priest wants to get rid of it." Collins's encouraging second view is that "with all the men of God that are doing the work of the Lord, it would not be a problem to fill up such a large church. People are hungry for the Gospel."

Discharging a Debt to God: Pastor John Grier, Los Angeles

Pastor John Grier is seventy-eight years old and is in a rush. Originally from Indianapolis, where he worked as a plasterer, the cold stalling his work every winter, Grier came to Los Angeles four decades ago so he could be employed year-round. He took on contracting and worked on some churches. But now he is building from the ground up "a church for God," namely, The House of God of the Apostolic Faith, Inc. He explains his mission: "I love God enough to spend my money for Him."

"It is a personal thing," Pastor Grier told me. "God put the idea in my spirit. Do you remember David in the Bible? He wanted to build God a house, but God wouldn't let him because he was a warrior; his hands were bloody. His son Solomon built it later." Although a humble, no-nonsense man, Grier doesn't hesitate to compare his house of worship to the Temple of Solomon.

He first started a church in his home a few blocks away, but soon tired of it: "We were in a house, and we wanted a church. We didn't want to be in a house forever." The riots of 1992 presented him with the opportunity to buy a site for $300,000. It had been occupied by a paint store that burned down, but its warehouse and parking lot were intact. Although the site was zoned for industry, Pastor Grier managed to get a variance from the city to refurbish the warehouse as a place of worship. But Pastor Grier disliked the fact that this warehouse-church faced a side street, and that the congregation filled less than half of it. "People don't know that there is a church there," he said. So the new church is going up in the area where the paint store once stood, facing a major thoroughfare.

Grier told me, "God puts a calling in your spirit, and you set to answer the call. We are doing something that is hard." He explained that his big undertaking was confirmed by a prophecy from "a brother in Texas who saw the old building refurbished and a new building going up." Grier had a desire to do a favor for God's people. "They must come together," he said, "You need a place to sit down to hear the word of God explained, and to worship. It would be very difficult to be moving like Jesus today. You can't have a congregation of nomads meeting in parks, in the deserts, or by the seashores."

Grier selected Saint John Chrysostom, a soaring Catholic

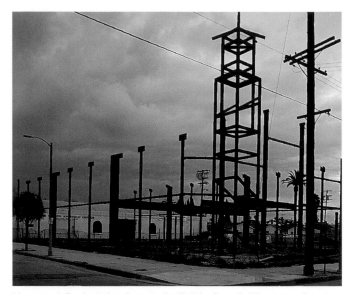

House of God of the Apostolic Faith, South Western Avenue, Los Angeles, 2000

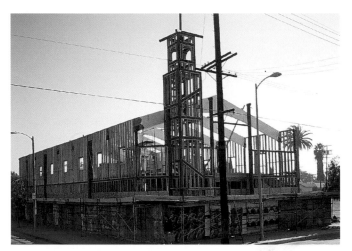

House of God of the Apostolic Faith, South Western Avenue, Los Angeles, 2002

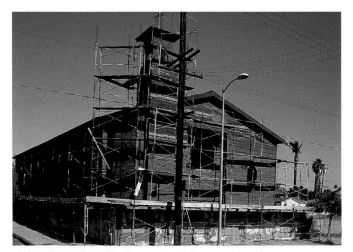

House of God of the Apostolic Faith, South Western Avenue, Los Angeles, 2004

church built in 1959 in southwest Los Angeles, as a model to show his architect, Hugo Suarez. He wanted something conventional, not modern, "a place of respect, a church that looks like a church." Elaborating, he said, "I want to put me a bell up there and play traditional music. When you get there, you want to feel the solemnity of the presence of God. You wouldn't need incense. Your prayers would be sweet smell enough."

I tried to envision the God for whom Pastor Grier is doing such hard work. A hymn called "He Will Do It Again," sung at his church, gave me the picture I sought:

> *There is a way out, you don't have to go under.*
> *He will take care of you.*
> *He will do it again.*
> *He is still God.*
> *He will not change.*
> *He is fighting for you.*
> *He will do it again.*
> *He is a faithful God.*
> *He is worthy of all praise.*
> *He is a God of a second chance.*
> *We do thank God for loving us.*

One of Grier's sermons characterizes God as Almighty, as holding up the stars: "There are billions of stars, all of them got their names, and none of them fall." He later added, "We should honor, extol, and praise God. We love God because he first loved us. I want to see people saved because God has been so good and merciful to me. I want others to find this love. You got reasons to go to church, to get a pardon for your sins. Jesus died for your sins. Don't wait until too late. Heaven's door is going to be closed. Don't wait until it is too late. Come into the ark before the door is closed." Important in his theology, too, is hell where "the fire is not going out, and the worm doesn't die." The worm is "the life that will be in your flesh. What you see is hellfire and the Lord is going to put folks in there. He is going to send some people straight to the fire. Liars are going to hell; fornicators are going to hell; nonbelievers are going to hell. The only way to be saved is to believe."

Pastor Grier believes in being close to his congregation. He maintains that people need to "know where the pastor lives, how he lives, and to know his family," because it "is

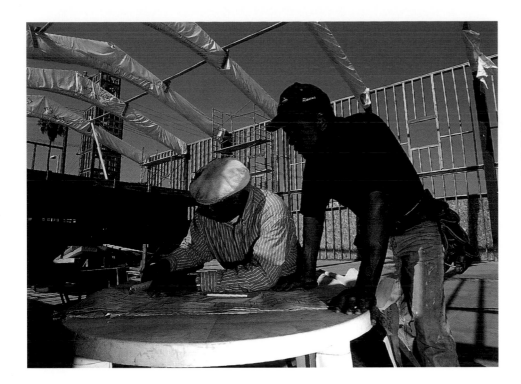

Pastor John Grier and Frank, looking at architectural plans for House of God of the Apostolic Faith, South Western Avenue, Los Angeles, 2002

harder to fool people when they know you and they know your neighbors." He feels people can easily be taken advantage of: "They don't know [personally] the television evangelists, who only may be wanting your money, or prestige and glory."

A church member, Frank, who is helping to build the new church, says of Pastor Grier, "He don't shortcut Jesus." Pastor Robert Nunley, whose church is nearby (and who repaired the organ for The House of God of the Apostolic Faith), describes Grier as different from most pastors, as someone who will "go out there and get an industrial building, and don't even put a cross on it." When I tell Pastor Grier that I like the look of the rising steel frame of the church, he replies, "It worked on your imagination to see a frame there and to imagine how it would come out. When completed, it will look even better."

Lily of the Valley Spiritual Church, Chicago

For almost three-quarters of a century Chicago has been a center for African American spiritualism. Among its tenets is that people were never born and will never die, that they return to their natural state as spirit. Rev. Evelyn Atwood, pastor of Lily of the Valley Spiritual Church, spoke these words to me from Genesis 1:1–2: "In the beginning, God created the heavens and earth. The earth was without form and void, and darkness was upon the face of the deep; and the Spirit of God was moving over the face of the waters." Her speech drew me in, sparking my interest in Lily of the Valley. The words darkness…upon the face of the deep" and "the Spirit of God…over the face of the waters," made

my imagination spin wildly, giving me a taste of grandeur and eternity.

Reverend Atwood, the pastor, explained to me that the name of the church came to Lucretia L. Smith, its founder, in a vision: "We like the attributes of the lily of the valley, and it is in the Proverbs. It grows under so many circumstances, it can die and come back, and it is not hard to raise." Her explanation connected the church's name to the Scriptures, to gardening, and to the power of the spirit over death.

Originally from Virginia, Lucretia L. Smith was ordained a minister in the African Methodist Episcopal (A.M.E.) Church in 1932. Her first job was as youth pastor for an A.M.E. church until, according to her granddaughter, who is also named Lucretia Smith (and is a member of Lily of the Valley Spiritual Church), "her gifts of prophecy and healing began to develop." It was then that she became aware of the Spiritual church. With her husband, a railroad worker, she moved to Chicago and founded her church in 1937. Smith's granddaughter sees her as a pioneer, opening up a way for women to pastor. "Back then, they were not even accepting women into the ministry, and she had the gumption to go for it," she says. At that time, the Bronzeville section of the city had about fifty Spiritual churches, about one-tenth of all African American houses of worship in the area. The spread of black Spiritual churches in Chicago is an example of the city's openness to new ideas, explains Tim Samuelson, the city's cultural historian: "You have people coming to Chicago from many different communities; there is no one group that predominates and tells the others how things should be. That is the city's essence."

**Lily of the Valley Spiritual Church,
West Forty-eighth Place, Chicago, 2003**

Claude Chapman, a member of the church since the age of seven, referred to Lucretia Smith as a "tremendous prophet," and added that the "leader in many Spiritual churches is very charismatic." Chapman saw in Pastor Smith someone he could relate to, who expressed a real connection with God in her sermons and prophecies. When I asked Chapman for an example of her prophecies, he remembered how close the Dan Ryan Expressway came to the church and how apprehensive the community was. "That was a time of great change; a lot of families were forced to leave the neighborhood. Pastor Smith predicted, 'The expressway will come close but not harm the church.'" Pastor Smith also predicted that Gregory Smith, the president of the Brotherhood of Lily of the Valley Spiritual Church, "will have a brand new car and a new job," and he got that.

Asked about faith healing, Chapman told me, "I have seen the blind see, as in the biblical days. The doctors tell you that it can't be done, that he [the sick person] is a goner. We say he isn't dead. Everybody prays and puts their hands on the part of the person's body that is being healed. You pray over and sing, and it would be healed. You can cure anything and anybody, animals too." Yet, instead of express-

ing gratitude, Chapman says that "people don't understand; they call those who make miracles happen witches."

Gregory Smith remembers Pastor Smith as having been an elegant lady: "You know how Southern women dress. Her umbrella, hat, and gloves would match her dress." In 1952, Bishop Murphy studied her life and concluded that she resembled Queen Esther of the Bible. To the right of the altar is a large formal photograph of Pastor Smith taken inside the church, framed like an Old Master painting. The portrait depicts her enthroned, wearing a pink robe and a golden cape. "Nobody had seen a likeness of Queen Esther," says her granddaughter Lucretia, yet most of the congregation had seen photographs of Elizabeth II, who had recently been crowned in London. Smith's silver crown and her wand tipped with a five-point star identify her as a medium, a spiritual advisor, and a reader.

To her granddaughter, Pastor Smith was a person inspired by God. She compares Smith to "Benjamin

Members of Lily of the Valley Spiritual Church, singing, "I really like my God. I do, I do, I do," on the occasion of Pastor Evelyn Atwood's anniversary, 2002

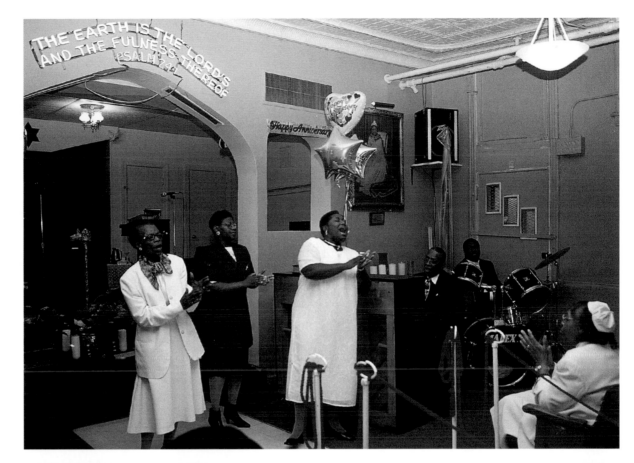

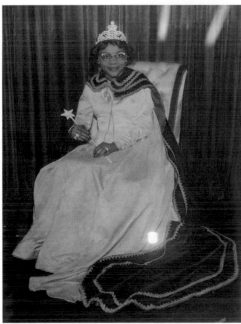

Portrait of Queen Lucretia Smith, founder of Lily of the Valley Spiritual Church, 2004

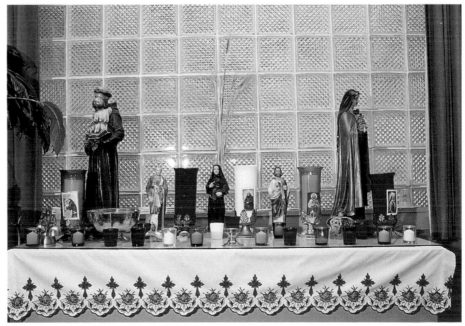

Window ledge of Lily of the Valley Spiritual Church devoted to Roman Catholic religious artifacts, 2002

[Franklin], George Washington Carver, and to the enlightened men and women who wrote the Bible." She explains Pastor Smith's likeness to Franklin: "Benjamin was tired of standing in the dark. He was inspired to invent electricity. God gave them [inspired people] that activity of thought. Then you think on the thing, and you put action behind the thinking, and it materializes. You see the results today."

Lily of the Valley Spiritual Church is affiliated with the Chicago-based National Spiritual Church, Inc. Some of its members attended its annual congress in July 2003 in Columbus, Missouri. "Each time a leader dies, it branches off again," explains granddaughter Lucretia, adding that another association called United Metropolitan Spiritual Church is also based in Chicago.

With its Old Testament and New Testament sections, its red cross on the ceiling and another on the floor, its pink walls representing success and love, its statues bought from Catholic churches, its portrait of Moses, its dozens of candles, and its stars of David ("because it is difficult not to embrace Judaism if you are going to be a prophet," according to Reverend Atwood), Lily of the Valley has remained unchanged for nearly sixty years. Asked how it was designed and how the objects were selected, Rev. Ricardo Croswell said, "That was between God and the founder."

"You wouldn't find any two Spiritual churches alike," says her granddaughter Lucretia. "The spirit may have led the pastor to do this and that, and another pastor to do another thing." Lily of the Valley Spiritual Church, perfectly maintained, with a small, mostly elderly congregation, is for its members a familiar place frozen in time. "There is no reason to change anything," Smith's granddaughter explains, "It works, and we continue to allow it to work. The members under her were her children. You know, when you nurse a child you expect them to utilize what you told them."

Rev. Lucretia Smith died in 1986, at the age of seventy-two. Between 1955 and 1975, the church was always full. But by 2003, Lily of the Valley had about forty members, most of them over the age of fifty. During my visits there I have never seen any children. Claude Chapman attributes the dwindling membership to a national campaign led by television evangelists during the eighties and nineties accusing Spiritual churches of being anti-Christian and demonic. Already in 1984, ethnographer Hans Baer found it not uncommon for founding pastors of Spiritual congregations to "cater to a flock of middle-aged and elderly members."

From her throne, magic wand in hand, Rev. Lucretia Smith continues to preside over her small sanctuary. Her portrait reminds Reverend Croswell of "the fairy godmother coming to Cinderella." The church is a tribute to this godmother who, when she inhabited a body, was inspired by God to establish a church and to assemble and arrange the objects inside it. Or, as the church members would put it, Lily of the Valley is a tribute to the spirit, and Lucretia L. Smith now dwells within the "Spirit of God."

House of Prayer for All People: Chicago, Newark, Brooklyn, Camden, and Harlem

Unlike other houses of worship in the inner city, each with their unique character, it is difficult to think of the many Houses of Prayer as independent from their denomination. I have been to their services in Camden, Chicago, and Brooklyn, and I have visited their buildings in Washington, D.C., and Baltimore. All Houses of Prayer have two lions guarding the entrance, modeled like those representing the British Empire; two brown fiberglass angels on the sides of the façade; and, sometimes, three crosses on the apse of the tower. Typically, in the sanctuary, to the side of the altar, there is a painting of the black Jesus that is signed by John Campbell. Placed behind the altar are large photographs of Bishop Madison, flanked by images of Bishop McCollough and Sweet Daddy Grace, the church's founder. Covered with plastic and located under the portraits is "a throne": a white heavy chair on wheels reserved for Bishop Madison when he comes to town. The leaders are "trying to look substantial and to attract attention. They want a building with a presence. They want to be identified as a United House of Prayer," explains Tim Samuelson.

In response to the question of why the churches are all named House of Prayer for All People, Deacon Golden of Chicago answered, "Why should we have different names for our churches?" Pastor Mack Friday, also of Chicago, explains, "The House of Prayer came straight out of Jerusalem. It is all about Jesus. It started out of little shacks, little storefronts during the Depression. It was done with pennies people put in a bathtub."

During services at the Brooklyn House of Prayer, one Sunday in November 2003, I saw women counting money

United House of Prayer for All People, Haverford Avenue, Philadelphia, 2004

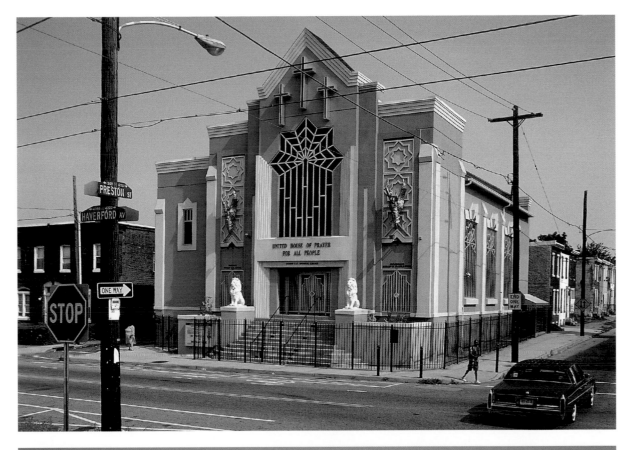

United House of Prayer for All People, South State Street, Chicago, 2000

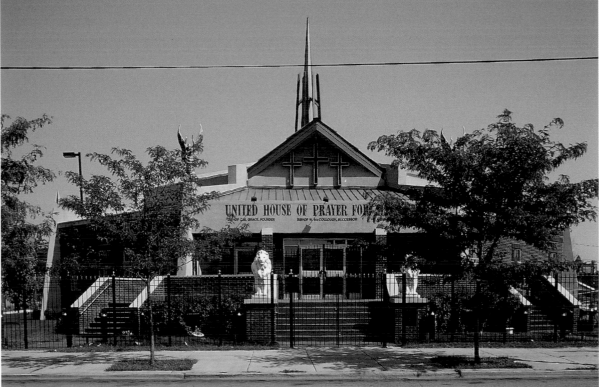

Stained-glass window with portrait of Sweet Daddy Grace, a Cape Verdian immigrant and founder of United House of Prayer for All People, Frederick Douglass Boulevard, Harlem, 2002

"Sweet Blessings," fiberglass angel, United House of Prayer for All People, Fulton Street, Brooklyn, 2000

on a table in front of the altar and announcing the names of congregants and their contributions. Sister Cornelia and Sister Sumpter each gave 5 dollars, Brother Williams gave 10 dollars, others gave as much as 140 dollars. People listen carefully to the reading of their contributions and correct the amount if it is wrong. On one Sunday morning in October 2003, in Newark, the collection total was 306 dollars.

Pastor Friday explained, "God is in control. He is in control of the sun, the moon, and the stars. God said 'Let there be light, and there was light'; we can't do that. One day is to the Lord like a thousand years." In the Chicago House of Prayer I saw a form labeled "Holy Ghost Evaluation Sheet," that asked where one stood with God. The possible answers were divided into two categories: "Fruits of the Spirit," and "Works of the Flesh."

Although members of the House of Prayer exemplify humility, the leaders do not. During a service I attended, a woman said, "Do whatever you have me to do, and I thank you. I could have had cancer; you kept these bones together." And people sang, "Where He leads me, I will follow," "Children, hold His hands," or "How sweet the sound that saved a wreck like me," while praising "Precious Sweet Daddy McCollough." Bishop McCollough, whose presence is felt through his white chair and his stern-looking portrait, holds center stage.

Jesus Goes to the Dirty Places: Skid Row, Los Angeles

The "down and outs" who populate skid rows across the country attract Christian missionaries. Amid degradation, the name of the Lord is constantly invoked. Here, much as in church graveyards, visitors are reminded that "what I see can be me." The locale's savior is Jesus, and its book is the Bible. "Jesus comes to you in skid row," reads the sign of the Azusa Lighthouse Mission on Fifth Street. "Jesus said to teach to the poor," explains Pastor Mike Davis of the Emmanuel Baptist Rescue Mission. When things go wrong, or a wife is unfaithful, or someone has a drug or an alcohol problem, people are ready to listen, and Pastor Davis believes, "The only thing that can change people's lives is Jesus Christ." He is convinced that "there will be more poor people than rich people in heaven."

Pastor Kim of The Street Mission @ Los Angeles goes out

Father Maurice Chase (in white baseball cap) distributing dollar bills on Easter Sunday on Towne Avenue, Los Angeles, 2003

Limousine rented by congregation of Holman United Methodist Church to take homeless families to Easter service at their church and then shopping, San Pedro Street, Los Angeles, 2003

Easter dinner for skid row residents, sponsored by Los Angeles Mission, Fifth Street, Los Angeles, 2003

to skid row because of his "calling." Minister Lee, also with The Street Mission, says: "We have to help poor people. It is in the Bible. They need the food, and they need spiritual food." Esther Gook Na of the Well Mission explains why so many Koreans are drawn to the area: "Do you remember the Korean War? We were very hungry. We are very sorry for the homeless, and we are very eager to feed them."

Every morning at 9 a.m., Esther drives her Dodge Caravan to pick up Krispy Kreme donuts, and then she distributes them at Sixth Street and Towne Avenue, but only after a short reading from the Bible. "I pick up donuts," she says, "and serve them, as many as they want. They appreciate them very much. Sometimes I bring them Korean noodles, and they like them very much, but they cost money. I can't do it very often." These activities are now threatened by City Councilwoman Jan Perry. Perry has introduced a motion that would end food handouts on the streets of skid row to bring it in line with other parts of the city. Perry reasons that the practice is unsanitary, that there are insufficient cleaning facilities, and that sometimes the food just comes from the back of a truck.

Father Maurice Chase, a Catholic priest, has been distributing dollar bills on Towne Avenue and Fifth Street every Sunday for the past twenty years. When someone seems particularly bedraggled, Father Chase occasionally bestows more. On a typical Sunday, he gives out three thousand one-dollar bills, sometimes donated by friends like Barbara Sinatra and the late Bob Hope. By the time Father Chase arrived on Easter Sunday 2003, people had already formed a line that curved around the corner of Fifth Street. Among those queuing up were people in wheelchairs, women with babies, and men pushing shopping carts. Alongside those waiting for handouts were two police vehicles, two security guards, and two television trucks with their crews. It felt more like Palm Sunday than Easter, when Jesus rode through Jerusalem and was hailed as the Messiah. Father Chase, a former public relations executive, has created a ritual that attracts large crowds of street people, a longstanding spectacle well suited for national television.

Why do people make so much fuss about an eighty-five-year-old priest who worships Jesus and is proud of his celebrity connections? For one thing, Father Chase doesn't look out of place on skid row, and he admits that he could

have become a drunk himself. Mother Teresa advised him to touch poor people. He gives out the bills with a kind smile, a handshake, and sometimes a blessing. I couldn't help but be moved by the solemnity of the encounters, and by people's intensely expectant looks, as if awaiting miracles. Father Chase told me that when he blesses people, he "asks in Jesus' name for them to be healed."

He doesn't mind if people use the dollars to buy a glass of wine. Sometimes he drinks two glasses himself, believing that if he lived on skid row he, too, would drink much more. Until recently, no one had ever tried to harm Father Chase. Then, he recounts, "A man hit me in April 2003. He almost knocked me over. What if this man had had a knife? It is a wild place here." Happy with his Sunday charity, but having no successor in mind, he thinks his job will die when God "takes" him. The reason, Father Chase tells me, is that he cannot pass along to somebody else the trust he has engendered among his famous donors.

Easter weekend in 2003 was a big event for many reasons. Security was tight all around. On Towne Avenue, Willie Jordan, co-founder of the Fred Jordan Mission, was taping an appeal for help for the mission. Holding a Bible, she said, "Family values, a term we hear a lot today, family values on the streets of skid row, fried chicken and children playing. We need your help to keep the doors of Fred Jordan Mission open." Festive tables and tents decorated with balloons were arranged on the streets, and lunch was served to the homeless by mostly white and Asian teenagers.

On San Pedro Street I saw two large limousines parked in front of the Union Rescue Mission, waiting to bring families to Holman United Methodist Church for service and Easter dinner, and then to take them on a shopping spree. Pastor Henry Masters explained that this was the second time he had brought families to his church by limousine. His inspiration was the Academy Awards, which, he had heard, depended on fifteen hundred limousines to chauffeur the celebrities. His intention was to invert the dominant priorities of society, "We wanted to make the least important person feel honored, like the most important person."

Later, a beat-up church bus parked in the same spot in front of the mission, and Pastor Mitchell emerged. He was there on Easter, as he is every Sunday, to pick up homeless people for a service at his church on Florence Avenue,

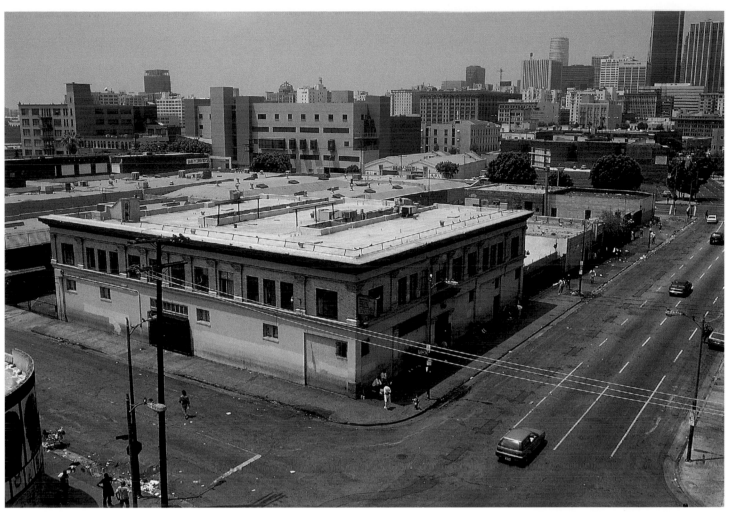

**Emmanuel Baptist Rescue Mission,
Fifth Street, Los Angeles, 1996**

complete with a breakfast of eggs and grits. People know him because of his faithful visits. For about three years, Mitchell was himself a skid row resident, "a practicing alcoholic, sleeping on Fifth Street and on Saint Julian Street." But, as he now strongly believes, "God delivered" him. He acknowledges that hunger is not a problem on skid row: "People are bringing food to that area every hour. There is food, food, food; they have more food on skid row than at my home." He visits here because "the homeless have the slave mentality, and need help to get out of there." He compares the street people to the Jews in Egypt, and himself to Moses, his mission to lead the way to the Promised Land. He would set up a recovery home were his resources not so limited. Like most religious activists, Pastor Mitchell believes that faith-based programs are effective in assisting people who need help overcoming their addictions and pulling their lives together. He is convinced that government-run programs preserve the mentality that keeps people in skid row.

Emmanuel Baptist Rescue Mission, Inc., Skid Row, Los Angeles

God came to seek and to save that which was lost. Luke 19:10

On my field trips I often drove past the Emmanuel Baptist Rescue Mission, but its heavy iron gates were always closed. A former hotel, the building is located on the southwest corner of Crocker and Fifth streets, at the heart of skid row, an ideal place for a rescue mission. The corner, however, is a busy crack spot; dealers and their clients make it difficult for people to attend services. To clear the area, Pastor Mike Davis, who runs the mission, often turns on the sprinklers.

Once I found the gate to the parking lot open, and so I went in. I asked Pastor Mike Davis to explain the difference between a church and a mission. He replied, "A mission is to get people saved, to increase the numbers of believers, a place for evangelism. A church is for people who are already saved to be trained to grow in Christ." The Emmanuel Baptist Rescue Mission was started by Joe Hill,

Room with three beds, Emmanuel
Baptist Rescue Mission, Fifth Street,
Los Angeles, 2003

Pastor Philip N. Bates of Fellowship Baptist Church
with his wife, Janet, at Emmanuel Baptist Rescue Mission,
a former skid row hotel, Fifth Street, Los Angeles, 2003

whom Davis described as "a drunk that got saved and dedi-
cated his life to get drunks out of skid row." A sign on the
wall inside the mission reads, "Blessed Information Bring-
ing Life Eternal," forming the acronym BIBLE. An aide
took me to a second-floor corner room, a place used by the
police to observe drug transactions on the street. I opened
the curtains, which were so frayed that they ripped, send-
ing dust flying all over the room.

Pastor Philip N. Bates, whose Fellowship Baptist Mission
Church holds regular services at Emmanuel, told me, "This
is very different. You don't have the normal constituency of
a regular church; this is not a stable environment. The
membership is very fluid, many of the people you see only

once. Here we do street evangelism; we go out on the
streets and hand out tracts. We preach the word of God."

On a later visit, I found Pastor Bates holding morning
services in the mission for a group of forty men and one
woman. He told them, "The Lord wants the best for all of
you. The Lord is good, and He is fruitful. You are wicked,
evil, ungodly, and depraved. It is by nature. Now Jesus
Christ came to save you. He can change your nature. He
went to Calvary. He died in your place. You can bring all
kinds of names today, but nobody can save you, only Jesus
Christ. Nobody else has that power. Only Jesus Christ can
revive you. We are lost in this world, but He sees a child of
God in you." One bench in the chapel bears a handmade
sign that reads "Canes + Crutches only."

Pastor Carl Shriver, of the Pine Street Baptist Church in
Norwalk, has been serving in the Emmanuel Baptist Rescue
Mission for thirty-two years, arriving every Friday to teach
the Bible. He remembers when the people coming were
electricians, carpenters, painters, and other skilled workers,
each with a drinking problem. They were much easier to
deal with than their more recent replacements, who tend to
be unskilled, disoriented, and addicted to drugs.

Inside the chapel, as well as in the dining room, I
encountered the bold, earnest paintings of John B.
Downey, described as "a gentleman that would come here,
stay a few days, and paint signs." As vernacular art, the
paintings include inscriptions that mix font styles, sizes,
and colors. Downey liked to start a line of text with a single
red letter and then continue in black. He also used red cap-
ital letters to spell out words such as *God, the Lord, Jesus,
Christ, drunkenness, hell,* and *fire.* The color blue he reserved
for heaven and salvation. His work fits well with the mis-
sion since it is about right and wrong, God and the devil,
and salvation or damnation. To prevent his images from
being taken as an inducement to idolatry, Downey wrote

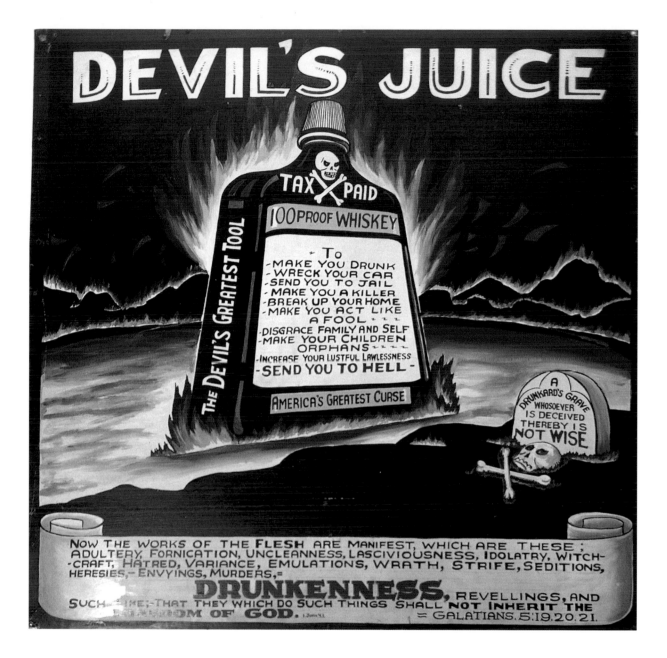

Devil's Juice: America's Greatest Curse,
painting by John B. Downey at Emmanuel Baptist Rescue Mission,
Fifth Street, Los Angeles, 2003

under one of his paintings, in uncertain English: "Picture not worshipple, just illustration: Gospel is true." Biblical quotations fill his works and, in one case, the text is painted as a representation of an open Bible.

Pastor Shriver remembers Downey coming to the mission about three times during winters in the late 1960s, and staying for about two weeks each time. "He was a black man in his late forties, about five feet, ten inches tall, with a forty-six-inch waist, a quiet man, not a fighter. He came in and out of the mission. He ate by himself in the back." Pastor Davis thought his paintings were a way to pay for his stay.

"We value the old values at Emmanuel," says Pastor Davis. "We go down there and preach, and that is about it. The room is not important; it is the people and the work of the Lord in the inside that matters." But the room is important enough, since John B. Downey's old-fashioned paintings are still intact and are in their original places after more than three decades. One of these paintings, done in a comic-book style, depicts a gigantic hand and is labeled *The Christ*. The hand is lifting a perfectly groomed white man, who is wearing a business suit, as if he were on his way to a job interview, and who has a smile on his face, from a black ocean that is labeled "Mire of Sin." (See photo page 186.)

A piece titled *Devil's Juice,* considered Downey's masterpiece, depicts a black whisky bottle rising from a sea of fire. On the shore in the foreground is a tombstone inscribed, "A drunkard's Grave." One can sense Downey was struggling to stay sober while craving whisky. Indeed, on the label of *Devil's Juice* he wrote: "100 proof whisky to—Wreck your car—Send you to jail—make you a killer—Make you act like a fool—Disgrace family and self—Make your children orphans—Increase your lustful lawlessness—SEND YOU TO HELL—," and on the banner below the bottle, he added: "Now the works of the flesh are manifest, which are these: adultery, fornication, uncleanness, lasciviousness, idolatry, witchcraft, hatred, variance, emulations, wrath, strife, seditions, heresies,— envyings, murders,=." Most of his signs have an old-fashioned threatening tone, such as "The wages of sin is death" and "Behold Now is the Accepted Time; Behold Now Repent or Perish."

Barely touched by time, the chapel and the dining room are filled with first-rate paintings and old promotional signs bearing witness to a God who died on the cross to save the wicked, the evil, and the depraved. The vision of John B. Downey includes a developed hell that he depicted as erupting volcanoes, a mire of sin, and an underground furnace, as well as a heaven that he portrayed as a modern institutional building erected on a rainbow-colored foundation, situated near a lake. (See photo page 198.) He warns us that because the wicked refuse to repent, God will take vengeance: "They will perish, He will destroy them and He will send them into the lake of fire."

Artist John B. Downey's whereabouts are unknown. Pastor Shriver believes he is now dead and that he died in a bad way. The mission has barely changed since he used to stop by. He slept upstairs in a room he shared with two other people. Near the showers is a room with color photographs of lighthouses, touristy images from Maine and other coastal places. At the mission, the light comes from God and is there to show people the way to salvation.

Preaching the Word of God on Sixth and San Pedro Streets, Los Angeles

Lawrence Moore, a resident of the Union Rescue Mission in Los Angeles, says, "God has given me a heart to preach to people who are lost down here. He gave a love to people who are on crutches." When I asked him why God allows them to be on crutches, he replied, "It is not the Lord that is treating them bad; it is Satan. The Lord wakes them up every morning; we don't wake up by ourselves. Everything comes from God. There are some that He chooses to go through a life of hardship and pain, and there are others that go through a life of prosperity and riches." Moore explained that while those lost are "down here," the fortunate ones are "all over the T.V."

I asked Moore how he made a living. "I don't have a working history," he responded, adding that he used to sell dope and steal before he became a believer. Now he supports himself by cleaning latrines in the mission, where he lives. When I asked Moore if he was a preacher, he seemed unsure and answered my question with a question: "What establishes a preacher to the world? God has allowed me to proclaim His word on Sixth and San Pedro streets." When I asked if I could take his picture, Moore said, "with my Bible" and, as I left, he said, "I pray that God will come and save you."

Lawrence Moore preaching,
South San Pedro Street,
Los Angeles, 2004

Sam preaching, Fifth Street, Los Angeles, 2003

Sam, Street Preacher, Skid Row, Los Angeles

I first saw Sam preaching on the corner of Fifth and Wall streets in the summer of 2003. He was wearing a suit, and a medal bearing the word "God" hung on a chain around his neck. He was holding a yellow *Good News Bible* in his right hand. Fifty-two years old and very thin, Sam originally hails from Montgomery, Alabama.

Sam told me that God had urged him to preach, but that he was "slow to answer his call." He had experienced his share of tragedy before he started preaching. His beloved mother died when he was eight years old. All he wanted was to be with his mother, but since this was no longer possible, he decided to do his mother's work. He took care of

his younger brothers and sister, neglecting his schoolwork. His father, an alcoholic, used to beat him. Later on in life, Sam's wife left him, taking his newborn son with her. All that Sam wanted was "the Lord to fix the situation," but she didn't return. Less than a year ago, after having been missing for a week, the body of his twin brother was found eight feet under water in a reservoir, next to a spot where his brother used to stop and pray on his way to work.

Sam had come to Los Angeles in 1965, at the age of fourteen. At twenty-four, he taught himself how to read, using the Bible. He would memorize the passage read during church service, mark the page where it was written, and go over it letter by letter until he could read it. Later, he

became addicted to crack and spent some time in a detoxification program at the Union Rescue Mission. While he was there, Sam met Pastor White, with whose help and that of God, he claims, he rid himself of his addiction. To make a living, he now works in a warehouse.

Called by God one year ago, Sam became a preacher on skid row. "I was walking along Fifth Street," he recounts, "and reading my Bible, and the Holy Ghost came to me." But, in another version, God called him through "this big, huge white man. He was a security guard. He was filled with God." Sam believes, "God is in the business of saving us. I am dominated by sin, but God is in my heart. If you seek his way, if you humble yourself, if you yield to God, He can overpower sin."

From his lodgings in the Alexandria Hotel, Sam walks east along Fifth Street to the section of skid row called "the Nickel." Sam explains that he doesn't know where he is going to preach or what he is going to say: "I leave it all to the Holy Spirit. It is just a matter of surrendering. When you surrender, the Holy Spirit speaks through you. You have to have that connection. Sometimes I start walking and just lose myself."

As I photograph Sam preaching on the corner of Fifth and Wall streets, a young black man approaches and gives him a hug. He asks Sam, "How are you doing, my brother?" Sam answers, "God bless you." Sam tells me that "when they respond to me, that is His way of encouraging me." But later he contradicts himself and says, "I don't pay attention to the people. They are God's business. Only God can open their minds."

Once a man told Sam, "All you need to do is being ordained." Sam replied, "I don't care about being ordained. All I care is about doing the will of God." I remark on the fact that the total of Sam's religious investment, including his Bible and his medal, cannot have cost more than twenty dollars. Sam tells me that he has more Bibles in his hotel room. He does not seem eager to have a church and a congregation; his mission is limited to preaching the word of God. When I ask Sam if he has made any disciples, he answers, "Once a man comes, we can relate in prayer until he can walk on his own." I also ask if he has made enemies, and he replies that he once was shown a long knife and told to stay away from a drug area near the Los Angeles Mission. Another time he was called a hypocrite.

While he was preaching, I noticed he repeatedly thrust his yellow Bible outward as if he were fencing with it. After a few of those thrusts, he would let the book drop onto the pavement and then quickly pick it up. I pointed this out to Sam, and he explained that he had not thrown the Bible but had let it fall gently, and that those listening understood that he did this "to bring up a point. I don't see another book on top of the Bible."

Once, when I was looking for Sam, I saw him walking north along San Julian Street, his yellow Bible in his hand. I parked my car in the middle of the street and climbed onto its roof to photograph him. A young, shirtless, homeless man ran over to mug me. I jumped off the roof, but he grabbed me. I screamed to Sam for help. "Don't do that," he told the man. "God will help you. I will give you two dollars, come on, come on."

The next time I saw Sam, he told me that my assailant was on parole. Sam had explained to him that it was crazy to do what he had done because it would put him back in jail. I asked Sam if there was anything I could do for him. Sam asked for nothing, not even my name.

3 Architecture, Design, and Urbanism

Varieties of Religious Expression

The lexicon that follows contains much documenta-
tion of the words I found people using to praise
God, to explain the various missions of the
churches, and to bring a congregation together as a
family. The terms selected cover only those I encoun-
tered most frequently, their meaning was explained
to me by church members and officials.

The Bible functions as the essential, originating
text, from which people create a primarily oral cul-
ture. The written words, for example, on signs, tend
to be fleeting. I have focused on biblical passages
and themes that appeared most frequently during
services and interviews; on church walls; in bul-
letins; and on church answering machines. Pastors
and church officials had selected these words with a
feeling for the issues facing their congregations.

Contact paper, The House of God,
139th Street, Robbins, Illinois, 2004

Church Styles

Most ghetto churches evolve from existing buildings whose forms and signs bear witness to former use. The people responsible for the design typically attribute their choices to a desire to make the building look like a church, to maintenance needs, to chance, to crime, or to the advice of the Lord. When I suggested that Christian symbolism had influenced the selection of colors, steeples, script, bushes, or furniture, I was often told that there was no symbolism involved. One pastor told me, "We base our-selves in one thing, and that is the Lord." Traditional churches are adapted to new congregations. New churches are often sanctified warehouses, anonymous buildings that lack architectural distinction; they mainly function as places of assembly.

Why am I looking for authenticity in structures that are often adapted for religious uses, express contradictory meanings, use "fake" and found materials, and are often the result of collective efforts? Through its physical fea-tures, a building affirms its presence as the house of God, as something permanent, a home for the religious life, a place to articulate beliefs, and a symbol of the identity of the pastor and the congregation. The use of "fake" materi-als may be the cheapest available means to portray the church's mission. It is ironic that the use of artificial mate-rials, along with a nonprofessional execution of renovation or construction, can add individuality and authenticity to houses of worship.

What is practical is more important than religious symbolism.
 Pastor Felipe Salazar,
 Iglesia Apostolica Hosanna,
 Compton, California

The Lord said "build a church." He gave us that style. We were
praying; God revealed that to my wife. She told me that the
Lord was saying we had to get blue bricks. We followed his lead.
We went to a place on Seventy-ninth Street on the West Side to
get them. They had to order them. We had to wait for three
months. We are making contemporary adjustments, to have a
contemporary church to accommodate the congregation.
 C. B. Garrett, pastor,
 Redeemed Tabernacle Church of God,
 Pulaski Road, Chicago

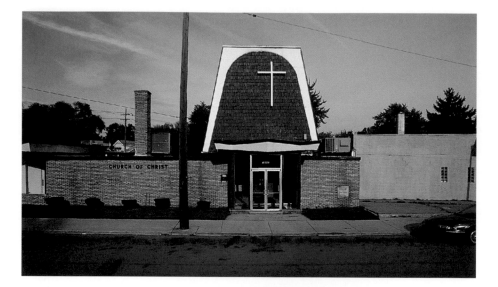

Church of Christ of Conant Gardens, Conant Avenue, Detroit, 2002

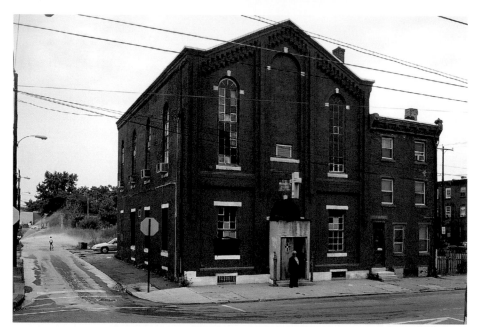

Lewis Temple Church of God, formerly First Mennonite Church, which was founded in 1885, Diamond Street, Philadelphia, 2003

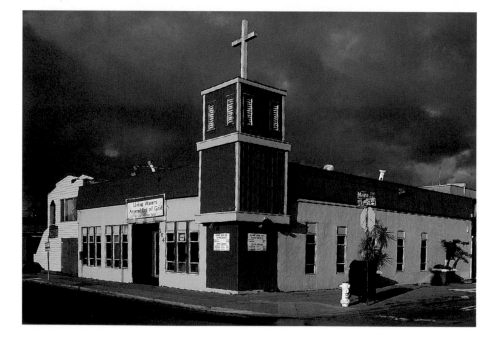

Living Waters Assemblies of God, Twenty-third Street, Richmond, California, 2004

Committed to Christian Christian Church, West Hopkins Street, Milwaukee, 2004

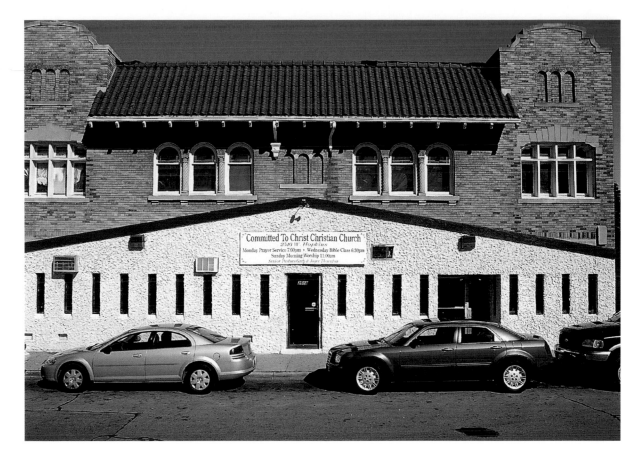

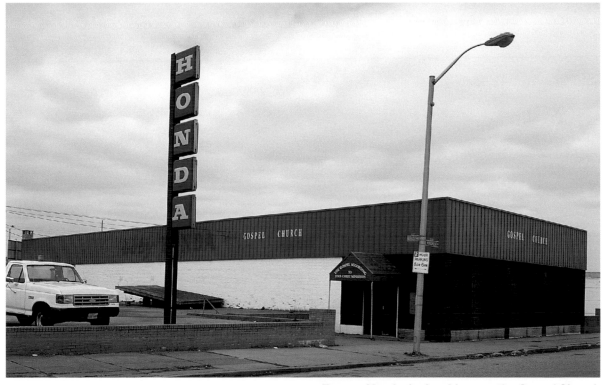

Former Honda dealership, now the Gospel Church According to Jesus Christ, East Monument Avenue, Baltimore, 2002. Pastor Gales told me in 2004 that she was pleased that the prominent sign had room for five letters because it had been easy to replace *Honda* with similar-size letters spelling the word *Jesus*.

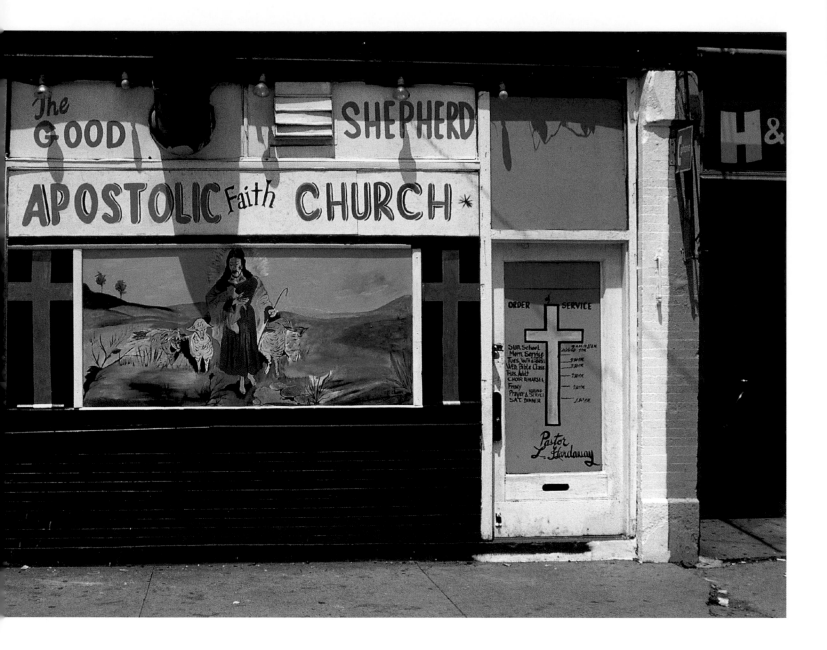

**Good Shepherd Apostolic Faith Church,
West Madison Street, Chicago, 1982**

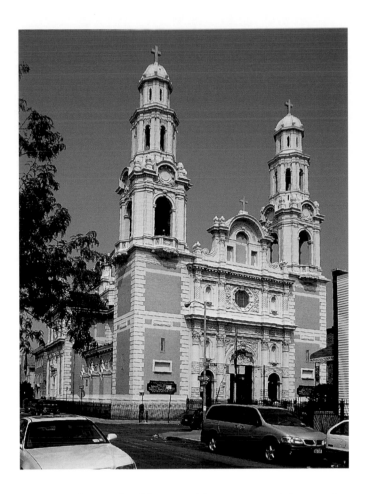

Santa Barbara Roman Catholic Church, erected in 1910 in the Spanish baroque style, Central Avenue, Brooklyn, 2002

I had seen churches in the South; I went to Atlanta and Florida. I had the design in my head. I wanted to give it character. The congregation liked my design.

Roy, an Hispanic contractor, is remodeling the Greater True Friendship Missionary Baptist Church, West Vernon Avenue, Los Angeles

This used to be a Safeway supermarket. When they were redoing the building, they sent for columns; it was the pastor's idea. They give the church a colonial or a Roman look. I don't think they connect to the Lord; it is just decor.

Gale Jones, West Eighty-eighth Street Temple Church of God in Christ, Los Angeles

I am going to wrap this building [a former bank] up with Dryvit [a Dryvit system exterior]. Do you know anything about Taco Bell buildings? This is what they are covered with. The flat roof will remain.

Pastor Isaiah Grover, Saint John Church of God in Christ, South Cottage Grove Avenue, Chicago

I do know it was originally a movie house because an old lady in the congregation said so, but when the church bought the place it was a garage.

Rev. Earl L. Stokes, pastor, Christ Chapel M.B. Church, East Forty-third Street, Chicago

It was a chicken place; they slaughtered chickens here.

Pastor Charlie L. Jones, Nadeau Street Community C.O.G.I.C., Los Angeles

Pastor McClintock moved from Greater Harvest to the Hollywood Palladium. The members were complaining of the smell of cigarettes or alcohol left from the night before when the place had been used as a theater. It means something when the building is dedicated exclusively to praising God.

Pastor Leonard E. White, Holy Mount Calvary M.B.C., South Main Street, Los Angeles

What I have here is attractive to me; no Scripture, no decoration at all except for the cross. If I was buying a church, I would want it to be more church looking [than the present building, a former post office].

Pastor O. C. Morgan, Evening Star Missionary Baptist Church, South Cottage Grove Avenue, Chicago

We want the Lord to bless us with a garage, with enough space to have a full ministry and a place of worship.

Pastor Robert Joiner, Broadway, Brooklyn

A church is supposed to look clean and whole, so that the spirit of God can dwell in it.

Elder Charles Mack, Holy Defender C.O.G.I.C., Los Angeles

You have to beautify the house of the Lord. Haggai, 1

Archbishop Anthony Monk, on a poster at Monk's Memorial Tabernacle, Fulton Street, Brooklyn

Outside beauty is not important. I want to know what are they doing for the community? Are you working with the youth? Are you working with the schools? Are you working with the police?

Minister, Central Brooklyn

It doesn't look like a church, but it has a sign saying, "Church of Christ" in front. You notice the name from the Dan Ryan Expressway. We are a different kind of church; it didn't bother us that it didn't look like a church.

Chatham-Avalon Church of Christ, Eighty-sixth Street, Chicago

We can make our own style because we use some Catholic things, we use statues of saints, we use the star of David, and

that would be more Jewish, and we use candles for the light of the world.

Rev. Evelyn Atwood, Lily of the Valley Spiritual Church, Forty-eighth Place, Chicago

We can be a Baptist church in a former synagogue. We have in our beliefs residuals of the Jewish faith. We share some of their symbols.

Pastor Jackson, New Mount Hebron Baptist Church, North Avenue, Baltimore

This is a nondenominational church in the building of a former German Lutheran Church. Lutherans are not different from us. They believe in Jesus. Besides, a lot of people don't know the history of the building. [Pastor Anderson added that blacks could not have joined the congregation as late as the 1960s and that, if they had become members in the 1970s, they would have been reluctantly accepted.]

Pastor Willie Anderson, Sword of the Spirit Christian Center, Kaighns Avenue, Camden, New Jersey

How Do Churches Evolve?

The pattern over time is for churches to become sober and established. The more a building resembles a traditional church, the less is the incentive to change it, for the building already conveys the image of religion and respectability that the congregation desires. For example, an established church may choose a more subdued color scheme, use professional lettering for its signs, and may add an A-frame or a steeple.

Making a building more like a church can mean different things, depending on whether it concerns the church's façade or the interior. First of all, the exterior needs to be fortified, windows barred, metal doors installed, and signs for alarms placed visibly. Secondly, the congregation eliminates discordant notes. Finally, the façade is made to approach the look of a traditional church by eradicating features of its former life—such as store windows and signs advertising its previous use—and through the addition of symbols like crosses and steeples. As the interior of the structure is upgraded to satisfy the city's code for public places, the building is also made more like a church because only with city approval can it legally operate as a house of worship.

Pastors dream of building their own churches and, when they do, they are often unable to see them completed. Typically, a pastor may buy the land and draw plans for the edifice, but his or her successor completes the project.

The majority of pastors interviewed denied the importance of the structure itself. "Jesus didn't have a building," said one. Another replied, "Buildings don't take people nowhere." Yet the building does matter; otherwise, the congregation wouldn't improve it. Pews and altar furniture are replaced, bathrooms are added, and new roofs are put on. Why would a congregation create imagery and commission decoration, unless they were making a conscious effort to give the building permanence and respectability?

We had an architect, but we didn't finish the building according to the plan. Then we had a contractor to follow the plans as closely as he could, but he didn't. We have to finish the Fellowship Room downstairs, put a fifteen-foot cross on the steeple, pave the driveway, and landscape the place. And we can't do it because we have a holding pattern on money.

Usher, Phillips Metropolitan Christian Methodist Episcopal Church, Morris Avenue, Newark

Eventually, Heavenly Rainbow Baptist Church is going to look like a church. I am going to add a toilet, a seven-foot-wide door, a baptismal pool, a choir platform, and a restroom for the handicapped. The outside of the church will always look the way it looks now.

Pastor Raymond Branch, Heavenly Rainbow Baptist Church, Western Avenue, Los Angeles

The church is going to be transformed through prayer. We are giving the plans to an architect to give us a design. We want to renovate the building inside to make it conductive [sic] *to services. There is a bathroom under construction right now, and we want to repair the electrical and plumbing systems inside.*

Pastor Olawale Olayinka, Calvary Touch of God Ministries, Bergen Street, Newark

Saint Peter's
Pentecostal
Tabernacle
Deliverance
Center, Home
Street, Bronx,
1993

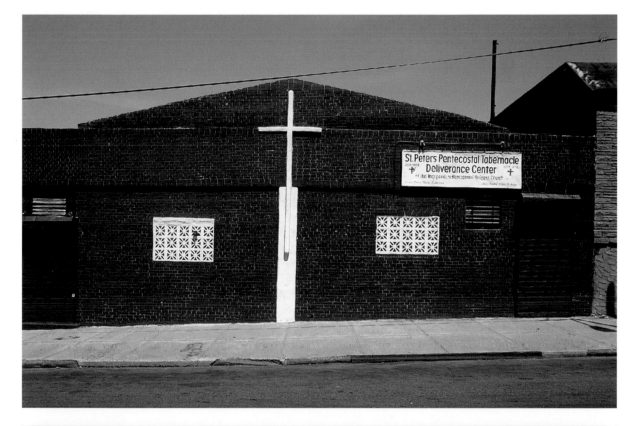

Saint Peter's
Pentecostal
Deliverance
Center, Home
Street, Bronx,
2002

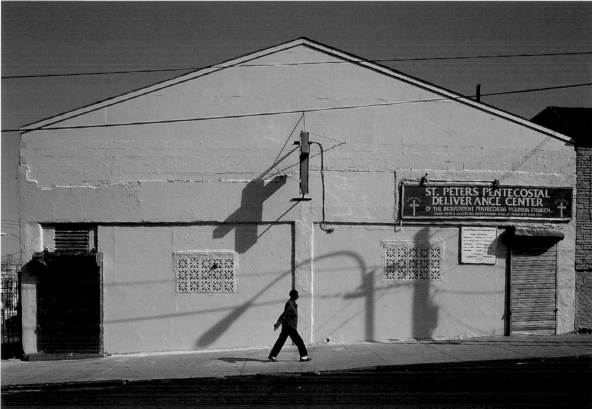

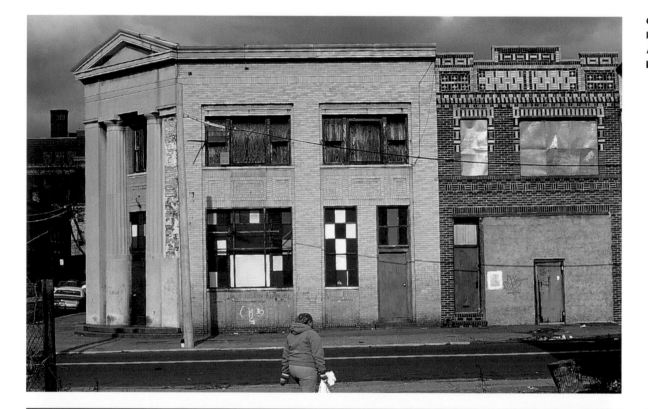

Church in former
bank, Sutter
Avenue,
Brooklyn, 1980

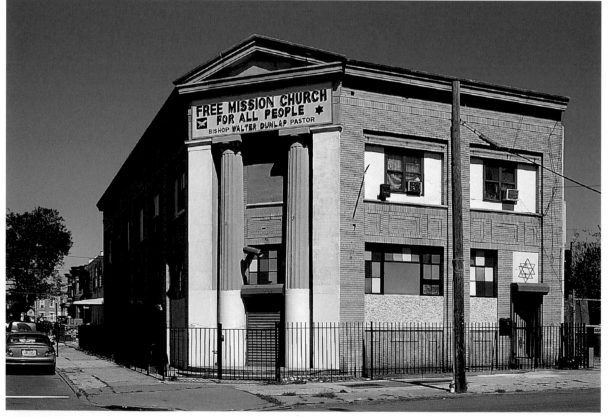

Free Mission
Church for All
People, Sutter
Avenue,
Brooklyn, 2004

**Evangelistic United
Church of God,
Blum Street,
Newark, 1980**

**Evangelistic Glorious
Church of God in Christ,
Blum Street,
Newark, 2002**

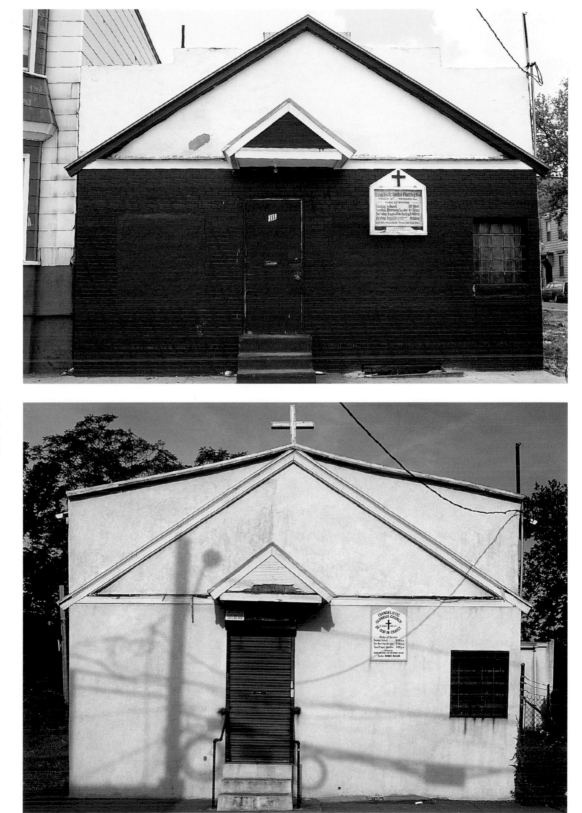

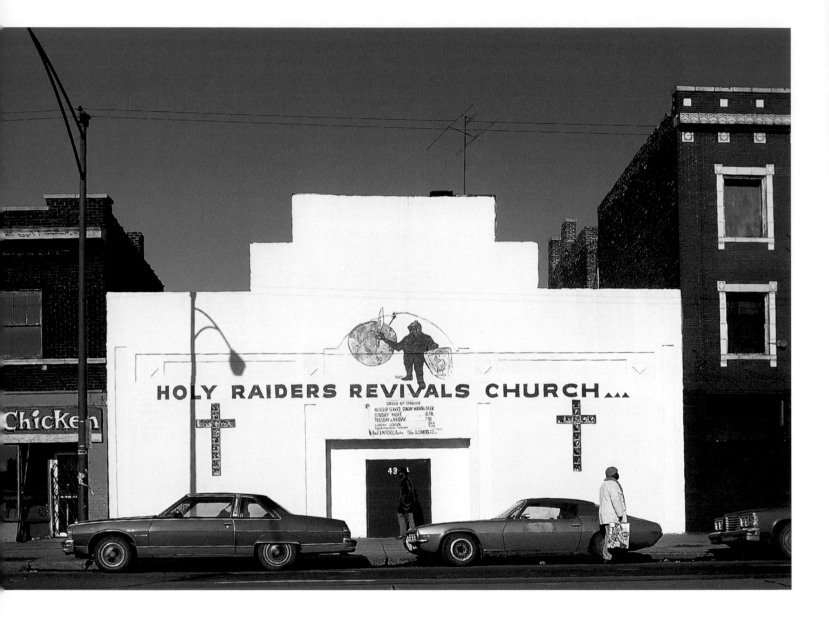

Holy Raiders Revivals Church, located in a former movie theater,
West Madison Street, Chicago, 1981. The red painted warrior is
ready to do battle with the world, protected by the shield of faith,
the sword of God, and the shoe of peace.

Holy Raider Revivals Church, with new door and new exterior of brick siding, West Madison Street, Chicago, 1989

Mount Zion Missionary Baptist Church, West Madison Street, Chicago, 2003

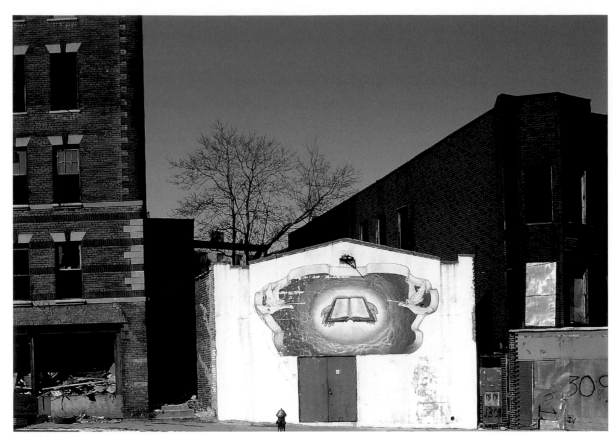

Church, West Farms Road, Bronx, 1980

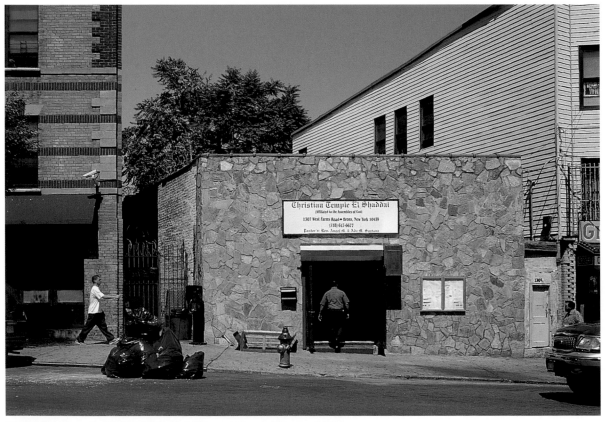

Christian Temple El Shaddai, West Farms Road, Bronx, 2002

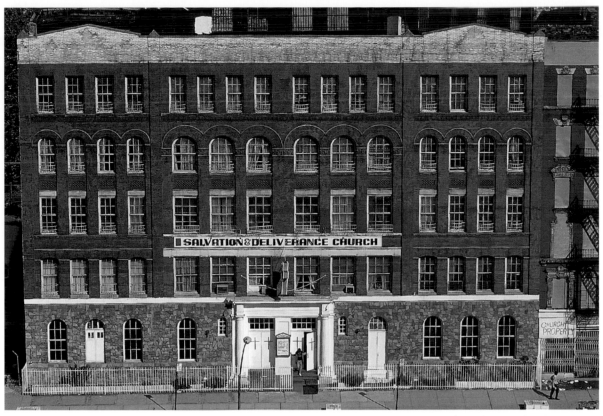

Salvation and Deliverance Church, West 116th Street, Harlem, 1988

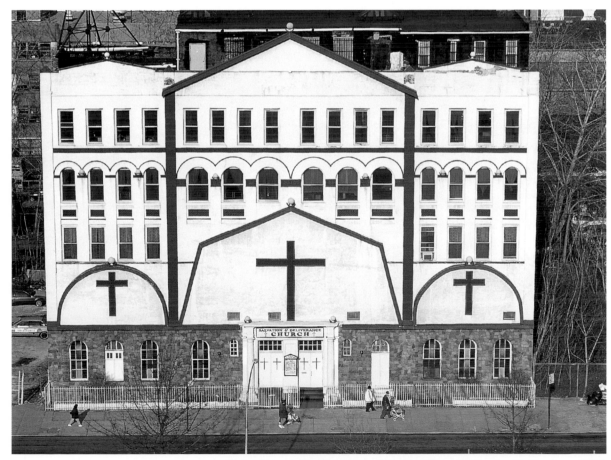

Salvation and Deliverance Church, West 116th Street, Harlem, 1998

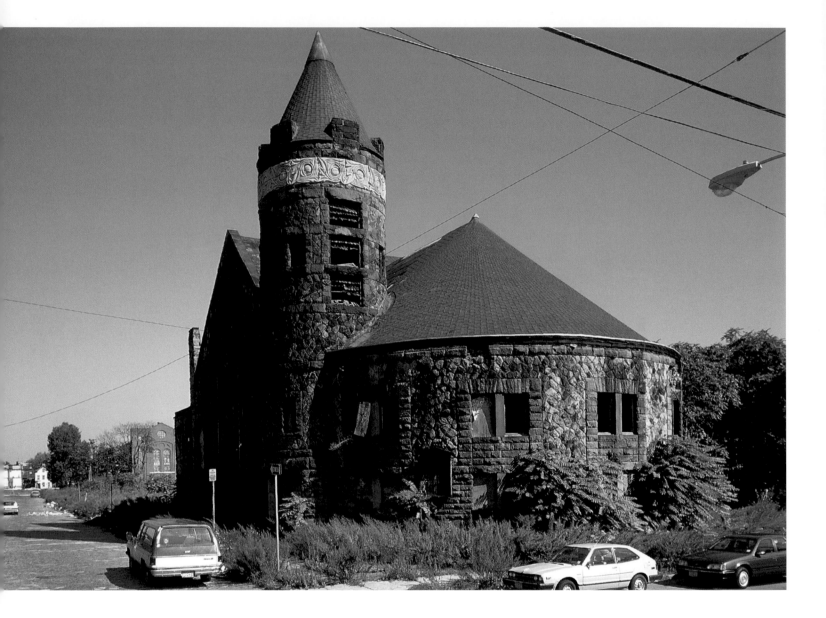

Thirteenth Avenue Presbyterian Church, built in 1888 in
Richardsonian Romanesque revival style, William Halsey
Wood, architect, Newark, 1987

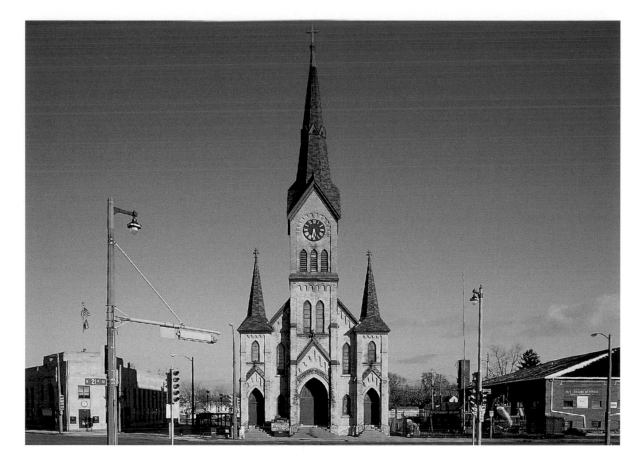

Bethel Baptist Church, formerly Ev Luth Zions Kirche UAC, built in 1908, North Avenue, Milwaukee, 2002

Traditional Churches

These houses of worship represent an architecture that inspires, establishes a sense of decorum, puts people in awe of God's house, and creates sacred spaces. Spires and Gothic arches cut a figure in the skyline that can be seen from a distance. These structures were built in revival styles, often in immigrant neighborhoods, in an effort to bring the best of home to this country. As the white population moved to the suburbs, traditional denominations were often unable to engage the blacks and Latinos who replaced them, forcing the hierarchy to subsidize or close these sanctuaries.

Some churches serve their communities as restaurants and soup kitchens. A handful of churches with historical and architectural significance are sealed, waiting to be restored; their onion domes are rusting, crosses are crooked, and stained-glass windows are fading.

Religious denominations don't want to be held responsible for what can happen inside a vacant church: What if a child goes inside and cannot get out? What if rapists bring their victims there? What if their heavy stones fall on passersby or cars? Local planners and developers first ask what can be done to rehabilitate the building; later, when they find out the cost of restoration, they ask how much it will cost to demolish it. With church leaders unwilling or unable to pay high maintenance fees for small and dwin-

dling congregations, many of these structures have been demolished. Typically, the ground on which they once stood now serve as parking lots.

In spite of this, black and Latino denominations do buy traditional churches and continue to use them as religious buildings. Pastor Victor Beauchamp of Bibleway Pentecostal Assembly of the Apostolic Faith in Detroit explained, "We always buy other people's churches. Who else is going to buy them in the city? Who else is going to buy that big church smack right in the ghetto?" After moving to a building, many congregations remove the cornerstone and replace it with another containing their own information.

Our church has a history. In the early 1970s, my mother cleaned this church; she was the custodian. We used to play in this church as children. We lived around the corner, and she kept it clean, dusted, and straightened out. We were one of the first to know that the church was going to be closing for services. She had the keys to let the movers in to take out the furniture when the church closed. We come from a Baptist background; at the time, my father was the pastor of an overcrowded church located in a former horse stable. He asked if he could buy the church. My mother didn't think it was possible for my father to take it over, but he thought that God was going to help them. After my father

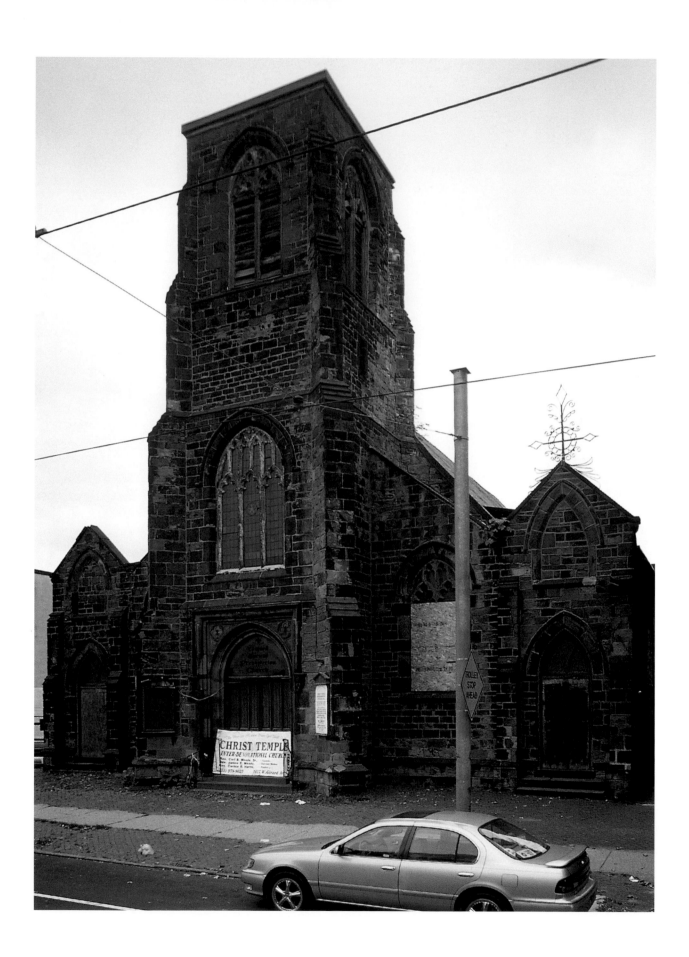

Christ Temple Interdenominational,
formerly Girard Avenue Presbyterian Church,
West Girard Avenue, Philadelphia, 2003

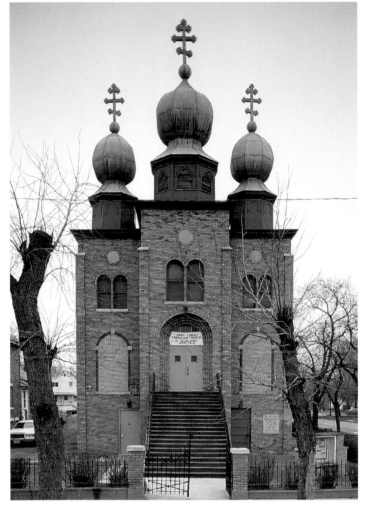

Gary Christ Christian Church,
Fillmore Street, Gary, Indiana,1987

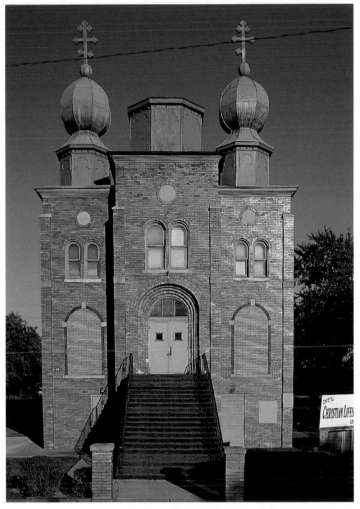

International Christian Lifestyle United,
Fillmore Street, Gary, Indiana, 2004

died, my mother became the pastor. Then I took over seven
years ago. I was ordained; I became an evangelist, then I
became a pastor.

Pastor Carlice Harris, Christ Temple Interdenominational
Church, formerly the Girard Avenue Presbyterian Church,
West Girard Avenue, Philadelphia

The churches that the black people own now, there, were once
owned by nice white people or Jews because we bought their
synagogues, too. That was during the time of the riots.

Pastor Eddie Douglas Anderson, Tabernacle of Jesus,
Clinton Avenue, Newark

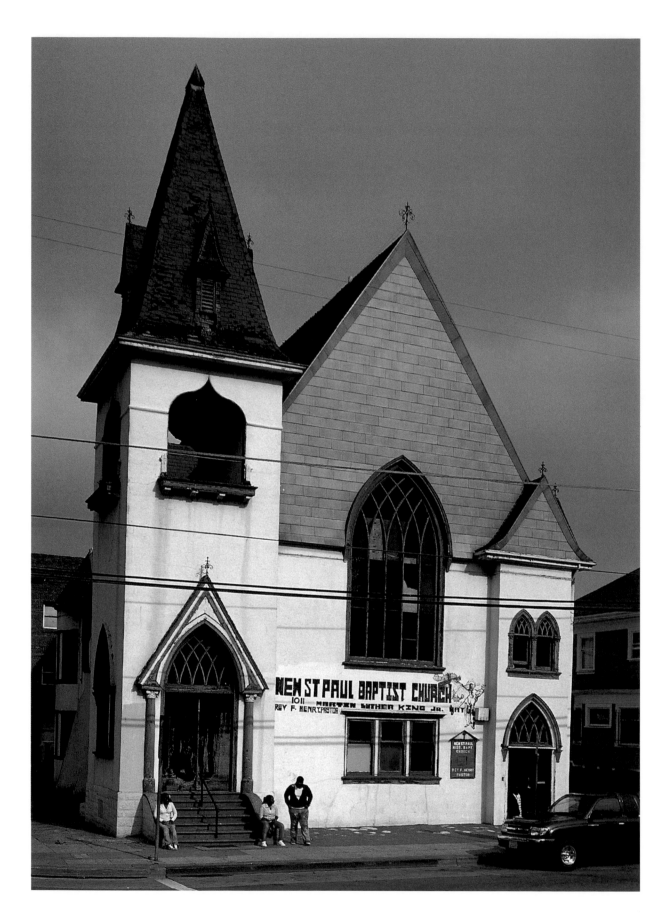

New Saint Paul Baptist Church, a former Lutheran church,
has a soup kitchen that serves the homeless congregating in
"Old Men Park," across the street from New Saint Paul,
Martin Luther King Way, Oakland, California

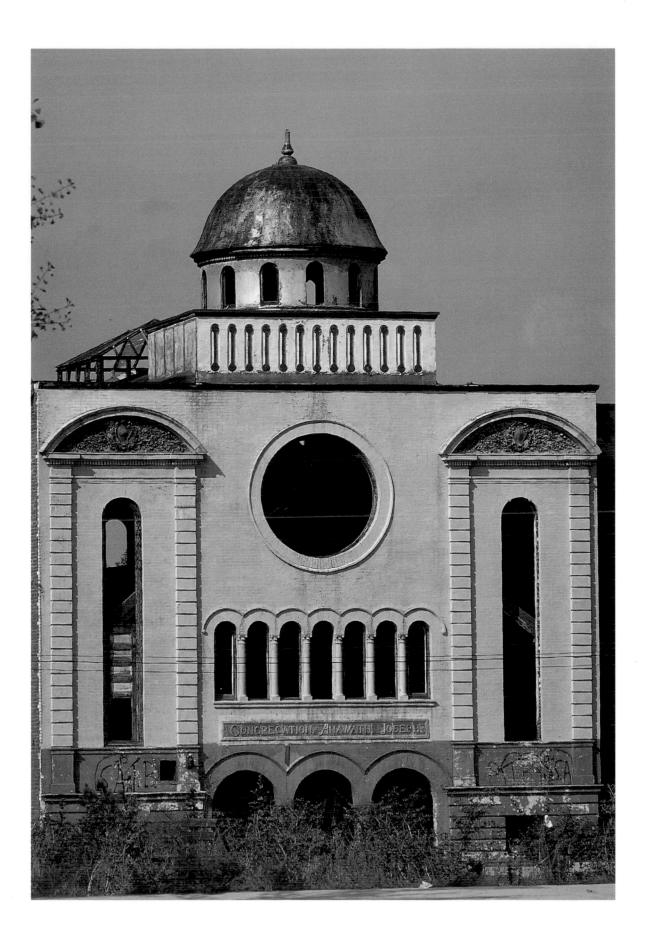

Congregation Ahawath Joseph,
former synagogue, Paterson, New Jersey, 1977

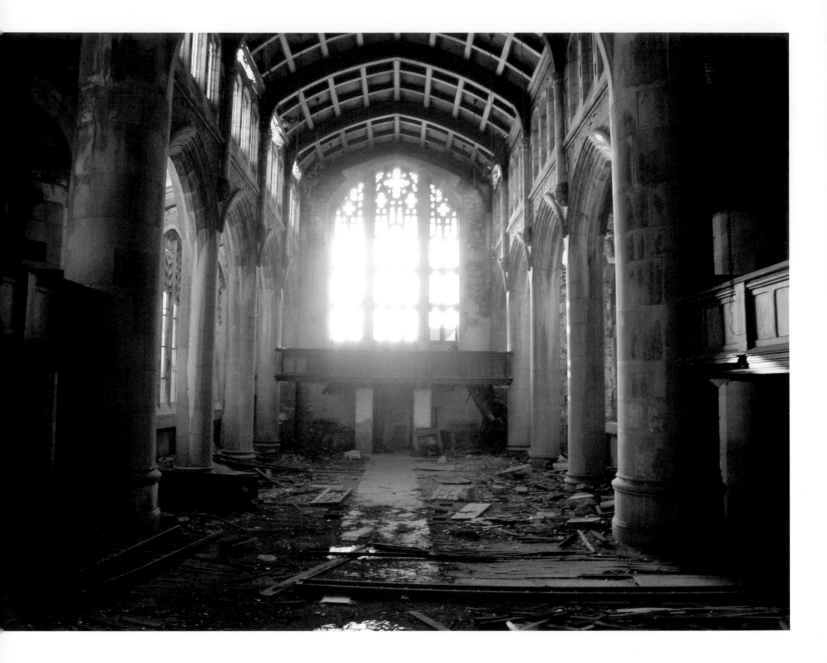

Interior of former City Methodist Church, built in 1928 at a cost exceeding a million dollars, Washington Street, Gary, Indiana, 2004

Catholic Churches in Ghetto Areas

After the flight of the ethnic white population in the 1960s and 1970s, many surviving traditional Catholic churches, inspired by Vatican II, made changes in style and liturgy to accommodate new Latino and African American parishioners. The changes are in response to the dominant ethnicity since one rarely finds blacks and Latinos worshipping together in the same church or attending the same service. The mass said in Latin is rare; English and Spanish are the most common languages used for worship.

In predominantly African American congregations, wooden statues of saints, Jesus, and the Virgin Mary have been refinished in darker tones to more closely resemble the new members. Lace has often been replaced by kente cloth for use over the altar, on the walls, as banners, and for religious attire. Protestant hymns such as "Leaning on the Everlasting Arms" and "Amazing Grace" are now part of the Catholic repertoire. African American congregations often have black pastors and assistant pastors, who conduct services in English. Instead of taking their places in rows of benches facing the altar, as in traditional Catholic services, members now tend to distribute themselves in circular patterns around the altar.

Our Lady of Guadalupe, patroness of the Americas, and the Peruvian seventeenth-century Saint Martin de Porres, a Latino saint of African origin sometimes labeled as "Patron for Interracial Equality," have replaced old Polish, Italian, German, or Irish saints and virgins. Canonized in 1962, Saint Martin is portrayed holding a loaf of bread to give to the poor. In the Catholic Church's affirmative-action policy for saints, he is the most popular; far behind is Saint Benedict the Moor, sometimes called "Saint Benedict the Black."

Compared to the days when the congregation was Caucasian, the new stained-glass windows, statuary, and paintings are smaller and less expensive. In Saint Jerome, a one-hundred-year-old parish in the Bronx, the newest statues are La Divina Providencia from Puerto Rico, the Dominican Virgen de Altagracia, and the Mexican one-year-old grotto to Our Lady of Guadalupe, all representing the main constituencies of the church. The statues have been placed in the back of the sanctuary. Saint Jerome is still dominated by European imagery—a stained-glass window with the names of donors, and statues of Jesus, the Virgin Mary, and assorted saints.

Sometimes even the name of the church is changed to a name that is more appealing to the new congregants. Saint Ann's Church in the South Side of Chicago became Saint Charles Lwanga, after a nineteenth-century Ugandan martyr, but that didn't save the church from demolition.

A declining number of Catholic churches continue serving their traditional Polish, French, and Slovak congregations, who drive to derelict urban neighborhoods and sit in barricaded sanctuaries in order to hear Sunday mass celebrated in their own languages. These houses of worship show no signs of a dialogue with their surroundings, but reveal a determination to survive and to remain the same. About two hundred parishioners, mostly senior citizens, remain at Saint Cyril and Saint Methodius Church in Bridgeport, Connecticut. On Sundays the church has a mass in English at 8 a.m., and one in Latin at 10:30 a.m. People come from Stratford, Milford, Trumbull, Norwalk, and Monroe, but very few come from the city. The church was built in 1912 for a Slovak congregation and, since then, nothing has been taken out; "basically being kept up and cleaned," according to the church's secretary. Saint Cyril's, she explained, "does not affect the neighborhood; it has nothing to do with the neighborhood."

In Detroit there is another former Slovak church, also named Saint Cyril and Saint Methodius. Above the altar, an inscription reads: "Everlastingly bless the blessed sacrament." The church was completed in 1929, a monument built by the immigrant community that surrounded it. The structure included a place of assembly and a high school. The last mass took place there in 1988, after which it became The Word of Truth Temple of Jesus Christ. In 2003, the building was in ruins.

Saint Martin's Church (1894) in the South Side of Chicago is based on a church in Cologne, Germany. It has a horseman on the roof. When the archdiocese closed Saint Martin's, vandals broke in and stripped the building, but were unable to loot the statue, which was painted gold and could be seen from approaching airliners.

Tim Samuelson, cultural historian, Chicago

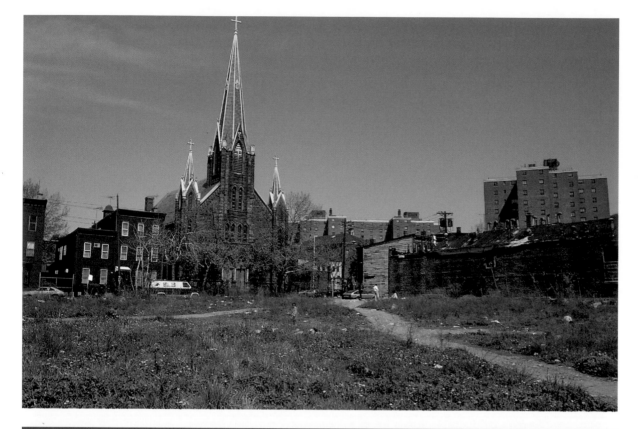

Saint Stanislaus
Roman Catholic
Church, built in
1901, Irvine
Turner Boulevard,
Newark, 1979

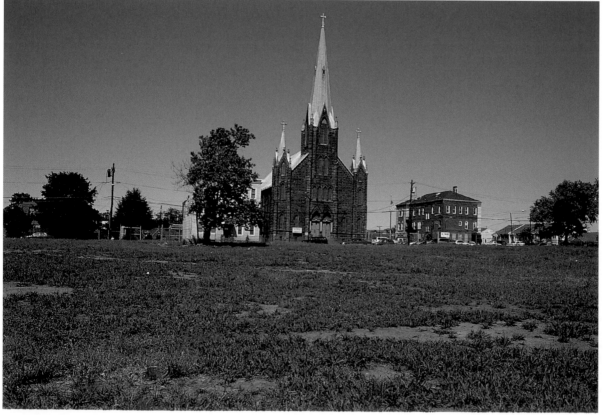

Saint Stanislaus
Roman Catholic
Church, Irvine
Turner Boulevard,
Newark, 2003.
Here, at the heart
of the city's
Central Ward, I
attended a mass
in Polish.

Grotto to Virgin of Guadalupe, inaugurated in 2002, reflecting the growing Mexican presence in the South Bronx, Saint Jerome Roman Catholic Church, Alexander Avenue, Bronx, 2004

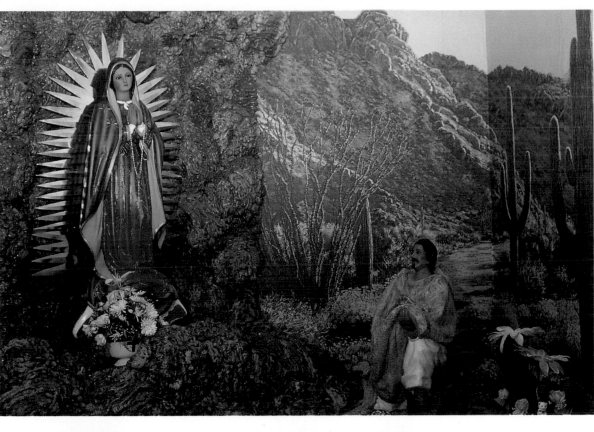

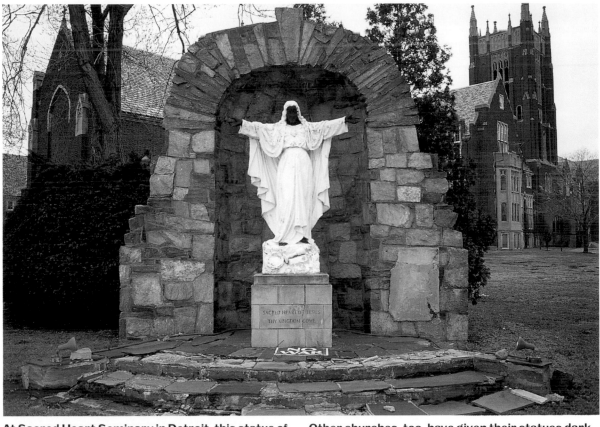

At Sacred Heart Seminary in Detroit, this statue of Jesus was once all white. Then, during the Detroit riots of 1967, someone painted the face, hands, and feet pitch black. First regarding the alteration as an act of vandalism, another person restored the whiteness. But soon, as a friendly gesture to the neighborhood, the seminary authorities repainted the skin pitch black. So it has remained ever since.

Other churches, too, have given their statues dark complexions.

The black paint on the seminary's statue, resulting from racial conflict, has been accepted as a sign of peace, and helped the seminary become integrated with the community. Sacred Heart Seminary, Chicago Boulevard, Detroit, 2003.

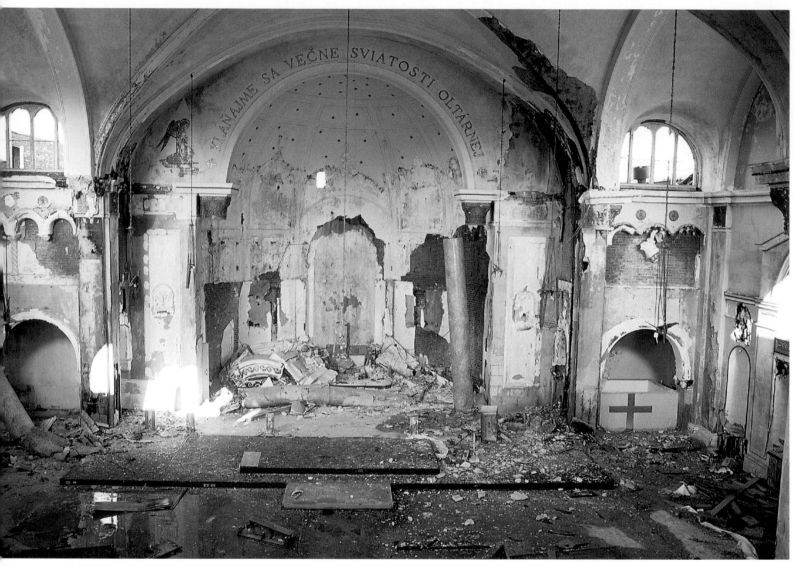

**Ruins of Saint Cyril and Saint Methodius, built in 1929
and closed in 1988, Saint Cyril Street, Detroit, 2003**

*We have tinted our statue of Saint Augustine; being from
North Africa, we don't know what he looked like.*
 Administrator, Saint Augustine Roman Catholic Church,
 Franklin Avenue, Bronx

*I gave the statue of San Martin de Porres to the church in
memory of my parents. They grew up in Ireland where, in the
1950s, Saint Martin was very popular among the Irish poor.*
 Father Ryan, pastor, Saint Luke's Church, 138th Street, Bronx

*Our Lady of Camden is holding a basket of fruit and has corn
braids. Father Carriere, the sculptor, found her face among
that of the women of the city. She is depicted slightly expecting.*
 Father Michael J. Doyle,
 Sacred Heart Church, Broadway,
 Camden, New Jersey

Formerly golden guardian angel and child, their faces painted dark brown, Blessed Sacrament School, Van Ness Place, Newark, 2004

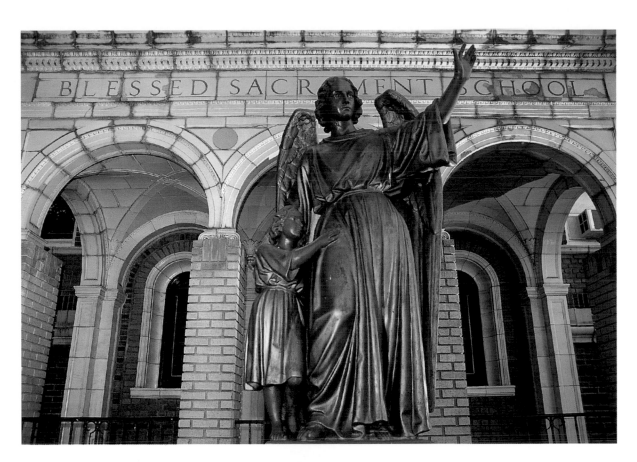

Statue of Peruvian saint Martin de Porres, Saint Antoninus Roman Catholic Church, South Orange Avenue, Newark, 2003

A cold little fortress named Triumph,
The Church and Kingdom of God in Christ,
West Twenty-fifth Street, Gary, Indiana, 2004

Storefront Churches

Churches in buildings that formerly housed stores are often recognizable by their store windows. They carry the connotation of being fly-by-night operations; they are poor, temporary, and with small congregations consisting mostly of the minister's family and close friends. A storefront church is considered by many to be the poor cousin to a regular church. While cathedrals and large traditional churches reflect the wealth and beauty of a city and are often sponsored by the city's elite, storefront churches are perceived as signs of economic decline.

Planners dislike seeing buildings transformed into churches because they don't pay taxes, and they often refuse to acknowledge that these churches bring vitality to streets that would otherwise be totally abandoned. Preservationist Eric Holcomb of Baltimore sees storefront churches as placeholders, enterprises that use a building temporarily, until a commercial tenant can be found.

Pastors of storefront churches are aware of the disdain that people have for their institutions, but they argue that every house of worship is unique. They deny that they are holding services in a former store, and they refuse to be lumped together under a term that makes them sound second-rate.

Members narrow the definition of a storefront church to a small structure that shares walls with the adjacent buildings and looks like a store. They exclude freestanding buildings and those that are partially attached. Others who have transformed original structures into temple-like buildings with the addition of A-frames, steeples, crosses, and painted Bibles feel that the former function of the building is irrelevant; their buildings function as and look like churches. Still others object to having their churches labeled as storefronts because they were formerly restaurants, factories, hotels, or warehouses. Pastors of churches that are affiliated with national organizations, such as the African Methodist Episcopal (A.M.E.), often deny being in storefronts, even if their buildings were stores. For these congregations, being part of a large denomination with a long history is a source of pride.

Most storefronts start small and remain small, confined to buildings that are similar to others in the surrounding area. Defenders of storefront churches argue that their mission is to serve the immediate neighborhood.

Church (on corner, left), Third Avenue, Bronx, 1981

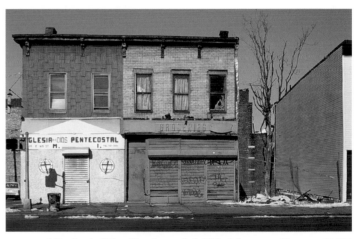
Iglesia de Dios Pentecostal, Third Avenue, Bronx, 1990

Iglesia de Dios Pentecostal Gihon, Third Avenue, Bronx, 2003

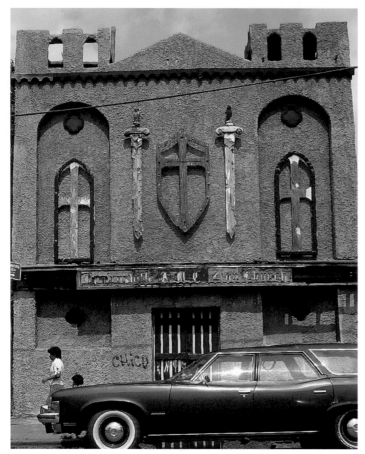

Brownsville A.M.E. Zion Church,
East New York Avenue, Brooklyn, 1981

Brownsville A.M.E. Zion Church,
East New York Avenue, Brooklyn, 2002

Holy Light
Missionary
Baptist Church,
South Broadway,
Los Angeles,
1992

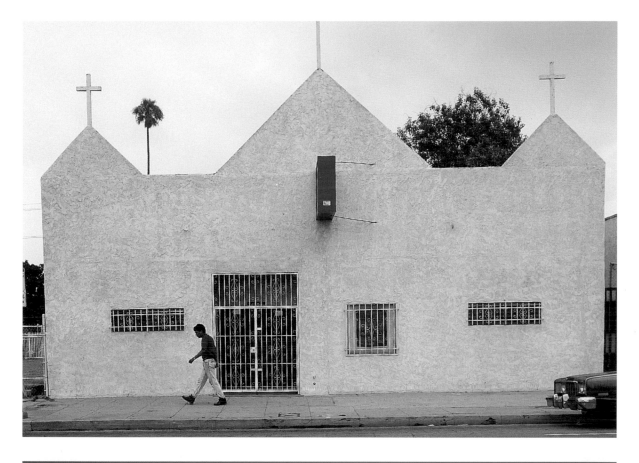

Iglesia Cristiana
Pentecostes
Jesucristo Es el
Camino,
South Broadway,
Los Angeles,
2002

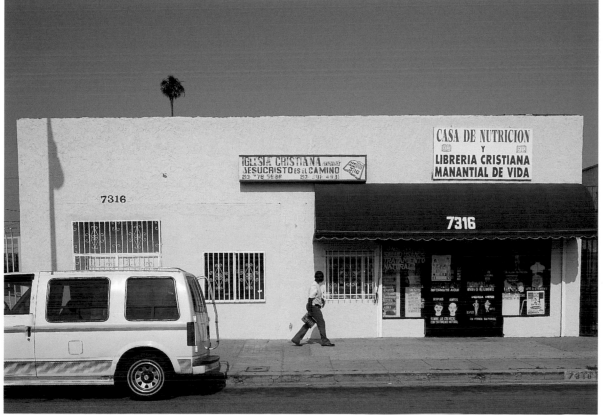

**"El Tabernáculo," study print,
Iglesia Pentecostal El Monte Horeb,
East 169th Street, Bronx, 2003**

They contend that being poor themselves makes them one with their congregations, and add that Jesus himself did not have a church.

Some storefront churches, like those in former Woolworth's or hardware stores—typical commercial buildings with flat roofs and rectangular shapes—are often described as examples of "tabernacle style." Tabernacles hold holy things. People pray to God to make their souls into tabernacles, worthy places for Him to dwell. A church can also be referred to as a tabernacle.

By transforming any type of ghetto building into a church, today's preachers are affirming the primary Christian experience in the most oppressive circumstances. Creating these heavens in the midst of ruins is comparable to the early Christians creating churches in the catacombs and placing upon them the sign of the fish, which was the sign of Christ.

 Michael D. Hall, sculptor, Detroit

In the past we didn't have churches. The slaves were not allowed to have a building. In the Deep South—Georgia, Mississippi, Alabama, and Florida—the black church used to meet outside in a place they called "hush arbor," which is a place where brushes were put together to form a cover. Today, storefront churches take the place of the "hush arbor."

 Elder James Culpeper,
 skid row, Los Angeles

A storefront church is normally a church that is just beginning. Historically, they were places where migrants from the South could gather together and form minifamilies. Storefront means everybody knows everybody. It also means struggling.

 Pastor Brown, Newark

Despise not a small beginning, the Bible says. It is just a building. Who is going to get mad about that? You should be grateful you have it.

 Pastor J. C. Tubbs,
 Living Rock Community Baptist Church,
 Compton Boulevard, Compton, California

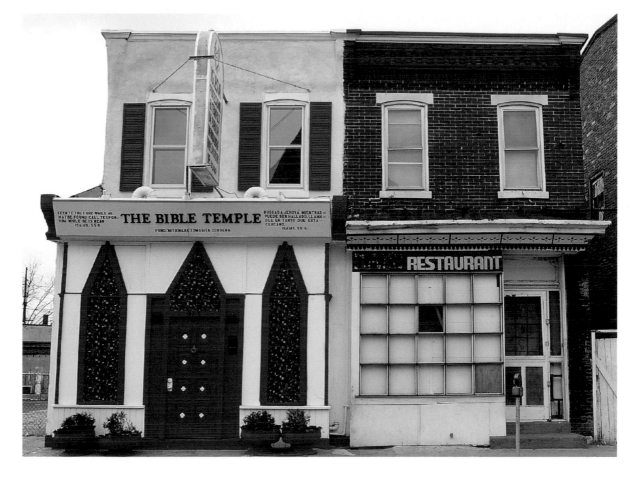

The Bible Temple, Broadway, Camden, New Jersey, 1980

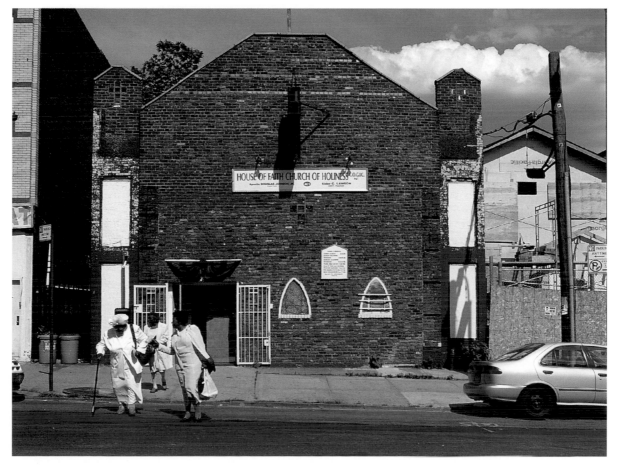

House of Faith Church of Holiness, a former movie theater, Saratoga Avenue, Brooklyn, 2003

**Everlasting Church of God in Christ,
Kinsman Road, Cleveland, 2002**

*This is a family church, family and friends. A congregation
can be twenty people, as long as they are faithful and pay
the tithes.*

> Pastor's wife, Revelation Baptist Church (a former state-run
> liquor store), Union Street, Philadelphia

*It looked like a storefront church. It had an apartment on
the right and a gift shop on the left. It was originally a
Masonic Lodge. When our church moved here from a place
near Manchester Avenue, they added the columns.*

> Elder, Manchester Baptist Church,
> South Vermont Avenue,
> Los Angeles

*A storefront church is integrated into a block; this is a church
with a parking lot.*

> Member, Gospel Church According to Jesus Christ Ministries
> (formerly Lubby Honda), East Monument Avenue, Baltimore

*This building was originally a house. It has been a church
for twenty-seven years, yet some people would still call it a
storefront church. I don't like the word storefront church. It*

*says that you are not a credible pastor; you are a little store-
front preacher. It says that you took an existing building,
that you were not able to build your own church. I am the
pastor of this church. It doesn't matter if it is a storefront
church, if people are saved.*

> Pastor Lonnie McNamee, Do Right Christian Church,
> South Central Los Angeles

*We want to make it more like a church than a furniture
store so the congregation would be proud of it.*

> Deacon Martin, Gravel Hill Missionary Baptist Church,
> Clinton Avenue, Newark

*We are not a storefront church. The church space was a
restaurant. I don't consider that a storefront. Our church is
over two hundred years old. We are a connectional denomi-
nation, an A.M.E. church. We are part of a large, organ-*

Pure in Heart,
Livernois Avenue,
Detroit, 2000

*ized body that can assist us, not like a poor independent
minister. Holiness and Pentecostal are storefront denominations.*

Rev. Melva J. Haden,
Brownsville A.M.E. Zion Church,
East New York Avenue, Brooklyn

*This church is much larger than a storefront, but that is
what it is labeled as.*

Youth Pastor Cooper, Saint Peter's Pentecostal Tabernacle,
Home Street, Bronx

*We are not a storefront church. We have parking in the rear,
and we fill all the city specifications.*

Bishop Robert Adam, Unified Free Will Baptist Church
(located in a former bank), Clinton Avenue, Newark

*Tabernacles are as tents—that is one-story, flat-roof buildings, very long and very wide, the original houses of worship
among the ancient Israelites.*

Archbishop Anthony Monk, Monk's Memorial, Fulton Street,
Brooklyn

Megachurches

The desire for the building that resembles a traditional
church ends when religious buildings are designed as
megachurches. Megachurches, unlike traditional houses of
worship, enclose space with little regard for the display of
sacred images in order to make a statement. These buildings
look like corporate offices, auditoriums, schools, or YMCAs.
Their priority is to create a place in which a large congregation can hear a famous and sometimes charismatic pastor.

Even though, for more than a decade and a half, Tim
Samuelson, the cultural historian of Chicago, drove past
the Apostolic Faith Church in the South Side of the city, the
block-long church was invisible to him. How is it that such
a large a house of worship can blend into the background?
Perhaps because it lacks symbols, has few windows, and its
bricks are earth colored. Buildings like these offer a wall to
the street, reminiscent of the New Brutalism style of the
1970s that relied on texture and mass.

Samuelson explains the absence of steeples and soaring
towers as part of the design of megachurches: "With the
advent of the skyscrapers, churches stopped being the city's
tallest buildings; people are not impressed by height anymore. Why would congregations pay more to build, to
paint, and to heat a building that failed to impress?"

At Christ Universal Church, a megachurch in West
Pullman, Chicago, Helen Carry speaks about symbols as a

**Paradise Baptist Church,
South Broadway, Los Angeles, 1992**

gardener speaks about weeds: "There is no symbolism around here. There are no crosses on anything that we do. We crucify our negative thoughts. We focus on the absolute goodness of God in our lives; we follow Jesus' teachings." Yet, at Christ Universal, symbols are directed at those who view the services on television monitors from the back rows, as well as to those who view them from home. At another megachurch, the Christian Cultural Center in Brooklyn, shadows reminiscent of those created by light passing through a traditional stained-glass window are included in the frames one sees on the monitors. And two giant doves hover above a sign that reads, "Jesus is Lord," sharing the screen with the choir and the pastor at the Apostolic Church of God in Chicago.

Because of their apparent success, pastors of megachurches often feel favored by God. Many pastors of small congregations, however, believe that the worldly success of megachurches is due to their interest in social status and material objects, and that they have compromised

the truth and made the church a place of entertainment. Large churches have lost the anointment; people go into these institutions "messed up" and come out "messed up." Critics complain that they play rap music until late at night, and because of this their pastors cannot cure the sick or perform miracles. Congregants of smaller churches testify that they prefer their house of worship to be small. During a Sunday service, a female member gave thanks for Mount Carmel Church in Newark, saying, "This is not a big cathedral downtown. It is a nice clean place."

It looks like a convention center.
 Minister describing the circular-shaped $50-million West
 Angeles Cathedral, Los Angeles

Today we are living in a different era. Churches reflect corporate headquarters. They have many ministers working together, each addressing a different need. They have reading rooms, coffee shops, offices, religious bookstores, and ATM

Christian
Cultural Center,
Flatlands Avenue,
Brooklyn, 2003

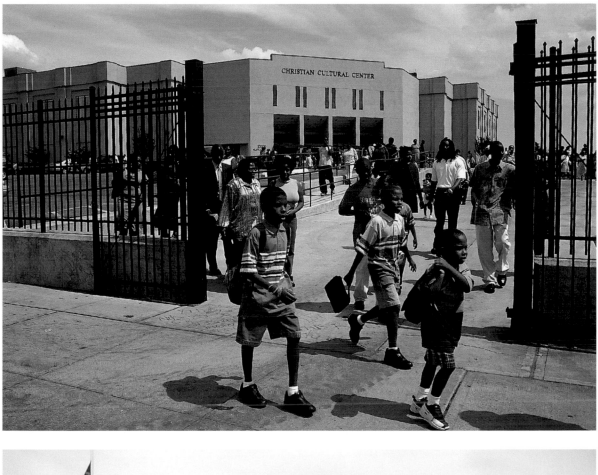

West Angels
Cathedral,
South Crenshaw
Boulevard,
Los Angeles,
2003

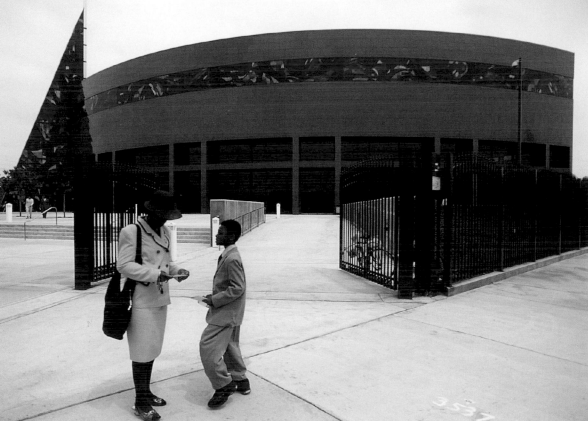

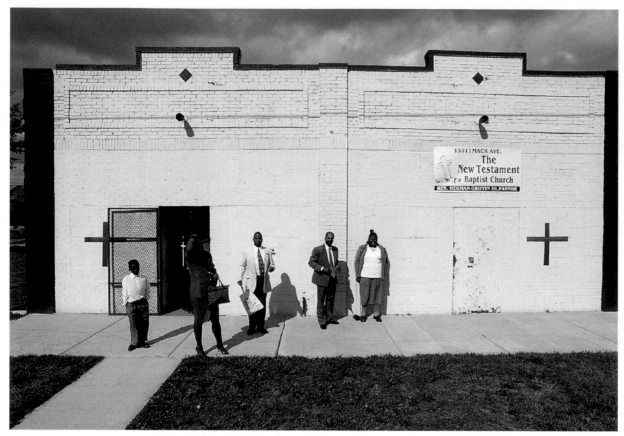

The New Testament Baptist Church occupying two storefronts, Mack Avenue, Detroit, 2002

machines. We are crucifying the church; we bring commercialism inside the church.

> Pastor Ireland Jones, Greater Peter's Church
> (a small storefront church),
> South State Street, Chicago

That is where most crowds of people are at. They are not interested in heaven; they are interested in material things.

> Pastor Robert Moore, Rising Star Missionary Church #2,
> Eleventh Avenue, Gary, Indiana

I got the biggest church in the world; everybody is out in the streets. I got the biggest house of God, the streets. I never preach for money; God takes care of me.

> Fred Marshall, street preacher, Martin Luther King Jr. Drive,
> Jersey City, New Jersey

Why Do People Go to Church?

Many people attend church to seek peace, health, companionship, or money. During worship the audience constantly hears how very able God is, that He loves them, and that no matter what their sins may be, He always forgives. Congre-

gants are told to keep the faith and hang in there, for God will give them a harvest of blessings: health, prosperity, love in this world, and paradise in the next.

Church communities function as families. People encounter an environment in them that is friendly and supportive, and one that offers companionship and hope. The congregation prays, visits sick members, and congratulates people when they graduate from school, get a job, or celebrate their birthdays. Members listen with interest and encourage those who are testifying, saying: "So true, so true," "Yes, yes, yes," "You have to tell somebody," "Amen," "That is right, that is right," and "Go on, sister."

I grew up coming to this church; then I stopped. I come here because this is my place, this is where I see the Lord's presence. I come here to pray, to be renewed by His presence. When I was out in the world, my hangout was a corner store, so now I make this my hangout. This is my home.

> Felix Hernandez, La Sinagoga, Snediker Avenue, Brooklyn

There are a lot of dysfunctional things going on in the community. People come to church for the same reason people join gangs, a sense of belonging. If you talk to a person who is in a

gang, they say my family is dysfunctional, they cannot protect and help me. In the church we care for them and love them.

Pastor Leonard E. White, Holy Mount Calvary M.B.C.,
South Main Street, Los Angeles

People need help; they have needs, and they come to have them addressed. We sometimes have people who are bound by drugs and depression. We share with them the Scriptures and give them a word of hope and deliverance to set them free.

Pastor Eddie Douglas Anderson, Tabernacle of Jesus,
Souls for Jesus, Clinton Avenue, Newark

We are trying to attract people who need food and clothing. We are not trying to attract the mayor.

Bishop B. J. Luckett, Plain Truth Mission,
South Avalon Boulevard, Los Angeles

People come to church for hope, for prayer. They need fellowship. Once they join a church, they become part of a family who cares for them. Jesus Christ has so much to offer, and the church is His organization.

First Lady Barbara Griffin, New Testament Baptist Church,
Mack Avenue, Detroit

They come because they have tried everything else—alcohol and drugs. They come because God calls them. They come because they want to change their lives. You have to trust either God or the devil. In the church they find a new family.

Toni, Apostolic Faith Church, South Indiana Avenue, Chicago

Going to church gets rid of your anxieties, and frustrations, and heartaches, and your diseases.

Superintendent Moses Green, pastor and founder, Community
Church of God in Christ, Inc., Beach Street, Queens

Do you think it is a bad thing to go to church? People go because they want to serve God and learn the truth. There is a lot of people living in sin, and they don't know it. We don't lie; this is a true church. Why don't you come to the service?

Member, Stop Suffering Universal Church of the Kingdom of
God, Southern Boulevard, Bronx

He would come home from work and get into a fight with his wife and get drunk. This was a pattern. The next day he could not get up in the morning. Now that he is in church, he is big enough to get up in the morning and to go to church. That establishes a new pattern.

Bishop William D. Broughton,
New Light Holy Church, Livingstone Street, Newark

We are a religious people; we know that God answers prayer, and it gives us relief. The church is set aside as a meeting place for Christian people. There is spiritual power that comes from God when there are more than one praying. The Bible mentions fear not to assemble together; that means that Christians should assemble themselves together for more spiritual help. We go to church praying to Our Savior because we want our spiritual soul to be saved when we pass away.

Pastor Robert Moore,
Rising Star Missionary Church #2,
Eleventh Avenue, Gary, Indiana

People have spiritual needs. America is a spiritual state. They had a sense of God; they put God in the constitution. People go to church for the fellowship; they need to assemble together, to worship with other people. If you want to dance, you don't dance alone in your room; you dance where other people are dancing.

Pastor Joe L. Parker, Wayside Baptist Church,
Broadway, Brooklyn

This is a refueling station. I am assuming that people come just to get refreshment or renewal for their spiritual life.

Pastor William Elliott, Zion Baptist Church,
Broadway, Camden, New Jersey

The main purpose people go to church is to praise God and give thanks to him, not solely to ask "give me this and give me that." That is why God created men.

Deacon James Ramsey,
Saint Peter's Pentecostal Deliverance Temple,
Home Street, Bronx

The Bible says God will bring them. We have a signboard on the front of the building; we pray, and we give out fliers.

Pastor Olawale Olayinka, Calvary Touch of God Ministries,
Bergen Street, Newark

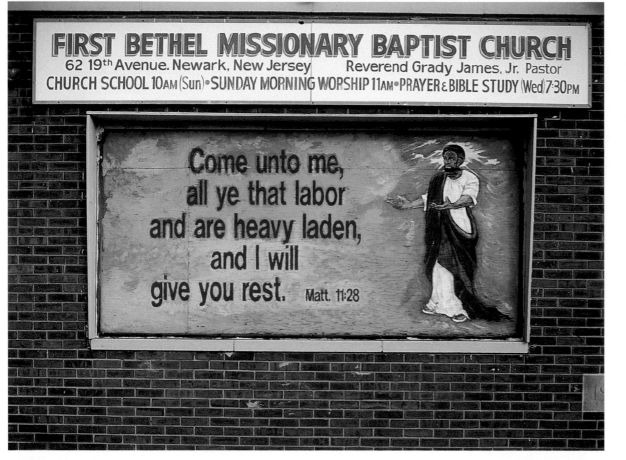

Christ inviting passersby to come to Him for rest, First Bethel Missionary Baptist Church, Nineteenth Avenue, Newark, 2003

Iglesia Pentecostal La Puerta al Cielo, North Avenue, Chicago, 2000

For souls to come to the church, the pastor has to pray; he has to fast; he has to live a holy life in front of God.

Pastor Tomas Velez, Iglesia Pentecostal El Monte Horeb, 169th Street, Bronx

They are curious. They come to church because they think that people inside get along, but when they find out otherwise, they rebel, tell people that they are a bunch of phonies and walk out. Curiosity causes all this.

Pastor Raymond Branch,
Heavenly Rainbow Baptist Church,
South Western Avenue, Los Angeles

They are having hip-hop in the church. Sometimes they use people who have not been born again, people who entertain in a nightclub. Going to a place that offers you entertainment until midnight doesn't get you in the kingdom. Other churches have the homosexuals preaching to them, and nobody there has the Holy Ghost; that is why when they do faith healing it doesn't work.

Bishop Wallace Furrs,
America Come Back to God Evangelistic Church,
Rockaway Avenue, Brooklyn

Thank you for worshiping with us today!
We hope that you received an
Abundance of
Blessings
A song sung
A word said
A message given
A smiling face
A welcomed hand
Or simply a hug
To carry you throughout the remainder of this week
Please come back and worship with us again soon!
As always, you are most graciously welcomed!!!!!
Rev. Dennis Tidwell,
Greater New Saint James Missionary Baptist Church,
South Kenneth, Chicago

How Do Churches Get Their Names?

Names make public the church's essence; names have power in themselves. Among Catholics, there is an ancient tradition to name the church after a saint and to have relics inside the sanctuary. Later, Protestants disregarded most saints and named churches after God, peace, grace, holiness, faith, and the Bible.

Typically, pastors pray to the Lord to give them a name for their church, and when it comes, in a dream, it is frequently taken from the Bible. Churches are often named after the house of worship that the pastor attended as a child. They are also named after the street, the borough, or the state where they are located, or the place where they originated. The founder's name is a popular source as well. If he or she is dead, his or her last name is followed by the word *memorial*.

When a congregation has selected a church name that is already taken and recorded with the secretary of state, they often keep the selected name and add, at the beginning, "First," "Second," "Third," "Greater," or "True." This practice was common more than a century ago among traditional houses of worship, when a second branch of an existing denomination moved into a city. Members of the second branch would add the word "New" to their church's name.

Divisions in congregations often result in bitter arguments, takeovers, and breakups. Disgruntled members often leave and start their own church with a different name. Stagnant congregations, seeking to be reinvigorated, often change their names as part of a revival strategy. On the other hand, several houses of worship that I visited retained older names that they didn't particularly like, simply in order to avoid a trip to the office of the secretary of state.

I was surprised to find several churches whose members could not remember the reason for its name. At Gravel Hill Missionary Baptist Church in Newark, for example, even deacons who had been members for a decade or longer didn't know the origin of its name. Deacon Brown could only say that gravel meant small rocks that represented the members, and that Jesus Christ was the big rock. Deacon Herb Griffith remembered that the church was a spin-off of Gravel Hill Missionary Baptist Church, "a church that burnt in Virginia." For Griffith the name was unimportant, "Gravel Hill didn't save my soul," he explained, "I love Jesus; Jesus saved my soul."

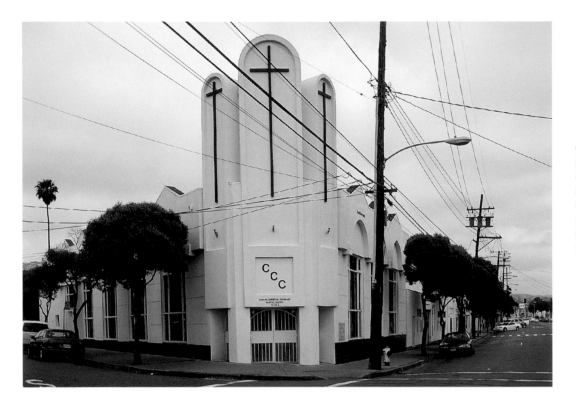

Canaan Christian Covenant Baptist Church, Jesus Christ, Chief Cornerstone, Foothill Avenue, Oakland, California, 2002. Before becoming a house of worship, the building was a branch of Bank of America.

The name Canaan Christian Covenant Baptist Church came from a group of members. They did it to honor the founder, C. Cedric Clayburn, whose initials are C.C.C.

 Anthony Mayors, pastor,

 Foothill Avenue, Oakland, California

When the church selects a name, they are declaring who they are to the community. I was thinking about different biblical terms and their meanings. I chose the word Hosanna, meaning "save us." I thought that people would ask me what the name meant, and I would tell them that it means salvation; then I could explain to them what salvation means.

 Felipe Salazar, Iglesia Apostolica Hosanna,

 El Segundo Boulevard, Compton, California

The Holy Ghost gave the name to me. It comes from the Bible. I love the eagle; that is my favorite bird. Eagles have an extra eyelid that allows them to look straight into the sun.

 Pastor Kennard Pettaway, Wings As Eagles C.O.G.I.C.,

 Marcus Street, Detroit

The Lord gave me that name. Gaza means strength, and Mount means strength, so that Mount Gaza means double strength, so that in my church the Lord would be double strength.

 Pastor Fred Houston, Mount Gaza Baptist Church,

 Raymond Avenue, Compton, California

When the Lord called me, I was reading the Book of Exodus, where they speak about Moses, the Ten Commandments, and Mount Sinai. I fell asleep in a place with many flowers;

I dreamt I was preaching to the flowers. I was preaching on the top of a mountain, and I saw all those flowers below. Upon reading Exodus, I was impressed by the name Mount Horeb, another name for Mount Sinai.

 Pastor Tomas Velez, Iglesia Pentecostal El Monte Horeb,

 169th Street, Bronx

The Lord gave Apostle Ernest Leonard a vision and a name for the church. It was to have lots of social programs: feeding the hungry, senior citizens, and day-care centers.

 Deacon Walter Rice, Provision of Promise Ministry,

 Clinton Avenue, Newark

The name New Frontier Baptist Church came from President Kennedy; he was blazing a new frontier. New frontier is the same thing as new horizon. I was wide awake when I thought up the name. It didn't come in a dream; God didn't give it to me.

 Pastor John Q. Adams,

 The New Frontier Baptist Church,

 Dean Street, Brooklyn

What really turned me on was a magazine called Plain Truth, *put out by man named Herbert Armstrong. That is a perfect name.*

 Bishop B. J. Luckett, Plain Truth Mission,

 Avalon Boulevard, Los Angeles

I was listening to a sermon on television in the 1960s, and the topic of the sermon was "Love Thy Neighbor." I said

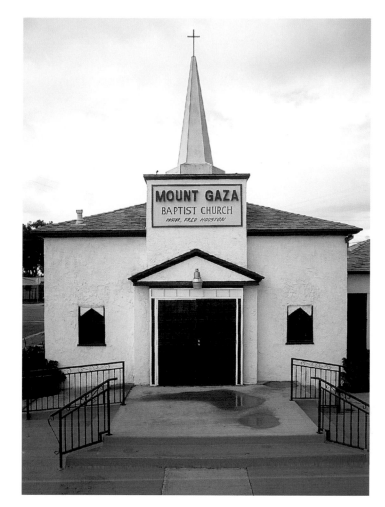

*this is what I am going to call the church I am going to
organize.*

Walter Willis, pastor, Love Thy Neighbor M.B. Church,
Twenty-first Street, Gary, Indiana

*A young lady from Cleveland sang a song called "Going Up
Yonder" with a group in California. That tells me something:
Going up all the way to be with the Lord in heaven.*

Pastor Martin, Going Up Yonder C.O.G.I.C.,
West North Avenue, Milwaukee

*The name came from the pastor. The pastor used to sing in a
quartet and had written a song called "America Come Back
to God." That became the name of our church.*

Brother McNeil, America Come Back to God Evangelistic
Church, Rockaway Avenue, Brooklyn

*I called it Rainbow because I worked for a Rainbow
Casino in Gardena, California. The payroll check had a
decal of a rainbow, and at the bottom it had a pot of gold.
Everything I got I name rainbow. I had a barbershop and
beauty supply I called rainbow; I sold hair products and I
call that business rainbow; I had a mattress store called
Rainbow Ray Mattresses. People think rainbow is my
name. One of the members of the congregation suggested to
name the church "Heavenly Rainbow." We think of the
rainbow that came after Noah's Flood, that way it ties with
the Bible.*

Pastor Raymond Branch, Heavenly Rainbow Baptist Church,
South Western Avenue, Los Angeles

*This was the Good Will Baptist Church, then the church
divided. We became the First Goodwill Baptist Church. The
church with the original name is on South Main Street and
118th Street.*

Michael Albert, minister in charge, First Goodwill Baptist
Church, South Compton Avenue, Los Angeles

*Mount Calvary was a Baptist church in my hometown of
Taylor, Texas. When I put in for Mount Calvary [in Los
Angeles], it was already taken, so I added Greater to the name,
not that I am any better than anybody else. I think of what
Calvary means, a place where Jesus Christ gave His life for us.*

*That is what makes it greater. I could have called it The First
or The Second Calvary Baptist Church, but I chose Greater.*

Eddie Ray Thomas, Greater Mount Calvary Baptist Church,
South Main Street, Los Angeles

*We took the name Double Rock Baptist Church from a
church in San Francisco. Our old pastor, Joseph Holmes,
fellowshipped with them. We don't do that anymore.*

Congregant, Double Rock Baptist Church,
Alondra Boulevard, Gardena, California

*The church was founded as the Pentecostal Missionary
Baptist Church in 1954. We changed the name because it
was being confused with the Pentecostal religion, and we are
Baptists. When the pastor asked for names, I thought
Security because when people are in church, they want to feel
secure in the presence of God. The name represents security
and stability on the spiritual plane.*

Mrs. Edwards, Security Missionary Baptist Church,
South Western Avenue, Los Angeles

*As you establish your church, each individual pastor has a
name as he sees fit. He asks his congregation to vote on it. I*

prayed and wanted a name that included the word trinity, that brought Trinity Temple Holy Church, Inc.

> Pastor William Storey, founder, U.H.C. America, Inc.,
> Utica Avenue, Brooklyn

Monk's Memorial was named in memory of my father. He was a great man. He was a community activist; he worked with the politicians to get jobs and housing for people. He died in 1977.

> Archbishop Anthony Monk,
> Monk's Memorial, Fulton Street, Brooklyn

My father was the pastor here. I kept the same name.

> Pastor Archie Arline, Great Antioch M.B.C.,
> South Compton Avenue, Los Angeles

It is called Greater New Light because, when we went to register it with the secretary of state, there was another church called New Light. To make ours different, we called it Greater.

> Shell, Greater New Light,
> East Ninety-second Street,
> Los Angeles

I think that it is a mistake to call a church greater. I think that hurts the name of the church; I think that makes one fellowship above the other. The weaker brother in Christ will see a difference.

> Pastor Harold B. George,
> Christ Union Missionary Baptist Church,
> International Boulevard, Oakland, California

I don't know why they gave the church the name New Eclipse. I came in after they had named it. I thought at one time about changing the name. I didn't do it because I didn't want to change all the papers of incorporation, so I just left the old name.

> Pastor Joseph White, New Eclipse M.B. Church,
> Fifty-first Street, Chicago

It's just a name; the name means nothing. Nobody can tell you why it is called that. The pastor doesn't know. The man that organized it has been dead for thirty years. There are

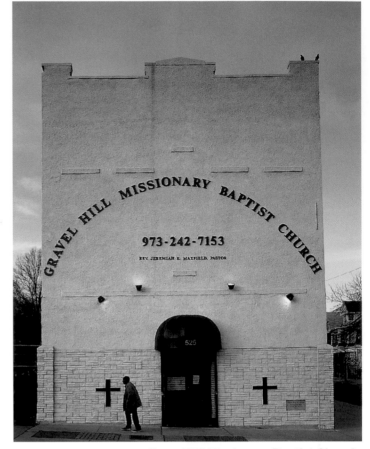

**Gravel Hill Missionary Baptist Church,
Clinton Avenue, Newark, 2000.
The building was formerly a furniture store.**

plenty of Friendships; there are some Second Friendships; but there is no other Little Friendship.

> Deacon John Knott, Little Friendship Baptist Church,
> South Tenth Street, Newark

You can pick any name you want; names don't mean a thing as long as you know the name of the Lord Jesus Christ. Don't get hooked on names; I am hooked up with the Lord Jesus Christ. I don't worry about material stuff.

> Pastor Louis Manley, Evangelist Church of God in Christ,
> South Avalon Boulevard, Los Angeles

We are not here for the name. We came here for the fellowship, for the people, and for the teaching,

> Lee King, member, Moore's Memorial Baptist Church,
> Dauphin Street, Philadelphia
> (At the end of Sunday services, as people were leaving the church, King asked an elderly member and his wife about the origin of the church's name, and neither of them knew.)

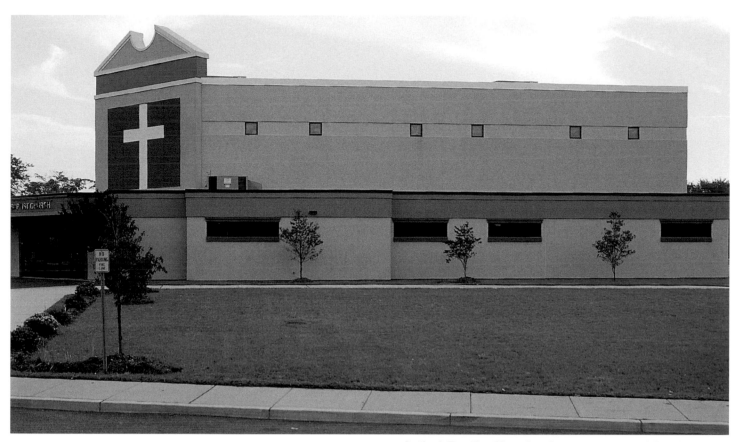

Antioch Baptist Church, where once a month local pastors gather to pray for their city, Ferry Street, Camden, New Jersey, 2003

Admirable Churches

Which churches do pastors admire? If they could select any building to move to, which one would they choose? In which of the houses of worship that they know do they feel God's presence the strongest? Pastors were asked to exclude their own churches as a possible choice. In their preferences, the beauty of the buildings came last as a consideration. More important to them was the size of the congregation, the charisma of the pastor, and the services provided to the community. Often they selected the mother church with which they were affiliated, or the place they worshiped as children.

Plain Truth Mission, South Avalon Boulevard, Los Angeles. They give out a lot of food. They counsel people down there.
Bishop Andrew W. Davis, Los Angeles

Saint John Chrysostom Catholic Church, Florence and Centinela avenues, Los Angeles. Very impressive.
Pastor John Grier

Antioch Baptist Church, Ferry Street, Camden. I admire Pastor Parker because he is a humble man. Once a month we come together to Antioch Baptist and pray for Camden.
Pastor William Elliott, Zion Baptist Church, Broadway, Camden, New Jersey

Naomi Temple, Roosevelt, Long Island. I went there when I was a kid. It was a small A.M.E. church. Naomi Watts, the pastor, was serious; she was not playing around with God. After she died, the congregation named the church after her.
Pastor Jack Walker, Bronx

Saint Francis Xavier Cabrini Catholic Church, Imperial Highway, Los Angeles. It takes money to put up those buildings.
Pastor Felipe Salazar, Compton, California

West Angeles Cathedral, Los Angeles. Everybody is not going to be a Bishop Blake.
Pastor Nelson, a South Central Los Angeles minister (Nearby, another pastor remarked, "Belonging to West Los Angeles Cathedral is a social thing.")

The former Reformed Church, 156th Street and Elton, South Bronx. [A brick church] is really what a church should look like.
Rev. Miguel Ortiz, Bronx

**Crystal Cathedral,
Anaheim, California, 2002**

The Elim International Fellowship, Putnam and Madison, Brooklyn. A former Catholic church; it's a beautiful structure, humongous. They have a school on Classon Avenue.

Archbishop Anthony Monk, Brooklyn

The Crystal Cathedral, Anaheim, California [Philip Johnson, architect]. A big operation, begun when Bishop Robert Schuller took over a drive-in theater on Sundays and used the speakers for the service.

Several respondents

Fellowship Missionary Baptist Church, Forty-fifth Street and Princeton, Chicago. The preacher [Clay Evans] is my idol. I have seen him touch the stars, but he never lost the ground.

Pastor O. C. Morgan, Chicago

Bishop Arthur Brazier's church [Apostolic Church of God] is one of the most outstanding and profound and unique buildings. He is an apostolic brother. In 1967, he had a little bitty church on Kenwood, a little bitty church.

Pastor O. C. Morgan, Chicago

Omega Missionary Baptist Church, Forty-sixth and State streets, Chicago. It has a pyramid shape. They have skylights all around it. They have the image of the all-seeing eye, like in the dollar bills.

Pastor Ireland Jones, Chicago

Gospel Truth Church, Hamilton and Tuxedo, Highland Park, Michigan.

Rev. Kennard Pettaway, Detroit
(Reverend Pettaway admires the pastor's ministry because he is a friend and has a large church.)

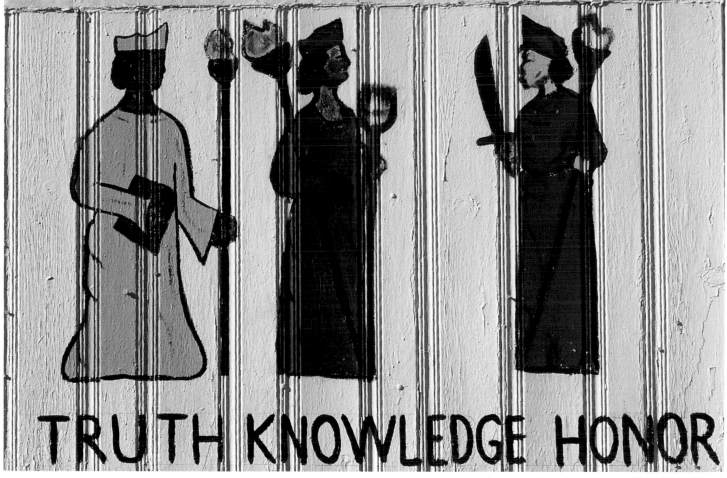

TRUTH KNOWLEDGE HONOR

Sign, the Almighty Church Kingdom of God, True Light Army, McDougall Street, Detroit, 2002

Repositories of Folk Art

Who are the men and women responsible for the design of these churches? How are their creations born and nurtured? What are the sources for their unique sense of color and form? How do they develop? Are they the vision of a single individual, or the result of collaboration?

Ephemeral and often overlooked landmarks, ghetto churches bring unexpected colors and forms to the inner city. Their designs are the result of sincere efforts by pastors and congregations who are not designers or builders; they are people who are driven to build and who often volunteer their time. They do not follow rules or seek advice from others about how to build or create an imagery of reverence on behalf of their faith. They mimic established religious forms, often with interesting results. Because of their inexperience or lack of funds to buy the proper supplies, they have to improvise and use donated or inexpensive materials.

This is not an architect- or designer-created front; this is creative improvisation. You have people trying to do something out of necessity. You have a pastor that has a vision and wants to make it a reality. There is a disparity between the idea and the execution. He or she usually doesn't have any background on design, construction, or technology, and is also forced to improvise with inexpensive or easily accessible materials. As a result, you get buildings that are nontraditional, and sometimes naive, but very effective in their innocence. The person responsible for the design may be the pastor or the contractor, or both. It doesn't make any difference who is driving it. Contractors in these areas of the city don't have the experience or seldom get the opportunity to execute high-budget projects. In years of working in projects where people have little to spend, they have developed an ingenuity and creative improvisation of materials and techniques. The pastors ask them: "Can you do this?" They say with absolute confidence, "Sure I can," often with unanticipated results. There are church façades that reflect dealing with problems at hand, such as adding an air conditioner, while not thinking about its effects on the rest of the building. Other improvements reflect the need to give an impression that the building is a respectable institution, to hide the fact that it was once a store, and to give the impression that it is a new church built from scratch.

Tim Samuelson, cultural historian of Chicago

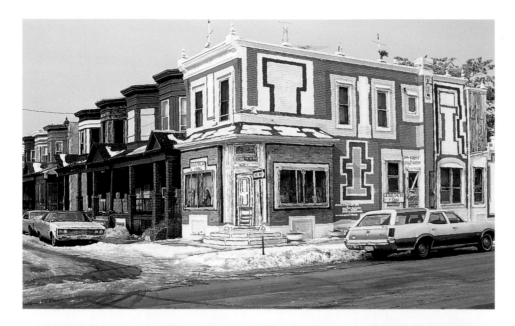

Iglesia de Dios Pentecostal, Ninth Street, Camden, New Jersey, 1982

God's House of Deliverance Church Apostolic, South Figueroa Street, Los Angeles, 2004. The building has been a church for more than two decades.

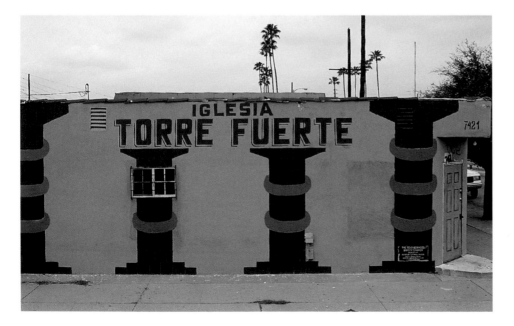

Iglesia Torre Fuerte, formerly the Neighborhood Baptist Church, South Avalon Boulevard, Los Angeles, 2003

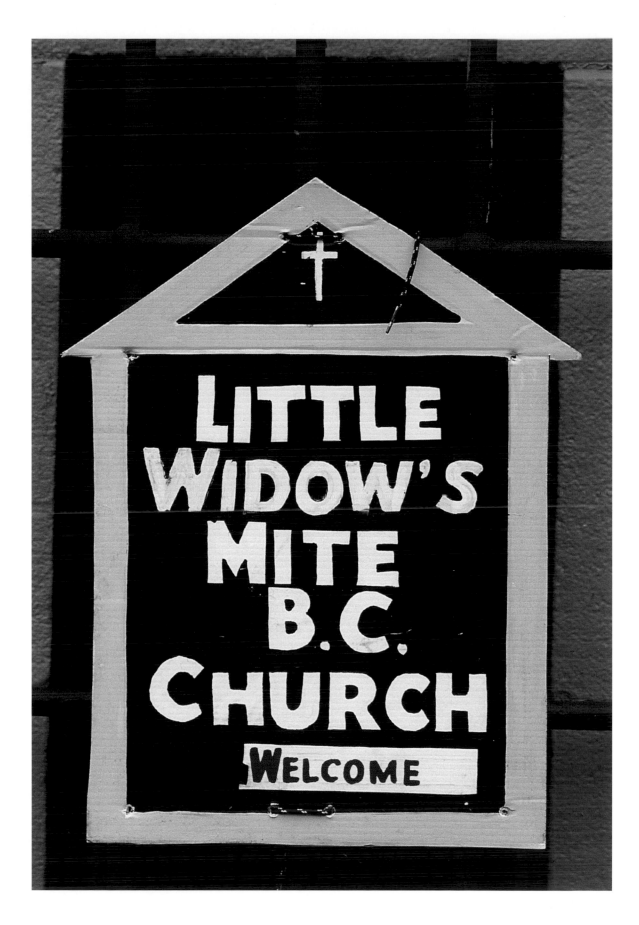

Portable sign to advertise Sunday services
of Little Widow's Mite B. C. Church,
placed on the Bronx Temple, Seventh Day Adventist Church,
where they rent space, Willis Avenue, Bronx, 2004

Church mural, Mission of the Gospel, Hooper Avenue, Los Angeles, 1996. A sign had been placed on the façade of the church welcoming "North, Central, and South Americans."

Mural of Christ crucified, painted above the city's Renaissance Center, with inscription, "HE PAID FOR IT ALL!" Joy Road, Detroit, 2000

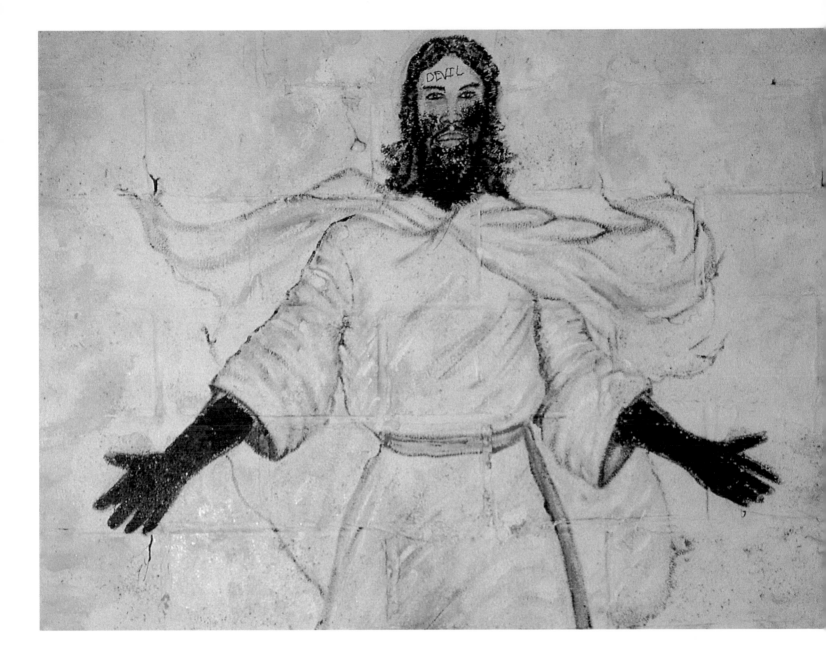

Christ-Devil, Grace Church of God in Christ,
South Michigan Avenue, Chicago, 2003

**Graffiti on wall depicts Christ carrying the cross,
San Julian Street, skid row, Los Angeles, 2003**

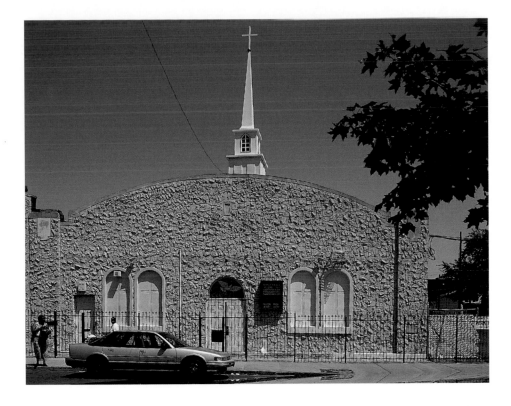

Steeple of Trinity Baptist Church, ordered from manufacturer's catalogue, Ashland Avenue, Newark, 2002

I did that myself. A fellow had painted a mountain and the waterfall, and he was to put the face of Christ. He meant well, but he didn't do a good job. I am kind of artistic. I cut the face of Christ from a tapestry and fix it on the wall. I like things nice. I like to bring things out, so I went and fixed it.

 Pastor Joseph Bright, Tabernacle of Deliverance,

 Eighth Avenue, Harlem

Steeples

A steeple says this is a house of worship, not a dry cleaner. A steeple serves the purpose of giving the temple visibility, making it look like a church, and creating a sense of reverence. Even though most steeples have no bells, pastors remark that by calling attention to the building, they bring people to church. A steeple on the roof of a former factory or union hall that has been turned into a house of worship can be mistaken for that of a nearby, traditional New England–style church.

At night the steeple was a beautiful sight to see. The whole community was ecstatic, but the lights burnt out and have not been replaced. What attracted me was that it looked like a crown. It is made of Plexiglas; I had never seen anything like it. I ordered it from a catalogue in 1987. I really liked it. The steeple displays light in the middle of darkness; it says that Jesus is the light of the world.

 Retired Pastor David Grayson, Sr., Temple of Blessings,

 Eastern Parkway, Brooklyn

The steeple that you see out there is about half the height of the wooden one that was there before and was blown by the wind. I told a gentleman from Hammond what we wanted, and I saw he was going to make a new one all metal. I was there when they put it up with a lift and saw that it was much smaller and didn't have a cross on the top. The gentleman told me that it was too heavy and [he] could not add to it.

 Pastor, Walter Willis,

 Love Thy Neighbor M.B. Church,

 Twenty-first Street, Gary, Indiana

The church is located in a former factory that made blinds. We decided to make the building look more like a church. We looked through a magazine and saw one [a steeple], and ordered it.

 Official, Trinity Baptist Church, Twelfth Street, Newark

My dream is to have one of them [steeples], but my money does not allow me to have one of those.

 Bishop Andrew Davis, God Tell It on the Mountain Full Gospel

 Church, Inc., South San Pedro Street, Los Angeles

A steeple is a good thing; it lets people know right away that this is a church. We don't want to do too much in this location. We are in the Empowerment Zone, and the city wants to buy the building. This was a hotel; we want to buy a regular church. People drive right by us and don't see that this is a church.

 Pastor M. Scriven, General Assembly Church

 of the Apostolic Doctrine, Broad Street, Philadelphia

Steeple and bell tower that houses the original bell from the former Lady of Lourdes Roman Catholic Church. After the church burnt to the ground, the congregation moved to a former car dealership nearby, Bushwick Avenue, Brooklyn, 2003.

Steeple shaped like an African hut, Bethel A.M.E. Church, erected in 1974, Warren Avenue, Detroit, 2002

Steeple of Gospel Missionary Baptist Church, South Avalon Boulevard, Los Angeles, 2003

Steeple of Springfield Baptist Church, Buchanan Street, Detroit, 2003

My husband's dream was to have a church with a steeple and a bell, and someone to ring it at the beginning of each service to call the people in like they do in the churches in the South.

> Geraldine Brown, wife of the former pastor
> of Good Shepherd Church of Christ, Disciples of Christ, Inc.,
> Springfield Avenue, Newark

A lending institution will tell you that the steeple lends the character and the distinction that makes a church. They won't lend you otherwise. The steeple comes on a truck; then you have to hire a company with a crane to put it up.

> Vivian Thomson, Messiah African Baptist Church,
> South Central Los Angeles

You are worshiping a high God, and that tower rise up to heaven. God deserves the best.

> John Grier, House of God Apostolic Church,
> South Western Avenue, Los Angeles

About twenty-five years ago this was a pharmacy. Five years ago the pastor and the congregation decided to make the building more like a church, so they added the steeple. We had a gentleman who offered to paint the church, and when we came here on Sunday morning the steeple was painted red. To not hurt his feelings, we kept it that way. He did something that was not exactly perfect in our eyes, yet we must honor that member for his devotion and his commitment.

> Lyman I. Dorter, Greater Providence Missionary Baptist
> Church, South Avalon Boulevard, Los Angeles

People have in their minds ideas that a church should have a steeple. We think in terms that are more functional. The immediate needs of a young church are to gather people together, to make them comfortable.

> Pastor Felipe Salazar, Iglesia Apostolica Hosanna,
> El Segundo Boulevard, Compton, California

God ain't into all that [steeple]. If bricks and mortar go to heaven, everybody would go there.

> Presiding Elder W. G. Belton,
> Pentecost Holiness Church of Deliverance,
> Albany Avenue, Hartford, Connecticut

New churches are built without a steeple. A steeple was built to watch the enemy and to toll the bells when somebody died. Today we have different means of communication.

> Pastor Raymond Branch, Heavenly Rainbow Baptist Church,
> South Western Avenue, Los Angeles

Colors

Although graffiti shows up very visibly on white walls, this color is a favorite of pastors in areas where "they spoil a lot." Shades of white are easier to match to the original when painting over graffiti. Churches are sometimes painted red in order to attract attention.

In 2001, the New Zion Hill Baptist Church in Baltimore had a door painted pink and a long stripe on the top of the building painted the same color. The rest of the church was painted white except for its name, which was painted black. I imagined that the bright pastel façade was meant to be an assertion of life next to the gloomy Baltimore Cemetery. When I called Pastor Wayne Barnes, the church leader, in 2004, he explained that he had changed the color of the building. The color pink had been "a random choice, made during a time when the congregation was without a pastor."

Most churches paint color don't come from the leader; it is more who donated it. Some things are dictated by circumstances.

> Pastor McNamee, Do Right Christian Church, Los Angeles

Green, white, and yellow, they represent the church.

> Rev. O. D. Morris, New Rising Sun M.B. Church,
> West Sixteenth Street, Chicago

Yellow was a random choice, not a choice that was made by prayer.

> Harold B. George, pastor, Christ Union Missionary Baptist
> Church, International Boulevard, Oakland, California

White represents cleanliness and purity; we always use white in the church.

> Elder Charles Mack, Holy Defender C.O.G.I.C.,
> South Normandie Avenue, Los Angeles

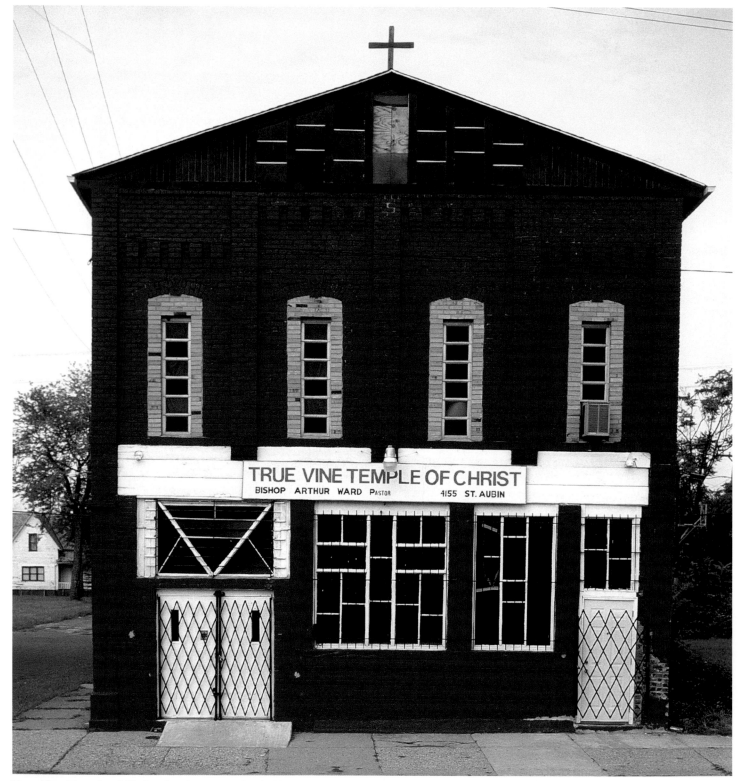

**True Vine Temple of Christ, in a former union hall,
Saint Aubin Street, Detroit, 2000**

New Zion Hill Baptist Church, East North Avenue, Baltimore, 2001

Redeemed Tabernacle Church of God in Christ, Pulaski Road, Chicago, 2000

Congregation members at the end of Sunday service at Trinity Faith Penticostal Church, a Jamaican church, East 187th Street, Bronx, 2004

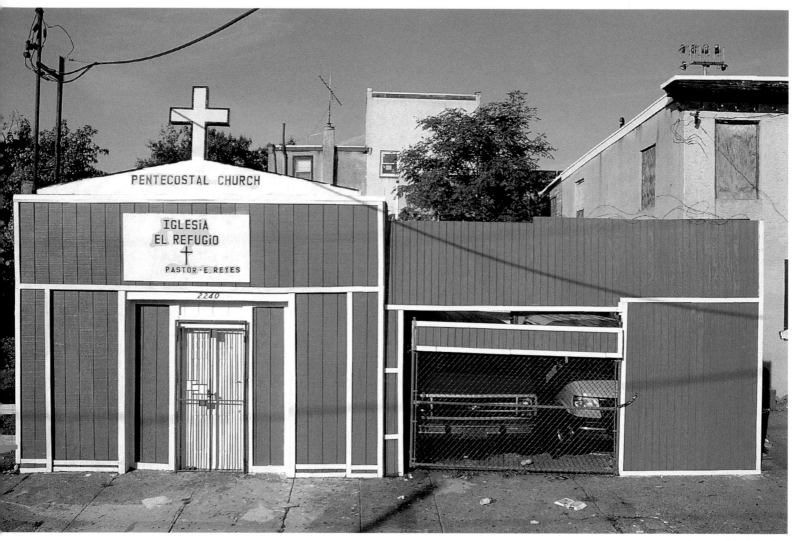

**Iglesia El Refugio,
Third Street, Philadelphia, 2003**

*Because this building, a former hardware store, is so narrow
and has no windows, white makes it roomy and airy.*
 Pastor Victor Beauchamp, Bibleway Pentecostal Assembly
 of the Apostolic Faith, West Warren Avenue, Detroit

*The red represents the actual blood of Christ—the death,
burial, and resurrection of Jesus Christ.*
 Pastor Robert Joiner, New Jerusalem Baptist Church,
 Broadway, Brooklyn

*We are not facing one of the avenues. We are on a side street.
Red was mostly for the church to be seen. Red lasts longer
than white.*
 Pastor Ben Butler, First Steadfast M.B. Church,
 East Bowen Street, Chicago

The extremely popular *Head of Christ* by Warner Sallman, 1940, known as the "Nordic Christ," is for display but not for sale at the Christian Boutique, South Broadway, Los Angeles, 2003.

The Color, Sex, and Ethnicity of Christ

In struggling churches, images of a "pale-faced Jesus with blond hair and blue eyes" are more popular than those of an African Jesus; whereas, in more established churches, Jesus is always depicted as dark skinned. Why are African American and Latino congregants in the ghettos of this race-obsessed nation so willing to accept and promote an image of a white Jesus, with white apostles? What motivates pastors to select a Caucasian version of Jesus? Pastors insist that "God is a spirit," that their "belief is in God," and that they "don't see color" when they select Caucasian holy images for their sanctuaries.

Three reasons for this are often given. The first is: Don't trust your eyes; see with the eyes of the spirit, and you will see no color. A historical explanation runs like this: In the old days, you couldn't buy images of a black Jesus in stores; people had no choice but to purchase and display images of a white Jesus, unless they ordered works of art from local artists. Finally, the sociological explanation goes back to slavery; the white Jesus was the God of the slave-owners, and his depiction as white lasted until the civil rights era when, according to Pastor C. L. Bonney of Newark, "We was heavy burdened by the white man." Prior to that time, Jesus was depicted as a white man so that His divinity would be accepted.

I inquired at a store one day about a large portrait of a Nordic Jesus by Warner Sallman, dated 1940. "A lot of people want it," the salesman at the Christian Boutique Store on South Broadway, Los Angeles, explained. "That is really nice, but it is not for sale." When I asked why an image of a white man was so popular in the black community, the salesman became annoyed and said, "If you are hung up on the colors and everything, that is one thing. For me it is just Christ; I am not looking at it for the color."

When they [slave-owners] taught black people about Christianity, they showed them a white Christ.
 Pastor Robert Moore, Rising Star Missionary Baptist Church #2, Gary, Indiana

How come you are going to put a picture of Christ up there if nobody took a picture of him or nobody alive today saw him?
 Ali, New Hope Community C.O.G.I.C., South Western Avenue, Los Angeles

We don't look at him that way [as black or white]. We look at him as God.
 Robert E. Lassiter, security guard, New Bethel Baptist Church, Springfield Avenue, Newark

He ain't white, he ain't white. I have never ran across a different kind of picture. I don't see no color.
 Bishop Andrew Davis, Go Tell It on the Mountain Full Gospel Church, South San Pedro, Los Angeles
 (Bishop Davis was justifying his choice of images, a Caucasian portrait of Jesus and a white Jesus with white apostles at the Last Supper.)

Jesus was a Jew, and I don't go for that discussion. I would believe him if he was green, as long as he died for our sins.
 Charlie L. Jones, Nadeau Street Community C.O.G.I.C., Nadeau Street, Los Angeles

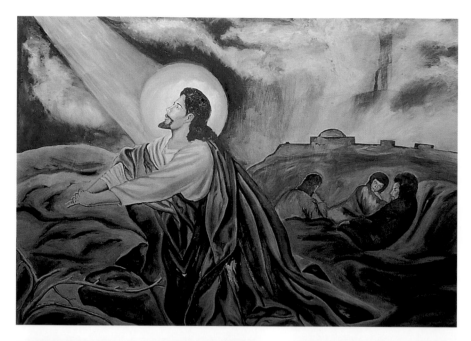

Painting of the accepting and resigned Christ at Gethsemane, Upshaw Temple Church of God in Christ Zion, Newark, 2003. The church's pastor, Joseph Deloatch, Jr., is planning to paint the Christ black.

Christ depicted as strong, commanding male who looks people in the eye, asking them to follow Him, First Steadfast Missionary Baptist Church, East Bowen Street, Chicago, 2002

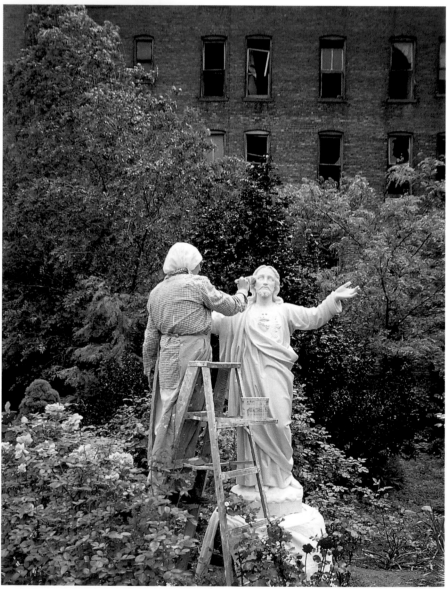

Statue of Christ being repainted white, Sacred Heart Garden, Missionaries of the Charity, East 167th Street, Bronx, 1989

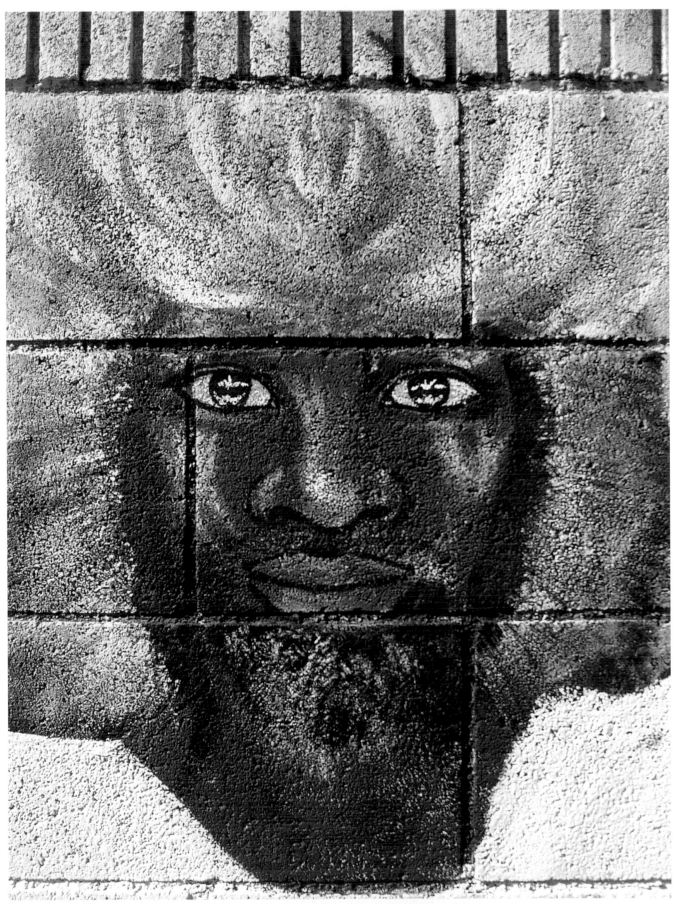

The face of Christ, taken from the Book of Revelation, decorates the parking lot of Greater New Jerusalem Baptist Church, Western Avenue, Los Angeles, 2002. This image is the work of a homeless artist.

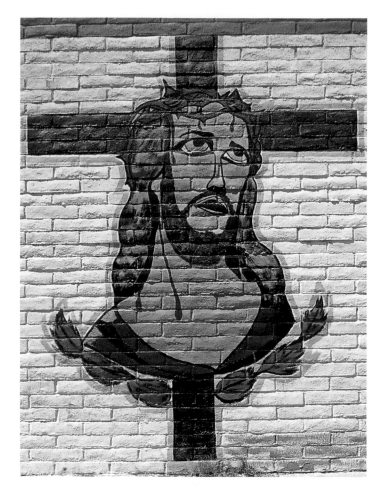

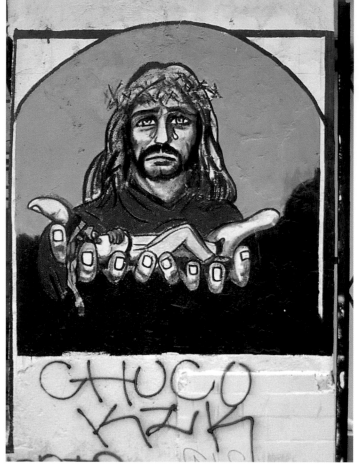

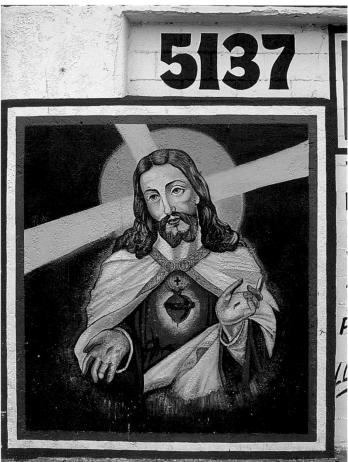

clockwise from top left:

Mural of blue-eyed Christ on wall of Westland Car Wash, South Central Avenue, Los Angeles, 2003. A local Mexican sign painter who goes by the name of Picasso explained, "Christ was a tall white man. He was a beautiful man."

Mural on the Restaurant Familia depicts Mexican-looking Christ holding the body of Chuco, a notorious South Central gang member, San Pedro Place, Los Angeles, 1996

Sacred Heart mural on façade of Michoacan Meat Market, South Compton Avenue, Los Angeles, 1999

Androgynous Christ,
painted by Tommy Brooks in 1997,
in an alley west of South Western Avenue,
Los Angeles, 2002

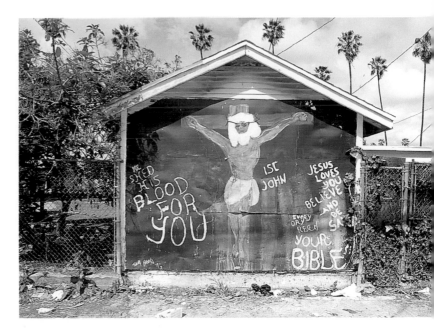

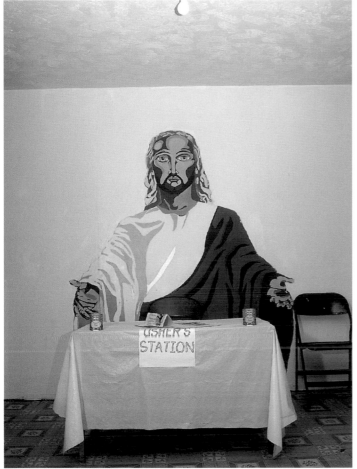

Sitting Christ painted by Nestor, for interior of God
Tabernacle of Faith Church of God in Christ, Hoover Street,
Los Angeles, 1996

Mural of a meek Christ depicted with torso of a bodybuilder,
His arms outstretched, giving His life to save
corrupt city dwellers, Catholic social service agency,
Gratiot Avenue, Detroit, 1995

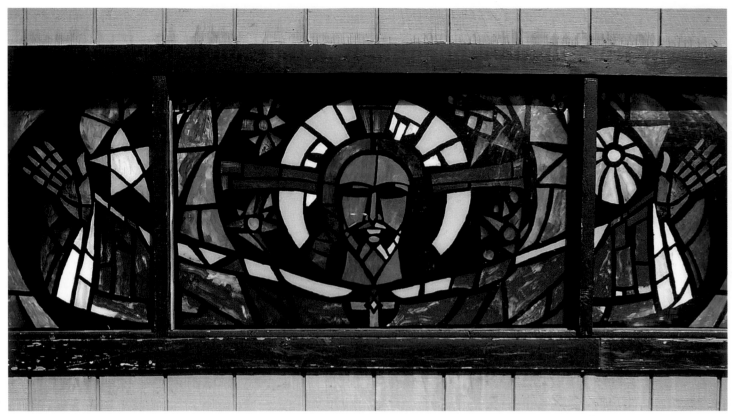

Blue and brown Christ,
House of Correction Church of God in Christ,
West Madison Street, Chicago, 2003

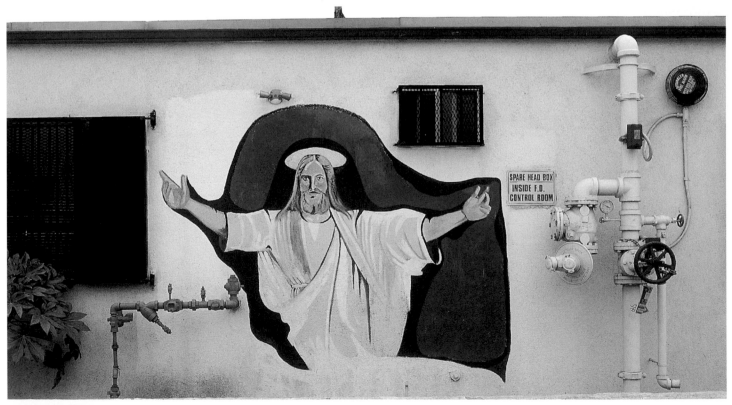

Welcoming Christ, painted by one of the residents of a drug
treatment facility, is green, the only color that was available.
Holmes Street, Los Angeles, 1996

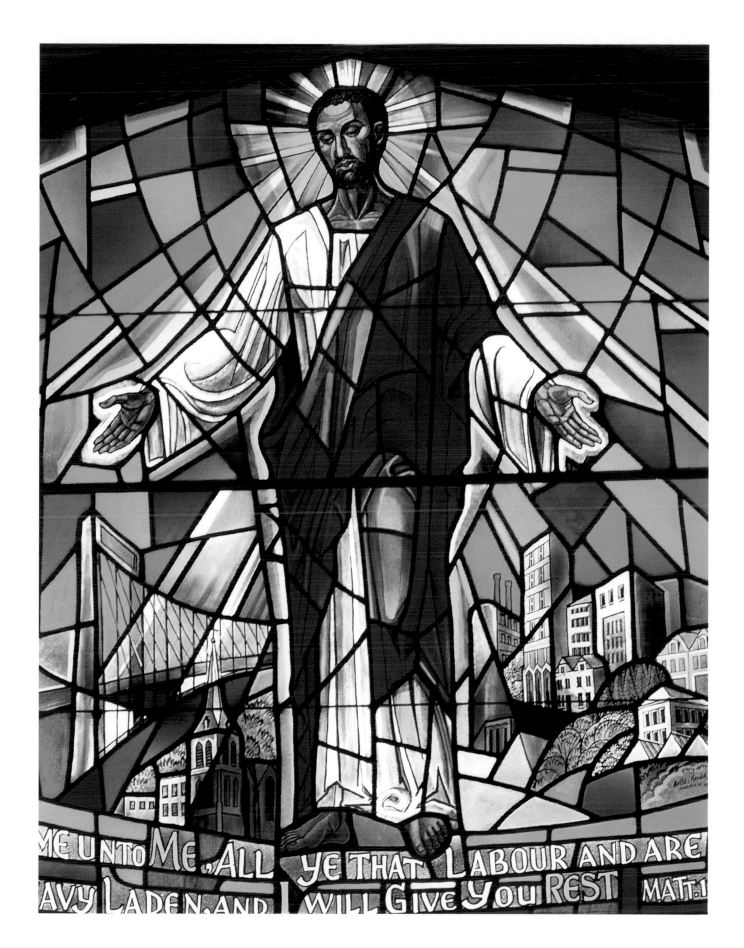

Stained-glass window depicts Christ towering above city of
Newark and the George Washington Bridge, Humanity Baptist
Church, Bergen Street, Newark, 1986

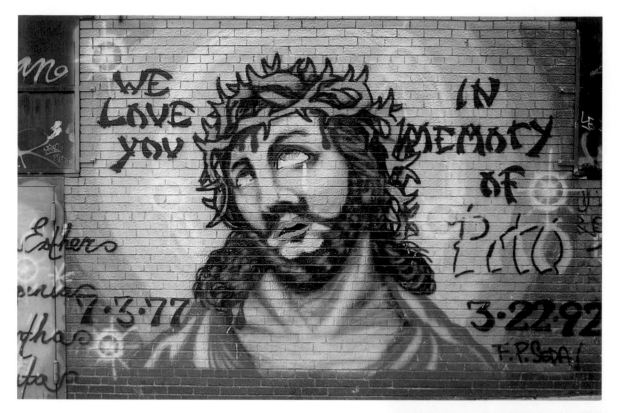

Inclined head of Christ after a painting by Italian artist Guido Reni is now part of Bronx street scene, Sheridan Avenue, 1994

Everybody does not see the same thing. If you ask a black man, he will put up a black Christ; if you ask a white man, he will put up a white Christ; if you ask an Italian man, he will put up an Italian Christ.

Pastor M. Scriven, General Assembly Church of the Apostolic Doctrine, Broad Street, Philadelphia

There is a danger of putting things on the walls. You saw a white Jesus on the wall, and you assumed that Jesus was white. I don't see Jesus in color. You are dealing with an identity crisis. They see a white Christ as someone to look up to, and they have been taught that white is better. This idea has become embedded in their minds. I don't have an identity crisis. I don't care what the color of Christ is, as long as He saves.

Pastor McNamee, Do Right Christian Church, Los Angeles

For Jesus to be powerful, for some pastors, he has to be white. This way of thinking is a leftover from slavery, when a white person could attract the attention of fifty blacks, and could even kill a black person with impunity if he so desired.

Pastor Raymond Branch, Heavenly Rainbow Baptist Church, South Western Avenue, Los Angeles

We have a white Lord's Supper. It was already there when we came in, and the wall behind it requires some repair, so we can't take it out. I don't think it has any significance; it will stay there until we remodel the church. In the beginning there were more white images of Christ. In recent years, as more people have become more knowledgeable of the

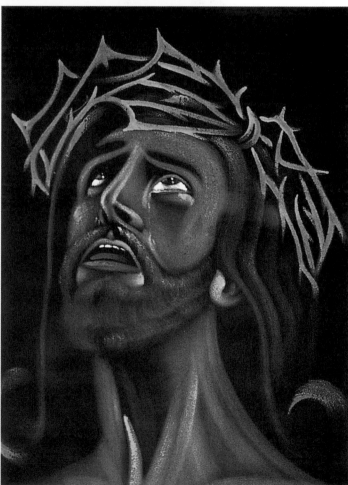

Head of suffering Christ, painted with felt pen, religious store, Bronx, 1970

Kingdom of God, the color of the skin has changed from white to black.

Pastor Evelyn Gaines, Divine Temple of Love Tab, Kaighns Avenue, Camden, New Jersey

The Lord Jesus and the twelve apostles [thirteen] in The Last Supper: Mary Bethune, Marcus Garvey, Elijah Muhammad, Harriet Tubman, Martin Luther King Jr., Kwame Nkrumah, Drew Ali, Frederick Douglass, Nat Turner, Malcolm X, Paul Robeson, Booker T. Washington, W.E.B. DuBois.

L'Eglise Baptiste Bethel Haitienne de Newark, Springfield Avenue, Newark

THE ANCIENT PICTURE OF CHRIST
Look not upon me because I am black.
 —Solomon Songs 1:6
All faces gather blackness.—Joel 2:6
His hair was like wool.—Rev 1:14
Their face is blacker than coal.—Lam 4:8
God formed man of the dust of the ground, and breathed it
 into his nostrils the breath of life and man became a liv-
 ing soul.—Genesis 2:7
Out of Egypt have I called my son.—Matt 2:15
I am black, but beautiful.—Song of Solomon
Our skins were black.—Lam 5:10
My skin is black.—Job 30:30

Poster by the Society of the Sacred Seven in Bishop J. Davis, All Nations Healing Ministry, Inc., South Vermont Avenue, Los Angeles

I believe in the black Jesus; I don't believe in the black God. Jesus had some flesh on; it was black.

Bishop J. Davis, All Nations Healing Ministry, Inc., South Vermont Avenue, Los Angeles

It is a historical fact that one of the popes commissioned Michelangelo to paint Mary, Jesus, and the disciples as white. It was painted on the inside of one of the cathedrals. Before that you could find images in France, Italy, and other certain European countries that take you back to Africa. The characters are different shades of people of color; some even look Caucasian.

Edward E. Young, pastor, Mount Zion Holiness Church of Christ, Chestnut Street, Camden, New Jersey

I want your mind to stay on black Jesus; everything is going to be alright. Dr. Jesus, great God almighty, the black Jesus, the son of the living God. He is a good God.

Prophet Banks, The True Temple of Salomon, South Halsted Street, Chicago

The image of the white Christ was already there [in the church]. The main thing is that I know the truth that it is a graven image; that is not what Christ looked like. If you look in the Book of Revelation, it says that Christ's eyes are as a flame of fire, and his voice has the sound of many waters, and his hair is like lamb's wool.

Rev. Hughes, Greater Saint John Gospel Temple, East Eighty-eighth Street, South Central Los Angeles

Church Interiors

Houses of worship range from those that have only pews, chairs, the altar, a sound system, and some musical instruments to those that, in addition to the essential furnishings, are full of objects. The walls of the latter are covered with texts, paintings, and photographs. Surprisingly, the larger the church the fewer the number and variety of religious objects one finds inside.

I don't like a lot of things hanging around.

Pastor, South Side of Chicago

Sometimes the outward appearance may not look like a church, but the inside is a sweet spirit. There are some places where you don't feel welcome, but in this you feel in the presence of the Almighty; it is calming, it is beautiful. Have you ever been in a beautiful garden where you feel comforted and relaxed? That is the spirit inside.

Sister Francine Hamilton,
Hickory Hill Baptist Church,
Bryant Avenue, Bronx

We are going to renovate the building inside to make it conducive to services. We are fixing the electrical wiring, the plumbing, and adding new bathrooms.

Pastor Olawale Olayinka,
Calvary Touch of God Ministries,
Bergen Street, Newark

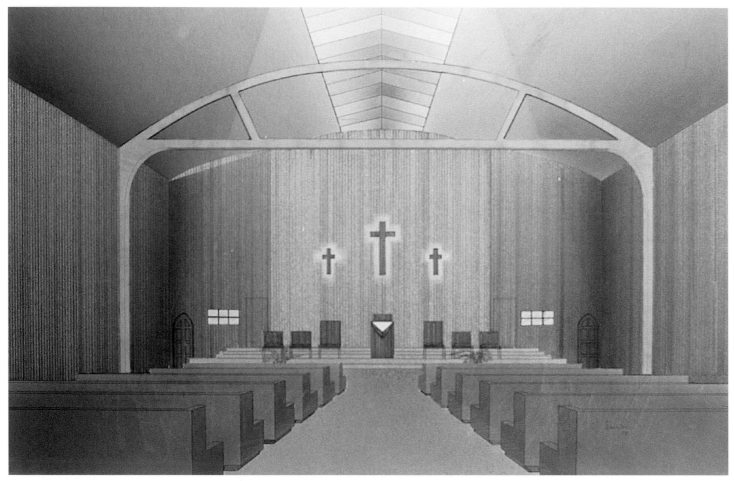

Drawing of design for a new sanctuary, New Covenant Gospel Tabernacle,
South Michigan Avenue, Chicago, 2002

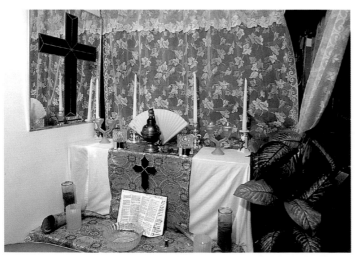

Small side chapel, All Nations Healing Ministry,
South Vermont Avenue, Los Angeles, 2002

Interior, Angels of All Nations Spiritual Church, West Garfield
Boulevard, Chicago, 2001. In addition to being a church, this
space was once used as a bedroom for three children.

Sanctuary, Una Luz en el Camino, with mural of waterfalls, the "living waters" so popular among Latinos, painted by Hermano Peralta, Concord Avenue, Bronx, 2004

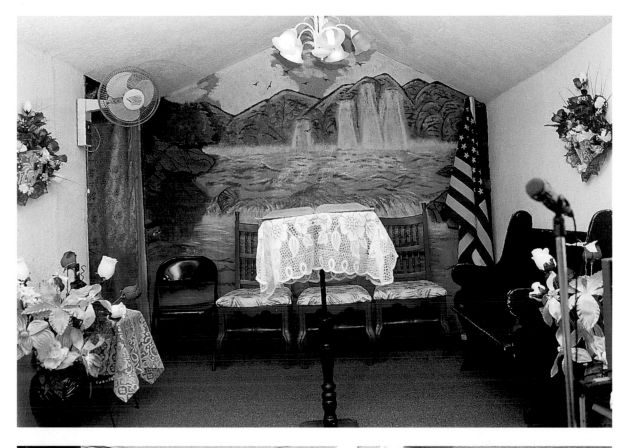

Pastor Gilberto de los Santos preaching to his congregation, Iglesia de Dios el Ancla de la Fe, East 154th Street, Bronx, 2002

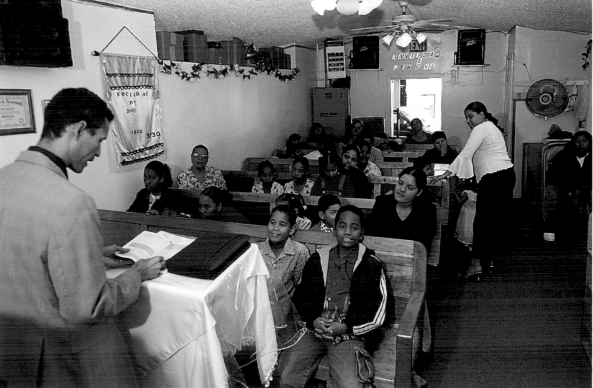

Contact paper purchased at Home Depot, New Ebenezer Baptist Church, Fifth Avenue, Harlem, 2004. This design, originally intended for churches and convents, was widely used in Victorian houses, and is now being rediscovered and used for church windows.

Imitation Stained-Glass Windows

In churches across the nation, windows covered with ageing contact paper are still ubiquitous. These colorful windows, simulating stained glass, produce patterns on the churches' floors that animate the light. By shutting the sanctuary off from its surroundings, they also help to create an inspirational environment. The patterns are simple and regular, without large defining motifs; they are designed for universal application so that the users don't have to worry about matching them. Members of traditional churches who liked the effect of stained glass but did not have the resources to purchase real art glass often bought contact paper to temporarily cover their windows. They hoped that at a later date a family would donate the funds to install real stained-glass windows.

Old-fashioned designs made up of contact paper have started to bubble and their colors have faded. Most officials I interviewed told me that, for at least a decade and a half, stores have not sold the old patterns of contact paper. Still, these vanishing textures and forms contribute to the unique look of these sanctuaries. More recently, ministers have sought out Victorian designs that give windows "the stained look" or "the frosted look," and have found them to be available in the home décor section of Home Depot.

Contact paper in Prairie School style, Zion Hill M.B. Church, South Indiana Avenue, Chicago, 2002

Taping the service for cable broadcasting, Iglesia Thessalonica, Saint Ann's Avenue, Bronx, 2003

He is not on TV because he is theologically correct; he is on TV because he can afford the air time.

Pastor William Elliott, Zion Baptist Church, Broadway, Camden, New Jersey

It does not matter if the pastor says it on television or he says it on the front porch; you are not accepting the pastor, you are accepting the word of God. His true colors will come up in time. Many big-time preachers on television have gone to jail for stealing people's money.

Pastor Bobby Wright, Last Day Baptist Church, South Tenth Street, Newark

Television

Congregations often record services, keeping the tapes neatly organized and labeled in the pastor's office. Pastors watch tapes of their services in order to improve their style of preaching, as well as to sell or give to members who are shut in or who are in the hospital. Megachurches use television to bring services to those who are sitting in the back of the sanctuary, and to record them for broadcast on cable television channels. Pastors of smaller churches are critical of televangelists, whom they feel are dishonest. They urge people to come to church to, "get the live word."

All that TV stuff don't mean nothing when people are still on the streets dying. What does that have to do with helping the people with broken hearts and the people with no jobs? I hate phony people. Don't you know, God hates corruption; God hates sin. God is going to start killing pastors in the pulpit for corrupting His name. I don't like people taking advantage of God's people.

Bishop Craig Hall, Saints of God House of Prayer, Bronx

By means of television, evangelists can teach, educate, and inspire people, but this approach does not make for healthy Christians. Pastors visit their members when they are sick and give them encouragement when they are feeling down. You can't do that with television.

Pastor Felipe Salazar, Iglesia Apostolica Hosanna, El Segundo Boulevard, Compton, California

Why Are There So Many Storefront Churches?

So ubiquitous are storefront churches that a Chicago developer once pointed to a West Side building and said to me, "If it has not been a storefront church, it will soon be one." According to a sign placed on the façade of the former Clinton Hill Post Office on Bergen Street, Newark, real-estate agents listed the types of businesses they expected to move into the space: "day care center, check cashing, liquor store, bill payments, supermarket, dry cleaners, laundromat, mail boxes." Although the real-estate agents did not include churches on the list, the building is now home to the Calvary Touch of God Church.

When they are starting out, congregations often hold services at a local Holiday Inn, Travelodge, or another hotel chain, or they rent space in an existing church. On a typical Sunday, three or four congregations rent banquet halls at the Hilton Newark Gateway, located in downtown Newark. The hotel advertises space for weddings, engagement parties, bridal showers, retirement dinners, sweet-sixteen parties, and holiday parties. On Sunday, their main customers are churches.

That is a question that so many have tried to answer [Why are there so many storefront churches?]. Number one, there are so many believers, some don't even know they are believers. Number two, some say the same things that you say, but people go to their churches because they like the atmosphere

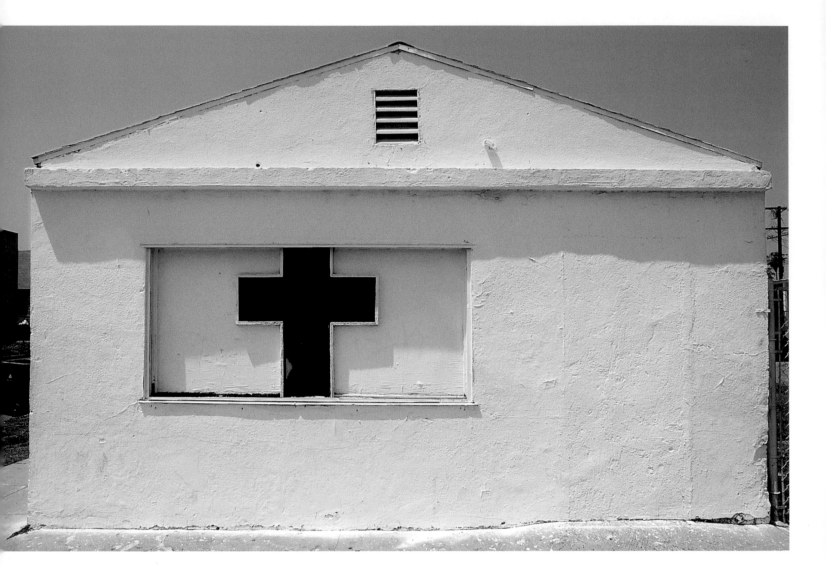

**Cluster of Grapes Ministries,
South Main Street, Los Angeles, 2000**

Prayer Center M.B. Church, South Halsted Street, Chicago, 2001. A sign on the side of the building reads, "Pray as You Enter."

Little Mission Church of God, Pacific Street, Brooklyn, 2001

Church of Christ, formerly a Chinese restaurant, South Ashland Avenue, Chicago, 2001

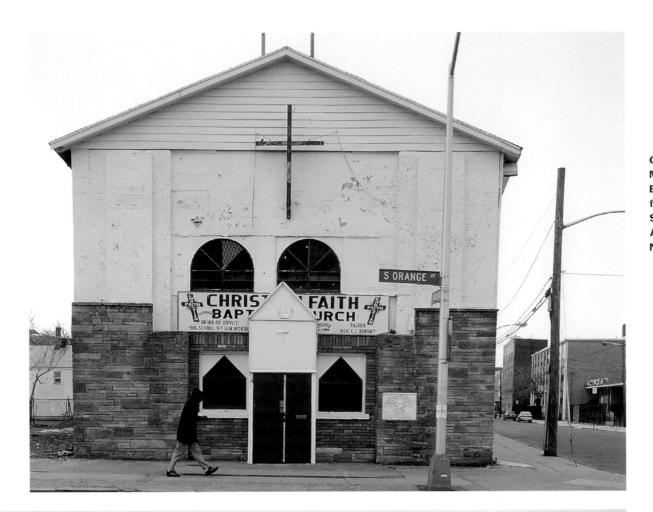

Christian Faith Missionary Baptist Church in former theater, South Orange Avenue, Newark, 2002

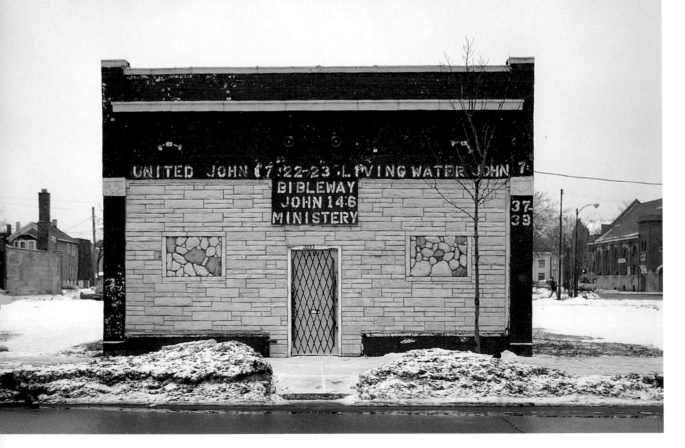

Bibleway John 14:6 Ministry, West Madison Street, Chicago, 2001

of fellowship. Others follow family members into a particular church.

Harold B. George, pastor,
Christ Union Missionary Baptist Church,
International Boulevard, Oakland, California

For when Judgment Day comes, there will be no excuse.

Timothy, New Hope Community C.O.G.I.C.,
South Western Avenue, Los Angeles

You can't have too many churches because the gospel has to be spread all over, starting with Jerusalem.

Bishop P. Rowe, Full Gospel Church, Aberdeen Street, Brooklyn

If someone told me that we have too many churches, I would ask how many prisons do we have? How many pregnant girls do we have? How many abortions do we have? How many drive-by shootings do we have?

Pastor Lillie Lu Grant,
New Nazareth Great Expectations Deliverance Center,
Martin Luther King Jr. Drive, Milwaukee

Storefront churches started because a member of a traditional church got antsy. They didn't like it there; they split and established their own churches. A lot of women would start churches because the Baptist Church wouldn't let women preach.

Pastor Willie Anderson,
Sword of the Spirit Christian Center,
Kaighns Avenue, Camden, New Jersey

The reason why there are so many storefront churches is because each pastor wants to be a king. You have a church in every corner because they feel the Lord has called them to that particular area to start saving souls.

Turner 3, First Goodwill Baptist Church, Compton Avenue,
Los Angeles

There was a point when our inner cities were suffering, properties were cheap. Now there is evidence of a transition; we need to be a lot more discriminating about where we put our churches. Those commercial spaces are needed for commerce: for nail shops, discount stores, even boutiques.

Rudolph Bryant, Pratt Institute, Brooklyn

The Street of God, Overflowing with Churches
In urban areas that have been shunned by businesses, I have observed a profusion of storefront churches on both sides of a street, making it look as if the block had been zoned for churches. Many of these former commercial stretches are located in the poorest and most dangerous neighborhoods in the nation. I asked if people in these religious enclaves were holier, or if they showed more love for their neighbors. A barber on South Orange Avenue, whose shop is a rare business on that block of Eighteenth Street, explained that the numerous storefront churches did not make the area safe: "It does not work that way; there are so many shootouts in this street." Pastor Jean White, whose church Naomi Memorial Baptist Church is located on a block of West Chicago Avenue in Chicago with four other churches, explains, "The churches are here for a purpose; they are here to save souls. The pastor of the church on the corner brought his members to the street. They had prayer and singing, and that stopped the drug dealing. The Bible says that righteousness and prayers prevail much."

SOME STREETS OF GOD
Fulton Avenue, between Sommers and Rockaway avenues, Brooklyn
2800 block of Germantown Avenue, Philadelphia
South Halsted Street between Seventy-fifth and Seventy-sixth streets, Chicago
Kinsman Avenue and 121st Street, Cleveland
Ralph Avenue, between Prospect and Park Place, Brooklyn

There is a MacDonald's, there is a Burger King around the corner, and a Jack in the Box across the street. Churches do the same. There are more people here than you think. We have enough people here to fill all the churches; we have 7 million Hispanics in the metro area.

B. J. Luckett, Plain Truth Mission,
South Avalon Boulevard,
Los Angeles

It all depends on how healthy those churches are, if they are offering quality Bible teachers, and if they are well-balanced churches able to serve the needs of the community. Many storefront churches are in places where many businesses died out.

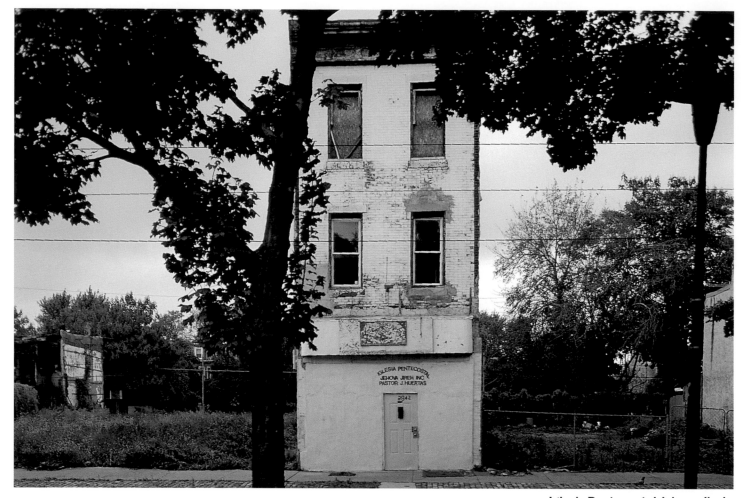

*They left a lot of storefronts open. A place where nobody wants
to do business can become a good place to start a storefront.*

 Pastor Harold B. George, Christ Union Missionary Baptist
 Church, International Boulevard, Oakland, California

*People are going to come where the anointed is; they come
where they can get the word from the anointed.*

 Pastor Connie Boatman, Deliverance Prayer Center,
 South Ashland Avenue, Chicago

*The place can be holy, but not the people. We believe that the
devil has hold of them; when you have to have a fix it makes
no difference.*

 Deacon John Harmon, First Steadfast M.B. Church,
 East Bowen Street, Chicago

*When I looked around in the 600 North block of Cicero
Avenue, I saw five or six churches, and I said, "I have to get
out of here."*

 Pastor Mitchell Bullock,
 Zion Missionary Baptist Church,
 West Madison Street, Chicago

Street of no tax paying; it is a debacle.

 Urban planner, Newark

Block of Roosevelt Road, Chicago, 2002

Street of God, section of West Florence Avenue, Los Angeles, 1998

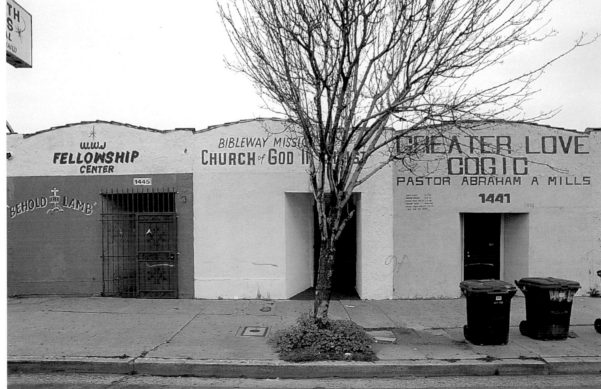

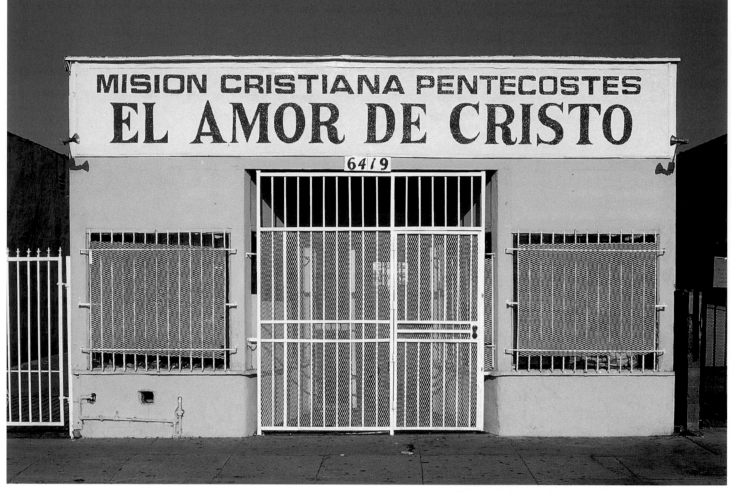

**Mision Cristiana Pentecostes El Amor de Cristo,
South Crenshaw Boulevard, Los Angeles, 1999**

Security

Most churches are empty except for Sunday services, evening prayer, Bible classes, and choir rehearsal on week-day evenings. Churches, like many of the neighboring homes and businesses, are broken into and robbed. In response to crime, the congregation hardens the building by eliminating or barring windows, replacing wooden doors with metal ones, and ringing the roof perimeter with razor-ribbon wire. Churches often have alarms, closed-circuit TV monitors, and are watched by neighbors. Buildings are kept locked even when people are inside. Some of the security devises, such as television monitors and lights, are themselves defended so as not to be stolen or vandalized.

On Sunday, the congregation drives to services in vehicles that have to be guarded by one of the members. Large churches hire retired policemen as security guards. Standing at the top of the steps to Saint Rocco Roman Catholic Church on Hunterdon Avenue in Newark, I saw a young and friendly off-duty Newark police officer armed with a large pistol. He was guarding the cars during Sunday service, aware of the irony of using a gun to defend the property of those attending a church whose stated mission was

"to reach out to the surrounding communities with love." A few blocks west on Springfield Avenue, Robert Lassiter, a retired Newark Housing Authority Security officer, guards cars for New Bethel Baptist Church. On Sunday mornings, he sits next to the pastor's SUV, ready to call the police if anyone tries to break into a vehicle.

They stole the video camera. The pastor had to put the new one in a cage. They steal everything around here.
 Member, Trinity Baptist Church, Twelfth Street, Newark

We have to be protected; we don't want people to steal our organ or our piano.
 Congregant, Holy Mission Baptist Church,
 East Vernon Avenue, Los Angeles

We have to take the neighborhood into consideration. Windows in the front would make the church vulnerable. I

**Kingdom Hall of
Jehovah's
Witnesses,
Brenner Street,
Newark, 1981**

**Kingdom Hall of
Jehovah's
Witnesses,
Brenner Street,
Newark, 1998**

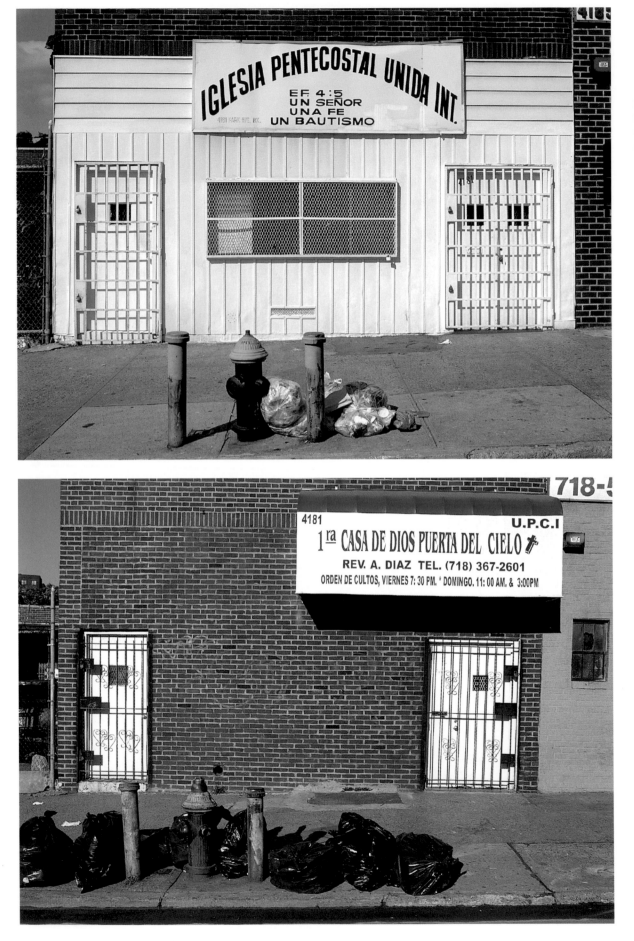

Iglesia
Pentecostal
Unida Int.,
Park Avenue,
Bronx, 1987

1ra Casa de Dios
Puerta del Cielo,
Park Avenue,
Bronx, 2002

Iglesia de Dios Pent. Exodo, Inc., Fairview Street, Camden, New Jersey, 2004

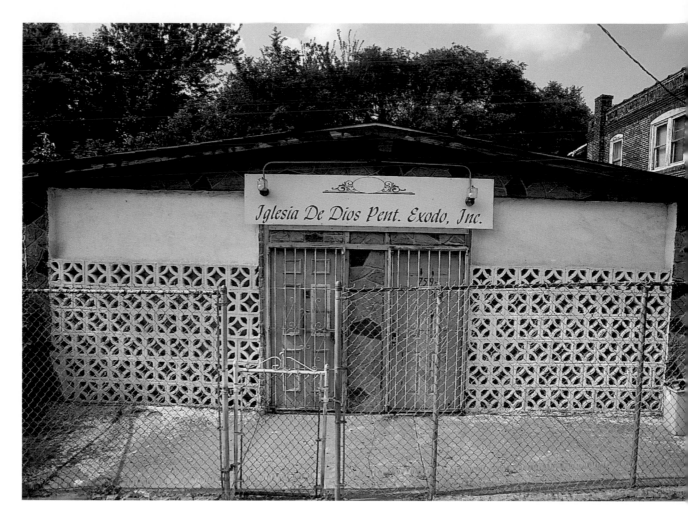

have narrow windows on the side. We constructed a metal box with a lock to store the sound equipment.
 Pastor Felipe Salazar, Iglesia Apostolica Hosanna,
 El Segundo Boulevard, Compton, California

I had the church's door open, and somebody just walked in and stole my drill.
 Elder Michael Diggins,
 Light of the World C.O.G.I.C.,
 Rosencrans Avenue, Compton, California

Warning!
Absolutely
No Loitering!
No Prowling!
No Wandering!
At any time on this property without visible or lawful business with the owner or tenants.
 Society of Saint Vincent de Paul,
 Martin Luther King Way, Oakland, California

A few years ago a lady bought a brand new car, and it got stolen during service. Everybody knows me around here, so nobody messes with the cars.
 Henry, car watcher, Zion Baptist Church,
 Broadway, Camden, New Jersey

I am here so they don't try to steal a car. It's the times that we are living. Brothers in the church rotate doing this so that it is no expense for the church.
 Deacon guarding the parking lot of Gravel Hill Missionary
 Baptist Church, Clinton Avenue, Newark

It is not unusual to guard the house of the Lord with a gun.
 Retired police officer guarding the parking lot,
 Grant African Methodist Episcopal Church,
 South Central Avenue, Los Angeles

I can see why people are nervous about their cars. A car thief could have his pick; he could have the best car in the neighborhood.
 Tim Samuelson, cultural historian of Chicago

Henry, car watcher for Mount Zion Baptist Church, reading the Bible across the street from the church parking lot, Broadway, Camden, New Jersey, 2003. When asked what he would do if someone tried to steal a car, he said, "I live down the block. Everybody knows me here; nobody would steal a car."

Bus belonging to Praises of Zion Baptist Church, South San Pedro Street, Los Angeles, 2000. When a church official was asked why the bus was placed in a cage, she responded: "What is the big deal? It doesn't run anyway."

Protected lights, Saint James Tabernacle A.M.E., Diamond Street, Philadelphia, 2004

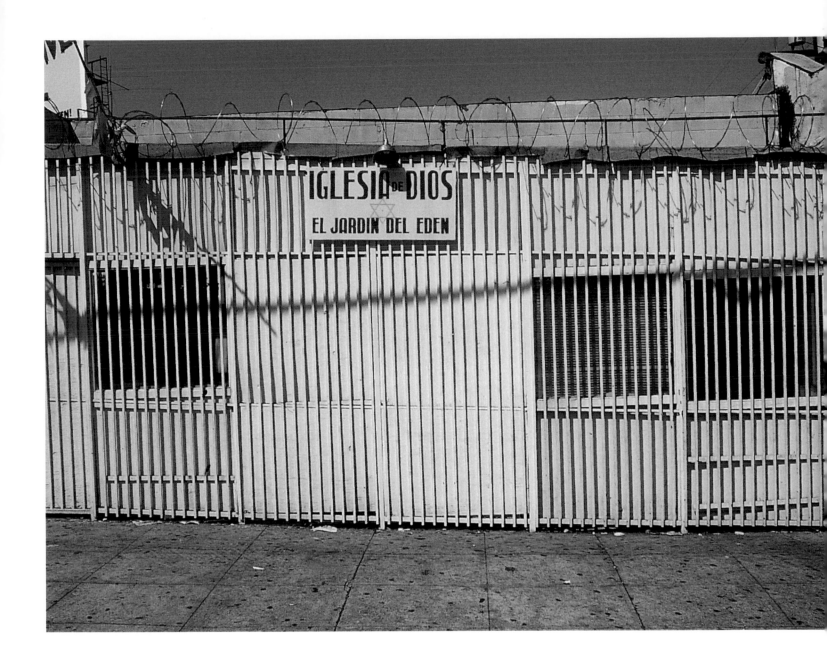

There is nothing Edenic about this Garden of Eden,
Hoover Street, Los Angeles, 1997

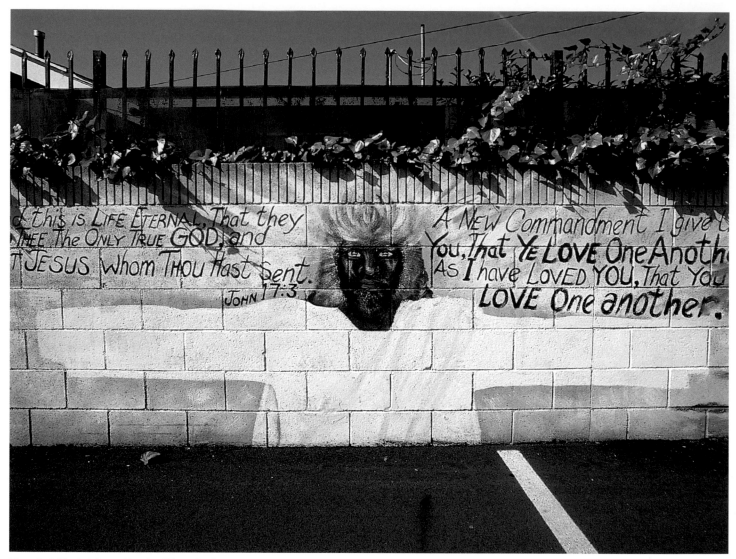

Mural of Christ from Book of Revelation
decorates parking lot of New Jerusalem Baptist Church,
South Western Avenue, Los Angeles, 2002

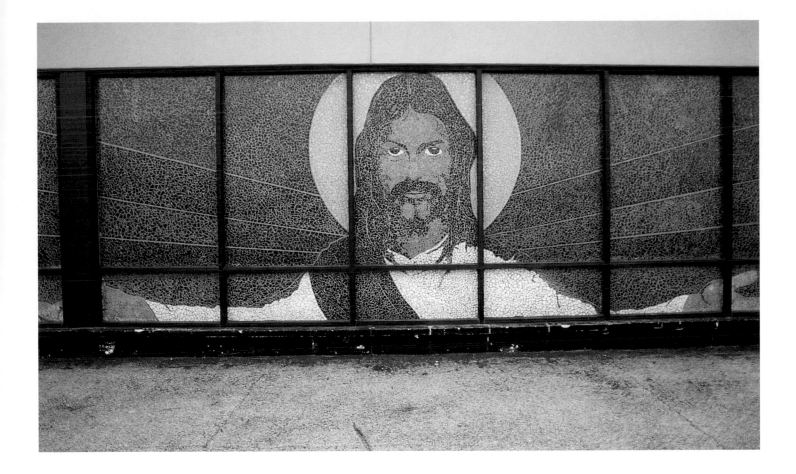

Parking

The provision for parking is essential for churches, particularly for those drawing most of their membership from outside the immediate neighborhood. Often the entrance to the sanctuary faces the parking lot and not the street; pastors block the original entrance to the building and place the sign for the church near the parking lot.

Chicago has allowed large churches to locate in areas zoned for industry. Because of this, thousands of members who drive to Sunday services from the suburbs and from distant sections of the city find easy parking. In these districts religion has replaced manufacturing.

If a building burns down in the block, it may be a good thing for the church. They wouldn't have to go through the expense to knock down a masonry building to create a parking lot.
　Tim Samuelson, cultural historian of Chicago

If you hold services at home or in a building that is not set up as a church, your neighbors are going to complain because they can't park. The city comes down on you. People from downtown [city officials] are going to visit you; they are going to check if you have insurance and if you have a permit to have a church. If you don't close down, they will padlock the building, and you will be going to jail and pay a big
fine. You have to have a parking lot and papers, and insurance for up to $100,000 in case anybody gets hurt.
　Pastor Robert McGee,
　New City Temple,
　South Ashland Avenue, Chicago

We are in the process of moving. We are looking for an area with better parking, with less restricted areas. Here people have to go far to find a parking space. The police precinct is near and ready to give tickets to those parked illegally.
　Pastor Ramon Madariaga,
　Iglesia Apostolica Maranatha,
　South Broadway, Los Angeles

What you call desolation, we call parking.
　Pastor Reyes, Iglesia el Refugio,
　Third Street, Philadelphia

4 I Am Here to Preach the Truth to You

Church Leaders

Dealing in Hope: Pastor, Preacher, Apostle, Minister, Elder, Congregant

There are three main types of religious leaders: those who have been called by the Holy Ghost to be the overseer of people and to start their own churches; ministers who work under the leader of an established church; and those who have been approached by a group of people to become their pastor. Some pastors who have experienced a calling from God and have resisted it for years have yielded after renewed calls and signals from the Lord. Regardless of whether they create an organization or move through the ranks of an existing one, most pastors claim that they owe their position to a calling from God. This calling is followed by an appointment by church leaders, or it induces them to establish their own church.

Pastors believe that God speaks through them. "The Lord directs the steps of the righteous man," explains Pastor C. L. Bonney, Christian Faith Missionary Baptist Church, Newark. He adds, "What I say is what the Lord has told me to say." Grassroots religious leaders are mistrustful of those with college degrees, suspecting that they take advantage of their education to exploit people.

Pastors are often referred to as "our man of God," and a decision concerning the church is rarely made without consulting them. Members who I approached frequently told me that they couldn't give me any information; I would have to speak with the pastor. Elder John G. Stevens, of Newark, explained, "The pastor is treated like God almighty, and people accept whatever he says. They don't even check it in their Bibles." As an appreciation for their service, many congregations celebrate Pastor's Day and Founder's Day. Leaders of large congregations have streets named after them. The Bishop Ford Expressway is named after the late Bishop Ford of Saint Paul's Church in the South Side of Chicago.

People admire pastors for their charisma, and for what they have been able to accomplish. In more than three decades of living in and visiting American cities, I have not encountered another occupation in which older African Americans and Hispanics of modest means were treated with so much respect. Pastor Edward E. Young, of Mount Zion Holiness Church of Christ in Camden, explained that people often show respect to the office of pastor and not to the individual. He calls this "positional status." As Pastor Young explains, "God can give you favor in the sight of man."

Pastor William Yancy of Leadership Missionary Church in Milwaukee agreed that pastors are respected, but he insisted that "you must purchase yourself that respect." He explained that things weren't always so rosy for pastors. He cited a case in which members of a church in Milwaukee were trying to replace an older pastor with a younger man.

By what credentials or magnetism do pastors draw their congregation? What transforms a Chicago Transit Authority train driver, on Sunday, into God's messenger? How does he get the people to come to his church every Sunday? How does he offer them words of counsel? How does he turn them on? Is it manipulation? These are guys who know how to work a crowd; they think on their feet. These are people who are from the people. What they talk about is not in the abstract. They are not preaching divinity school dogma.

Tim Samuelson, cultural historian of Chicago

I tell you what sets the church afire; it's the leader.
Pastor Ireland Jones,
Greater Peter's Rock Church, South State Street, Chicago

Bishop Wallace Furrs is a man who has been called and sent by God. He believes in Holiness and sanctification, and bases everything in the infallible Word of God. Knowing that there must be a difference between the saved and the unsaved, his motto is Hebrews 12:14: Follow peace with all men, and holiness, without which no man shall see the Lord. He will not compromise the word of God for anyone....
Excerpted from "America Come Back to God"
Convention Program, 2003, Charlotte, North Carolina

Pastor Jackson was a servant of the Lord Jesus Christ. He was from Louisiana. He was the third leader of this church. He was here a good ten years. He was a very good preacher; he practiced what he preached. He lived for the Lord. He was a family man, providing spiritually and materially for his family. In

Saint Samuel Cathedral,
East 125th Street, Harlem, 2002

Portrait of the late Pastor Walter Jackson,
New Jerusalem Baptist Church,
Peralta Street, Oakland, California, 2002

West Oakland, Pastor Jackson made a lot of key decisions. He was a community leader; he advised people. They are trying to uproot people around here. He told people that this was prime real estate. He told them to be involved in the redevelopment.

> Pastor Richard L. Williams, describing his predecessor at the New Jerusalem Baptist Church, Peralta Street, Oakland, California

In the name of the Lord Jesus Christ, the great Head of the Church, and by the authority of the Bible Way Church of our Lord Jesus Christ World Wide, Inc., I do pronounce and declare that Elder McKinley Hand is duly constituted the pastor of this congregation. Let us therefore pray unto God, the Fountain of all Grace and Glory, that he may be pleased to sanctify with his heavenly blessing this relationship between pastor and people, which has now been established in his name.

> Apostle Huie L. Rogers, chief apostle and presiding bishop, order of pastoral installation, Bibleway Church of Our Lord Jesus Christ, Evening Light Apostolic Church, Bible Way World Wide, Germantown Avenue, Philadelphia

I am employed by God; I was hired by God and can be fired by God. I work for the people, but my employer is God.

> Pastor Lillie L. Grant, New Nazareth Great Expectations Deliverance Center, Martin Luther King Jr. Drive, Milwaukee

In the church where I was, the pastor resigned. I became a pastor. A pastor is leading his flock; he leads God's people. He has no other help than the spirit of God.

> Pastor Robert Moore, Rising Star Missionary Baptist Church #2, Eleventh Avenue, Gary, Indiana

I was a Sunday school teacher, then a deacon, then evangelist, then I was ordained. I came through the ranks; the Baptists come through the ranks.

> Rev. Marshall Smith, pastor, Greater Jerusalem Baptist Church, Pitkin Avenue, Brooklyn

***Luke 4:18–19:** The Spirit of the Lord is upon me, because he hath anointed me to preach the gospel to the poor; he hath sent me to heal the brokenhearted, to preach deliverance to the captives, and recovering of sight to the blind, to set at liberty them that are bruised, To preach the acceptable year of the Lord.*

> Pastor L. Summers, House of God, West 139th Street, Robbins, Illinois (calling card)

I was in the kitchen of my home, my wife was cooking, and the Lord said "Go and preach," and then said it again, "Go and preach." This was in 1991. I ran from my call until 1994, when the Lord told Pastor Richardson, "I called Willie

Sign at Praise Tabernacle of the Apostolic Faith, in which the Bible is on fire and the preacher is drunk on the spirit, South Western Avenue, Los Angeles, 2000

Cast of King Louis H. Narcisse, portrayed as a bishop, made in Bakersfield, California, in 1964, Mount Zion Spiritual Temple, Fourteenth Street, Oakland, California, 2004

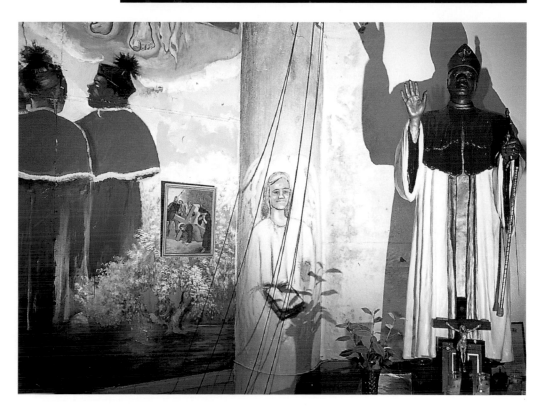

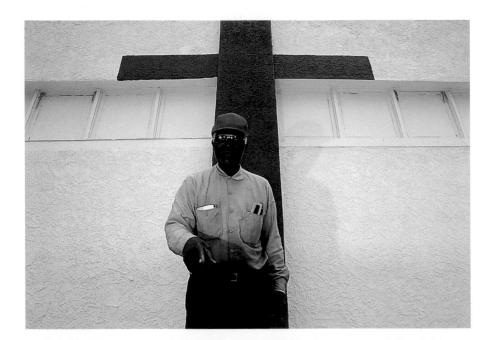

Elder Charles Mack, Holy Defender C.O.G.I.C., South Vermont Avenue, Los Angeles, 2002

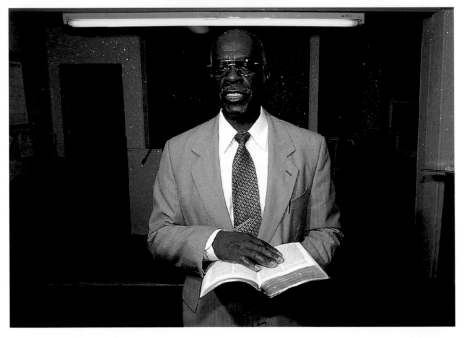

Pastor M. Scriven quoting from the Bible, General Assembly Holiness Church of the First Born, North Broad Street, Philadelphia, 2003

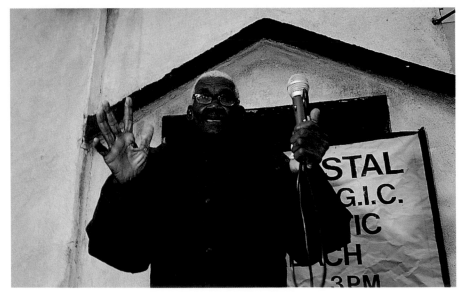

Elder Delroy Brown, originally from Jamaica, preaching to drivers passing by South San Pedro Street across from his Church Pentecostal Temple C.O.G.I.C., Gardena, California, 2003

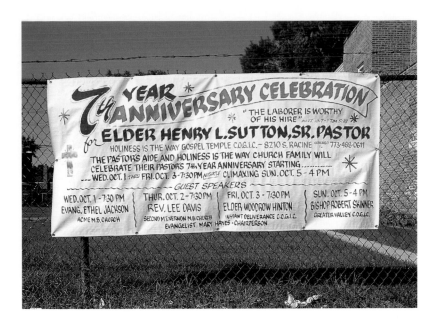

Sign announcing Seventh Year Anniversary Celebration of Henry L. Sutton as pastor of Holiness Is the Way Gospel Temple C.O.G.I.C., South Racine Avenue, Chicago, 2003

the Preacher, and he has been running." God's voice is a different type of voice. He does not say it in a demanding way. He says it in an inspiring way.

Pastor Willie E. Ware, New Calvary M.B. Church, East Eighty-seventh Street, Chicago

A voice in the spiritual wilderness
Elijah came anew
A watchman upon Zion's wall
A trumpet with a sound
That is true.

Oswald P. White, describing the work of Pastor Dr. F. E. Roy Jeffries of The Sabbath Cathedral, Philadelphia Church of Universal Brotherhood, Eastern Parkway, Brooklyn

I was a little twenty-one-year-old preacher, preaching in Texas and Arkansas and Oklahoma. I am pastoring ever since I left Texas, thirty years ago. I recently got in touch with my old seminary roommates from Texas. I am the only one that has kept his vows. What happened? What is going on? I have had my share of ups and downs; I even told God he had made a mistake, but I am in a good place. My roommates were smarter than me; they came from blue-blood background, but I alone made it. Thank you, God, I have nothing to moan and groan. It is good to look back on my life and to see that I have been blessed. It is special when you know you are in the inner circle. Not everybody gets a chance to experience the glory of God; now you have that chance. Stop crying, stop worrying; you are going up to glory, don't stop here. Don't let this moment pass you by. Say yes to the Lord.

Rev. Anthony Lowe, Pastor, Mount Carmel Baptist Church, Prospect Avenue, Bronx

Pastor Will A. Wheat is our man of God. The spirit of God is moving in this place; it is holy ground.

Tracy Blackwell, New Creation Christian Faith Center, South Crenshaw Boulevard, Los Angeles

We are supposed to live as close to Christ's life as we can. We get out and witness to the people.

Pastor Archie Arline, South Compton Avenue, Los Angeles

The pastor is filled up with the Holy Spirit. You feel people drawing from you; God uses people.

Pastor Sarah Daniels, Whole Truth Gospel Church of Faith, Eleventh Avenue, Gary, Indiana

I preach because people need to hear the word of the Lord and be converted.

Elder Delroy Brown, Pentecostal Temple Church of God in Christ, San Pedro Street, Compton, California

God didn't call me to be a white pastor or a black pastor; he called me to be a pastor. There is no black church, there is no white church, there is no Latino church; God has a church.

Bishop Floyd Goodwin, Cluster of Grapes Ministry, South Main Street, Los Angeles

I am here to tell you that God died for your sins.

Pastor Hughes, Greater Saint John Gospel Temple, East Eighty-eighth Street, Los Angeles

The measure of validity as a pastor is being a good shepherd; he needs to have an ongoing relationship with his people. A good shepherd knows the smell of each one of his sheep.

Pastor Edwin L. Williams, Institutional Baptist Church, South Broadway, Los Angeles

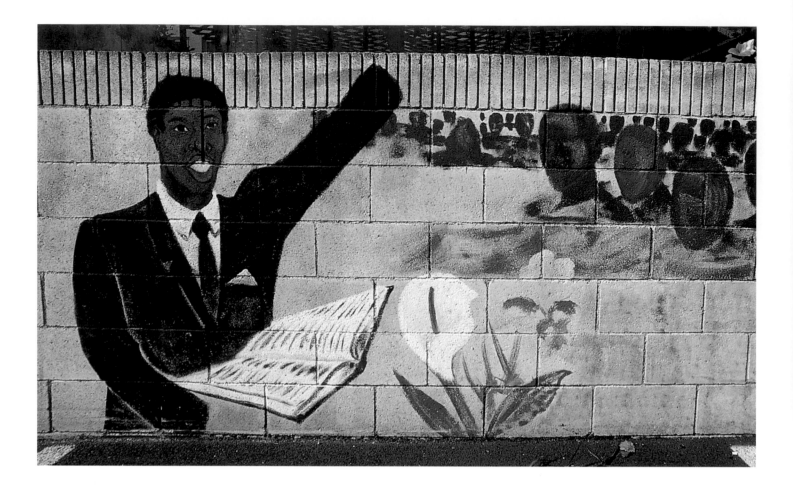

You don't need to know me; you need to know Jesus.
> Pastor Willie Anderson, Sword of the Spirit Christian Center, Kaighns Avenue, Camden, New Jersey

A preacher takes responsibilities. We broadcast the word of Christ. We take it upon ourselves to take up the slack [when other people turn their backs on God].
> Pastor Branch, Heavenly Rainbow Baptist Church, South Western Avenue, Los Angeles

The pastor is like a maintenance worker or a boiler operator for God.
> Dr. Edward Young, Pastor, Mount Zion Holiness Church of Christ, Chestnut Street, Camden, New Jersey

I have had four Cadillacs. This is the fifth one. Not one was paid by the church.
> Elder Robert Harris, Way of Holiness Church of God in Christ, Indiana Avenue, Chicago

The money is not in the church. For every large church where you find a pastor that has a good deal, many pastors are broke. They get the money, and they give it away.
> Pastor McNamee, Do Right Christian Church, Los Angeles

The reason I dress like that is to present an image of organization, correctness, and respect. In the black church, when a person is put into leadership, they expect him to be dressed up so he stands out from the others.
> Elder James Culpeper, skid row, Los Angeles

He wore crowns, robes. He wore capes. He had a golden, crystal-clear voice. He was real. He was really, really, really real.
> Princess Lillian Roberts, Mount Zion Spiritual Church, Fourteenth Street, Oakland, California, describing King Louis H. Narcisse, the church's founder

My family was Baptist in North Carolina, and we have a long line of Baptist preachers, but they didn't live right. They womanized; they were drunk; they fathered children out of wedlock.
> Overseer Rosa Vick, pastor, Pillar of Truth Apostolic Church of Christ, Prospect Place, Brooklyn

I don't have time to talk to you now. I am on my way to the hospital to see one of my members that is having surgery.
> Pastor Robert Moore, Rising Star Missionary Baptist Church #2, Eleventh Avenue, Gary, Indiana

Mural of preacher reading from the
Scriptures to a crowd, parking lot,
Greater New Jerusalem Baptist Church,
South Western Avenue, Los Angeles, 2002

Pastor Edward E. Young,
former maintenance mechanic and union official,
Holiness Church of Christ, Camden,
New Jersey, 2003

Why People Become Pastors

Many factors can contribute to the choice of becoming a
pastor. Often cited are being part of a family of which one
or more of the members is or has been a pastor, having
been a pious child, or both. After the death of a pastor, it is
common for a family member—a wife, a son, or a daugh-
ter, for instance—to take over as church leader. People who
have survived near-death experiences, such as victims of
serious crimes, or those who have suffered grave illnesses
often become religious leaders. Most pastors explain that
they chose their profession because God called on them to
operate in that capacity. During moments of prayer or med-
itation, God gives them the strength to be His worthy rep-
resentatives.

*I believe that a man that is chosen, is chosen from his
mother's womb. I grew up in Alabama; I used to pray funer-
als to a dead cat I kept in a sandbox for that purpose.*
 Rev. C. F. Bonney, pastor, Christian Faith Baptist Church,
 South Orange Avenue, Newark

*He knew he was called at a very early age because as a child
in Alabama he preached to the chickens in the barnyard.*
 Deacon John Harmon, speaking about Pastor Ben Butler of the
 First Steadfast M.B. Church, East Bowen Street, Chicago

*I felt the call of God in 1978 when I was in high school. When
I told my pastor, he said, "Go home and pray." I preached my
first sermon in high school. I went to Bible College in Virginia.
There was a calling, but there was also preparation.*
 Pastor William Elliott, Zion Baptist Church, Broadway,
 Camden, New Jersey

*When you think and meditate, you communicate with God.
It is like you sit down there one day and all of a sudden you
receive a thought, a thought for you personally. And when the
word that God speaks directly into your mind* (rhema) *lines
up with the word of God in the Bible* (logos), *then you start
walking as an evangelist. You start teaching once you receive
direction and anointing from God; you need to have revela-
tion from God. If God has called you, don't wait for a piece of
paper to step out. They didn't have a piece of paper for me.*
 Minister Reggie Jackson, Christ Temple Inter-denominational
 Church, Girard Avenue, Philadelphia

*My father was a pastor. I first heard the voice of the Lord
when I was sixteen or seventeen. I received him as my savior
in 1976, when I was in my mid-twenties. My father and my
uncle ordained me to the ministry in 1986.*
 Elder John G. Stevens, Community House of Prayer,
 South Orange Avenue, Newark

*My father was a preacher in Houston, and I didn't want to
become one myself; but if you are called, you have to do it.*
 Pastor Henry Ellis, Revelation Baptist Church,
 South Western Avenue, Los Angeles

*My father is a retired pastor, and I liked caring for people
and sharing with people.*
 Pastor Leonard E. White, Holly Mount Calvary M.B.C.,
 South Main Street, Los Angeles

*My father is a head bishop of this church in Florida, and my
uncle used to be the bishop in Camden. I used to operate
front-end loaders, and I had free time to myself between*

trucks, so I used to preach in the open. It was just me and the machines.

Bishop Sylvester Banks, Bible Church of God, Fourth Street, Camden, New Jersey

My uncle was a pastor. I was called to preach; the call came from God. Most people don't really want to pastor, to be responsible for other people. Sometimes He [God] has to work with you.

Pastor William Yancy, Leadership Missionary Baptist Church, Martin Luther King Jr. Drive, Milwaukee

After being in the ministry for eighteen years, I became an assistant pastor. My pastor elevated me to that position. I felt that I was ready, but I needed to follow protocol. A lot of pastors out there have made themselves pastors. To be a pastor you need to have a love for God, a love for people, and discipline. There are many people out there who say "I am this and that," but God is a God of order. There are offices in his ministry: apostle, prophet, pastor, preacher, evangelist, and teacher. When God calls you, you find certain things in the way you act that confirm you. My pastor could see those things.

Assistant Pastor Andre Faison, Bronx Christian Charismatic Prayer Fellowship, Third Avenue, Bronx

I ran into several people that had been purged in several churches. They were listless because they stopped going to church. Someone came to me and asked me if I would pastor to them. This is something I had to consider and pray over until I received an answer in my spirit. I had the calling, but I didn't want to become a pastor until I had verification.

Edward E. Young, pastor, Mount Zion Holiness Church of Christ, Chestnut Street, Camden, New Jersey

First you have to get the calling to be a pastor. We see people who want to be led by the individual; then he became a pastor of this people. Peter says, Acts 20:28, the Holy Ghost makes you be the overseer. Sometimes you can feel the rejoicing, and then sometimes there will be tears in my eyes. I will sometimes speak in other tongues, and sometimes people will be prophesizing. God deals with the individual one on one; nobody sees this happening. This is different from someone speaking out of his mind; there is

no power to someone speaking out of his mind. If it is of God, you cannot be hindered; if it is not of God, it will come to nothing.

Pastor M. Scriven, General Assembly Church of the Apostolic Doctrine, Broad Street, Philadelphia

I got shot through my neck during the course of a robbery. I became a preacher very quickly after and never looked back.

Bishop B. J. Luckett, Plain Truth Mission Church, South Avalon Boulevard, Los Angeles

I was brought up in a Christian home. I was influenced by the church so much. I realized that God wanted me to work for Him. I was a youth pastor. In 1982, I got up one morning and was paralyzed from the neck down. The doctors told me I had Guillain-Barré syndrome, a paralyzing disease. Everything has to be done for you; they have to dress you, they have to brush your teeth. That is when the Lord started talking to me. Since I made my submission, things have been drastically different.

Elder Winston E. Thomson, Ebenezer House of Prayer of the Apostolic Faith, West Fiftieth Place, Chicago

I became a pastor because the pastor of my church resigned and the church was left without a pastor. I was the church's secretary, and the bishop asked me to become the pastor. My calling was confirmed by a dream. I was pulling a cart like a horse, and there were children and elderly people in the cart. As I was walking, I was approached by two beast-like animals. They were like human beings with awful faces and claws, their eyes were red like fire. I was so afraid, I wanted to leave the cart and run. And then I saw the children screaming and heard the spirit of God saying, "You can't leave this. Be not afraid; I will protect you." And direct at that time, I closed my eyes and rehearsed the Lord's Prayer. Then I opened my eyes, and the beasts were gone.

Rev. Dr. Mark Carrington, National Church of God of Brooklyn, Inc., Saratoga Avenue, Brooklyn

I was in bed, and my wife was sleeping. It was like a vision. I could see these two bishops I knew, and they were anointing me with oil. I felt the burning sensation on my forehead.

Pastor Gloria Lawton, dressed for Sunday service, New Life in the Great I Am, Bostwick Avenue, Jersey City, New Jersey, 2004

Later people who didn't have any idea who I was called me minister. That confirmed the calling.

 Rev. Townsend,

 Christ Healing Temple of Faith,

 Fenkell Avenue, Detroit

I was sleeping when He called me, and I went back to sleep, and He said, "Peter, feed my sheep," and I woke up and turned the television on, and the Spirit told me, "I didn't wake you up to turn no television on," and I went to the kitchen and went down on my knees and prayed. At the climax of my prayer, He told me to get up and read the twenty-eighth chapter of Saint Matthew; that is where Jesus commissions His disciples. I didn't feel worthy. I felt that my education was insufficient; you know, how this society sees you. A lady I had never seen before approached me on the street and told me, "You know God called you to preach; you should go ahead and do that."

 Pastor Jim Young, Sr.,

 The Lord and Holy Ghost Apostolic Faith Church,

 South Racine Avenue, Chicago

I was standing at the sink doing dishes when He [God] told me I was going to work; that was Him dealing with my heart. I didn't know what the work was going to be. Fifteen years later, He called me to be a pastor. I was thinking that there was no way in the world He would want me, a woman, to be a pastor. I didn't accept Him for five years.

 Pastor Sarah Daniels,

 Whole Truth Gospel Church of Faith,

 Eleventh Avenue, Gary, Indiana

Women Pastors

Although pastors like to say that "God don't look on gender," the overwhelming majority of religious leaders in poor communities are men. Women pastors are often found at the head of smaller Pentecostal and Holiness congregations.

The ban on women pastors in the regular churches has increased the popularity of the Pentecostal, Holiness, and Spiritualist churches where ambitious women may rise to the top.

 Saint Clair Drake and Horace R. Cayton, *Black Metropolis*, 1945

They think that the woman is not supposed to be a pastor, but He [the Lord] does what He wants. He chooses who He wants; He just wants a clean vessel. There are a lot of evangelists and missionaries that are women.

 Minister Climmie Gamble, Nevin Avenue, Richmond, California

I was married to Bishop Lucas when he had a heart attack and was unable to function in the office. I was elevated and installed by him.

 Pastor Margaret Lucas, The Mount Calvary Church of God United in Christ, Holland Street, Newark

The church was left in my hands. I was not planning on being a pastor. It was closed, and the members got together and formed a committee, and I was elected president. We found a pastor from Philadelphia who came back and forth for four years, then he ordained me and passed the church on to me.

 Pastor Gloria Lawton, New Life in the Great I Am Church, Bostwick Avenue, Jersey City, New Jersey

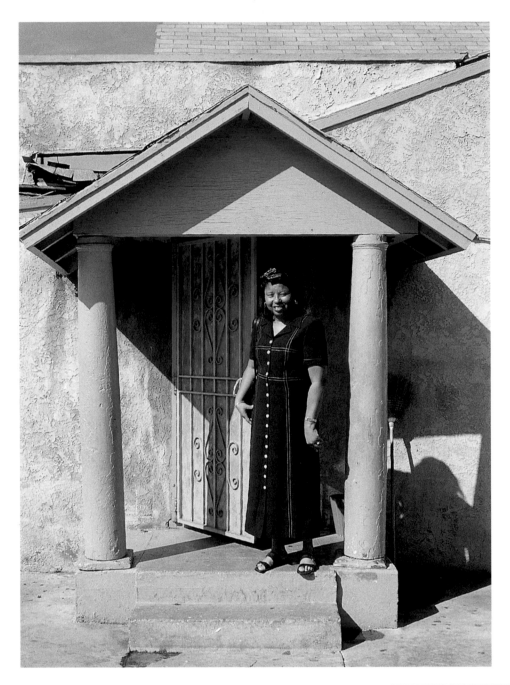

Reverend Denson,
Fellowship M.B. Church,
East Thirty-first Street,
Los Angeles, 2002

*I was one of ten children. My mother was a pastor of a
church in Guyana, South America. I had many signals,
many calls. I became a pastor because there is a love for
God in me and a love of the things He had done for me.
I am not just talking God; I experience God. Jesus' first
appearance after His crucifixion was to a woman. Jesus
met Mary Magdalene first and sent her in assignment
to tell the apostles that He had resurrected.*

Pastor Marva Edmonds,
Truth Center of Divine Awareness,
Ralph Avenue, Brooklyn

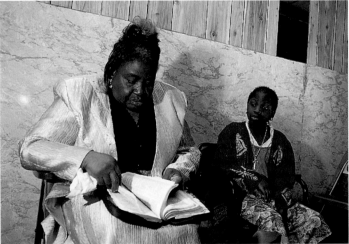

**Dr. Ruth D. Singletary and her granddaughter, The World
Evangelical Deliverance Center, Third Avenue, Bronx, 2002**

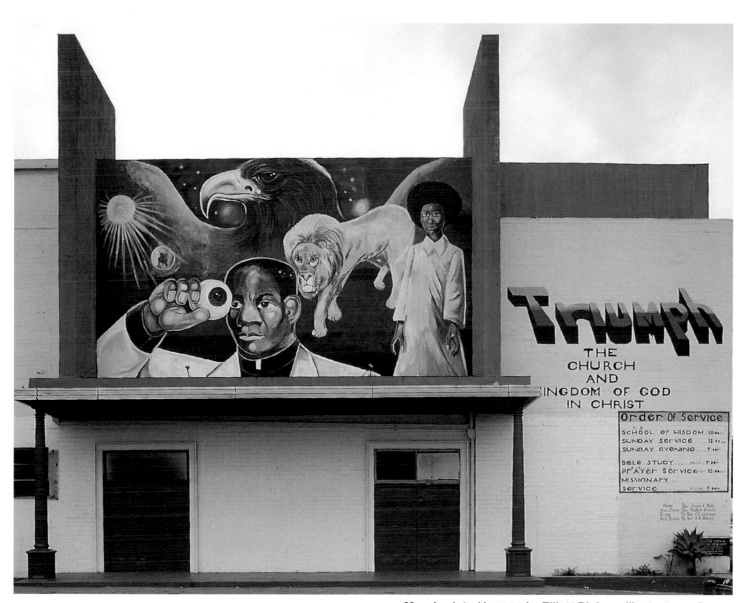

Mural painted in 1978 by Elliott Pinkney illustrates a dream church founder Elias Dempsey Smith had while traveling by boat on the Mississippi River in 1905, South Compton Avenue, Los Angeles, 1987. The vision led Reverend Dempsey Smith—shown in the mural holding an eye in his right hand—to establish Triumph, the Church and Kingdom of God in Christ.

The Pastor's Vision

To give hope to the congregation, a pastor has to have a vision and be able to communicate it. Members need to feel certain that their church is a good church with a promising future. This encourages them to volunteer their time, share their resources, and recruit new members. It also discourages them from looking for other places to worship. Building plans, new programs, revivals, fellowshipping with other churches, fundraising campaigns, purchases of land for parking, and strategies such as renaming the church are a vital part of the life of a congregation. Derrick Williams, of the Miracle Temple United Church of God, a new church in Brooklyn, says, "We have to have goals. We have to see ourselves in five years with a church full. God is doing great things in this place."

Some congregations accept decline. As members age, they find comfort in their memories and are not driven to change their messages or to proselytize. They cherish memories of their late charismatic founders. Once, when speaking with Princess Lillian Roberts of West Coast Kingdom, Mount Zion Spiritual Temple, in Oakland, California—a church with a small and elderly congregation—I suggested that its name be changed to "Temple of the Twilight." She found the name beautiful.

One day I am going to have an educational center around here. I am having a computer center, a Bible study program, and a food depository.

Elder Robert Harris, Way of Holiness Church of God in Christ, Indiana Avenue, Chicago

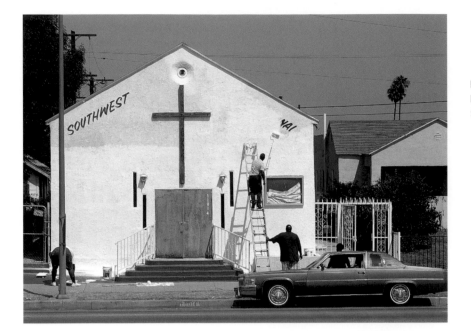

Painting the facade of Southwestern
Institutional Baptist Church,
South Broadway, Los Angeles, 1996

Billboard along East Lincoln
Highway depicts the new
home of Saint Bethel M.B.
Church, "A Vision in Motion,"
the vision of Pastor John H.
Rice, Sr., Chicago Heights,
Illinois, 2004

Bronze head of Rev. Benjamin Lowry,
pastor for several decades of
Zion Baptist Church,
in a small New York City park,
Atlantic Avenue, Brooklyn, 2001

Rev. William H. Rozier, portrayed above a photograph of Pleasant Hill Baptist Church,
the church he founded and pastored until his death in 1937,
Evergreen Cemetery, Los Angeles, 1985.
The tombstone has the inscription "Go ye into all the world and preach the gospel."

We would want to rehabilitate the whole block. We need a new spot to have classes; we aim to teach the young. A lot of children today have lost hope.

 Deacon Martin, Gravel Hill Missionary Baptist Church, Clinton Avenue, Newark

I would like to put a senior-citizen building on that empty lot across the street, but it is too expensive.

 Bishop B. J. Luckett, Plain Truth Mission, South Avalon Boulevard, Los Angeles

We want to keep the church from decaying. It needs a new floor. When you are in a ghetto type of community, you want to serve that community. We want to put a catering hall on one side of the church, a funeral home on the other side, and a drug program and a unisex parlor. We have barbers, morticians, and caterers in the congregation that need work.

 Archbishop Anthony Monk, Monk's Memorial Church, Fulton Street, Brooklyn

I would like to liquidate the mortgage and build a bigger church so that parishioners can use it for weddings and seminars. I would like to minister to the entire needs of people, for example, to have a Boy Scout troop.

 Pastor Edwin L. Williams, Southwest Institutional Baptist Church, South Broadway, Los Angeles

THE VISION GOD GAVE THE PASTOR

1. *Marriage classes once a month.*
 Singles classes once a month.
 Youth services.
 Evangelistic services on Sunday evenings.
 Women and men's day services at the church.
 Christian film night ministry.
 Leadership courses.
 Outreach ministries for the sick and shut-in
 (nursing homes, hospitals etc.).
 "How to prepare a sermon" courses.
 A room that will be consecrated for nothing but prayer.
 A recording studio for upcoming gospel artists.
 Finally: Focus on Jesus Bible Church #2.
 Rev. George W. Fischer, pastor,
 Focus on Jesus Bible Church, Inc., Clinton Avenue, Newark

Twenty years ago, my father, when he was still the pastor of this church, had a vision. He saw Christ with His arms outstretched and His hands open to the people, welcoming them to the church. He talked about his vision to a group, and a young man said, "Let me do that picture." The picture has been there all this time. Once it was covered with Plexiglas and somebody shot it. I replaced the Plexiglas. It cost me more than a hundred dollars, and then somebody stole it. Recently, we had it repainted. That picture is our symbol; we are going to bring it inside the church.

 Rev. H. Grady James III, First Bethel Baptist Church, Newark

Church Portraits of Religious Leaders

One often encounters formal portraits of the minister and his wife in the lobby of churches. It is also common to see, behind the altar presiding over the sanctuary, a portrait of the church's founder. It is sometimes the only image in the sanctuary, as if it were an object of worship. In the sanctuary of the House of Prayer for All People, the portraits of the founder and two of the bishops are more prominent than that of Jesus, which is placed to the side.

Portraits of church leaders fall into three categories: an anointed prophet—Moses perhaps—against a background of clouds or sky, dressed in biblical attire and holding a staff; a responsible member of the community, portrayed wearing church robes or dressed in a business suit, holding a copy of the Bible; a family man, with his wife, also known as the first lady, by his side.

It seems to me that the most interesting of these portraits, perhaps because they reveal only the shapes of bony faces set off by luminous eyes, were the old, fading black-and-white photographs of the founders of churches. Looking at these portraits, one can easily understand the meaning of the expression "That man walked with God."

In my years of going to black neighborhoods, I have encountered a great interest in honoring their heroes and to emphasize their presence with portraiture. The pastors are important as people who have achieved in the community and in their particular church. And as the church grows, and the

Billboard announcing a Harvest Crusade shows photographs of participating pastors, International Boulevard, Oakland, California, 2004

pastor becomes less and less accessible, the photograph remains to reaffirm the leader's presence.

Tim Samuelson, cultural historian of Chicago

It is important for people to know who is directing the congregation. People are attracted to their leaders. It is important to honor good, hardworking pastors with a vision. We are thinking of putting portraits of all of our pastors to give people a sense of history.

Pastor Felipe Salazar, Iglesia Apostolica Hosanna, El Segundo Boulevard, Compton, California

The bishop said that he wanted Pastor Little to have a picture by the altar in the church.

Deacon Long, Saint James Church of God, Inc., McDonough Street, Brooklyn

The members want it [portrait of the minister] up front; I prefer it in the back of the church.

Pastor Henry Ellis, Revelation Baptist Church, South Western Avenue, Los Angeles

He [William E. Hedgebeth] started a program "Focus on You," where he would give food to the needy. He founded

many churches. He ran for mayor of Newark. His picture was put up when he was still alive. He was a humble man. He used to say, "Don't serve me, but serve God, because I don't have a heaven or a hell to put you in."

Rev. Malcolm J. Williams, Ben Hedgebeth Temple Disciples of Christ, Central Ward, Newark

People worship an image of you. The pastor out there is to connect people with God, not to be worshiped by the congregation.

Pastor John Henderson, Home of Life Missionary Baptist Church, West Madison Street, Chicago

Christ is the head of the church; I am just a humble servant. The congregation see me and look beyond, and see Jesus.

Pastor Joseph White, commenting on his portrait holding the Bible, placed behind the altar at New Eclipse M.B. Church, Fifty-first Street, Chicago

Minister Thomas was the first founder of this church. He went and purchased the land. This is what church people do. His portrait with his wife is by the altar. We are not worshiping the pastor. The portrait is like a monument to a great person you

Photograph of Pastor Frank Olmedo and his wife, Jennie, founders of Primera Iglesia de Dios Pentecostal Alpha & Omega, Pitkin Avenue, Brooklyn, 2002

Photograph of Annie Scornier, overseer and pastor, on façade of Travelers Rest M.B. Church, South Racine Avenue, Chicago, 2004

find when you are going through the park. This is an old-time religion church, designed for saving souls and helping people.

J. Fergins, Gethsemane Tabernacle,
South Compton Avenue, Los Angeles

My mother had the picture of the Reverend P. T. Turner and his wife made and put in the lobby of the church. That photograph was taken when they were celebrating their sixtieth wedding anniversary.

Turner 3, First Goodwill Baptist Church,
South Compton Avenue, Los Angeles

Maybe one day we will have a picture of me and mother to leave behind.

Pastor M. Scriven, General Assembly Church of the Apostolic Doctrine, North Broad Street, Philadelphia

What is more important is what is in your heart. Christ is the true leader of this house.

Dennis, True Prince of Peace, Melrose Avenue, South Bronx. [Dennis made this comment to correct my impression that ministers in his church were more important than Jesus; in the

sanctuary of his church, he has five portraits of ministers and only one drawing of the three crosses on Calvary.]

It is not wrong for the preacher to have a picture of himself in the church, but what is the purpose? It is vanity. If there is a picture of the founder, that is okay, that is a memorial.

Pastor Victor Beauchamp,
Bibleway Pentecostal Assembly of the Apostolic Faith,
West Warren Avenue, Detroit

Will my picture heal you? Will my picture deliver you? Will my picture save you?

Pastor Lillie Lu Grant, New Nazareth Great Expectation Deliverance Center, Martin Luther King Jr. Drive, Milwaukee, explaining why she hasn't put her portrait in her church

The younger black preachers want to inject more of their image than the image of Christ. Some preachers take most of Christ out of the church and put pictures of themselves in. We consider them the anti-Christ.

Pastor O. C. Morgan, Evening Star Missionary Baptist Church,
South Cottage Grove, Chicago

Bishop Sylvester Banks in the sanctuary of Bible Church
of God, Spruce Street, Camden, New Jersey, 2004.
Bishop Banks bought the church from a Latino congregation
that had commissioned the mural behind the altar.

Bishop

A pastor becomes bishop when he or she consecrates other
pastors. The promotion to bishop is attributed to the will of
God. The use of the titles bishop and archbishop are often
seen as an attempt to make the official and institution
seem more important.

A bishop has other churches, has a jurisdiction.
 Pastor Hughes, Greater Saint John Gospel Temple,
 East Eighty-eighth Street, Los Angeles

I work with people; the people gave me that name.
 Bishop W. A. Davis, Go Tell It on the Mountain Full Gospel
 Church, Inc., South San Pedro Street, Los Angeles

*Bishop is just a word, something like reverend, something
that is higher. If a preacher has five or six churches that work*
together, *then he is a bishop of these guys. Head man and
bishop is the same thing.*
 Pastor Raymond Branch, Heavenly Rainbow Baptist Church,
 South Western Avenue, Los Angeles

*The man who is using the title is disassociating himself from
the rest. They can only associate with those who share the
title. The word* pastor *is scriptural. The Bible says, "I will
give you pastors." I call myself pastor.*
 Pastor Edwin L. Williams, Institutional Baptist Church,
 South Broadway, Los Angeles

Bishop Henry Cobb, Chief Apostle,
Church of God II, North Fifth Street, Philadelphia, 2004

Mother

Exemplary older women who advise the young and testify
to the congregation are mothers of the church. Only once
did I see a mother of the church actively take part in a serv-
ice; it was at Saint James Church of God, Inc., in Brooklyn.
on a Sunday in July 2002. The woman was old and frail
and was wearing a new silver dress that the congregation
had given her. She asked for the dress to be blessed so that
it could be a healing dress. Six older black men, dressed in
black, surrounded the mother of the church, and the pastor
blessed the dress in front of the congregation.

 Mother Duckett, the widow of the founder of the Holy
Revival Baptist Church on East El Segundo Boulevard in
Compton, California, has more energy than her old limbs
can respond to. When I found her in 2004 teaching Bible
summer camp at her church, her theme was peace. She
taught a song entitled "Wonderful Peace" to a group of pre-
teens. She wrote the lyrics with a felt pen on a large piece
of paper. They went like this:

Far away, in the depths of my spirit tonight,
Rolls a melody sweeter than Psalms.
In celestial-like strains it increasingly falls
Over my soul like an infinite calm.
Peace, peace, wonderful peace,

Mother Young,
Mount Zion Spiritual Temple,
Fourteenth Street,
Oakland, California, 2003

Mother Betty Dasher,
Fire Baptized Holiness
Church, Fulton Street,
Brooklyn, 2002

Mother Downs, House of Blessings C.O.G.I.C., South State Street, Chicago, 1991

Coming down from the Father above
Sweeps over my spirit forever.
I pray over fathomless rivers of love.

She urges her students to "sing it to the Lord" and tells them "tomorrow we will sing it again so you can get it in the spirit. You can say it softly to Jesus: 'Peace, peace, wonderful peace.'" I mused about how would her students imagine "fathomless rivers of love."

Her next song was "Peace Like a River," and it goes like this:

I got peace like a river
I got peace like a river
I got peace like a river
In my soul, my soul
I got joy like a fountain
I got joy like a fountain
In my soul
I got joy like an ocean....

Mother Duckett told the children: "The Mississippi River passed about five blocks from my house. The Mississippi River is the longest river in the world. When I say I got peace like a river, it means I have a lot of peace. If you have love like the ocean, you have a whole lot of love." Then she urges the children to "stand up" and asks them to tell their neighbor "I got peace like a river." She explains to them,

"This is what is called an action song. If you don't have it written, you have it in your heart. These songs are very meaningful; they stick with you all your life."

All of our churches on our bodies have mothers. The young look up to her and respect her. She is the one that tells the teenagers how to dress. The mother of our church had a birthday a couple of weeks ago, and the congregation gave her a four-hundred-dollar silver dress for the occasion.
 Deacon Long, Saint James Church of God, Inc.,
 McDonough Street, Brooklyn

The mothers of the church are the leaders other members of the church look up to. They are to encourage the young how to conduct themselves. They play a very beautiful role.
 Pastor Henry Ellis, Revelation Baptist Church,
 South Western Avenue, Los Angeles

The mother of the church is a woman that teaches the young and the old; she has to be real and truthful. You have problems in your home, and you ask the mother what to do. My pastor asked the congregation, "How would we like for Sister to be a mother of the church?" You can't pick out any and anybody; you have to see how they conduct themselves.
 Betty Dasher, mother of the church,
 Fire Baptized Holiness Church,
 Fulton Street, Brooklyn

Deacon E. M. McGee,
New Jerusalem Baptist Church,
South Halsted Street,
Chicago, 1998

A church mother would be considered very consecrated, on the order of a nun. When there are certain problems, you bring them to the church mothers. Some women don't want to be church mothers because it makes them feel like they are old. Today, they are not respected like they used to be.

Rev. Joseph Bright, Tabernacle of Deliverance,
Eighth Avenue, Harlem

Mother of the church is like an old lady. They just sit down; sometimes they testify.

Pastor Robert McGee, New City Temple,
South Ashland Avenue, Chicago

Deacon

Deacons lead the congregation in singing and praying; they are the pastors' helpers. Often they become trustees of the church and are responsible for painting and repairing the building; for buying pews, lamps, and Bibles; and for ordering signs and other necessities.

The deacon is supposed to be the right hand to the pastor. He is supposed to back the pastor in what he is trying to portray.

Deacon John Harmon,
First Steadfast M.B. Church,
East Bowen Street, Chicago

I was consecrated and ordained a deacon by the presbytery. I am consecrated by God through the eldership of the church; I didn't consecrate myself. Deacons are second in leadership after the elders. Deacons are in charge of ministries, the tape ministry, book ministry, restoration ministry.

Deacon Walter Rice, Provision of Promise Ministries, Clinton Avenue, Newark

The deacon takes care of the church; he has to make sure that the lights go on, the gas works, and of the upkeep. If the building needs remodeling, the deacon has to take care of that.

Betty Dasher, mother of the church, Fire Baptized Holiness Church, Fulton Street, Brooklyn

Present or Past Employment of Pastors, Ministers, Deacons, Preachers, and Elders

Often, congregations lack the resources to pay a full-time pastor. Nearly half of the church leaders I encountered had jobs with the public sector, in transportation, the military, schools, hospitals, or the water department. Several were active in their unions. Many worked in factories. Home improvement, construction, and barbering were popular occupations among those self-employed. When their jobs involved dealing with the public, church leaders often took advantage of this for the purpose of "spreading the word of God." Many pastors were retired and devoted their lives to their congregations and churches.

I worked in the hospital. I operated cranes in the steel mills.

Elder Robert Harris, Way of Holiness Church of God in Christ, Indiana Avenue, Chicago

I was in the U.S. Navy for twenty years.

Elder James Culpeper, skid row, Los Angeles

Worked for the Department of Water and Power.

Pastor Henry Ellis, Revelation Baptist Church, South Western Avenue, Los Angeles

He is a bus driver in Newark, in the number one line. People riding the bus hear him talking about the goodness of God.

Pastor Emma Barr, introducing Minister Leroy Stubbs to her congregation, Greater Concord M.B.C., Bergen Street, Newark

Worked in the supply room at the Newark Housing Authority. I was a union official. Now I am retired.

Pastor Bobby Wright, Last Day Baptist Church, South Tenth Street, Newark

I am a counselor for the Board of Education. I have worked for them for eighteen years.

Andre Faison, assistant pastor, Bronx Christian Charismatic Prayer Fellowship, Third Avenue, Bronx

I worked for the city. I was a maintenance mechanic, then a supervisor. I was a union official; I got to meet politicians.

Edward E. Young, pastor, Mount Zion Holiness Church of Christ, Chestnut Street, Camden, New Jersey

I work for the fire department.

Rev. Dr. Mark Carrington, National Church of God of Brooklyn, Inc., Saratoga Avenue, Brooklyn

Worked for the gas company; I am on disability.

Elder Nathaniel Burney, Holy Temple Baptist Church, South Eighteenth Street, Newark

I was a community organizer for a city councilman in Dallas.

Pastor Anthony Mayors, Canaan Christian Covenant Baptist Church, Foothill Avenue, Oakland, California

I operated heavy equipment for the city.

Pastor McNamee, Do Right Christian Church, Los Angeles

I work for the Social Security Administration. Even though it's the government and you are not supposed to do it, it is a good place to minister.

Pastor William Elliott, Zion Baptist Church, Broadway, Camden, New Jersey

I am a lawyer with the Environmental Protection Agency.

Rev. Melva J. Haden, Brownsville A.M.E. Zion Church, Pitkin Avenue, Brooklyn

I have been a barber all my life.

Rev. Raymond Branch, Heavenly Rainbow Baptist Church, South Western Avenue, Los Angeles

Pastor Evelyn Atwood of Lily of Valley Spiritual Church, Forty-eighth Place, Chicago, 2002. Like other Spiritual churches, Lily of the Valley has a red cross painted on the floor and another on the ceiling of the sanctuary. Pastor Atwood worked in the stockyards, in a laundry, and as a caregiver.

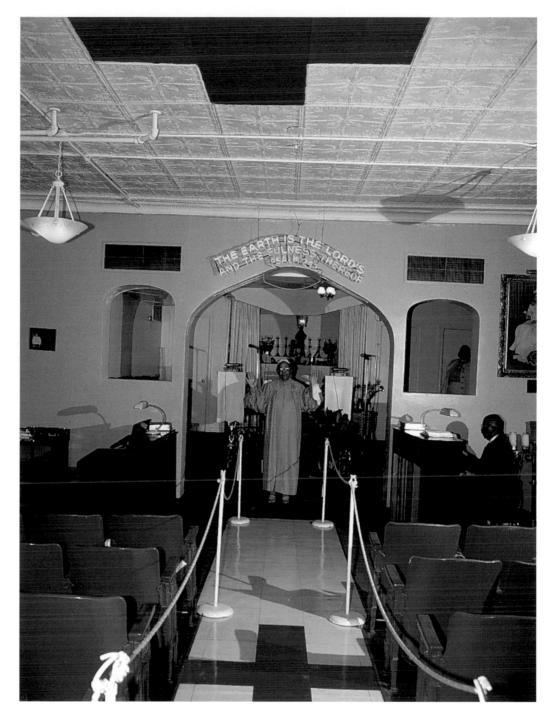

I was a gypsy cab driver.
 Pastor Tomas Velez,
 Iglesia Pentecostal El Monte Horeb,
 169th Street, Bronx

I am a counselor for rehab. centers, and run a computer business.
 Pastor M. Barron, Higher Ground Temple C.O.G.I.C., Inc.,
 Pine Street, Camden, New Jersey

The new pastor is Pastor Taylor. He is a truck driver.
 Janitor, Mount Zion Missionary Baptist Church,
 West Madison Street, Chicago

Mechanic and minister; those two identities merge— mechanic of the soul.
 Elder Charles Mack, Holy Defender C.O.G.I.C.,
 South Normandie Avenue, Los Angeles

Now I am a pastor full time. Before I was a core supplier; I sold automobile parts.
 Pastor Fred Houston, Mount Gaza Baptist Church,
 Raymond Avenue, Compton, California

Worked in a factory making electric cables.
 Cesario Morales, Iglesia de Dios Pentecostal Unidad
 Cristiana Alpha y Omega, Orange Avenue, Newark

Pastor John Grier, a former plasterer and contractor, searching for quote in his Bible, The House of God of the Apostolic Faith, South Western Avenue, Los Angeles, 2002

Worked on the railroads, was a cook on a train for twenty years, then a security guard.
> Fred Hunt, East Eighty-eighth Street, Los Angeles

I come from a history of Baptist preachers in Oklahoma City. I worked in my father's Jack in the Box franchise.
> Pastor Edwin L. Williams, Southwest Institutional Baptist Church, South Broadway, Los Angeles

Worked in the racetrack.
> Deacon Briscoe, Greater Mount Olive Church of God in Christ, South Figueroa Street, Los Angeles

General labor, forklift operator.
> Pastor Ireland Jones, Greater Peter's Rock, South State Street, Chicago

Inspector, air-conditioners factory in City of Industry.
> Glen Bowden, Full Christian Fellowship Center, South Western Avenue, Los Angeles

I do construction.
> Harold B. George, pastor, Christ Union Missionary Baptist Church, International Boulevard, Oakland, California

I do termite work.
> Rev. Jones, Miracle of Faith M.B.C., South Central Avenue, Los Angeles

Carpenter and apartment manager.
> Michael Albert, minister in charge, First Goodwill Baptist Church, South Compton Avenue, Los Angeles

I worked in the stockyards, and I worked in a laundry and as a caregiver.
> Evelyn Atwood, pastor, Lily of the Valley Spiritual Church, Forty-eighth Place, Chicago

I am a musician; I teach in a Lutheran school.
> Pastor Victor Beauchamp, Bibleway Pentecostal Assembly of the Apostolic Faith, West Warren Avenue, Detroit

Retired assembly-line worker.
> Superintendent Booker T. Williams, Hicks Memorial C.O.G.I.C., Mack Avenue, Detroit

I was a truck driver. I was driving a thirty-foot tractor-trailer when I was called by God.
> Rev. William Pinkney, pastor, New Greater Straightway Baptist Church, North Seventh Street, Philadelphia

Retired steelworker; worked for Inland Steel.
> Pastor Robert Moore, Rising Star Missionary Baptist Church #2, Eleventh Avenue, Gary, Indiana

I was a singer. I sang for twenty-one years on radio and television. I moved to Gary and went to work for U.S. Steel,

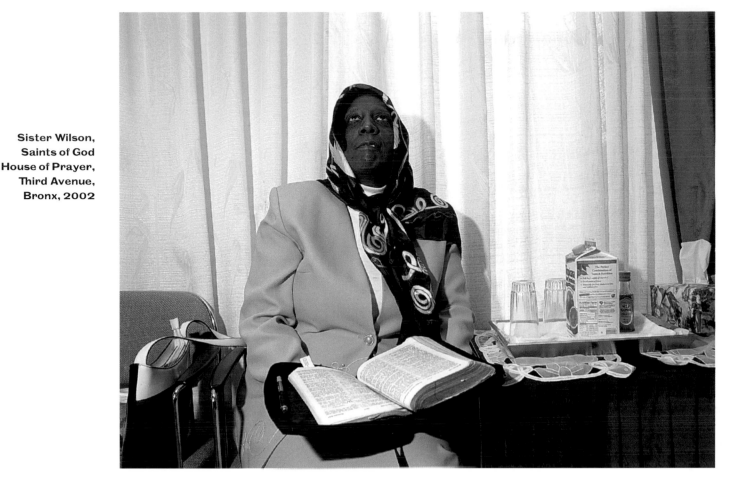

Sister Wilson,
Saints of God
House of Prayer,
Third Avenue,
Bronx, 2002

where I was a maintenance man. I know quite a few preachers that came out of the steel mills.

 Walter Willis Pastor, Love Thy Neighbor M.B. Church,
 Twenty-first Street, Gary, Indiana

I worked in a buffer shop. At one time, I owned a buffer shop [polishing metal].

 Earl L. Stokes, Christ Chapel M.B. Church,
 East Forty-third Street, Chicago

I worked for a factory in Alabama that made cooking oil. We crushed peanuts and made oil. Later, I owned a grocery store in New Jersey; I did very well. I owned several houses. I had a late-model Cadillac with a writing table in the back seat.

 Pastor C. L. Bonney,
 Christian Faith Missionary Baptist Church,
 South Orange Avenue, Newark

I had a business; sold building supplies and hardware.

 Bishop B. J. Luckett, Plain Truth Mission,
 South Avalon Boulevard, Los Angeles

I have my own business, light construction.

 Elder Michael Diggins, Light of the World C.O.G.I.C.,
 Rosencrans Avenue, Compton, California

Congregants, Pew Members

People who gather together at one particular church are called congregants. The image of a good congregant is that of an obedient, clean, and accepting Christian, and a good family member. Many pastors believe that their mission is to seed the word of God; those receiving the message may ignore it or embrace it and become congregants.

Bishop Joe Ross of Prayer Temple Church in the Bronx says, "God is looking for good soldiers. You do your part, and God is going to bless you." A sign on the façade of the Innis Chapel in Richmond, California, reads: "The steps of a good man are ordered by the Lord, Acts 37:23." God does what he wants, and nobody can ask questions.

Despite calls for obedience, churches are often split into factions struggling for control. This sometimes results in the creation of new houses of worship and the start of new denominations.

The Scripture says that the gospel is like a seed, that if it falls in good ground, it grows and develops; sometimes it falls into rocky, sandy soil and dies. Some people don't want to join a church, others want to be pew members, while others want to be church officials. Some even want to become ministers.

 Pastor William Yancy, Leadership Missionary Baptist Church,
 Martin Luther King Jr. Drive, Milwaukee

Olivia, Iglesia de
Dios, Griffith
Avenue, Los
Angeles, 1996

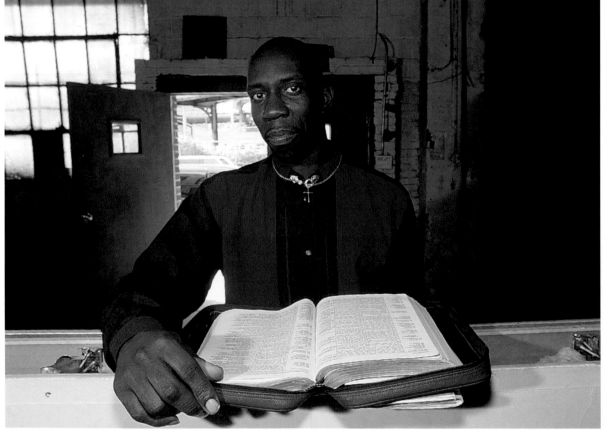

Anthony Ray, The
Greater Temple
of Praise,
Snediker Avenue,
Brooklyn, 2002

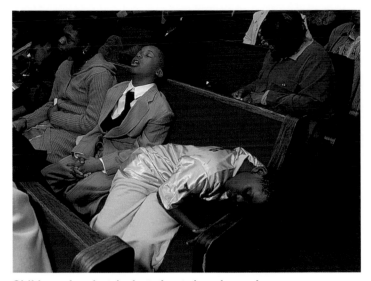

Children sleeping during a long church service, a common occurrence, Refuge Tabernacle Baptist Church, Clinton Avenue, Newark, 2003

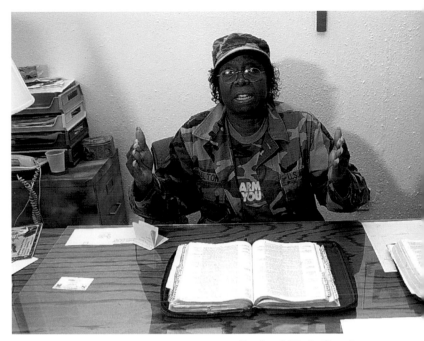

Pastor Lillie L. Grant,
Great Expectations Deliverance Center,
Martin Luther King Jr. Drive, Milwaukee, 2002

You become a member when you join and are willing to be ruled by the Bible. I want all nations to join in; I want the Caucasian people, the Indian people, the Japanese. I want God to send us all nations. Robbins is composed mostly of poor and black people, but these nationalities are in the surrounding area, and they come here to the health clinic.

Pastor Summers, 1st House of God of Robbins,

139th Street, Robbins, Illinois

Everybody wants to be a pastor. Everybody wants to be head; nobody wants to be hands or feet. A Christian has to be peaceful, but astute. The gospel says, "I am sending them like sheep in the middle of wolves." They will find Pharisees and demons; they may even lose their lives. One must be prudent.

Pastor Juan, Iglesia Cristiana del Valle, Inc.,

East 156th Street, Bronx

Reactions to My Questions and Photographing

Most of my conversations with pastors and members of their congregations, several of whom I spoke with repeatedly, were friendly and polite. Some questions I often encountered were: Are you a Christian? Do you believe in God? Do you believe in Jesus Christ? Are you saved? What religion are you? Do you have a home church? Where do you fellowship? Who do you represent? Do you have a card? Do you have a picture ID? In addition, several people asked me if I was shopping for a church, if I was going to start my own church, or if I was there to improve my preaching.

A few times I was asked for donations for the church. Pastor L. C. Wooden, of Grace Church of God in Christ in Chicago, compared my book to Bill Clinton's biography. He asked, "How much did he wind up with, 14 million?" He then requested "some finance, whatever you decide over fifty cents." When I told him that there was no chance I could make that much money because this particular book was not dealing with powerful people or sex, he told me to "put it out anyway; your book is more important to God."

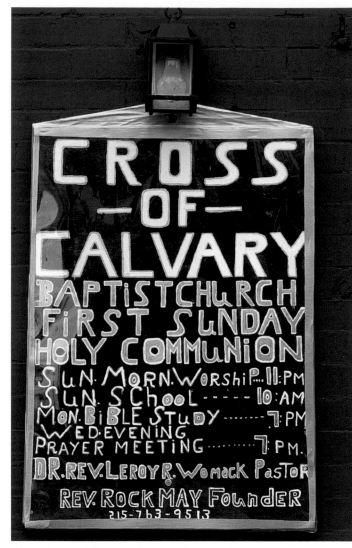

Sign, Cross of Calvary Baptist Church, "a friendly church with a future." Twenty-ninth Street, Philadelphia, 2004

On several occasions members explained to me that, even if I was not aware of it, I was at their church for a reason. Luz Rojas, at the Iglesia de Dios on Brook Avenue in the Bronx, told me, "God loves you," and explained that otherwise he would not have sent me to their church.

In Richmond, California, during Sunday service, Pastor William Pree, of Sion C.O.G.I.C., described me to the congregation as a "curious and inquisitive fellow," and asked me to come to the front of the sanctuary to be anointed with oil. Holding my business card, Pastor John T. Greer, of House of God Apostolic Church, told his flock, "He has good will in his heart." Upon finding out that I was not "born again," Rev. Glenn A. Bowden, of the Full Christian Fellowship Center of Los Angeles, urged me, "When you go home, go down on your knees, and you tell the Lord, 'This little pastor tells me that You exist and that You are a personal God. I don't know if You really exist, but if You do, please reveal Yourself to me. I want to know the truth in Jesus' name.'"

In a few instances, pastors annoyed by my curiosity told me that my questions were worldly or carnal, that I looked only at physical reality, and that without faith I could not understand salvation. Sister Womack, of the Cross of Calvary Baptist Church in North Philadelphia, urged me to "write from the spiritual point of view. Talk to God on your own for yourself. Tell Him to come into your heart." She then said to God, "We ask You that the book that he is trying to write will be a book that everyone can read and can understand." I was repeatedly told that I needed to read the Scriptures and learn to see with my spiritual eyes.

A few pastors did not believe that I was writing a book about religion and wanted to know the real reason for my questions and photography, and who paid for it. They asked if I was working for a developer, or if I was a building inspector working for the city. While visiting a church located in a former settlement house in Gary, Indiana, the female pastor, whom I had never seen before, greeted me by saying that she was not going to hire me to clean the floors. Once I was asked if I was the anti-Christ, and another time if I was working for the devil.

Although I was careful not to offend people, I sometimes approached them at the wrong time and spoke clumsily, arousing suspicions that resulted in aborted interviews. Many resented being asked if their church was a storefront church, if it was in the ghetto, or if it was in a poor area. In order to avoid antagonizing them, I reserved these questions for the end.

Often I had to speak to several officials before getting approval to see the sanctuary, or to discover something as noncontroversial as the origin of the church's name. For example, when I asked a member the origin of the name of her church, Gravel Hill Missionary Baptist Church of Newark, she said, "I can't reveal information about my church without clearing it with my deacon." Turning to one of the members accompanying me, she added, "He should ask to speak to the board." When I asked an usher to show me the way to the bathroom at the Mount Sinai Cathedral C.O.G.I.C. on Fulton Street, in Brooklyn, he asked if I was a member of the church and upon learning that I was not, he reluctantly showed me the way. He waited outside the bathroom to escort me out.

In July of 2002, I was escorted out of Sunday service at the First Corinthian Baptist Church on Eighteenth Avenue,

LAST DAY BAPT. CHURCH
REV. BOBBY WRIGHT PASTOR
COME NOW DON'T LET IT BE SAID
TOO LATE. 417 SO. 10TH ST.

in Newark. An usher led me out of the church to search my camera bag for weapons or explosives. I left, angry and humiliated, telling him that his behavior was unchristian.

How are you doing, brother? I am so glad to see you.
 Member, Last Day Baptist Church,
 South Tenth Street, Newark

You are welcome here. Don't ask me to pronounce your name because I can't.
 Rev. Robert L. Moore,
 pastor, Rising Star Missionary Baptist Church,
 West Eleventh Avenue, Gary, Indiana

If you are hungry, you can have breakfast upstairs.
 Member, The Glorious Temple Deliverance Center
 C.O.G.I.C., Sutter Avenue, Brooklyn

Every time you pass by here and you see the light, just come in. We are just like Motel 6.
 Elder Herman Durden, pastor,
 House of Prayer Temple,
 West 120th Street, Chicago

In your nationality, are there a lot of churches? Where do you come from? Why did you pick this church?
 Pastor Connie Boatman, Deliverance Prayer Center,
 South Ashland Avenue, Chicago

I don't want you to write things to make me look like a jerk. I want to sit down with you and see what you write. I want to make sure you don't change the way I say it.
 Pastor Alan Fisher, Doers of the World Christian Center,
 Webster Avenue, Bronx

There is a Jewish preacher that comes on TV; he looks just like you.
 Pastor Virginia Shaw, Shiloh Temple Church of God in Christ
 Jesus, Nineteenth Street, Newark

I hope I didn't confuse you. You want a whole lot of information, a hundred years of information, and it's hard to put it into words. What you are looking at is the local church, run by local people; you can be a member of the local church and go to hell, not if you are a member of the universal church.
 Pastor E. Holland, New Nazarene Missionary Baptist Church,
 B Street, Richmond, California

Pontius Pilate washing his hands, detail of a mural by Manuel G. Cruz,
Fresno Street, Los Angeles, 2001

*The pastor wants to pray for you; come up to the altar. It is
something special when the pastor wants to pray for you.*
 Usher, Provision of Promise Ministries,
 Clinton Avenue, Newark

Are you Spanish?
 Congregant, Greater Concord M.B.C., Bergen Street, Newark

You are from Egypt? Where are you from?
 Pastor Eddie Douglas Anderson, Tabernacle of Jesus,
 Clinton Avenue, Newark

*Are you a Christian? Are you a practicing Christian?
Are you one of those Jews for Jesus?*
 Dennis, True Prince of Peace, Melrose Avenue, Bronx

*What are your reasons for calling? Are you a supporter
of the church?*
 Former Pastor Wilford D. Collins,
 New Jerusalem Missionary Baptist Church,
 Halsted Street, Chicago

*Why are you collecting that data? Are you trying to put
the churches out of business?*
 Pastor Lillie L. Grant, New Nazareth Great Expectations
 Deliverance Center, Martin Luther King Jr. Drive, Milwaukee

You advertise my church. Is there any donation?
 Pastor Forrest Newell, Saint Rest M.B. Church,
 West Polk Street, Chicago

*You have a foreign accent, and you say you are from New
York. I know people from New York, and they don't speak
like you. I don't have anything against foreigners.*
 Pastor Brown, Refreshing Spring Church of God in Christ,
 Kercheval Avenue, Detroit

*What is your nationality? Are you sure you are not with
Osama Bin Laden? The devil comes in all ways. A lot of
people take pictures; the CIA takes pictures; the FBI takes
pictures. You are picture crazy.*
 Elder Robert Harris, Way of Holiness Church of God in Christ,
 Indiana Avenue, Chicago

Trees like this one come in different sizes and are popular for fundraising, Evening Star Missionary Baptist Church, South Cottage Grove Avenue, Chicago, 2002. The names of donors are written on the leaves; the congregation's goal is to complete the tree.

We own the building. The church is not for sale.
Pastor Hughes, Greater Saint John, East Eighty-eighth Street, Los Angeles (wanting to know why I was photographing his church)

This is the most interesting conversation I have ever encountered before. You have really awakened my curiosity.
Evelyn Gaines, Divine Temple of Love Tab, Kaighns Avenue, Camden, New Jersey [The next morning I received a call from Pastor Gaines, wanting to know if I was a real-estate speculator interested in buying cheap properties in Camden.]

God has a way to do for your country and your nationality. God wants you to receive God. God is going to use you on television.
Pastor Inez Ashford, Third Street, North Richmond, California

You are looking for signs and wonders; we don't have that here. We have the word of God here.
Elder Nathaniel Burney, Holy Temple Baptist Church, South Eighteenth Street, Newark

If I gave you an apple and I said this is a pretty apple, you wouldn't understand until you bite into it. You are searching the things of the spirit, but you will never understand them with your flesh. You are like Nicodemus; he was trying to figure Jesus out.
Minister, Center of Hope, Life Changing Ministries, West Madison Street, Chicago

Tithes: God Loves a Cheerful Giver

The most powerful argument for supporting the church is that, by doing so, members are giving to God, to whom they owe their very existence. God, in turn, is generous; He "gives you double for your trouble," as a common saying goes. Pastor Dingle, of the Memorial Baptist Church in Newark, speaking for God, asks his congregation, "to give me back some of the praise, some of the blessing, some of the glory, some of the peace that I have given to you." Banners near the altar ask, "Are you giving God a tip or a tithe?"

Fundraising is essential to keep a church operating and growing. For the edifice to look attractive, it needs to be well maintained and landscaped. Officials want to keep their membership comfortable, providing air conditioning during the summer and heat during the winter. Pastors, deacons, and choirs need to be outfitted with robes that can cost several hundreds of dollars each. And to keep abreast of the latest news, up-and-coming personalities, and religious articles, the pastor attends religious conventions, often accompanied by his wife and other church officials.

Giving is rarely done anonymously. At the Perfecting Church in Detroit, Pastor Marvin Winans asks those "who give more than thirty dollars, but only those who give more than thirty dollars" to stand in the aisle and bring their offering to the front. He told his Sunday audience, "I want you to give 'cause we need a bigger church." As a reward for donations, the Utica Avenue branch of the Universal Church of the Kingdom of God in Brooklyn keeps "Holy Oil for the Consecration of Tithers." Popular for raising funds is the image of a tree to which people add leaves

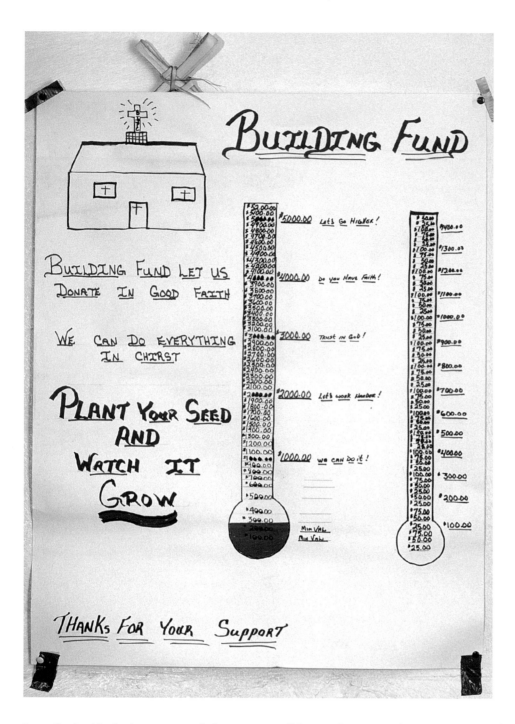

Poster designed by a member keeps track of donations to the Building Fund, Back to Jerusalem Pentecostal Church, Boston Road, Bronx, 2003

inscribed with their names and the amount of their gifts. Another way to publicly show who is contributing to the church, popular in Latino churches, is to use a rack—similar to those into which workers insert time sheets in factories—where members place their envelopes. In addition, churches usually write the amount collected during the last service on a tablet placed to the side of the sanctuary.

Pastors often push their congregants to publicly pledge large amounts of money so that, after their Sunday offering, families may not have enough left over to pay rent or utility bills or to buy food. Congregations that are building or rehabilitating a church need to borrow from a bank, but they often lack the assets to use as collateral. Members who are willing to help take a mortgage on their homes. If the congregation forfeits on the loan, the bank will go to the homeowners for payment. Unable to pay, many members lose their homes.

We don't have to be spiritual to know that we have to pay the rent, the gas bill, and the electricity. We can't go to P.G.W. and start speaking in tongues; we would have to pray cold. Everyone stand with your gift on hand.

> Elder Terrence Moore, founder and pastor, House of Prayer for All People Church of God in Christ, Thirteenth Street, Philadelphia

Folks turn Christmas into a commercial holiday time. When this season is over, the spirit of giving is over, and people go

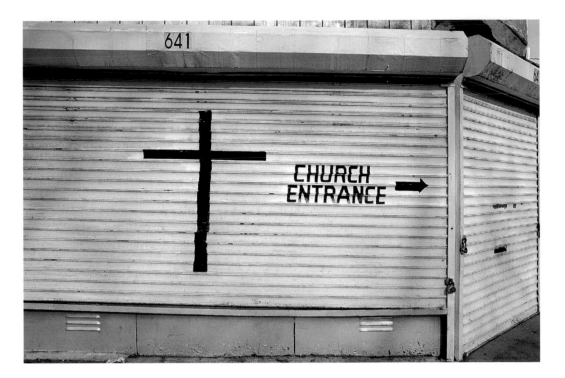

Focus on Jesus Bible Church, Clinton Avenue, Newark, 2003

back to the same old mean selves. *Men's way of giving looks for something in return: "Scratch my back, and I'll scratch yours." Being led by selfishness is not a good way. If I am giving your funeral, I want to be able to say that you gave. A true Christian is marked by the way that they give of themselves; giving with no strings attached make them shine so much. When people go into commercial giving, churches like ours get shortchanged. God wants us to walk into the biblical giving. When you have thirty dollars in your pocket, and you give only two dollars, you are giving grudgingly. You could have given five or ten dollars. The person who saw sparingly should reap sparingly. We rearrange money, and find money that we don't have, to give to people. Why don't we use the same mentality to give to God? God loves a cheerful giver.*

Pastor George W. Fisher,
Focus on Jesus Bible Church, Inc., Clinton Avenue, Newark

We like to thank you for sixty dollars for the church. We like to thank you for fifty-eight dollars for the pastor.

Member, Last Day Baptist Church,
South Tenth Street, Newark

Only 20 percent of the congregation are carrying the church.

Pastor Nelson, First Holy Mount Zion Baptist Church,
South Main Street, Los Angeles

Give, and it shall be given back to you. And the more you give, the more He gives to you. You can't beat God, no matter how hard you try.

Rev. H. Grady James III, pastor, First Bethel Baptist Church,
Nineteenth Avenue, Newark

Bring ye all the tithes into the storehouse that there may be meat in my house, and prove me now herewith with the Lord of hosts. If I will not open you the windows of heaven and put you out of a blessing, that there shall not be room enough to receive it. Malachi 3:10.

Banner, Greater Eternal Baptist Church,
Elton Avenue, Bronx

We just don't give money; we give with a purpose. We give with excitement. Wave your envelopes; wave them like this.

Bishop Larry Trotter,
Sweet Holy Spirit Church,
South Chicago Avenue, Chicago

Your faithful and consistent financial support is an expression of gratitude toward God and a recognition that you are a part of something much greater than yourself. The depth of loving is known by the degree of giving. Jesus said, "Where your treasure is, there will be your heart also."

Christian Cultural Center, Flatlands Avenue, Brooklyn
(printed on the flap of a donation envelope)

REMINDER: *While you are out of town, on vacation or business, your church's expenses go right on. At home or away, make a sincere Christian effort to see that your offertory envelope is filled and either mailed or contributed each Sunday.*

Dr. William Augustus Jones, pastor,
Bethany Baptist Church,
Marcus Garvey Boulevard, Brooklyn

God has done more for you than you deserve. You could be in the hospital; you could be in the hands of an undertaker. It is important for people to come to church with an attitude of gratitude, to spontaneously give. When we are trying to hold out from God, we hurt ourselves. You send something up, and He sends something down.

> Pastor David Jefferson, Metropolitan Baptist Church, Springfield Avenue, Newark

I mean no less than five dollars, amen. Put your hand in no less than five dollars, a ten, maybe even a twenty. As the musicians play something nice, come here [to the front of the church] and give, hallelujah. Give to us! Give to us! Give to us!

> Pastor Barbara Ward,
> Faith Tabernacle Church of the Living God, Spruce Street, Camden, New Jersey

In the 1970s, Brenda gave her furniture to the church, and it was not cheap furniture, but the Lord was not pleased. She had given her living room furniture, bedroom furniture, kitchen furniture, and He was not pleased because she had not given everything. She had not given her clothes. Her sister took a knife and ripped off her clothes. God always demands all because half is not enough. If you have not done your part, why are you surprised when God does not change your circumstances? Jesus says, give and it will be given to you. God never leaves you high and dry.

> Rev. W. R. Portee, Southside Christian Palace, South Vermont Avenue, Los Angeles

Will a man rob God? Yet, you have robbed me. But ye say, wherein have we robbed thee? In tithes and offerings. Ye are cursed with a curse: for ye have robbed me, even this whole nation. What shall I render to God for all his blessings? Malachi 3:8–9.

> Dr. W. M. Jackson, pastor, First New Revelation Missionary Baptist Church, South Halsted Street, Chicago

Ten percent of what you earn belongs to the Lord, and you have to give it. Whether it is the lottery, cigarettes, numbers, or pornography, you are giving God's money to the devil; you are robbing God.

> Pastor Jerome A. Greene, Bronx Christian Charismatic Prayer Fellowship, Third Avenue, Bronx

People sign their homes off for the church. If a congregation wants to build a church that costs $150,000, and they only have $50,000, they ask ten people to mortgage their homes for $10,000 each. They put their homes up for a loan for the church that they are going to build. The church is not worried if they can't meet their obligations. The members who mortgaged their homes find themselves in a bind; if they can't pay the bank, the bank will put their homes up for sale.

> Rev. James Haskins, Hallelujah Baptist Church, Inc., Greenmount Street, Baltimore

Sixty dollars we are going to get there in the name of God. She needs eighty dollars; I got ten dollars. I need seventy dollars for her. I got fifteen dollars here. Thank you, Jesus, hallelujah.

Come on, He is worthy. Oh, thank you, Lord. Oh, glory to Jesus. God bless you, sir. Thank you, Jesus, hallelujah. Fifteen dollars more, and she is there. God bless you, oh glory, oh glory. Fourteen dollars, fifteen dollars—Oh, thank you, Jesus, hallelujah.

Thank you, Lord. Just up to fifty-two dollars; He is going to one hundred dollars. We believe you, God, hallelujah.

We thank you, Jesus; we thank you, Lord. Let me see your hands.

We praise you; we praise you. Give Him the glory. I am not going to give in.

One dollar, two dollars, three dollars, four dollars; that is twenty dollars. He is going to one hundred dollars. God bless you, twenty-four dollars more. See how much you have there. Give me some worship and praise in the house.

Ninety-four dollars; we need six dollars. We believe in God. Eighty-seven, eighty-eight, eighty-nine dollars; Sister Ashley needs ten dollars. She has fifty dollars in her hands; she needs forty-seven dollars more. Oh, thank you, Jesus. He takes us this far; He never leaves us. Oh, give God the glory.

Make sure it is there. Do you have it? Eighty-four dollars; thank you, Jesus. You got it alright. If there was anybody that didn't give anything because it was too small, give now. What a mighty God we serve.

> Bishop Leonard Nathan,
> Faith Worship, Inc., Pitkin Avenue, Brooklyn
> (At a fundraiser organized in September of 2004 to prepare the building for the winter. Ten church members of different ages, both male and female, stood facing the congregation. Their mission was to raise one hundred dollars each.)

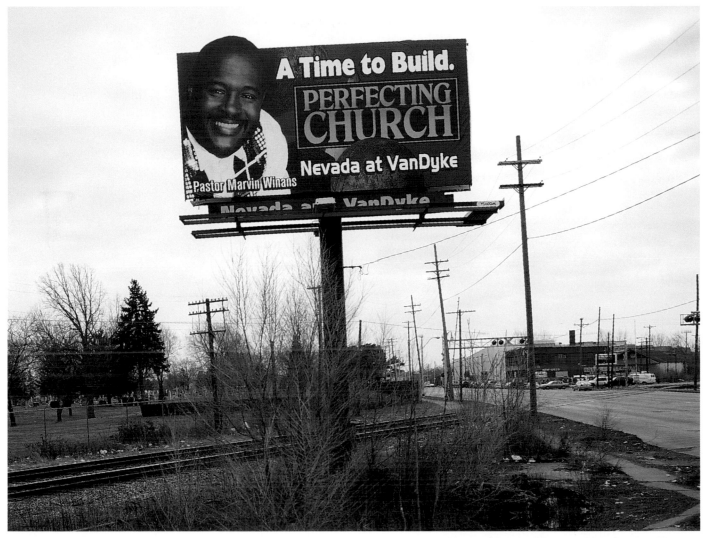

Pastor Marvin Winans, of Perfecting Church, announces his intention to build a new megachurch. Billboard on Van Dyke Avenue, Detroit, 2003.

When we give, we give out of the heart. I don't want to teach people that if they don't want to give they are going to be cursed. You give according to how you are purposed to give. God loves a cheerful giver. Remember Brother Gray, who was homeless and could not give anything, and then he got a job and started giving. Now he is a pastor; the Lord blessed him with a church.

Pastor John Alan Fisher,

Doers of the World Christian Center, Webster Avenue, Bronx

They teach you to give money, so you can get money; they call it seed sowing. I don't believe you have to buy your blessings.

Overseer Rosa Vick, Pastor,

Pillar of Truth Apostolic Church of Christ,

Prospect Place, Brooklyn

Whatever God gives you, He has the right to ask you for it. Your paycheck is not a gift from God; you had to work for it. You have preachers that know how to tap into people's needs and fears and, out of that, they get monetary substance.

Deacon Eddie Daniel,

Holy Bethel Pentecostal Temple, Inc.,

Broadway, Camden, New Jersey

5 Theology and Devotional Practice

This book is an exploration of the beliefs, congregations, and buildings that make up ghetto churches, creating a portrait of people coming together to worship. I am convinced that what I heard from pastors and what I read in church texts—messages of salvation, a loving and forgiving God, and the promise of eternal life—are essential to understanding how poor people give meaning to their lives. I wanted to know who this "awesome guy" called God is, who His pastors are, and how He chooses them. In these churches people recognize the power of God as "the boss-man of the universe," and yet, instead of being awed, they are on familiar terms with Him.

People expect the pastor to release the power from the Holy Ghost, healing sicknesses, casting out demons, alleviating anguish, and bringing joy and prosperity. During services congregants ask for families and jobs to be restored, for "broken lives" to be put together, and to be born again. They bring suffering and pain, but also hope to their churches. Congregants "drunk on the spirit," often share a few ecstatic moments. During a typical visit to a sanctuary, I saw adults dance and shake their bodies in a frenzy of religious fervor while two ushers, one in the front and one behind, followed closely to prevent them from falling, and children, oblivious to the commotion, lay on the pews sleeping. While happiness and eternal life are promised and God is constantly thanked, money is asked for and, at times, even publicly counted in front of the altar.

Pastors see their presence in communities as civilizing; they are bringing Jesus and His saints to the neighborhoods. Rev. William Pinkney, pastor of the New Greater Straightway Baptist Church, asks, "If we didn't have the pastors, if we didn't have the preachers, if we didn't have the Christians, what kind of world would we live in?" And Rev. H. Grady James, Jr., thanked the Lord on Sunday service at First Bethel Baptist Church in Newark, saying, "It is a miracle that we have come so far this year, and we have not been shot down on the streets, that our children have not been abducted, our seniors have not been murdered in their houses or swindled of their savings."

Window in the ruins of the former Scoval Protestant Church, erected in 1898. Grand River Boulevard, Detroit, 2005

A focus on the role churches play in providing a better life for minority communities, through their involvement in urban redevelopment, civil-rights activism, and political participation, fails to account for their existence and for people's attendance at services. Other organizations exist besides the churches to fulfil these roles. I wanted to bear witness to the intensity of feelings, not the politics, of Deacon E. M. McGee, as she said to me, "I don't intend to go to hell, no way, nothing on this earth is worth losing my soul." I could not disregard her response and turn the conversation to her voting record or her efforts to improve her neighborhood. The forms people develop to express their faith need to be documented, even if they cannot be explained.

One night, while standing on the steps of her church, Whole Truth Gospel in Gary, Pastor Sarah Daniels said to me, "We are born in this world: How do we learn how to care for other people? How do we learn to love other people? How do we learn how to be good?" The answers to these questions, she told me, she got from God. I didn't know what to say; all I could do was listen and write.

God, the Lord

Who is God? What does He do? Where can a person find Him? How can you recognize God? Is the God of the ghetto different from the mainstream God? People interviewed believe that there is only one God for rich and poor, for black and white. For God, nothing is impossible. He is the God who woke you up this morning; you are alive because of Him. He loves you. He sent His only son Jesus to the world to die for your sins. Who else would do that for you? God is good. We cannot build a place that can contain God; we can build a place where we can praise God and let the world know that God is still God.

During services church members are asked not to give up hope, even though there are all kinds of problems and they are in desperate need of help. They are told not to turn their backs on God because God is still with us; He never forgets about us. He is going to give you deliverance. Sometimes it looks like you are the last on the list; it is because the devil wants you to believe that God has forgotten us. The devil is a liar. God is real. God is here with us; He is touching us. You can feel His touch right now. Did you feel Him? God is here to help us.

Chair mounted on a wall, gift from local gangbanger to Juan Flores, minister of Hand of Christ Vineyard C.R.C., West Chicago Avenue, Chicago, 2001. Minister Flores thanked the donor for his gift and told him: "Let it be the hand of God over the community."

The power of God protects us
The presence of God watches over us
Wherever we are, God is there.

> King Louis H. Narcisse, founder,
> West Coast Kingdom, Mount Zion Spiritual Temples, Inc.,
> Fourteenth Street, Oakland, California, June 15, 2003

A MESSAGE FROM THE CHAIRMAN
As I pass the gavel to my cochair, who will become
the chair for our seventy-fifth anniversary in 2005,
I would like to leave her this thought:
There is never a teardrop
That God doesn't see.
He knows when a sparrow
Falls from the tree.
There is never a moment
When God doesn't care
Never a time when He
Won't hear our prayer.
May God richly bless you.

> Joseph Miller, chairman, Unity Day 2004,
> Jones Tabernacle African Methodist Episcopal Church,
> West Diamond Street, Philadelphia

And without controversy, great is the mystery of godliness;
God was manifest in the flesh, justified in the spirit, seen of
angels, preached unto the Gentiles, believed on in the world,
received up into glory. 1 Timothy 2:16.

> Rev. Walter Washington, Jr., pastor, Greater New Light Baptist
> Church, East Ninety-second Street, Los Angeles

TEN THINGS GOD WON'T ASK ON THAT DAY
1. *God won't ask what kind of car you drove; He'll ask how many people you drove who didn't have transportation.*
2. *God won't ask the square footage of your house; He'll ask how many people you welcomed into your home.*
3. *God won't ask about the clothes you had in your closet; He'll ask how many you helped to clothe.*
4. *God won't ask what your higher salary was; He'll ask if you compromised your character to obtain it.*
5. *God won't ask what your job title was; He shall ask if you performed your job to the best of your ability.*
6. *God won't ask how many friends you had; He'll ask how many people to whom you were a friend.*

Familiar terms frequently used to refer to God are "boss," "awesome guy," "friend," and "great surgeon." Church members are told that "nothing is bigger than the Lord that you serve"; they are asked "to give God a clap because He is worthy of a hand clap." A pastor explained to me the nature of God by comparing Him to "electricity," and another declared God to be his greatest desire, much superior to "a million dollars." As they declared their God to be a "good God" and a "covenant-keeping God," I often got the impression of people having gone shopping for God and then bragging about having gotten the best God available.

God speaks to people through the Bible (*logos*) and directly to an individual (*rhema*). Since the devil can also speak to us, and our minds can play tricks on us, people ask for a sign to confirm that the communication is truly from God. Mr. Hatcher of Saint Theresa Holiness Science Church suggested that an individual may ask to get a call from Joe, who has not called for six months; a call from Joe is then proof that the message is from God. Others find confirmation by checking their Bibles and finding that the message they received is aligned with the Scriptures.

The light of God surrounds us
The love of God enfolds us

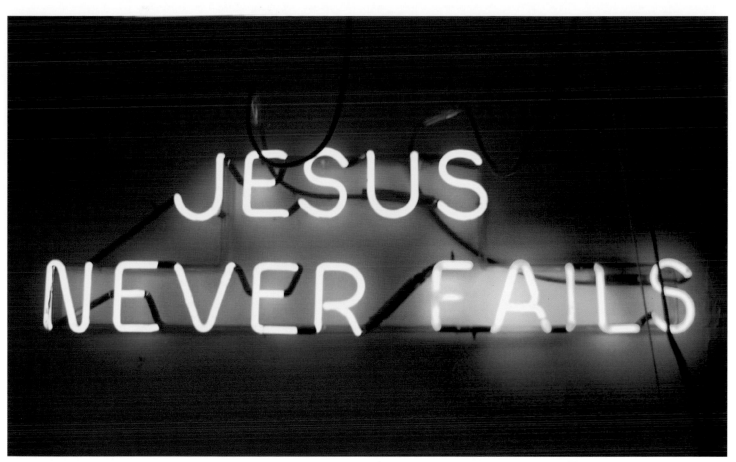

Neon sign, sanctuary, Travelers Rest M.B. Church,
South Racine Avenue, Chicago, 2004.
The glowing words convey an otherworldly aura.

7. *God won't ask in what neighborhood you lived; He'll ask how you treated your neighbors.*

8. *God won't ask about the color of your skin; He'll ask about the content of your character.*

9. *God won't ask why it took you so long to see salvation; He'll lovingly take you to your mansion in heaven, and not to the gates of hell.*

10. *God won't have to ask how many people you forwarded this to; He already knows whether you are ashamed to share this information with your friends.*

 Rev. Charles Anderson, Providence Baptist Church,
 Madison Avenue, Harlem

If you call Jesus, then you know it is His voice because the devil trembles at the voice of Jesus. It is a voice you never heard before.

 Pastor Inez Ashford, True Gospel Church,
 Third Street, North Richmond, California

Jesus said, "I am the true vine," John, Chapter 15, Verse 1. Be a good branch and stay on the vine. Stay on the vine. Wind may blow, storm may come, but stay on the vine. No matter what you think or hear, stay on the vine. If you stay on the vine, you can live. Don't let nothing separate you from God. As long as you stay on the vine, you can still live. Bad times, they too come, but I would not let nothing separate me

from God. All of your help must come from God. The branch on its own has no life. On our own, we are nothing; we can do nothing. Stay on the vine. Stay on the vine. God says He will never forsake you. Oh, wretched man that I am, God delivered me. Stay on the vine. Peace as long as you stay on the vine. Don't put your faith and confidence in man 'cause nobody died for you except Jesus Christ.

 Pastor Bobby Wright, Last Day Baptist Church,
 South Tenth Street, Newark

When God speaks to you, it's not the way you and I talk. You really can't explain it; your heart really arises, and you try to be obedient to his words. He is in all of us. You have to have faith; you have to pray and cultivate a relationship with God. He has a way of speaking to the real you, the spiritual you, the man that you can't see in the mirror. There is no set formula; you have to find the Lord for yourself. God will direct you. If God moved the same way for everybody, it would be like a bunch of soldiers.

 Pastor Bobby Wright, Last Days Baptist Church,
 South Tenth Street, Newark

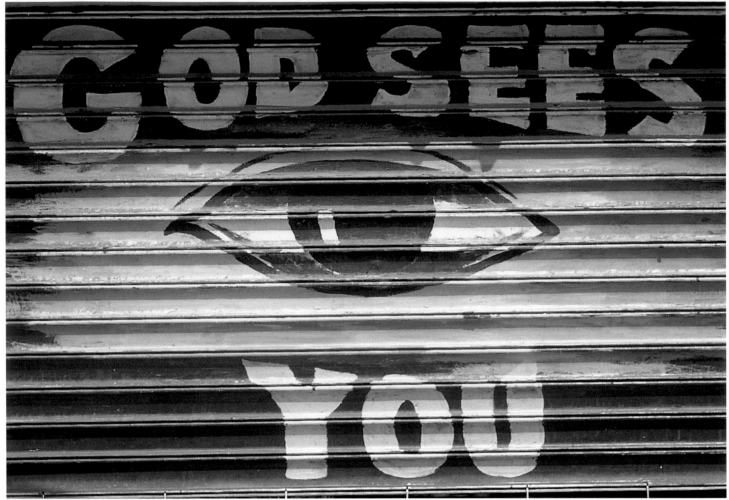

The eye of God at Sluggo's Laundromat, Martin Luther King Jr. Drive, Jersey City, New Jersey, 2004. Sluggo is the nickname of Fred Marshall, a local street preacher and businessman.

God is one friend that will never let you down. God is in charge of even hell; the devil cannot make a move unless God gives him permission.

 Rev. Wilson Daniels, United Baptist Church,
 West Roosevelt Road, Chicago

No man has seen God. God is the boss-man of the universe.

 Pastor Hughes, Greater Saint John,
 East Eighty-eighth Street, Los Angeles

We love you. We praise you. You are an awesome guy. Hallelujah! God is an awesome guy.

 Pastor A. R. Bernard, Christian Cultural Center,
 Flatlands Avenue, Brooklyn

God is in the miracle business. God is the great surgeon.

 Pastor J. B. Richardson, Security Missionary Baptist Church,
 South Western Avenue, Los Angeles

God is a painkiller; He is a deliverant [sic]. When there is no way out, then there is God. Now we got help, and it's all through the blood of Jesus.

 Pastor Sarah Daniels,
 Whole Truth Gospel Church of Faith, Gary, Indiana

Whatever you need from God, he can supply it. If you have a question this morning, he has the answer. If you have a problem, he has a solution. Lord, O Lord, we thank you and praise you for your only son, sweet, sweet Jesus.

 Elder W. C. Howell, pastor, House of Prayer for All People,
 Springfield Avenue, Newark

Lord, as we stand here right now, we turn all our sickness to You, all of our addictions to You, all of our burdens to You because we know that You can bear it. Lord, we thank You.

 Rev. H. Grady James III, pastor, First Bethel Baptist Church,
 Nineteenth Street, Newark

God is saying there is some money waiting for you. God is saying there is some peace waiting for you, and you can't get peace at the grocery store.

 Pastor Danielle Elliott, Mount Paran Baptist Church,
 Broadway, Brooklyn

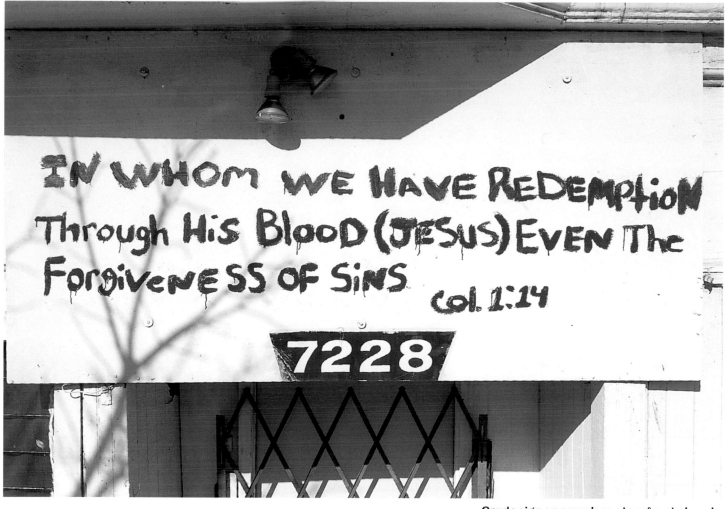

Crude sign on nameless storefront church,
South Halsted Street, Chicago, 2004

I said, "God, I want fifty thousand dollars; I need it."
Rev. W. R. Portee,
Southside Christian Palace,
"The All Things Are Possible Place,"
South Vermont Avenue, Los Angeles

The Blood of Jesus

The innocent blood of Jesus is a concrete symbol of redemption. His sacrifice on the cross is what saved mankind. The blood of Jesus is also known as "the blood of the Lamb."

The blood of Jesus was a sinless blood. Adam took on the sin and passed it on. It took another sinless man, Jesus of Nazareth, to pay the penalty of sin, which was death.
Associate Minister Russell Yancey,
Leadership Missionary Baptist Church,
North Martin Luther King Jr. Drive, Milwaukee

Who can tell me something about the blood of Jesus? Jesus' blood never loses power; it cleans us from sin. Many other bloods were tried, but they didn't clean sin. The high priest had to go to the holy of the holies to offer animal sacrifices, but animal blood didn't wash sin.
Sunday-school class, America Come Back to God
Evangelistic Church, Rockaway Boulevard, Brooklyn

You will be in hell without the blood of Jesus. When you have been deepened in the blood of Jesus, you lose all racism.
Bishop Wallace Furrs, pastor, America Come Back to God
Evangelistic Church, Rockaway Boulevard, Brooklyn

Jesus alone does not mean too much, until the blood was shared. There is no other blood like that precious blood.
Bishop B. J. Luckett, Plain Truth Mission,
South Avalon Boulevard, Los Angeles

The blood of Jesus protects you. It puts a shield around you.
Member, Saint Peter's Angelic Church of God,
Eleventh Street, Newark

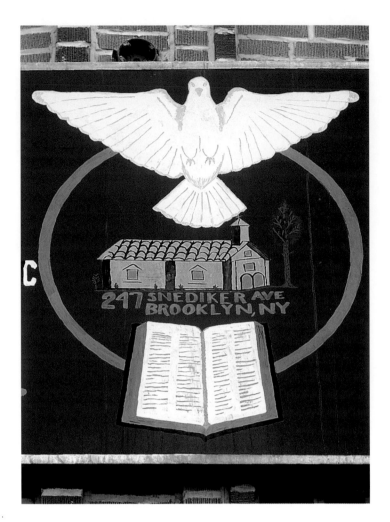

Mural depicts Bible, church, and Holy Ghost, La Sinagoga, Snediker Avenue, Brooklyn, 2002

The Holy Ghost

One can feel the presence of the Holy Spirit as fire in the bones. It is a heat that gets inside us, in our brains, our ribs, deep inside our bodies, and makes us take off our coats, dance, and speak in angelic tongues. He saturates us when the spirit goes high. People can't use the Holy Ghost, but the Holy Ghost can use them. The Holy Ghost tells us to take a road, and we do it even if we do not like it. Who am I? Who am I to resist such great power?

Speaking in unknown languages is recorded in the Bible, and it is a highly respected sign that the Holy Ghost is speaking through a person. The person speaking in tongues is often unable to understand what he or she is saying.

The anointment that stems from the Holy Spirit is like fire. Fire! Fire! Fire! Holy Ghost fire. Set it in my soul. Fire in my soul. Stir it up, stir it up. When the Holy Ghost is moving, you feel something. The Holy Ghost is life. What you feel is life radiating from the Holy Spirit, reaching to others. I thank the Lord for His precious Holy Ghost.

> Pastor L. Summers, House of God,
> West 139th Street, Robbins, Illinois

The Holy Spirit gave me the name "Thank God for Jesus" for my church; it came to my mind. The Holy Ghost tells me what to do. I don't think on my own no more. If you don't want to accept that, I can't talk to you no more.

> Pastor Wiley Taylor, Thanks for Jesus Church,
> North Bond Street, Baltimore

Sin hardens our hearts. You get irritable; you are ready to jump on somebody. The comfort of the Holy Spirit softens our hearts. The Pharaoh's heart was hardened.

> Bible class, Christ Temple Interdenominational Church,
> West Girard Avenue, Philadelphia

The Holy Spirit is the ever-present and ongoing activity of God. It is the voice that comes to me as the quiet but absolute knowing what I am to say and do. It is the guide to continuously illumine the peaceful path for me. It is the guardian that shows me around obstacles. It is the counselor who gently encourages me to always choose the higher way.

> Pastor James Rivers, Jr., Three Rivers Tabernacle Prayer House, Inc., East 161st Street, Bronx

The Holy Ghost is the spirit of Jesus who died. To be a Holy Ghost, you have to die.

> Bishop Sylvester Banks,
> Bible Church of God,
> Fourth Street, Camden, New Jersey

The "spirit of God" is the third person of the trinity [the Holy Ghost], who comes to the speaker and animates scripture. It is the "mind of God," the power that speaks in the speaker's words. They would not presume to say "God" because the spirit of God is the agency by which God reveals Himself in Scripture and to the preachers. Both Old Testament prophets and Saint Paul spoke by the "spirit of God" as their unique authority. Modern preachers do likewise.

> Professor David Morgan,
> professor of Christianity, Valparaiso University,
> Valparaiso, Indiana

The "Book" says that if you don't speak in tongues, you don't have the Holy Ghost.

> Darryl, minister,
> Triumph the Church and Kingdom of God in Christ,
> Compton Avenue, Los Angeles

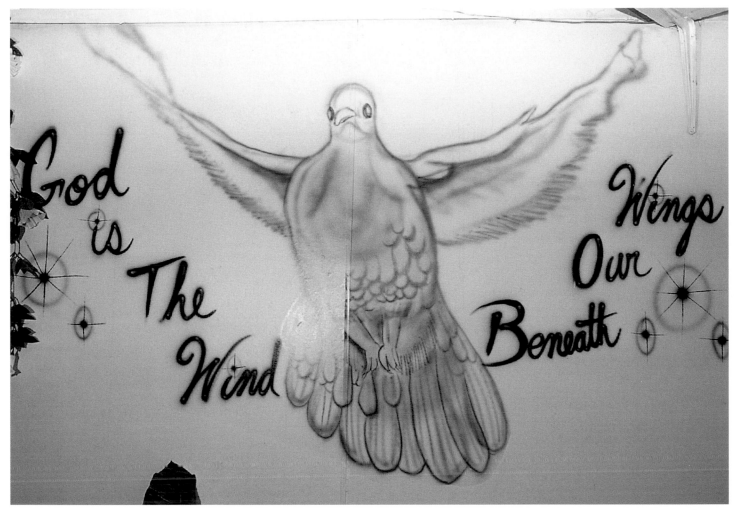

Representation of the Holy Ghost,
Naomi Memorial Baptist Church,
West Chicago Avenue, Chicago, 2004

*Next, the eye was arrested by the appearance of tongues
of fire, which rested on each of the gathered COMPANY,
of a new strange power to speak in languages they had
never learned "as the Spirit gave them Utterance."*
From "The Story of Our Church," C.O.G.I.C Web site

*Unknown tongue, that is the Holy Ghost. You need
the gift of interpretation to be able to understand it.*
Betty Dasher, mother of the church,
Fire Baptized Holiness Church, Fulton Street, Brooklyn

*The other churches don't believe that you can speak in
another language, in a language of the spirit, a language that
you didn't learn in school. It comes from no man; it comes
directly from God; it just comes like a sound from heaven.*
Pastor Inez Ashford,
True Gospel Church of the Living God,
Third Street, North Richmond, California

*Speaking in tongues is not a form of witchcraft; it is in the
Bible. You find it throughout the Protestant world.*
Pastor Victor Beauchamp,
Bibleway Pentecostal Assembly of the Apostolic Faith, Detroit

Images of God

Symbols of God that are often represented on the
façades of churches or that are used as part of churches'
names are: water, as in "living water"; fire, as in
"burning fire"; and bursts of light, as in "the light of the
world." The Holy Ghost is often depicted as a dove
placed above the baptismal fountain. Overall, images
are used sparingly in most houses of worship, and they
are generally limited to those of Jesus praying in
Gethsemane, walking along the highways, at the Last
Supper, or in the company of His apostles.

*We let people be the example. People are alive, not the
pictures. Looking to being like that picture is based in
a tradition not supported by Scripture.*
Guide, Crenshaw Christian Center, Faithdome,
South Vermont Avenue, Los Angeles

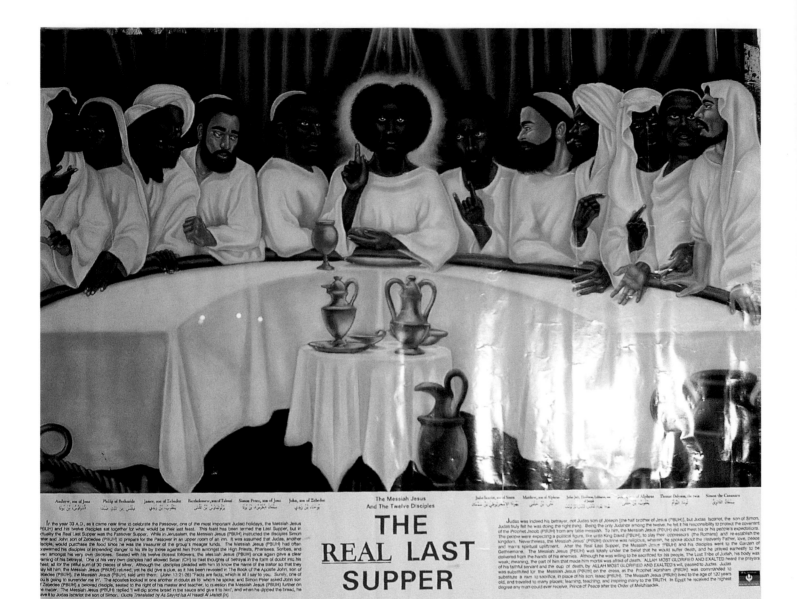

God's history from a black perspective: "The *Real* Last Supper," Mount Zion Holiness Church, Chestnut Street, Camden, New Jersey, 2003

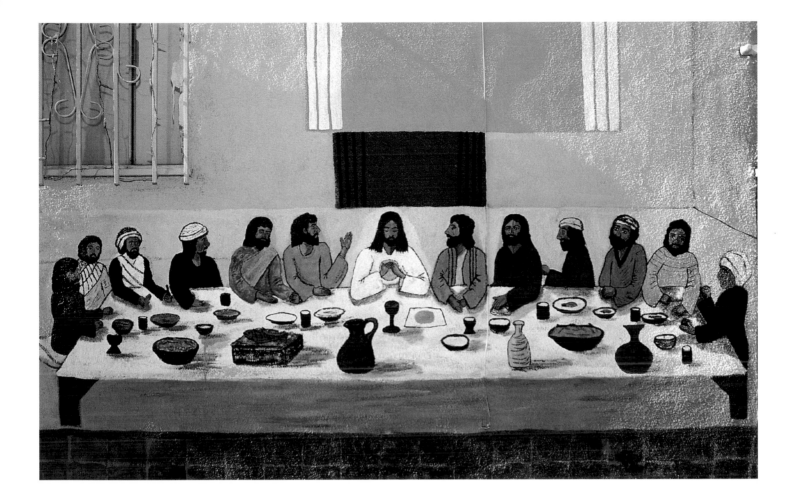

Last Supper by Manuel G. Cruz,
Fresno Street, Los Angeles, 2001

We worship God; we don't worship images at all.
We go straight to God. That is what Exodus says.
　　Usher, Kingdom Hall of the Jehovah Witness,
　　Madison Avenue, Harlem

God is a spirit; you can't put him on a piece of wood.
We worship him in spirit; we don't have images.
　　Pastor Jose Cruz, Iglesia La Luz Del Mundo,
　　East Santa Clara Avenue, San Jose, California

Christ presented himself as water, living water.
　　Pastor Cruz, Instituto Biblico de las Asambleas de Jesus,
　　Clay Avenue, Bronx

All of these images represent Christ and his makings.
　　Deacon Briscoe, Greater Mount Olive Church of God in Christ,
　　Los Angeles

Jesus is not on the cross no more, and everybody has their
own Bible. We don't need to put their images on the church.
We have our fairs. We put banners on the walls. We have
flags representing countries we pray for.
　　Deacon Walter Rice, Provision of Promise Ministries,
　　Clinton Avenue, Newark

The Passion of the Christ

Shortly after it opened in late February of 2004, Mel Gibson's movie became an essential topic of conversation for church officials. The mass media described *The Passion* as a gratuitously cruel film, depicting the brutal beating of an innocent man, culminating in His bloody crucifixion and death. In ghettos it was seen as showing the terrible sacrifice Jesus willingly went through to save mankind. Pastors were eager to acknowledge that Gibson had done them a service by showing the suffering that Jesus went through to save us. They discussed the film during services, recommended it to their congregations, and brought it up in interviews. In response to the accusation that the film showed too many beatings, most officials I spoke with felt that Gibson's account had fallen short of what actually took place.

Pastor E. Holland, of the New Nazarene Missionary Baptist Church in Richmond, California, went to see the film to find out if Gibson "was sticking close to the Bible story."

His assessment was that "it gets the message over. He got a lot of it right; he got some of it Hollywood; and he got people thinking about the suffering of Christ. That was more important than anything else." The movie made such an impression that people in the audience decided to become members of a church right at the movie theater. Turner 3, an officer of the First Goodwill Baptist Church in Los Angeles, told me about a man in Los Angeles who, after seeing *The Passion*, went to the nearest police station to confess to a murder he had committed years earlier.

I saw *The Passion of the Christ* at the Magic Johnson multiplex in Harlem. The audience was like that of no other movie. Some family members were pushing strollers and wheelchairs, having brought small children or their disabled grandparents along. Among the elderly there were those who could hardly see, but who were eager to watch this movie, perhaps the last they would ever see in a theater. A woman sitting next to me moaned loudly with every blow Jesus received. When the movie ended, the audience left slowly and silently, with tears in their eyes.

I cannot recall another movie about which the interpretation of the critics has been more at odds with what a large segment of the audience felt. The *New Yorker* critic David Denby, and many others, saw *The Passion* as a historically inaccurate film, anti-Semitic, and one of "the cruelest movies in history." Yet, I never heard an anti-Semitic remark in any of the churches I visited or from the people I interviewed. The only person who mentioned Jews in connection with *The Passion* was Pastor Willis of the Love Thy Neighbor M. B. Church in Gary, Indiana. Willis mistakenly explained to me that Mel Gibson was Jewish and that other Jews had not been willing to back him up, so that he had had to pay the entire cost of making the movie himself.

The brutality of *The Passion* was universally acknowledged. "They whipped him [Jesus] quite a lot," said Pastor Henry Sutton of Holiness Is the Way in Chicago. Pastor Reggie Jackson in Philadelphia explained that Jesus did not have to do it, "He was the son of God; he could have called ten thousand angels." Some in the movie audience found it hard to take and wanted to get up and leave, but nobody called it sick or sadistic. It had to be brutal to be accurate, according to the officials I interviewed. The suffering of Jesus was perceived of as an expression of love for mankind; this is as it is written in the Bible. People did not see the

In this mural, razor-ribbon wire echoes the crown of thorns of the crucified Christ, Menahan Street, Brooklyn, 2003

Crucifixion painted in an alley near Union Avenue, Los Angeles, 1997. The mural, completed in 1990, was commissioned to bring peace to a high-crime area and was blessed by the local parish priest.

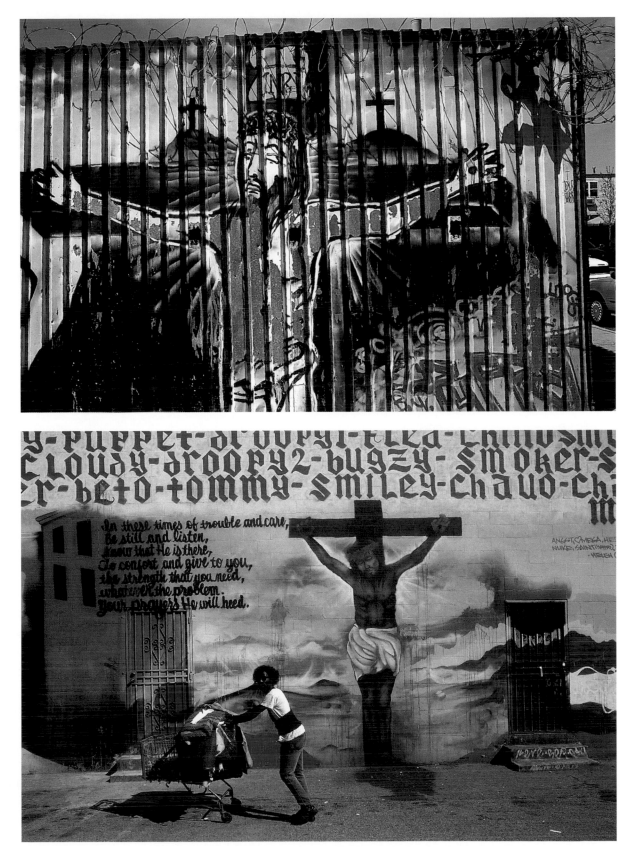

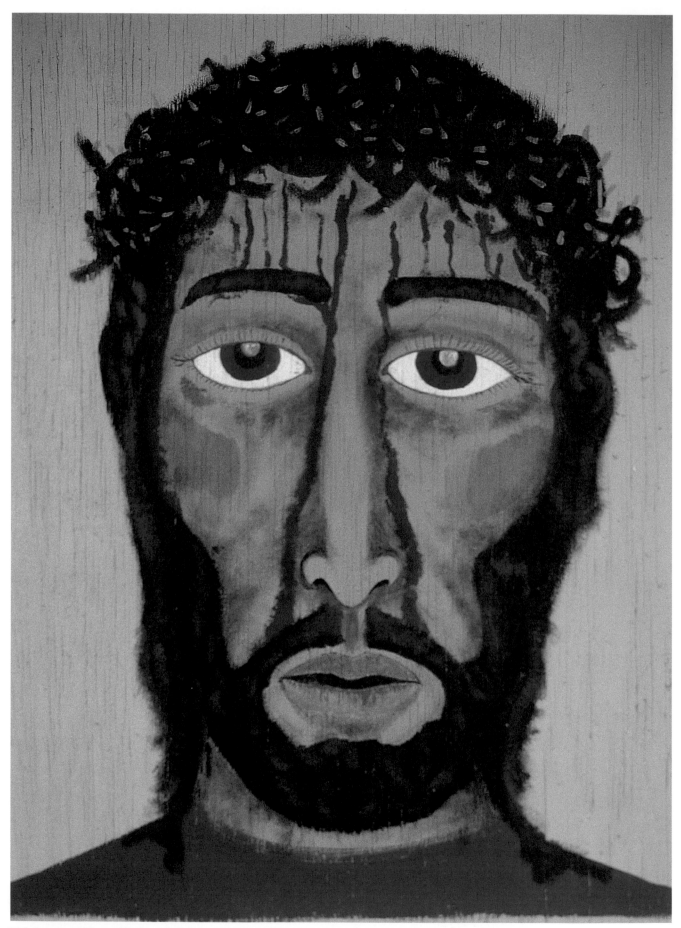

This image of the suffering Christ looking directly at the viewer was painted by an ex-convict.
Crossover Inner City Gospel Ministry, Cass Avenue, Detroit, 1994

Painting at True Gospel Tabernacle Church depicts the day of Pentecost, West Tremont Street, Bronx, 2001. The artists, Erwin and Neville, consider the painting one of their best and occasionally stop by the church to see it.

movie for entertainment, but for their own edification.

Churches in Chicago and Newark made arrangements to rent entire theaters for private screenings for their members, while others urged their congregations to see it independently. Church members who preferred to watch the movie in the privacy of their homes bought one of the widely available DVD versions.

It is difficult to understand how Protestant churches that traditionally refuse to show the body of Christ on the cross, and preach the gospel of joy and prosperity, accepted wholeheartedly a movie with so much scourging. Why did so many religious leaders make an exception to their belief that "Thou shalt not make graven images of the Lord"? Why did they go to see *The Passion* and encourage others to see it? When I asked these questions, church officials denied that a movie telling the story of the Passion was the same thing as a graven image. They replied that it had actors in it. One pastor added that nobody knelt and prayed to the movie. From Catholic to Baptist churches, officials declared *The Passion* to be an accurate historical account, while emphasizing that it was a movie and not real life.

Gibson's film has rekindled the faith of believers, and it has become a powerful tool to recruit new members, particularly among those who have difficulty reading the Bible. Pastor Charles A. Mickens, of Lights of Zion M. B. Church in Chicago, explained, "Mel Gibson changed a lot of people,

but if we can't add on, it will just be awareness. The Bible talks about scourging, but we never saw it like this, using jagged bones that tear the flesh. My people said, 'It felt like I was there; it was heart-wrenching.' They went home and read the words, and the words came to life. After seeing someone doing all this for us, we all got a different look at love." Several pastors remarked on the fact that *The Passion* was not more terrifying than many popular horror films.

Gibson's movie has not encouraged pastors to put bloody images of Christ's Passion on the walls of their sanctuaries, and it has not changed the emphasis on joy and abundance characteristic of many churches. Now when pastors ask who else would be willing to die to save us, they can direct people to see the movie. Sister Womack, of The Cross of Calvary Baptist Church in Philadelphia, said, "It spoke the truth. Nobody could have taken a whipping like Jesus did. It has done its job." Thanks to Mel Gibson, religious officials now have a film to watch, a set of teaching aids to use to convert nonbelievers.

The Passion *depicts the journey that Jesus took for our salvation. It is the only story that comes close to depicting what actually happened in the last twenty-four hours of His life. It is very brutal, but the actual beating that Jesus took was worse than that. Did you see the leather straps with the cat bones; they used that more than twice. Being a gospel*

Mural of Christ and the cross behind the altar of the former Shiloh Temple Apostolic Faith. By showing Jesus seated alone in a bleak Michigan landscape, clasping the cross in front of Him and looking not at the viewer but at the sky, the artist has deviated from established imagery. Linwood Avenue, Detroit, 2005

When we think of the cross, we think of Christ that died on the cross. We don't need to have the body there.

> Pastor O. C. Morgan,
> Evening Star Missionary Baptist Church, South Cottage Grove
> Avenue, Chicago

Christ on the cross represents his death. The glory of the church is the resurrection. The empty cross is a sign that Christ has resurrected; His absence from the cross indicates his presence in heaven.

> Felipe Salazar, Iglesia Apostolica Hosanna,
> El Segundo Boulevard, Compton, California

The cross goes down to a small point in the bottom and spreads out wide at the top; it is a naturally unstable shape.

> Tim Samuelson, cultural historian of Chicago, discussing
> why so many crosses are crooked or fall over

Faith

The most common quote on the subject of faith in the churches I visited is Hebrews 11:1: "Now faith is the substance of things hoped for, the evidence of things unseen." Christians, according to Pastor Rafael Lozada, of Word of Life Ministries in the Bronx, believe because they trust God, and they are going to heaven because of what they believe. Lozada tells his congregation, "We need to take the words of God and warehouse them in our spirit; we then have a supply of living water for the storm. God loves you and cares, even if things don't go the way you want. In a relationship with God, faith is essential: it tells you what to expect; it gives you clarity; it is solid. Not one syllable of the word of God is going to change."

Often Abraham is shown as a model of faith, a man who was willing to sacrifice his only son, Isaac, because God had asked him to do so (Genesis 22:1–14). Pastor Darrin Leonard, of Provision of Promise Ministries in Newark, tells his congregation, "Isaac comes in many forms today. Isaac can come in the form of your money, he can come in the form of your land. When we are not willing to sacrifice Isaac, we don't believe in God." Members are encouraged to walk their faith, to activate the faith, and to release their faith with their offerings. People with limited incomes are asked to make a gift to the church that bears no relation to their circumstances. Pastor Leonard continues, "This is not what the preacher is saying; this is what God is telling you. Jesus is looking at your offering."

On a given Sunday, congregants of Provision of Promise are asked to come up to the front of the church and make a pledge of up to five hundred dollars. The contribution is the seed the person will plant, a seed that will be repaid one-hundred-fold by God. God will provide. God! God! God! Faith activated by a financial contribution can keep cancer away, save children from being killed in a drive-by, extend the length of lives by two decades, and provide promotions or a better job. Those who give three hundred dollars or more get a small piece of paper on which to write their petitions. Pastor Leonard tells contributors that the petitions are "a token from God. Everything you write in here until the end of the year is warranted by God."

The Bible speaks about three types of faith. One is natural faith; that is our ability to communicate with God with our five senses. The next is what we call dead faith; that is the

Sign by John B. Downey at Emmanuel Baptist Rescue Mission,
Fifth Street, Los Angeles, 2003

Sign at J. Claude
Allen Christian
Methodist
Episcopal
Church, West
147th Street,
Harvey, Illinois,
2003

Section of sign at Faith Tabernacle
Church, Compton, California, 2002

Keep your faith, and hold on, hold on; don't let it go. I am coming to tell you, you can make it. Hold on to faith; faith is going to deliver you. Faith is going to put you through. You must believe; take that home with you. This whole Bible is a faith book. You have to believe it; you have to walk the walk with it. Although your miracle has been delayed, you must believe. You have to trust God and recognize that you are a son of God. He will bring you through, but you have to have the now faith. You only have now; the past is gone, and the future has not been promised to you.

Elder Jeffrey White, Temple Royale Pentecostal Church,
Snediker Avenue, Brooklyn

Taking Advantage of Our Weak Nature: The Devil, Satan, Lucifer, the Anti-Christ, the Enemy

The most common characteristics of the devil are that he is a constant source of temptation, a liar, and the main creator of confusion in the world. Satan is described in sermons across the country as the cause of evil in the world and the enemy of men's souls. He seeks to put people in bondage, to enslave them. Sneaky and aggressive by nature, the devil can take many disguises.

People are weak, but God is greater than Satan. Only with the help of God can a Christian overcome temptation. Church officials had much to say about the devil's powers. I was told, for example, that Satan controls epilepsy and suicide, and that he can't say Jesus' name. Yet, when I asked how I could tell the devil from all other creatures, I got no clear answer.

The devil remembers when you were unsaved. He puts in front of your face the things you lusted for before you were saved: women, money, cars, and liquor. He uses that to draw you back to him. He was an angel. They say that he was the prettiest angel that there was. Devil was not his name; Lucifer was his name. God kicked him out of heaven into the deepest part of the earth.

Darryl, minister, Triumph the Church and Kingdom of God
in Christ, South Compton Avenue, Los Angeles

I don't think evil would be here without the devil. The Scriptures teach us that when Jesus comes back again for one thousand years, He is going to set up His kingdom, and the

people that they believe in God, but not in the works of Jesus Christ, which is the death, the burial, and resurrection. Satan believes in God. He has faith because he was there with God from the beginning, but he doesn't believe in the works of Jesus Christ. The third type is the supernatural faith. This is the essential part: "Faith is the substance of things hoped for, the evidence of things not seen." You have to have faith number one to connect to faith number three."

Bishop Sylvester Banks, Bible Church of God,
Fourth Street, Camden, New Jersey

You have faith in a natural world. If you go to work, you have faith that your employer is going to pay you. Spiritual faith is what you believe even though you can't see it. Your faith has to be in God, not in yourself.

Pastor Gloria Lawton,
New Life in the Great I Am Church,
Bostwick Avenue, Jersey City, New Jersey

When you stop looking at God, you sink; this is what happened to Peter. Peter sunk, and the Lord reached out to him. Peter looked at Jesus' eyes, and they both walked together on the water toward the fishing boat.

Pastor Juan, Iglesia Cristiana del Valle, Inc.,
East 156th Street, Bronx

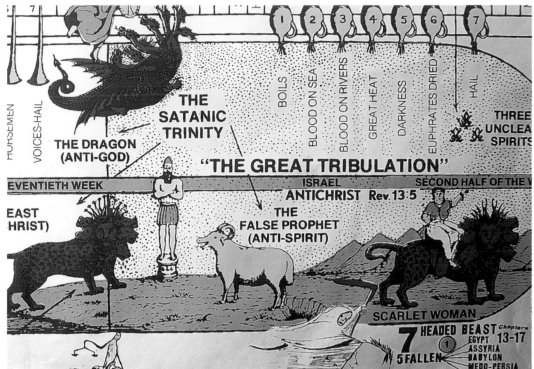

Detail of Revelation of the World showing the satanic trinity, on display at General Assembly Holiness Church of the First Born, Broad Street, Philadelphia, 2003

devil is going to be bound for one thousand years. That is going to be the time when there is no evil because it's the devil that causes people to do evil.

Rev. Dr. Mark Carrington,
National Church of God of Brooklyn, Inc.,
Saratoga Avenue, Brooklyn

The enemy comes to kill, steal, and destroy; that is the devil's job. When the enemy tries to mess with your stuff, when he comes to get you, then is when you have to praise the Lord. We rebuke the enemy right now. You vile demon, we cast you out. The devil has no authority. The devil is a liar.

Pastor Shaw, Shiloh Temple of God in Christ Jesus,
Nineteenth Street, Newark

If you clap your hands and praise the Lord, the devil gets confused.

Pastor A. R. Barnard, Christian Cultural Center,
Flatlands Avenue, Brooklyn

What messed up your life in 2003 will do the same in 2004, unless the demon is cast out of your mind. He is hiding in there and doing his dirty work in your head and spirit. I rebuke the devil. I rebuke the demon of the evil imagination. I loose them from sexual immorality. I loose them from every secret sin. I loose your mind, I loose your spirit in the sacred name of Jesus. God wants to heal you! You are headed in a new direction. You are headed to a better place.

Bishop W. R. Portee, Southside Christian Palace Church,
South Vermont Avenue, Los Angeles

Satan is a contrarian mind, an evil mind. He is the force that fights against God, the creator. He wanted to be over God, but there is only one God. There is no room for him, so he was cast out.

Rev. William Pinkney, pastor, New Greater Straightway Baptist Church, North Seventh Street, Philadelphia

The devil has a counterfeit for everything God has. You have to ask: Is this the right spirit? To find out if it is of God, you have to wait.

Pastor M. Scriven,
General Assembly Holiness Church of the First Born,
Broad Street, Philadelphia

Every time since I have been saved, I have been watching. If you let the devil ride, he wants to drive. Anything you want to let the devil do, he wants to control it. He wants to control your emotions. He knows that we are in a materialistic world.

Pastor R. E. Sutton, The Church of Our Lord Jesus Christ,
Dauphin Street, Philadelphia

People are still people; the devil is still the devil. When he came down out of heaven, he came to wreak havoc among the people in the earth. Without God, we are powerless against the devil.

Pastor Sarah Daniels,
Whole Truth Gospel Church of Faith, Gary, Indiana

I have never seen Satan per se, but I have seen his work. I have no idea what he looks like. He is in a spirit form.

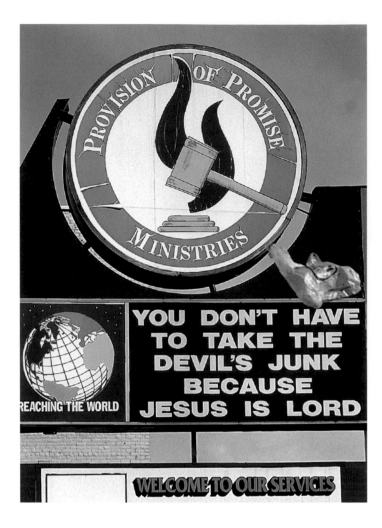

Men and men are having sex; it is Satan. Satan whispers to some men, "You are gay." Satan whispers to some women, "You are lesbian." His voice is very soft. He was a singer in heaven until the Lord kicked him out. When this world is over, the devil is going to hell.

 Rev. Marshall Smith, pastor,

 Greater Jerusalem Baptist Church, Pitkin Avenue, Brooklyn

All of you that love the devil and its activities, all the people who sneak around and connive and listen to the devil, will be cast into a lake of fire and brimstone forever and ever. Do you believe in the Bible? You are supposed to live holy. God told John that the beast is already here.

 Bishop Wallace Furrs, pastor, America Come Back to God

 Evangelistic Church, Rockaway Boulevard, Brooklyn

Satan also has a church. Satan worshippers have a church in the state of Florida; they worship the fake prophets.

 Pastor Nelson, Star of Bethlehem Baptist Church,

 Park Avenue, Harlem

We command the power of demonic forces to loose their forces. We come against the spirit of confusion, the spirit of distortion, the spirit of witchcraft. Go now in Jesus' name; go now in the name of Jesus. I break the power of mind-control spirits, of spirits of divination; I release the anointing to cast out devils. Start that anointing; every tie of witchcraft is broken. The east wind! There is something about the east wind.

 Apostle Ernest Leonard,

 Provision of Promise Ministries, Clinton Avenue, Newark

The devil has us in a vicious circle: stress, depression, worry, fear, doubts. He got us in a vicious circle, but God is still the devil's boss. This is a serious time, but I feel like pressing on.

 Evangelist Richardson,

 Jesus Deliverance Mission Church, Avon Avenue, Newark

People put things on the devil, but they are not of the devil. I am a firm believer that the devil has no authority unless you give it to him. They are confused. They need help; life overwhelms them. They need to perform some action to solve their problems.

 Rev. Townsend,

 Christ Healing Temple of Faith, Fenkell Avenue, Detroit

A person is demonic because they have excessive behavior directed at Christ or at Christ's people.

 Pastor Evelyn Gaines,

 Divine Temple of Love Tab,

 Kaighns Avenue, Camden, New Jersey

Don't fool yourselves; the devil is here. He came here in a body. He does not like it when you praise God.

 Pastor Lacy Douglas, Jr., South Thirty-fourth Street,

 Richmond, California

I feel something in my spirit; it's no good. The enemy is busy; he is attacking everybody. The enemy is on our track. I know what the enemy wants to do. Our young children are dying of starvation. The devil is not going to have our children. I command you in the name of Jesus, in the name of the blood of Jesus, to take your hands off our young people. We ask you to move like never before, God. Move God! Move God! Move God! Hallelujah!

 Bernice Brown, New Freedom Full Gospel Church,

 Liberty Street, Camden, New Jersey

 (Ms. Brown was preaching on October 26, 2003, after having

 heard about the alleged starving of four children by their foster

 parents in nearby Collingwood.)

Red Bible resembling a flying butterfly, The House of Prayer, West Fifteenth Street, Chicago, 2002

Satan deposed becomes the prince of the "powers of the Air." John 12:3, 14:30, Ephesians 2:2. The Satanic Trinity: the dragon, anti-God, the beast, anti-Christ, Revelation 13:5; the false prophet, anti-spirit.

Rev. C. L. Gosey, Ph.D, Th.D., S.T.D., D.D., founder, sign at Clear Visions Bible Studies, Norfolk, Virginia

The Holy Bible, the Scriptures, the Word of God in All Its Power

Churches frequently begin their declaration of principles by stating: "We believe the Bible to be the inspired and only infallible word of God." Some declare on their façades that they are "Scripturally Correct," that is, they preach God's literal truth as it is written in the Scriptures. Others have included the word "Bible" in their name.

Inside houses of worship one often finds an open Bible, displaying a chapter or verse that is particularly meaningful to the congregation. The Bible radiating divine light is typically depicted in churches as a central symbol of the faith. Pastors face their congregations with the holy book in hand, a sign that God speaks through them. In the course of interviews, church leaders often stopped conversation to search their Bibles, showing me that they were quoting passages correctly. Pastors often say that God speaks to them. When asked why they need additional guidance if the Holy Ghost directly communicates with them, pastors

reply that God speaks through the Bible and will not say anything contrary to the Scriptures.

The Bible is second only to the cross as the most prominent and widely used symbol of Christianity. Pastors acknowledge that their members have problems understanding the Scriptures, so most churches have Bible study. A teacher at the Messiah Missionary Baptist Church in Brooklyn told the congregation that, in her class, the words "jump up the page."

I often perused Bibles that I found lying on church pews, unaware that people consider their personal copies to be private. Once I was looking through a Bible that belonged to a congregant of the Saint Luke Powerhouse of God Church in the Bronx, when an usher came over to me and said, "Excuse me, sir, are you here to see somebody? And what is your name? Why are you writing our church's name in your notebook? Do you want to speak to the pastor?" When I tried to leave, the usher blocked my exit from the church until the pastor intervened and asked her to let me go.

All members believe the Scriptures of the Old and New Testaments, commonly known as the Holy Bible, to be the source of faith and the absolute rule of conduct for human life. They have determined to build their lives on this truth.

Rev. A. R. Bernard, pastor, Christian Cultural Center, Flatlands Avenue, Brooklyn

Bible painted on façade of Day of Pentecost Evangelistic Church, Caroline Street, Gary, Indiana, 2002

Sometimes pastors try to please the people, but you don't compromise the Bible; you don't sugar-coat it.

> Pastor William Elliott, Zion Baptist Church,
> Broadway, Camden, New Jersey

The word of God is in the Bible; it is our first priority. That is what we are all about. That is all we can be about.

> Pastor Ben Butler, First Steadfast M.B. Church,
> East Bowen Street, Chicago

Our faith is based on the historical evidence. It is a known fact that the Bible was written.

> Pastor Harold B. George,
> Christ Union Missionary Baptist Church,
> International Boulevard, Oakland, California

We give the Bible to all young Christians when they are baptized at the age of five. Then when they reach the age of ten, we give them another Bible, a standard Bible, one that is not too expensive.

> Elder John G. Stevens, Community House of Prayer,
> South Orange Avenue, Newark

The Bible tells us that we are rich because we have faith. Poor people who have Jesus may be richer than those among the wealthy who don't.

> Mother Williams, mother of the church,
> All Nations C.O.G.I.C., York Street, North Richmond, California

The voice [of God] is going to say the same thing as the Bible; it does not go contrary. If it goes contrary, it is the voice of the devil.

> Pastor Inez Ashford,
> True Gospel Church of the Living God,
> Third Street, North Richmond, California

You can imagine what a mess it would be if everybody would say God speaks through them and the Bible doesn't back it up. If the Bible doesn't say it, it isn't so.

> Pastor E. Holland, New Nazarene Missionary Baptist Church,
> B Street, Richmond, California

Familiarize yourself with your Bible; underline it so you can go back to it and find the passages that you are looking for. It doesn't matter if it looks raggedy, with some of the pages coming out.

> Pastor Dingle, Memorial Baptist Church, Newark

If you go out to the Motor Vehicles Department to get your license, you have to go by their manual. They give you a book. I preach the gospel; I read God's word, the sixty-six books of the Holy Bible. Reading newspapers, you get bad news; reading the Bible, you get good news.

> Fred Marshall, street preacher, Martin Luther King Jr. Drive,
> Jersey City, New Jersey

We preach the death, burial, and resurrection of Our Lord Jesus Christ. We believe in the moving of the Holy Spirit, and we are free in our praise and worship from traditional liturgical bonding.

> Pastor Eddie Douglas Anderson, Tabernacle of Jesus,
> Clinton Avenue, Newark

We preach the gospel. We don't cut corners; we declare sin to be of the devil. Other churches just have entertainment; they take certain parts of the Bible.

> Superintendent Moses Green, founder and pastor,
> Community Church of God in Christ, Inc.,
> Beach Street, Queens

A full gospel church preaches the gospel from Genesis to Revelation.

> Elder W. G. Belton, Pentecost Holiness Church of Deliverance,
> Albany Avenue, Hartford, Connecticut

Traditional churches, they don't have the laying of hands and the speaking in tongues. We operate in the gifts, speaking in tongues.

> Pastor Henry Ellis, Revelation Baptist Church,
> South Western Avenue, Los Angeles

**Baby Dorion and Bible,
New Friendship M.B. Church,
Harvey, Illinois, 2003**

That is some of their way to indicate that they have the full message of Christ. Once one denomination implies that it has the full gospel, this implies that the others do not.

 Pastor Harold B. George,

 Christ Union Missionary Baptist Church,

 International Boulevard, Oakland, California

When you travel on public transportation in the South Side of Chicago and you see somebody reading a book, it is most likely the Bible. People read their Bibles with a yellow marker on hand, highlighting passages as they go along.

 Tim Samuelson, cultural historian of Chicago

**Mural portraying Latinos praying,
Mission of the Gospel, Hooper Avenue,
Los Angeles, 1996**

Prayer: Praising God, Thanking God

How does one know when one is praying? Is it better to pray alone or to pray as part of a group? How much should a person pray? How can one know if a prayer is being answered? In the churches I visited, the Lord's Prayer is the most popular prayer.

I was taken by surprise to discover how much prayer was centered on thanksgiving in African American churches. Congregants work themselves up into a frenzy of gratitude during a service. I found myself asking who is this God that demands so much gratitude and praise? Isn't being God enough? Persistent thanking is perhaps a form of prayer that intensifies the anointing, makes people feel the power of God, and invites the Lord to come and saturate them. Expressing gratitude then becomes a ritual to achieve a mystical union between the Creator and His creature.

Church members loudly and repeatedly thank the Lord, God, or Jesus for improvements in their lives—for getting a better car or house, or having a better job than their parents. People thank God for having woken them up in the morning, for keeping them out of the intensive care unit, or for helping them to deal with a family crisis, such as getting their son out of jail. Gratitude to God is expressed loudly: clapping one's hands, telling one's neighbor that "we serve an awesome God," and testifying to one's debt to the Lord in front of the congregation.

When church members read about accidents like plane crashes or train wrecks, or see them on television, they say, "It could have been me, O God." Sometimes when I stood amidst the members as they thanked God and rejoiced, I wondered at the lack of empathy for the victims of these tragedies.

During service one Sunday in 2004, at Saint James Apostolic Church in Camden, New Jersey, I heard the pastor thank God for having provided everyone with a bed to sleep in at night. When I saw a homeless man who had come into the sanctuary to warm up, I pointed him out to two of the church members and suggested that among us was a man who had slept outdoors the previous night and that they should modify their expressions of gratitude. My remarks, however, were treated as incomprehensible and were politely ignored.

Prayer is sincere communication from our hearts to God. It can be a silent or it can be a verbal prayer. The word of God says that two praying together is better than one.

Pastor Lillie L. Grant, Great Expectations Deliverance Center, Martin Luther King Jr. Drive, Milwaukee

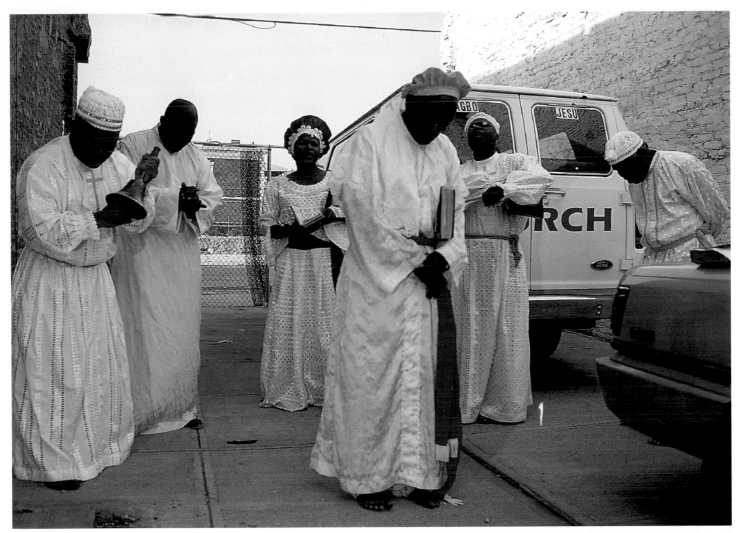

Nigerian members of Pentecostal Church bless parking lot
in the location where they plan to build a church extension,
Saratoga Avenue, Brooklyn, 2003

*Prayer is the only way to communicate with the Lord; even
David used to pray three times a day. You can't dictate to
people what to pray; when you are praying, you say every-
thing that goes through your spirit. Some people prefer to
pray from a prayer book that is the same for everybody.*

 Pastor C. L. Bonney, Christian Faith Missionary Baptist Church,
 South Orange Avenue, Newark

*Words of My Mouth: Let the words of my mouth, Let the
words of my mouth, And the meditation of my heart be
acceptable in Thy sight; Wilt Thou teach me how to serve
Thee? Wilt Thou teach me how to pray?*

 Rev. Henry Mack, Jr., pastor,
 Gospel Hill Baptist Church,
 Third Avenue, Bronx

NO PRAYER—NO POWER
LITTLE PRAYER—LITTLE POWER
MUCH PRAYER—MUCH POWER

 Superintendent William T. Pree, SION C.O.G.I.C.,
 Vernon Avenue, North Richmond, California

*We know that God answers prayer. Black people have done a
lot of praying; they get a lot of relief out of prayer.*

 Pastor Robert Moore,
 Rising Star Missionary Baptist Church #2,
 Gary, Indiana

Pray for my mother; her kidneys are failing.
Pray for my family to unite in love,
 pray for my business to be prosperous.
Pray for world peace.
Pray for Salvation.
Pray for happiness.
Pray for final Blessings.
Pray for his case to be dismissed.
Pray for help with drug addiction, scared,
 not listening to my mother.

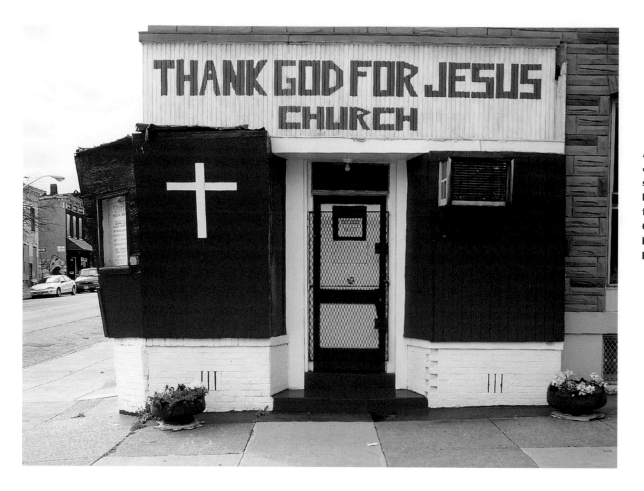

At Thank God for Jesus Church, a sign reads "Our Mission Is to Win the Lost to Christ," North Bond Street, Baltimore, 2002

Pray for help with cancer.
Pray for help with love problems.
Pray so that things are over.
Pray for child in danger of the streets.
Pray so I can keep my apartment.
Pray because I need a job and a new home.
Bless us with the children.
Praying for Kevin to stop walking the streets and stay
 with his mother.
To help her do good, to pass her test on Saturday.
 Petitions, Iglesia Universal Pare de Sufrir,
 Southern Boulevard, Bronx

PRAYER REQUEST FORM (CHECK ONE)
Dear Pastor Woods,
Please pray for: _Physical Healing _Heart Trouble
_Diabetes _Blindness _Cancer _Fear _Voodoo
_Loss of Nature _Wife _Husband _Children
_Finances _Loneliness _Anger Control _Elderly
Abuse _Depression _Drugs _Loss of Self-Esteem
_Other_____.
 Ebony Missionary Baptist Church,
 South Main Street, Los Angeles

*Is God all right? Is God all right? I am going to praise Him
for all His goodness. I am going to praise Him for all He did*
*for my family. I am going to praise Him for all He did for
my church. Can you give God a hand clap?*
 Bishop B. J. Luckett, Plain Truth Mission,
 South Avalon Boulevard, Los Angeles

*If we had ten thousand tongues, we couldn't thank You
enough.*
 Rev. R. T. Mitchell, pastor, New Revelation M. B. Church,
 Twenty-first Avenue, Gary, Indiana

Thank you, Jesus, for Your Holy Ghost.
 Pastor David Jefferson,
 Metropolitan Baptist Church, Springfield Avenue, Newark

*I don't know about you, but God has been good to me.
If God has been good to you, turn around and repeat it to
your neighbor. Why don't you give Him a clap if He has
been good to us?*
 Pastor David King, Sr., Community Baptist Church,
 Mount Ephraim Avenue, Camden, New Jersey

*God gives you breath every morning. God makes our blood
run. God defends us from our enemies. He is giving you the
use and activities of your limbs. God always gives hope. He
always gives a second chance. In Him all things are possible.
The Lord will make your enemies your footstools. Death,*

bills, problems at home, problems in the neighborhood—you look here, and God bless you with a house, and then you look again, and God has blessed you with a brand-new car.

Pastor Dingle, Memorial Baptist Church, Central Ward, Newark

When you go to the hospital and see the children all crippled up and deformed and then go home and see your children healthy, you should praise the Lord.

Pastor, Saint James Church of God, McDonaugh Street, Brooklyn

We can still lift our voices and say thank you, Jesus. We thank you for not being what we used to be. We thank you, Lord, that we didn't sleep outdoors last night. Lord, You kept us on the highways and byways until 2003. You watch us coming home safe again and again. You are a doctor that never lost a patient. Thank you, Lord, for saving my soul. Thank you, Lord, for taking me home. Thank you, Lord, for saving my soul. Thank you, Lord, for making me whole. Thank you, Lord, for giving to me salvation so rich and free.

Rev. H. Grady James, Jr., First Bethel Baptist Church, Nineteenth Avenue, Newark

I thank you, Lord, for waking me up and keeping me through the night, and I was not consumed. We have the potential right now in the Los Angeles Basin for an earthquake called "The Big One." God's mercy and His grace have kept it from happening.

Elder James Culpeper, skid row, Los Angeles

We have so much to be thankful for. Last week one man was killed on the subway tracks while fixing the signals. The next day another man was killed doing the same thing, and you are here. I say thank you, Jesus, for what you have done for me. We don't have to go to the hospital.

Jerry McKenna, minister, church in the Bronx

I have had one husband for eight years, hallelujah! I don't have to look for nobody. If the cops pull me up, I have my license and insurance. I don't need alcohol or cigarettes. Thank you, Jesus!

Sister Shante, Holy Bethel Pentecostal Temple, Broadway, Camden, New Jersey

Show me a thankful person, and I show you a happy person. The sunset does not know it is a sunset; the conscious human *being appreciates, celebrates, and thanks. Jesus did an awful lot of thanking.*

Pastor Michael J. Doyle, Sacred Heart Church, Broadway, Camden, New Jersey

Some have hearts that are so hard that they can't even say, "Thank you, Jesus."

Bible class, Evangelistic Church of God in Christ, South Avalon Boulevard, Los Angeles

The Lord likes to hear good things. The Lord likes compliments; everybody likes compliments. Don't you like to hear good things said about you?

Elder Miguel Davis, Holy Miracle House of Prayer, South Racine Avenue, Chicago

Salvation, Accepting God

Are you saved? This is the central question for a born-again Christian. God saves. Jesus is loved, praised, and thanked because He came to the world as a man and gave His life on the cross to save mankind. In order to be saved a person needs to accept Christ.

Salvation is the church's mission. God makes a path to heaven. Some pastors deny that they teach a religion, saying instead that they preach salvation. Pastor Robert Durr, of the House of Prayer in Chicago, explained that "religion does not hold us up; religion is not what gets us to heaven." What is important to Pastor Durr is "knowing God as your personal savior." And Pastor Rafael Lozada, of World of Life Ministries in the Bronx, tells his congregation, "You don't have to join a religion; you have to join Jesus Christ."

In interviews, church officials explained the advantages and disadvantages of activities such as adding a steeple to the building, renaming the church, or organizing a tent revival in terms of whether they would contribute to saving souls.

Salvation: We believe the terms of salvation are repentance toward God for sin and a personal, heartfelt faith in the Lord Jesus Christ. This will result in a new birth. Salvation is possible only through God's grace, not by our works. Works are simply the fruit of salvation (Acts 3:19–20; Rom. 4:1–5, 5:1; Eph. 2:8–10).

Pastor George Fischer, church leaflet, Focus on Jesus Bible Church, Inc., Clinton Avenue, Newark

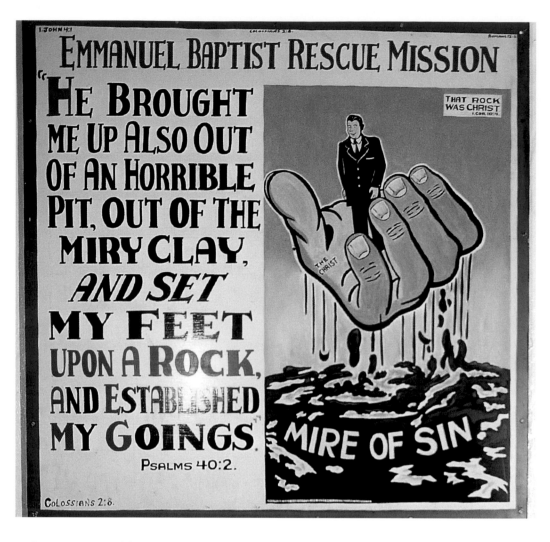

Rescued from the "mire of sin" by the hand of Christ, a painting by John B. Downey, Emmanuel Baptist Rescue Mission, Fifth Street, Los Angeles, 2003

Salvation means deliverance, complete deliverance, as when God delivered Israel from out of Egypt. You know when you receive the Holy Spirit; it is an individual thing. You don't do the things that you used to do anymore—you don't drink, you don't smoke—you have been delivered from those worldly things. We don't do things decided by the flesh; we tell the flesh we cannot have things of the world. When you go into the sanctuary and praise the Lord, the anointment of the Holy Spirit comes to you. God wants us to praise Him. You know what they do in heaven twenty-four hours a day: He has the angels and the elders praise Him day and night.

Pastor M. Scriven, General Assembly Holiness Church of the First Born, Broad Street, Philadelphia

When a person is born again they make a commitment to Jesus Christ. Every day we try to be godly. Followers of Christ think no evil or follow no evil; they shun that which is bad. The unrighteous people who do evil, who cast evil spells, are not Christians, although they may still be in the church. They still have the old habits; they hold on to things that give them pleasure; they have not dropped the old man.

Rev. Dr. Mark Carrington, National Church of God of Brooklyn, Inc., Saratoga Avenue, Brooklyn

I was in a dark position, in a place where nobody could save me: beer, the Colt 45, the coke. I needed the Lord in my life. For sixteen years, I had been carrying the Bible. I began to study the word. I felt the word of God began to pour me. The Lord said either you are going to serve Me, or you are going to die. When I heard the word. I took it personally. I said, "Lord I am coming to You wholeheartedly." I got saved in 1987, and I haven't drunk since then, and I haven't smoked since then. They baptized me at Greater Full Gospel.

Pastor R. E. Sutton, The Church of Our Lord Jesus Christ, Dauphin Street, Philadelphia

You just can't get saved and not join up. Say: "I got to join. I got to be part of this ministry. Something is telling me to come." God is moving here. Come on, black man; come on, white man; come on, Indian man; come on; there is room for you. Young ladies are being saved. Young man, you will never be the same again. Father, in the name of Jesus, don't let him be the same after today. Fill him with the anointing of the Holy Ghost. Everybody say, "Yes, Lord." God Jesus is in this house. People are being filled with the Holy Ghost down here; people are speaking in another tongue.

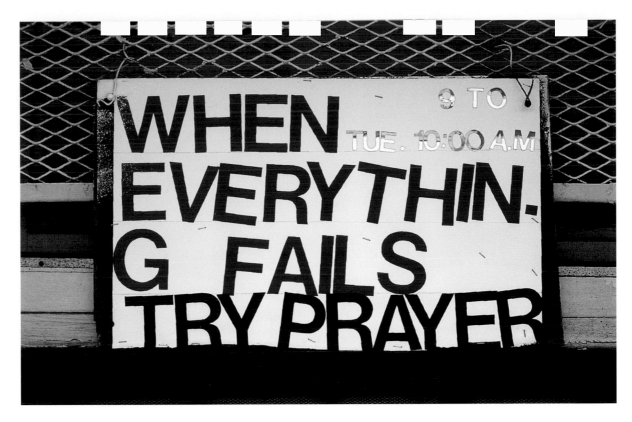

Sign at Way of
Holiness Church
of God in Christ,
South Indiana
Avenue, Chicago,
2003

*Shalalalamo! Oh, this is beautiful. It is a wonderful thing.
God brought you here so you are connected to a group of peo-
ple that believe in destiny, that believe in promises that were
made to us. God wants you to disconnect and reconnect with
people that are walking to Zion. You become part of the des-
tiny that God has made for ourselves. Do you realize that
this is new relations, new friendships, new families?*

Pastor Hezekiah Walker, Sr., The Love Fellowship Tabernacle,
Liberty Avenue, Brooklyn

Deliverance, Setting the Captives Free

Often an explanation of deliverance begins with the story
about the Jews being held in bondage in Egypt, and about
how God used Moses to set them free. After the story of
Moses, the accounts of deliverance are most often about
slavery, addiction, and sickness. People who know Christ
and have faith have been delivered; they can live, be fruit-
ful, and be at peace. Church members believe that they can
be delivered from sin, and also from suffering, loneliness,
illness, despair, and poverty. The word healing is often used
in conjunction with the word deliverance; while one
restores the physical body to health, the other frees the
spirit from the powers of Satan. Pastor Sarah Daniels
explains, "People sought Jesus because they wanted to be
healed; He came to set people free," and she adds, "It is all
about faith because without faith it is not going to work."

*Deliverance is a person who was drowning and, as he was
taking his last breath, he was sent a rope and saved.*

Pastor Russell W. Seymour, New Creation Ministry,
Sutter Avenue, Brooklyn

*Delivering from gambling, from lying, from blasphemy—
before God healed me, I did it all. I would frolic all night
long. Fifty years ago, I was sickly. Now I am seventy-four
years old—I can cut wood, I can saw wood, and I can build.*

Presiding Elder W. G. Belton, Pentecost Holiness Church
of Deliverance, Albany Avenue, Hartford, Connecticut

*Be delivered from: Generational Courses, Witchcraft,
Spirits of fear, Anxiety, Bitterness, Suicide, Barrenness,
Rejections, Poverty.*

Apostle Ernest Leonard, Provision of Promises Ministries,
Clinton Avenue, Newark

*Casting out demons, opening blind eyes, unstuffing deaf ears,
causing the mute to speak, and healing people from sickness
and diseases. It is a power of the most high God. It is an
anointing that comes from Christ Jesus. A person who is not
spiritually equipped may not be able to do it. People come
in—they may be drunk, on drugs—and when they leave, they
leave sober as a judge. Certain things happen in a deliverance
service, and only God can give you direction at the time. You
are not acting on your own; the Spirit gives you directions.*

Pastor Evelyn Gaines, Divine Temple of Love Tab,
Kaighns Avenue, Camden, New Jersey

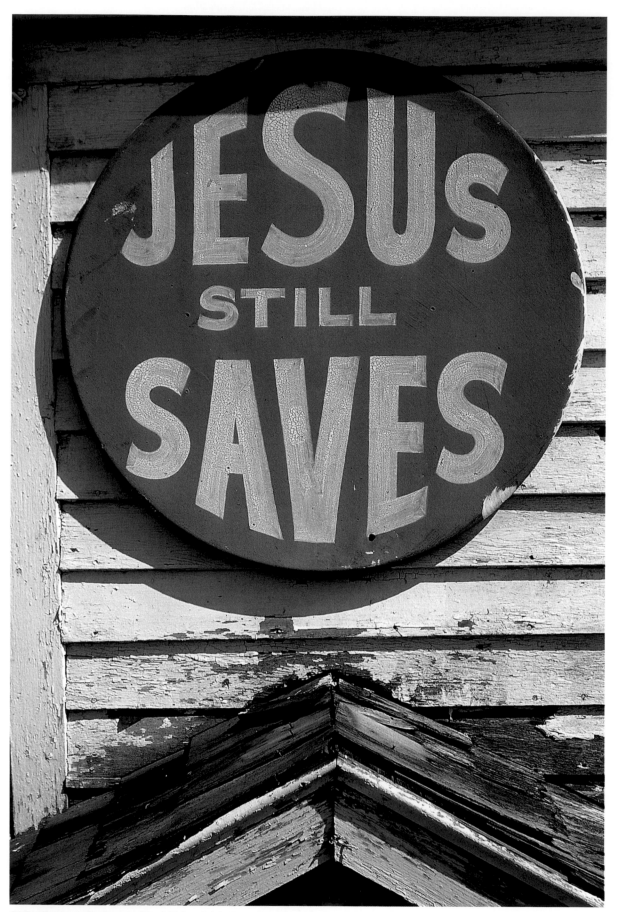

**Sign above entrance to East Friendship Baptist Church,
Van Dyke Avenue, Detroit, 2003.**
"I am letting people know, positively, He still saves,"
says Reverend Sanders, the church's pastor.

Mural on an outside wall of Iglesia Compañerismo de Palabra Viva, Van Nuys Boulevard, Los Angeles, 1996

Central Avenue Deliverance Tabernacle, Pitkin Avenue, Brooklyn, 2002

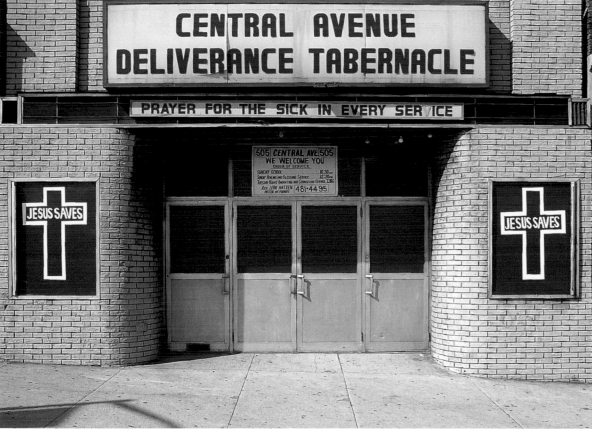

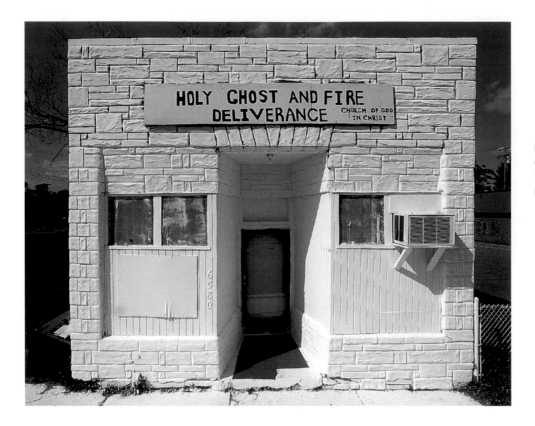

Holy Ghost and Fire Deliverance
Church of God in Christ,
West Warren Avenue,
Detroit, 2000

I got drug addicts, and I pray with them, and God delivers them. Through prayer and fast people have been delivered from whatever. The head of minister board liked to drink wine all the time, the head of my devotion had a three-hundred-dollar-a-day drug habit; they both have been delivered.

Pastor Leon Hatten, Central Avenue Deliverance Tabernacle,
Central Avenue, Newark

He sanctified my soul one day. Why should I be bound? He delivered me. He delivered me. The Lord delivered me. Why should I be bound? He healed my body; He delivered me. He waked us up this morning. We are still in the land of deliverance.

Brother Hanna, Fort Motte Baptist Church,
Willis Avenue, Bronx

I am looking for my deliverance. I am going to trust Jesus; I am going to believe Him. I am not a statistic. I don't want to be confined to what people say I am. I am going after the purpose for which I was born. I am walking by faith; I am living by the spirit. Jesus is a mighty God. Thank you, Jesus.

Pastor Marvin L. Winans, Perfecting Church,
Van Dyke Avenue, Detroit

Deliverance is a little used too much. Deliverance means freedom from whatever binds you or holds you that is not from God. If you are on drugs, you don't need deliverance but freedom; you need to be delivered from attitude. If you are in jail, you need to be delivered out of jail. You need to be

delivered from the demonic clutches of the devil, and from bondage to things that people can't get out.

Andre Faison, Bronx Christian Charismatic Prayer Fellowship,
Third Avenue, Bronx

Anointing

To be anointed is to have power from God to carry out His will. People, sensing this power, seek religious leaders who act on behalf of the divinity, and who can set them free from bondage. Some pastors boast that they have more anointing than others claiming to be among the "most anointed messengers today, having the power to burn the ropes of every bondage." Religious officials speak of aggressive anointing, penetrating anointing, and breakthrough anointing "to break up any demonic forces we encounter."

This word is used in two ways. A primary meaning refers back to a Hebrew custom of "anointing with oil," and it is associated with healing rituals among charismatic individuals and others who practice healing services. The oil is seen as a kind of balm that has healing properties, although the healing is actually a spiritual process, and the oil is an objectification of that process. The word is also used metaphorically to indicate that someone has been blessed or called by God to undertake some mission.

For a church to be anointed, people must feel the presence of God inside. A church can lose the anointing: "There was a cry given in the Old Testament when the presence of the Lord departed from the house of God," explained Pastor

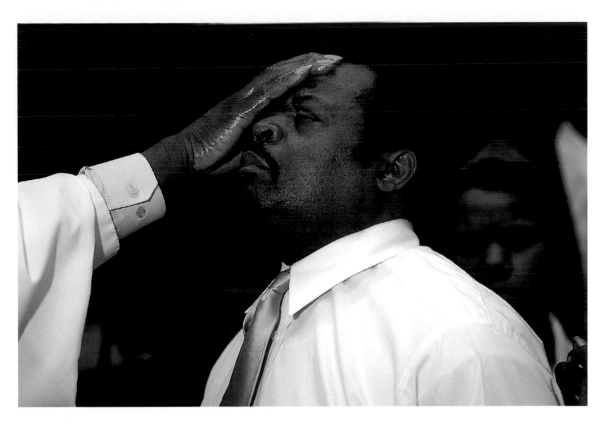

Bishop Wallace Furrs anointing a congregant, America Come Back to God Evangelistic Church, Rockaway Avenue, Brooklyn, 2004

Edward Young of Mount Zion Holiness Church of Christ in Camden, New Jersey. Speaking to Pastor Russell Seymour of New Creation Ministry in Brooklyn, I once compared the strength of the anointment to the octane rating of a gasoline brand, and he agreed with the analogy.

Anointed means to be empowered. God gives you a special gift or power symbolized by oil; He empowers you to do His will or, like Samson, to do some special exploit.

Andre Faison, assistant pastor, Bronx Christian Charismatic Prayer Fellowship, Third Avenue, Bronx

When we think of the anointment, we can think of David, where Samuel, God's Overseer, anointed David to be a leader, to be a king, according to God's instructions.

Dr. Edward Young, pastor, Mount Zion Holiness Church of Christ, Chestnut Street, Camden, New Jersey

You have to have someone anointed to touch you; if you are anointed, you can lay your hands on the sick. I love when God does miracles.

Apostle Christina Gooden, World Alive Ministries, South Michigan Avenue, Chicago

You have to fast, lie before the Lord and kill your flesh, no eat, no drink—that will give you the anointment back. You can't play with the devil; you have to have the power of God.

Pastor L. C. Wooden, Grace Church of God in Christ, South Michigan Avenue, Chicago

The Church, the House of God

A church's success is reflected in its size, the wealth of its congregation, and the fame, reputation, and political power of its pastor. I was surprised to hear church officials deny that the physical structure is of importance. At an outdoor service, Pastor Russell W. Seymour told his congregation, "The first church was not contained in a building." Pastor E. Holland of Richmond, California, said, "The church for us is the person itself; our temple is our body," and his views were echoed by many others. A church official responded to the modest appearance of his place of worship by saying, "Jesus didn't have a building." Another said, "What is important is that they come to seek their salvation, not the building. You can be on a field; you can be on a street." To show officials that they care about their buildings more than they are willing to admit, I described the changes they had made to their churches, which were evident in my time-lapse photographs.

Church finances are often precarious. To cut costs, many congregations share a structure with other sects. Yet, if rents continue to go up, they are often forced to move. Others get together in basements and in living rooms, or they rent a motel room for a couple of hours in order to hold services. Some pastors preach on the streets and in parks. Churches were ubiquitous in the Lower East Side of Manhattan in the 1970s, but are scarce in 2004, after decades of gentrification.

Most churches list types of behavior that are unacceptable during service, such as chewing gum, littering, walking

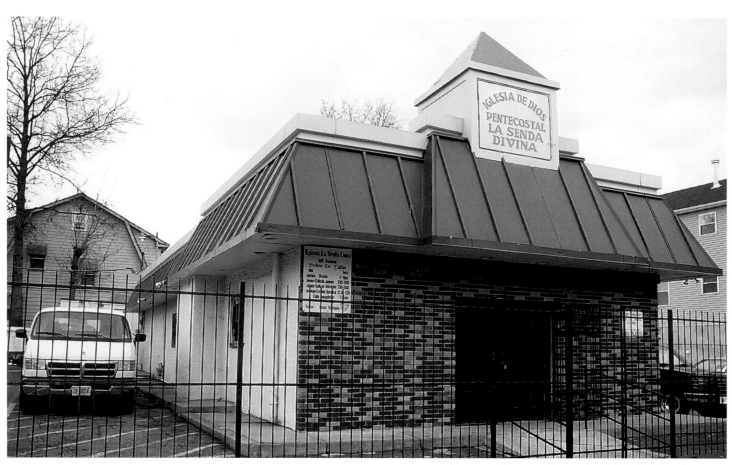

In 1991, a former Kentucky Fried Chicken became Iglesia de Dios Pentecostal La Senda Divina. Hector Rodríguez, the church's pastor, commented, "When it was selling fried chicken it went bankrupt; now that we praise God, it is more popular."

around the church during service, allowing children to run around the sanctuary, and leaving cell phones on. Pastor Monserrate Guzman explained to members of Iglesia Cristiana La Nueva Gethsemane in Spanish Harlem, "We come to this sanctuary to praise God. God does not like confusion. God wants respect; that makes Him happy. Disorder leads to cooling off fervor and loss of anointing. We want to do things orderly for God, so the spirit of God moves about easily."

Houses of worship are often in turmoil, divided by what officials call "disorder, confusion, and disobedience." Bishop Wallace Furrs, of America Come Back to God Evangelistic Church in Brooklyn, explains, "Satan is right there among the people of God. There are false prophets and false teachers, people that said they were from God, but were deceivers." Often two churches struggle for control under one roof. Pastor Eduardo Reyes, of Iglesia El Refugio in North Philadelphia attributes divisions to the lack of prayer and to the lack of the spirit of God. He counts himself fortunate. Even though he spent a month in bed after a heart attack, his flock prayed and waited for him until he was able to minister to them again.

Sacred Heart Parish: A people called to be a Christian community and to stand on the side of life with all the struggling people of Camden and the world. Gathering around the table

of the Lord on the Lord's Day, we celebrate that Christ is Risen and, ultimately, all is well.

Father Michel Doyle, Broadway, Camden, New Jersey

Mission Statement: To equip each believer to fight the good fight of faith while preparing each believer to be repaired in order for them to pair with an unbeliever for preparing. "Till we all have a little heaven on earth."

Pastor Donnie Featherstone, Faith Temple Church of God in Christ, Fourth Street, Richmond, California

Church Mission Statement: To equip our believers to share the gospel in order that every lost person in the neighborhood and community may be reached, and those responding led to baptism and meaningful church membership.

Rev. William Pinkney, pastor,
New Greater Straightaway Baptist Church,
North Seventh Street, Philadelphia

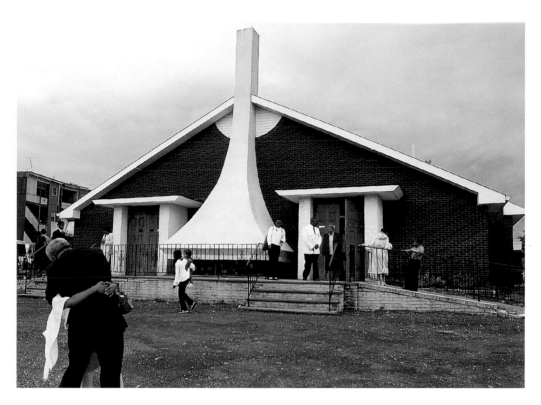

End of service, Phillips
Metropolitan Christian
Methodist Episcopal Church,
Morris Avenue, Newark, 2003

Mission Statement: Collaborating with the Lord through the Holy Spirit so that His Kingdom can be established on the earth as we work with each other and with the lost.

Bishop S. A. Garvey, Universal Church of God in Christ,
Fulton Street, Brooklyn

ZION MISSION STATEMENT: *The Zion Baptist Church is a congregation of believers, biblically based and centered on Jesus Christ as Savior and Lord. It is a spiritual fellowship which focuses on evangelism and Christian nurturing as priorities. The church sees itself as a family which provides learning experiences and resources for holistic growth to individuals and family units of the Church. The Zion Church reaches out with Christian concern to its immediate and broader communities to improve the quality of living as a witness to the love of God. Further, the Zion Church seeks to provide an advocacy and action ministry about issues, utilizing Christian principles which will give liberation to all people, especially the oppressed.*

Rev. Daly Barnes, Jr., D.Min., pastor, Zion Baptist Church,
North Broad Street, Philadelphia

WORD FROM THE PASTOR: *Emmanuel United Pentecostal Church is an independent, Fundamental Bible believing, Soul Winning, New Testament Local Church. I seek only to glorify God, be a credit to Jesus Christ, honor the Holy Spirit, edify believers, and win precious souls for our blessed Lord. The Bible is our sole authority in all matters of faith and practice.*

Bishop Sherman Diggs, Sr.,
Stevens Street, Camden, New Jersey

We are a Pentecostal Church that originated in Nigeria. We believe in the use of oil, candles, and water for prayer. We mix the African religion, we play drums, we clap, we dance, and we jump. Beating drums is spiritual by itself. Our service is not like the Catholic service that is solemn, very quiet, and with nothing exciting. We dance and sing, we beat the drums, and people go into trance, and they prophesize. Some in our congregation are endowed with the power of prophecy.

Special Apostle Francis E. Ohikuare,
Glorious Morning Star Cherubim and Seraphim Church,
Saratoga Avenue, Brooklyn

The church mission is ministering to people, caring for people. We are trying to put the emphasis on Jesus and on everybody being special. We are trying to get back to basic things of loving and caring for people.

First Lady Barbara Griffin,
The New Testament Baptist Church, Mack Avenue, Detroit

Don't ever feel that the church has no good news. Behold your God; He has come to save you; He has come to deliver you. He is God all by Himself. God thinks a whole lot about you. Remember that God is God, and He cares about our problems.

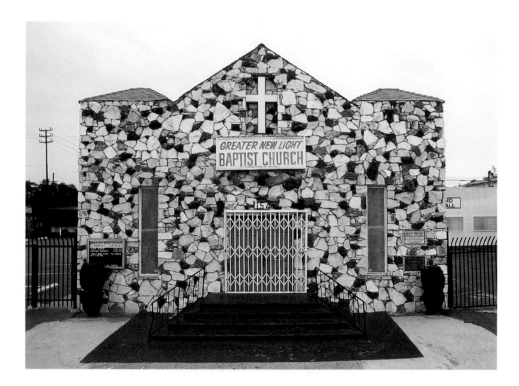

Greater New Light Baptist Church, a building designed as a church, East Ninety-second Street, Los Angeles, 2002

We are moving a little slow in the new building. I just have to trust the Lord, that He will provide and make a way.

District Elder John T. Grier, pastor and founder,
House of God Apostolic Church,
West Fifty-ninth Street, Los Angeles

A church is like a hospital: people who come in depressed should never leave depressed; they should leave with joy. We try to take out that suffering. That is why we sing with so much enthusiasm, because there is a Jesus that said, "Come unto me all ye that labor and are heavy laden, and I will give you rest." We give food; we visit hospitals.

Bishop B. J. Luckett, Plain Truth Mission,
South Avalon Boulevard, Los Angeles

Number 1, this church is Christ-centered and people-oriented. Number 2, you want people to become family. Number 3, you have to have a purpose, to win other people for Christ.

Pastor Edwin L. Williams,
Institutional Baptist Church, South Broadway, Los Angeles

God had given David the vision to build him a house. Inside the tabernacle was the ark, containing the presence of God. What we call church today should be a holy place, a clean place. God is not limited to the church; let's say He is like electricity. Electricity is everywhere, but its home is in the transformer. Like the church is the house for God, the transformer is the house for electricity.

Dr. Edward Young, pastor,
Mount Zion Holiness Church of Christ, Chestnut Street,
Camden, New Jersey

God is in your heart, but you have to have a building to fellowship with your brothers and sisters.

Pastor Robert McGee, New City Temple,
South Ashland Avenue, Chicago

When you build a new church, you have a special ceremony to dedicate the building to God. If I was cut off from the Christian Faith Missionary Baptist Church, I wouldn't know where to go. I wouldn't last very long.

Pastor C. L. Bonney, Christian Faith Missionary Baptist Church,
South Orange Avenue, Newark

Before the service, we speak to God; During the service, God speaks to us; After the service, we speak to each other.

Rev. Ben Yancey, Leadership Missionary Baptist Church,
North Martin Luther King Jr. Drive, Milwaukee

We will make a church out of anything. If you give me a house, a garage, if it is big enough, I can make a church. Give me an old McDonald's: we would gut it up, set it up, and go screaming and hooting and speaking in tongues. We would put our sign on the door and tell you what time services are. We take what we got and make what we can, 'cause we are survivors. Glory to God, hallelujah!

Pastor Victor Beauchamp, Bibleway Pentecostal Assembly
of the Apostolic Faith, West Warren Avenue, Detroit

The Lord is not looking for the great churches. Anywhere people are adoring Him, He is there.

Pastor Armando Moran, Iglesia Cristiana Pentecostes El Amor
De Cristo, South Crenshaw Boulevard, Los Angeles

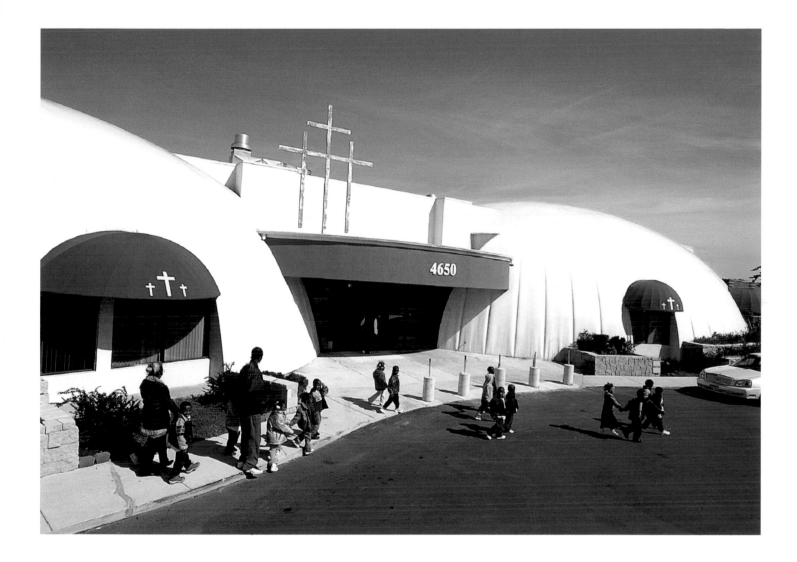

Home of Life Missionary Baptist Church in Chicago was inspired by "domes in Arizona, where local Indian tribes have their pow-wows, and by structures build by the military during Operation Desert Storm," explained the church's pastor, Johnny Henderson. Reverend Henderson is proud of his church and community development organization, each housed in its own tough bubble. He explains: "This building was designed to stand hurricanes and bombs. You can't shoot it, it [the bullet] won't penetrate it." The church "gives the people something to look forward to. It's building the neighborhood up." Even those who have never seen a anything like this will know it is a house of worship, "The three crosses and the sign tell people this is a church." Reverend Henderson called his church Home of Life because: "The church derives out of the home; without the home there is no church; it begins with the family coming together to worship God. The pastor out there is to connect them with God."

Tim Samuelson finds the style of the church and other facilities common sense: "All self-supporting universal spaces with a distinctive look that advertises their mission." "Because it does not have columns inside, they can adapt the space any way they want," he comments. "See, that is Chicago, someone with an idea and the guts to carry it through."

The church is the people; the building is the place where people come to worship. The sanctuary is important; we consider ourselves walking into a holy place.

> Geraldine Brown,
> wife of the former pastor of
> Good Shepherd Church of Christ, Disciples of Christ, Inc.,
> Springfield Avenue, Newark

The church is truly in the heart. We want the souls of men to reach heaven. If truth and love are not in the building, it doesn't matter what it looks like.

> Pastor Jones, Greater Peter's Rock Church,
> South State Street, Chicago

The church is supposed to be converting people to Christ. Any other purpose is wrong.

> Pastor Hughes, Greater Saint John,
> East Eighty-eighth Street, Los Angeles

Once people are comfortable with the church and with the leader, it takes something dramatic for them to leave.

> District Elder Winston D. Thomson,
> Ebenezer House of Prayer,
> Fiftieth Place, Chicago

ALL ARE WELCOME!
BIENVENIDO!
HWAN-YONG!
CHAO-MUNG!
A church where the word of God is taught,
and the people are friendly!

> Pastor Gerald Agee,
> Friendship Christian Church,
> Adeline Street, Oakland, California

There is a man that stands every morning on the corner of Vernon and South Central Avenues with a sign saying, "Are You Saved?" He has been doing it for five years. That does not make him a church. He is spreading God's word.

> Turner 3,
> First Goodwill Baptist Church,
> South Compton Avenue,
> Los Angeles

Paradise, Heaven, the New Jerusalem: Joy in the Presence of God

In *Utopia, A Survey of Ideal Societies in the Western World* (by Roland Schaer, Gregory Claeys, and Lyman Tower Sargent), heaven is described as a place "where abundance is offered and shared by everyone in an eternal springtime. . . . The splendid fields are constantly in flower and form a garden. . . . Rivers everywhere flow with milk. . . . The inhabitant will suffer from no misfortune, he will know no storm, he will be sheltered from heat, cold, affliction, hunger, thirst and privation." Pastor Fred Houston, of Compton, California, says, "It has to be like the Garden of Eden, like nothing on earth." It is "a place of serenity, paradise, with the river of life coming from under the throne of God," Pastor Edward E. Young, of Camden, New Jersey, tells us. Pastor Inez Ashford, of North Richmond, California, sings, "I got to make it to that city, if it cost my life."

Pastor Jerry Casey, of Clinton Avenue Baptist Church in Richmond, California, displays a sign outside of his church. It asks: "In your personal opinion: What does it take for a person to enter heaven?" The sign is from a study called Faith and is designed to engage the passerby. People's answers, according to Casey, are: "Because I have faith in Jesus Christ; because I am a good person; because I give money to the church; because I don't hurt anybody."

A golden city, fifteen hundred miles in each direction, is being prepared for us in heaven. The trees will be green like the ones in this world; the street will be covered with gold instead of asphalt. God will have His throne on the top of the tallest mountain, and the river of life will spring from the throne. If you want to know more, read Revelation, twenty-one and twenty-two.

> Brother Craig, New Jerusalem Seventh Day Adventist Church,
> New York Avenue, Brooklyn

When the old earth passes away, then we are going to have a new heaven and a new earth. God Himself is going to illuminate the new heaven; there will be no stars or sun or moon.

> Pastor Nelson, Star of Bethlehem Baptist Church,
> Park Avenue, Harlem

Don't you want to be in the presence of the Lord? The one that made all that stuff is the one that is going to take us to

Paradisical wallpaper mural behind the pulpit, Santidad a Jehovah, Southern Boulevard, Bronx, 2004

New Jerusalem. I saw the beautiful city: the light was so bright, it flashed in front of me, and I was so happy that I hollered for joy and started jumping. I saw beautiful mansions there, big castles, and the angels. Have you seen real crystal? The wings of the angels looked like real crystal. Their faces looked like babies; they were white, but they were not the color of a white person—they matched the crystal wings. The same thing that happened to those people in Pentecost happened to me. You see, the Lord took a little piece of black dirt like me. It came unexpected, and I surely want to see it again. The same thing that takes me to go to heaven, it is going to take the queen of England and the president of the United States.

> Pastor Inez Ashford, True Gospel Church of the Living God,
> Third Street, North Richmond, California

Most of all, I want to see Jesus. I have a lot of preacher friends that I want to see there [in heaven].

> Rev. Walter Washington, Jr.,
> Greater New Light Baptist Church,
> East Ninety-second Street, Los Angeles

The end of time is coming, and the beginning of eternity. What is life in heaven, where all that sin and sorrow have passed? What are they doing in heaven today? There is a life of holiness in that eternity. Everyone who has died in the Lord is fellowshipping with Jesus Christ. In heaven we shall see Him like He is.

> Bishop Wallace Furrs, pastor,
> America Come Back to God Evangelistic Church,
> Rockaway Boulevard, Brooklyn

Hell, Eternal Agony, and Torture: Despair Over the Absence of God

Although scenes of hell are prominent in Western art, its existence was doubted early on. Christians had a hard time believing that God could torture people for eternity. Hell became reinterpreted as separation from God. African Americans constantly speak and sing about heaven, while hell is rarely mentioned. For Latinos, suffering is what Jesus did. In their churches, depictions of the flames of hell engulfing the damned are common.

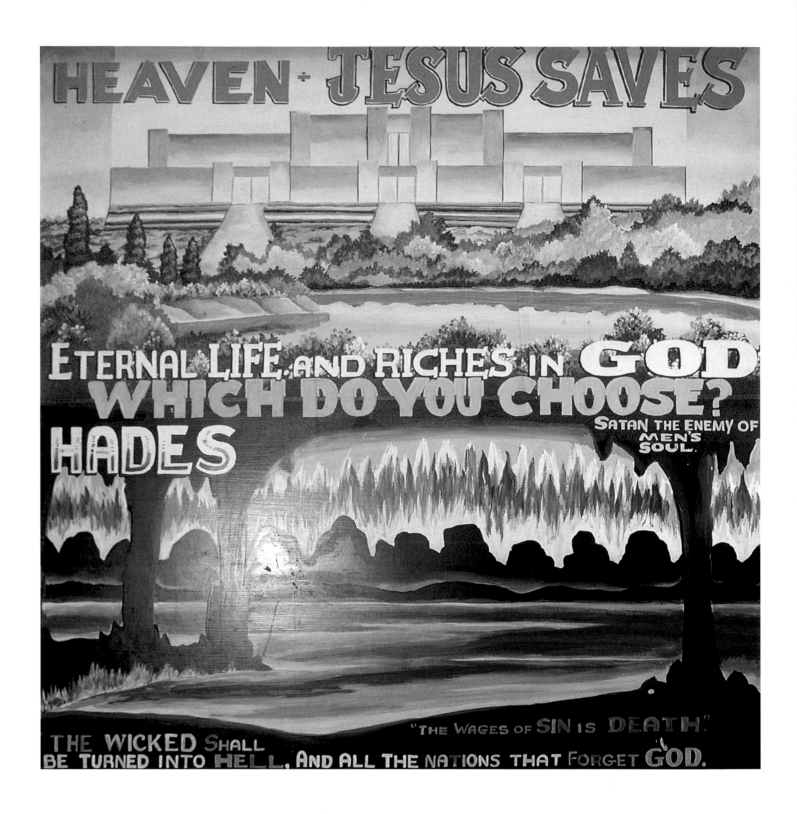

Heaven or Hades, painting by John B. Downey,
Emmanuel Baptist Rescue Mission,
Fifth Street, Los Angeles, 2004. In its stark
geometry, heaven resembles a cold
modernistic institution while hell is a
wilderness of irregular forms.

Hell has gone downhill. We don't talk about hell because most people don't really believe in hell. If you go to fifty churches on Sunday, you would be doing well if five of them would mention hell. Most preachers tell people what they want to hear—how they can have a wonderful life here on earth. We like to hear the good parts of the Bible, where it says how much God loves us and wants to bless us, not the bad stuff.

 Pastor Victor Beauchamp,
 Bibleway Pentecostal Assembly of the Apostolic Faith,
 West Warren Avenue, Detroit

We are so geared on attendance that the average minister tones down hell. Human nature doesn't want to talk about hell, especially those who haven't confessed their faith in Christ. They don't want to hear the bad; they want to hear the good.

 Deacon James Ramsey,
 Saint Peter's Pentecostal Deliverance Temple,
 Home Street, Bronx

The white experience was based on social control. Whites have been the hell-mongers forever. The Puritans were big on hell. Black history is not as fixated with hell. The black experience was based on acquiring heaven rather than avoiding hell.

 Michael D. Hall, sculptor, Detroit

Hell is right here on earth; you have more demons on earth than you have in hell.

 Melvin Jones, Progressive Missionary Baptist Church,
 Carolina Street, Gary, Indiana

Hell is not my favorite subject, but it is part of the Bible and the word of God. Since we are Bible believers, I believe that where there is an up, there is a down. Where there is a right, there is a wrong. If there is a heaven, there is a hell—a place of heat and fire, a place of agony.

 Edward E. Young, pastor,
 Mount Zion Holiness Church of Christ,
 Chestnut Street, Camden, New Jersey

God does not desire that anyone dies and goes to hell. God doesn't put anybody in hell; people put themselves there. If you don't make it, it is not because you haven't heard the gospel, but because you have rejected it. If there is anyone here that has never invited Jesus to be their Lord and Savior, come down here.

 Pastor John Alan Fisher, Doers of the World Christian Center,
 Webster Avenue, Bronx

Hell, that is in the Bible. I preach a lot about hell. If the world down there don't change [indicating the neighborhood around the church], they are going to hell.

 Rev. Jones, Miracle of Faith Missionary Baptist Church,
 South Central Avenue, Los Angeles

Hell, according to the word of God, is a place of unrest; you don't have any peace, you are in agony, you moan and groan there, your body is in pain. Hell is there forever and ever. I have had dreams and visions of people in hell. People were in pots packed with ash up to their necks so they couldn't move their arms, and there was fire all around the pots. Their tongues were hanging out and drooling. They were sweating. There were plenty of people in hell. Some I knew; some I didn't, but you couldn't communicate with them.

 Evangelist Mary Cox, First New Rising Sun M.B.C.,
 East Alondra Boulevard, Compton, California

If hell didn't exist, I wouldn't be here preaching. Hell is where the teeth of every man that does not accept our Lord Jesus Christ as Divine Savior gnash.

 Pastor Tomas Velez, Iglesia Pentecostal El Monte Horeb,
 169th Street, Bronx

Hell is real. If I can tell you anything, hell has no age. It is a place of torture, separated from God and full of rage.

 Rev. Robert Durr, God's House of Prayer,
 East Sixty-seventh Street, Chicago

Hell: The abode of the souls of the wicked dead. Luke 16:19–31

 Revelation of the World Chart, Rev. Gosey,
 Clear Vision Bible Studies, Norfolk, Virginia

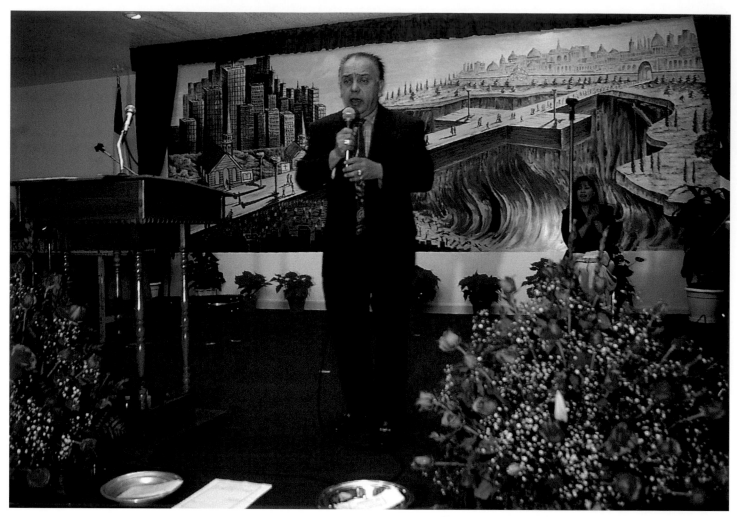

Painting, "On the road of life few arrive to Heavenly Jerusalem, many more fall into the flames of hell," Iglesia Evangelica de Jesucristo Betania, East Adams Boulevard, Los Angeles, 2002. Pastor Adalberto Reyes met a Korean artist in Las Vegas and commissioned the painting at the cost of five thousand dollars.

Faith Healing, Demonic Possession, and Speaking in Tongues

An intensely personal encounter between a person over-whelmed by problems and a healer, an instrument of God, takes place in front of the congregation. The will of the minister is focused on the person seeking help while laying hands on him or her in the name of the Lord, speaking to God and, at times, speaking in tongues. The talk is reassur-ing: What is the problem? God is here right now; He is working on you right now; God still can and will perform miracles. There is healing on the person's name. Cancer, lupus, arthritis, kidney disease, or demons are cursed to their roots, rebuked, and ordered to leave the body. After the healing, the congregant often looks startled, starts cry-ing, and sometimes has to be held so as not to fall.

Healers speak of God as Dr. God, who has never lost a patient, yet they admit that they cannot tell if the person will be healed because that is a decision made by God. For some pastors, healing takes time and faith; they don't know if the individual will be able to "water the healing," to "appropriate the healing," that is, to keep believing that they will be cured and to continue praising the Lord. For Reverend McCullers, of Mount Olive A.M.E. Zion Church, Jesus never fails. She told her Newark congregation that, even if the body does not heal, "God can heal the sick person's spirit," so that he or she can accept "what would come." Pastor Suzie Elliot, at Mount Paran Baptist Church in Brooklyn, asked the members of the congregation: "Did you say George has trouble with his eyes?" And then she said to George, "Come and let me touch your eyes." I saw George after his eyes had been touched, and he appeared to be as troubled as before.

In July of 2004, as I took notes on the corner of Third and Chestnut in Camden, New Jersey, in front of Mount Zion Holiness Church, loudspeakers carried the lamenta-tions of the congregation: "Help us, Lord. We need your help. We ask for your blessings, O God. We need a sign. We need a sign, O God. We need a sign that you hear our prayers. We need a sign, God, hallelujah! O, we need a sign

**Praying Hands,
Tehillin Church of God in Christ,
McNicholls Road, Detroit, 2001**

that you heard our prayer. Work a miracle. Work a miracle. Work a miracle in this building. We need a miracle. We need a miracle in the name of Jesus. Remember us in this corner. Remember us in this corner, O God. O, we need a blessing. We need a blessing. We need a blessing. We need a blessing from you." Edward E. Young, their pastor, was very ill, waiting for a kidney to be available for a transplant.

Most healers see the official medicine of doctors and hospitals as complementary because God works through natural hands. Pastor Joel H. Moorefield of Lansdowne Avenue, Camden, New Jersey, told me, "When I had heart trouble, I took my medicine. I didn't throw it away." Overseer Rosa Vick of Brooklyn explained, "You go to a doctor, the doctor says you have diabetes; we pray to God that he may deliver you from that condition. Many people have been healed, some from drug addiction, some from schizophrenia, some from hepatitis, some from a stroke." Apostle Christina Gooden, of World Alive Ministries, whose sign on the façade of her Chicago church reads, "We believe in Miracles, and they are happening," was unable to get a miracle for herself. When in need of a hip replacement, she "let the doctors do it."

Pastors claim to cure people, most of them women and children, from demonic possession. Women are often seen as more vulnerable to the devil, weaker, more open to witchcraft and spirits of fear than men. The Bible, they argue, says that Eve, in the Garden of Eden, wanted to see the serpent, to be as God. Others explain possession among women as a reflection of their openness; they are more likely to come up front, while men are more private. Then there are many more female church members than there are males.

Pastor Wallace Furs, of America Come Back to God Evangelistic Church in Brooklyn, tells of being called at night by a woman's family. She had been taken to a mental institution. "A devil attacked her," he told his congregation. "She was trying to strip in the church." The family said, "Oh, Pastor Furrs, would you cast the devils out of her?" Furrs asked the woman, "How many devils do you have?" and she told him, "Three." A church member explained, "The anointing that is on him cured her so completely, she didn't have to wait until the next day to be released out of the institution."

Demonic possession and mental illness are often seen as being the same thing. Pastor L. C. Wooden, of Grace Church of God in Christ in Chicago, explained, "Most people that

lose their minds, that is a trick of the devil, and that is done by worrying, overloading their minds. Once you blow the fuse on your mind, you can't go to the hardware store and get another one; you have to wait until the Lord delivers you."

I asked if the power to heal could be used to harm people, to give them diseases instead of curing them. "The devil has a counterfeit to everything God has," officials told me, but if an individual is trying to harm you, God will let you know. "If I don't feel the power of God, I stay away from it," explained Pastor M. Scriven, of Philadelphia. He added, "Healing only operates by love. You cannot operate after hate; God will not answer. God will only use His power for good; He will not harm you."

People are overwhelmed from every side; the load is too much for them. Faith healing is a vehicle to release tension; it is not always rational, but it works. The established churches have more sedate services. If the pastor of one of these churches would do faith healing, half of the congregation would walk away.

 Professor William Sales, Seton Hall University,
 South Orange, New Jersey

In the name of Jesus, we break the courses upon these people's lives back to ten generations, and cast them out. We speak destruction to diseases, sickness, and poverty in our lives and each life. They are bound with chains of iron and the blood of the Lamb. We loose upon these names, deliverance, adoption, health, healing, and prosperity. We call them forth in Jesus' name.

 Bishop W. James Bell, Jr., pastor, Bethel Church of Our Lord
 Jesus Christ, Third Avenue, East Harlem

I was in Saint Luke's Hospital. I was very ill; I had surgery. There was a nursing strike going on. I was perspiring. It was like blackness was moving all over the room. I was sinking in blackness. I heard a voice saying, "I told you to tell my people." I felt a hand on my stomach 'cause I had been cut from hip to hip. I was sinking in blackness; I was lying down and I was looking at my body. I began to wake up, and this lady in the next bed was screaming, "This lady is dying." My spirit had left my body. The nurses were shaking me, trying to wake me up. I heard them saying, "We almost lost her." The lady next to me said, "God is in the room." She asked

me to read the Bible with her, but I was too weak and could not read. I asked her to read Psalm 27. Then I called my husband and told him, "I am coming home." Five doctors came in to examine me. They said, "All your tests say you are alright." "I am going home," I said. I told the lady in the next bed, "You are going home, too." Then is when I opened my church. I have had it for thirty years.

 Overseer Rosa Vick, pastor,
 Pillar of Truth Apostolic Church
 of Christ, Prospect Place, Brooklyn

Faith healing does not come through man; it comes through God. He does not heal everybody; you may pray for somebody and he may get healed, and some don't. That has nothing to do with the man that is praying; it's a mystery. It is no good to lead everybody to lay hands on you because the devil has people laying hands; that is the way you can pick up evil spirits from somebody else. If I don't feel the power of God, I stay away from it. If you are a worldly person, you can't tell the difference between a man of God or a witch, until things start getting worse.

 Pastor M. Scriven,
 General Assembly Holiness Church of the First Born,
 Broad Street, Philadelphia

The doctor told me I had a big mass, and she drew the picture. She was an Indian doctor from Cooper Medical Center; she knew what she was talking about. I said, "Jesus, I need the healing of my body." I laid my hands on myself in the name of Jesus. That was in 1990. I am a living witness that Jesus Christ heals.

 Dr. Marguerite Davis, minister, biblical counselor, teacher,
 Will-Mar Gifts Christian Supplies, Market Street, Camden,
 New Jersey

Sister has a swollen hand. Hold it up. Put it down. Hold it up. Put it down. Shake it. Put it down. It will be alright.

 Bishop J. Davis, All Nations Healing Ministry, Inc.,
 South Vermont Avenue, Los Angeles

Total Healing Service Old Wounds! Hidden Wounds! Secret Wounds! Unknown Wounds! Healed! Deliverance from Backsliding. Deliverance from Known, Hidden, and Unspeakable Sex Habits. Complete Victories Breaking the

Mount Zion "Ekklessia" Holiness Church, Chestnut Street, Camden, New Jersey, 2004

Curse of Generational Sickness and Financial Poverty. Southside Christian Palace Church.

 Bishop W. R. Portee,
 South Vermont Avenue, Los Angeles

Sometimes you have a picture of praying hands because they are healing hands. They cure all kinds of diseases. It is not the hand that do the curing; the Lord needs something to work through.

 Bishop W. A. Davis,
 God Tell It on the Mountain Full Gospel Church, Inc.,
 South San Pedro Street, Los Angeles

A person possessed by Satan asks for water, twists the body as a snake, and screams. During healing they make fun, speak without making any sense, and laugh. One cannot anoint people possessed by devils with oil; to expel them one has to do it in the name of Jesus.

 Pastor Eduardo Reyes, Iglesia El Refugio,
 North Third Street, Philadelphia

Devil, loose your hold and get out of here in the name of Jesus.
 Pastor Booker T. Williams, Hicks Memorial C.O.G.I.C.,
 Mack Avenue, Detroit (as he made the motions of taking
 something that was ailing out of a young woman, whose head
 was downcast and who was sobbing)

Terrance Cottrell, Jr., an autistic eight-year-old, died on the floor of a hot, dingy storefront church in a forgotten strip mall. His shirt was drenched in sweat when the congregants *who were holding him down, saying they wanted to rid him of demons, finally noticed that he was dead. He had urinated on himself, and his small brown face had a bluish cast. Mr. Ray A. Hemphill, the pastor's brother who led the spiritual healing service for Terrance, has been charged with felony child abuse, which carries a minimum sentence of five years in prison and five years of court supervision. Mr. Hemphill was released from jail on Wednesday and will be free until his next court hearing, on September 8, on the condition that he conduct no further spiritual healing sessions or exorcisms.*

 Excerpted from "Faith Healing Gone Wrong Claims Boy's Life,"
 by Monica Davey, *New York Times*, August 29, 2003

On July 9, 2004, Mr. Hemphill was found guilty of abusing an eight-year-old autistic boy. Pastor Lillie L. Grant, Great Expectations Deliverance Center, Martin Luther King Drive, Milwaukee, commented, "When he [Ray Hemphill] left home that night, he didn't leave home to kill a boy. What the devil did was to take one stone and kill two birds. He took the boy out of this world, and the pastor is here; he made him bring an embarrassment to God. Satan pushed him over the edge because he loved this boy." Minister Russell Yancey of the Leadership Missionary Baptist Church in Milwaukee, explained that Ray Hemphill, the healer, had made a mistake by lying on the autistic boy and not keeping his distance: "Anytime the apostles wanted to heal somebody, they gave them a command. Jesus just called the demons out; we need to go according to the Scriptures. This was too much like *The Exorcist* or *Rosemary's Baby*."

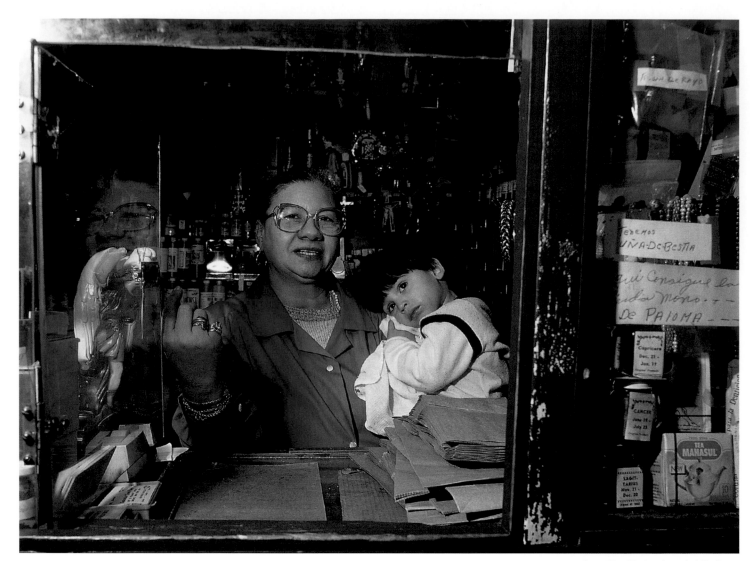

**Juanita, Botanica del Cobre,
East Tremont Avenue, Bronx, 1980.
Among the items Juanita sells are beast claws,
power from lightning, and shit from monkeys and doves.**

Witchcraft

The word witchcraft comes up often in sermons, yet the phenomenon is seldom described. It is just a term that the congregation can link to their fears and fantasies. It draws people closer to the church, where the pastor, the anointed man of God, can say the proper words while holding a person's head and rebuke demons, delivering the sufferer from the "spirit of witchcraft."

That is the devil; it doesn't come from God, and I don't want to speak about it. Spiritism and witchcraft belong to the devil. People who want to inflict pain to others, who want to have a woman they desire, they ask devils for help. Devils can perform miracles. Witchcraft is to do damage to others.
 Pastor Tomas Velez, Iglesia Pentecostal El Monte Horeb,
 169th Street, Bronx

Witchcraft is real, and people do use it. Church people use it, too. Amen. But God is not pleased.
 Pastor Emma L. Barr, Greater Concord M.B.C.,
 Bergen Street, Newark

Evil prayers, evil forces, evil spirits, unclean spirits, psychic powers—the Lord rebukes them today.
 Evangelist Richardson,
 Jesus Deliverance Mission Church,
 Avon Avenue, Newark

Haiti is synonymous with witchcraft. They are coming to mainline America. You hurt people because somebody controls you. You are in bondage to somebody else. They can take your wages.
 Elder Winston D. Thomson,
 Ebenezer House of Prayer, Apostolic Faith,
 West Fiftieth Street, Chicago

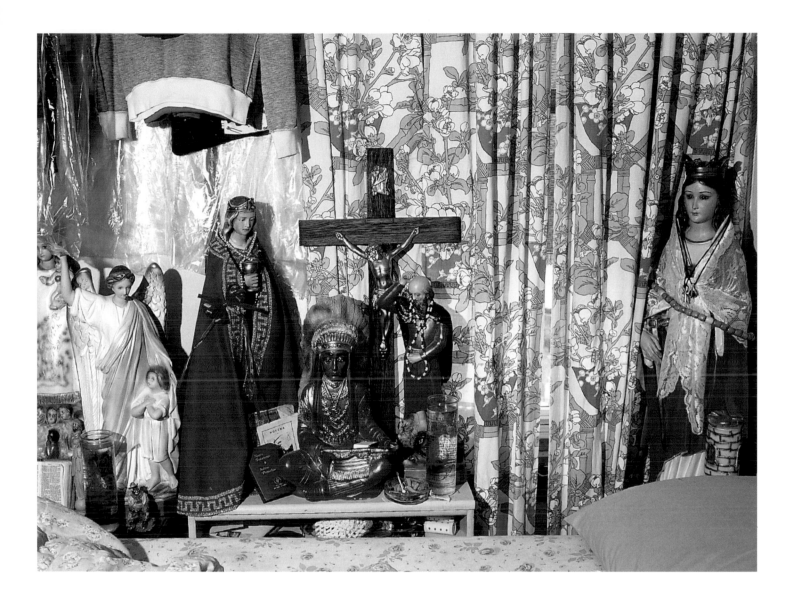

**Elizabeth Valentin's bedroom
with Santería objects,
Longwood Avenue, Bronx, 1991**

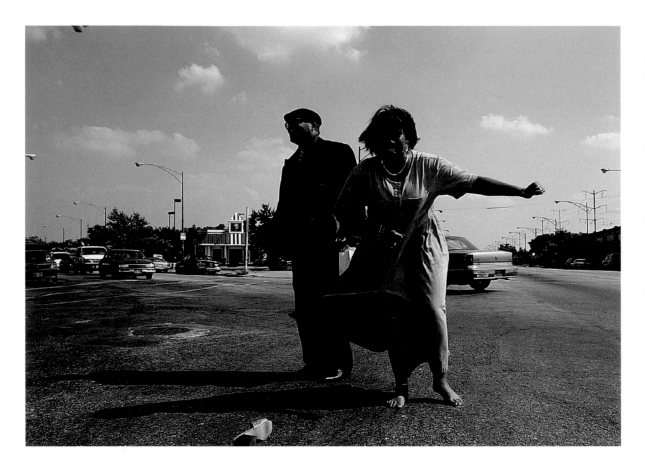

Tish, drunk on the spirit, on South Chicago Avenue, outside Calvary M.B. Church, Chicago, 1998. When I asked Latasha, a congregant, if running into a busy street in that condition was dangerous, she replied, "The Lord was watching, and my brother was watching over her."

Drunk on the Spirit

Holiness churches encourage members to tap into their deep self and to give full expression to their feelings. People undergoing an ecstatic experience lose control of their movements, make animal sounds, jump for long periods of time and, on occasion, even run out of the church barefoot and into the busy streets, praising the Lord. The faces of those drunk in the spirit are sometimes ecstatic and at other times distorted, as if reflecting intense pain. People seem to be on the verge of crying and at risk of losing their balance. More established branches of Christianity, afraid that such behavior may turn away members from their churches, reject public outpourings of intense emotion, while accepting mild and private expressions of religious zeal.

When the Spirit comes to you, it is the difference between feeling and no feeling. On Tuesday at eight o'clock, while I was in the Lincoln Tunnel, the Spirit moved into the bowels of my belly.

 Visiting Minister Leroy Stubbs,
 Greater Concord M.B.C.,
 Bergen Street, Newark

The Holy Spirit was what he was drunk off [explaining what Stubbs meant].

 James, deacon, Greater Concord M.B.C., Newark

He [a church member] is a prophet; he has God's spirit in him. He stands up on his walker, and he dances when the praises go and the anointing of the spirit goes on high. They will say, "Thank you, Jesus." Sometimes I, too, dance in the spirit when I feel the power of God. He saturates us. The sabbath is to refresh us and to give us some joy. It is important to have the spirit in us.

 Pastor Summers, 1st House of God of Robbins,
 Robbins, Illinois

I am a Spirit-led pastor. Everything I do is by the vision of God. God talks to me; He speaks to me as you are speaking to me. I can feel Him moving in my stomach. Before I found the Lord I was cursing and dancing; I was doing what everybody else was doing. Flesh will do anything. When God quicken to me [when I was born again], I did not see things anymore like I used to do.

 Presiding Elder W. G. Belton, Pentecost Holiness Church
 of Deliverance, Albany Avenue, Hartford, Connecticut

Man is a spirit; he has a soul, and he has a body. When a person is out of control like that, that is the person that is not God. That is coming from your soul-like area. God don't want people acting unseemingly [sic]. If God would make people act like that, people would turn away from the church.

 Deacon Walter Rice, Provision of Promise Ministry,
 Clinton Avenue, Newark

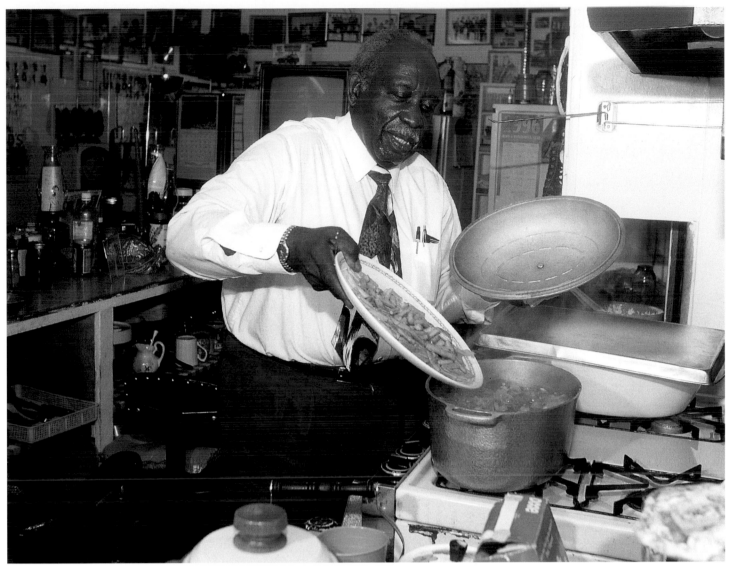

Eddie Ray Thomas, cooking lunch for the Latino men who run the rummage sale, the rental apartments, and the moving company he created so that they can make a living, Greater Mount Calvary Baptist Church, South Main Street, Los Angeles, 1996

Fellowshipping

Fellowshipping is coming together to worship, make plans, discuss things, and strengthen each other. It includes all activities that involve the gathering together of the congregation, which may include additional people who are not members. Congregations often share celebrations such as Pastor's Day with another church; this is most often done with a local church, but sometimes it involves traveling out of town. Congregations from Los Angeles have fellowshipped with churches in San Francisco and Las Vegas. These are bus or plane trips that include sightseeing and entertainment.

Congregations assign officials to make visitors feel welcome. Friendly members stand near the door to greet the people coming for services, and pastors shake people's hands as they leave. In the lobby and in the dinning areas outside the sanctuary, one frequently encounters bulletin boards filled with snapshots of members socializing. Houses of worship are referred to as "church home."

Fellowship is when we Christians come together to worship and praise God. You come together as a group, worshipping with another church. God doesn't object to Christians having fun; he is not that type of a guy.

Deacon James Ramsey,
Saint Peter's Pentecostal Deliverance Temple,
Home Street, Bronx

They fellowshipped with us. Their church would come to our church, and vice versa. They would take a plane or a bus.

Turner 3, First Goodwill Baptist Church,
South Compton Avenue, Los Angeles

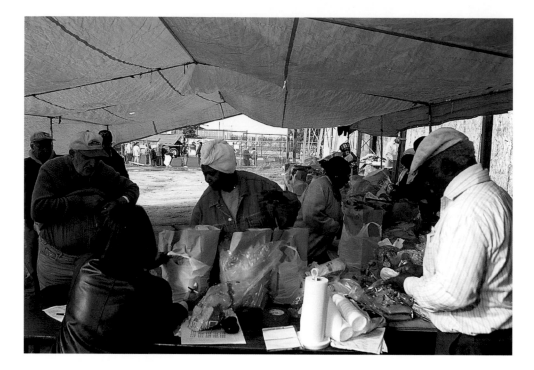

Food distribution, The House of God of the Apostolic Faith, South Western Avenue, Los Angeles, 2003. In this section of South Central, poor whites from Eastern Europe, Asians, and Latinos join African Americans in the food line, making this program a rare example of ethnic and racial diversity.

Members of Iglesia Misionera Pentecostal Rehoboth having lunch as a form of fellowshipping with one another, Southern Boulevard, Bronx, 2004

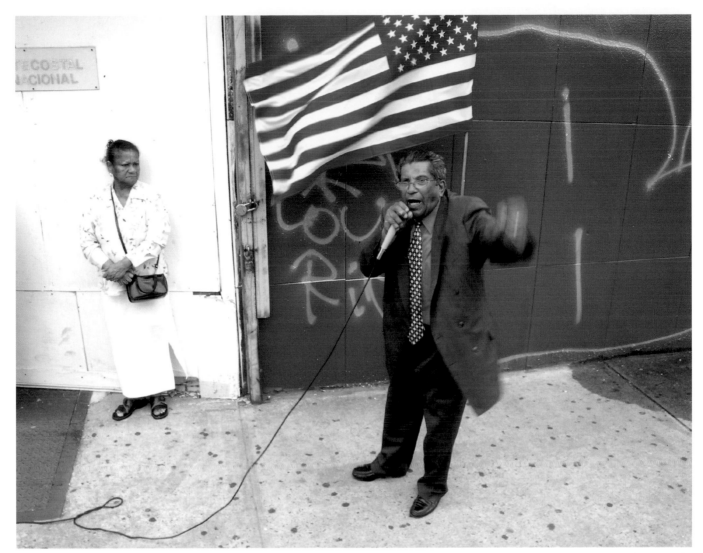

Puerto Rican evangelist Martin Capeles preaches to people
waiting at a bus stop and in cars stopping at a red light
on Southern Boulevard, Bronx, 2004

Evangelizing

The purpose of evangelizing is to spread the word of
God, to bring the gospel to those who can't come to
church—those in prisons, hospitals, and shut-ins.
Churches assign members to rescue souls, to preach on
street corners and in subway stations. Most of the
evangelists I saw were street-corner preachers representing
various churches. Those walking along the streets in
small groups, knocking on doors, were Jehovah's
Witnesses or Mormons.

*We are not just here waiting for people to come in. We have a
nursing-home ministry. We have a prison ministry. We are
on a mission: deliverance from sin.*

Mother Wilder, Full Life Assembly Gospel Church, Bronx

*I am concerned about people, the sick and the dying, the
bereaved, the brokenhearted, the ones that are shut in, and the
lost. I have been on street services all over Newark and Brooklyn.
I visit Rikers Island; Green Haven; Downstate; Westchester
County; Orange Correctional Facility up in Warwick, New York;*

*and Caldwell and Essex counties in New Jersey. I preach to drug
addicts on Forty-second Street in New York.*

Evangelist Richardson, Avon Avenue, Newark

*We are following what is written in the Bible, Matthew
28:19, to go to all nations and preach the word of God.*

Edward, Jehovah's Witness, South Main Street, Los Angeles

*Right before I came to the Lord, I used to go and see a girl in
Camden. I was walking the streets, and a guy pull a shotgun
on my head from an open window, but he did not shoot me.
The Lord said, "I want you to go up and preach." He told me
not to go alone. That was eighteen years ago. We ride around
the whole city until the Holy Ghost tells me to stop. We
preach at any corner. We give food, clothes, and furniture.*

Tom Williams, graphic designer, South Jersey

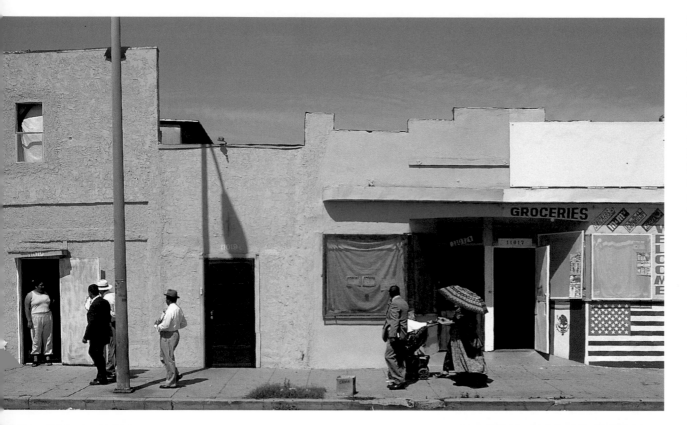

Men dressed in suits and ties, and a woman pushing her baby, slowly make their way along South Main Street, under the scorching and blinding sun of Los Angeles, on a mission to save souls, Jehovah's Witnesses, 2004

Morman Missionaries, Freeman Street Station, Bronx, 1994

Tent revival, America Come Back to God Crusade Services, Rockaway Avenue, Brooklyn, 2003

Revival

The word "revival" refers to rebirth. More specifically, it refers to a series of meetings conducted by an evangelist from outside the congregation, someone who comes to the church to reawaken people and to recruit new members. This evangelist is very different from the pastor, whose task it is to run the church. The evangelist does not have any investment in the church and is therefore free to admonish people more directly without putting his or her job in jeopardy.

Some congregations are in a constant state of revival. According to Pastor Leonard Rayam, of the Supernatural Deliverance Revival Tabernacle in Newark, "Souls don't just come in; sometimes you have to recruit them. You want the person to return to God; for that purpose you have to be in a revival attitude." Pastor Mary Joiner, of Healing and Recovering Church in Brooklyn, thought it useless for me to try to understand what a revival was unless I was an involved member of a church. She explained, "You need to be in it; when you are in it, it is like an electrical connection, a beautiful connection."

A revival, people think, is for the unsaved, but you need to be spiritually reinstated. Have you become a reproach to God? A revival is new obedience to God. You have to be careful how you live; you have to take inventory of your lives, cleanse yourself from all filthiness of the body and the spirit. You need somebody to tell people the truth. A lot of the young people who come to the church don't know what

holiness is. I don't care what everybody says, but I am going to get a revival.

Bishop Wallace Furrs, America Come Back to God Evangelistic Church, Rockaway Avenue, Brooklyn

They shall receive a New Heart and a New Spirit! We, the pastor, First Lady, and Members of God's House of Prayer wish to express our gratitude to each of you for participating in our Revival. For, truly, our faith has been refreshed.

Rev. Robert Durr, pastor, East Sixty-seventh Street, Chicago

Soul Saving 2 day Crusade, August 1 & 2, 2002, 7 p.m., Dr. Robert Lacy of Channel 26 & 27 of the Bay Area, Mississippi, Preaching right here in LA.

Sign on God's House M. B. Church, Pastor Isac Lacy, Jr., West Florence Avenue, Los Angeles

I like tent rallies because they attract attention. People who wouldn't stop their cars to go to a revival inside a church get out to see what is going on inside the tent. The prostitute, the alcoholic, the junkies on drugs, and the drug dealers would come in. If we can bring deliverance to one soul, that is great. Our evangelist, Pastor Adale Jefferies, raised his family at the Robert Taylor Homes in Chicago and then he retired to Lamar, Mississippi. He preached like Paul, and I wouldn't say that of many preachers.

Pastor Ireland Jones, Greater Peter's Rock Church, Chicago (speaking about the late Pastor Jefferies, who preached a revival at Greater Peter's Rock in 1999)

Tent service on
Rockaway
Avenue, America
Come Back to
God Evangelistic
Church,
Brooklyn, 2003

Tent service,
Ghetto Missionaries,
West Sixteenth
Street, Chicago,
2001

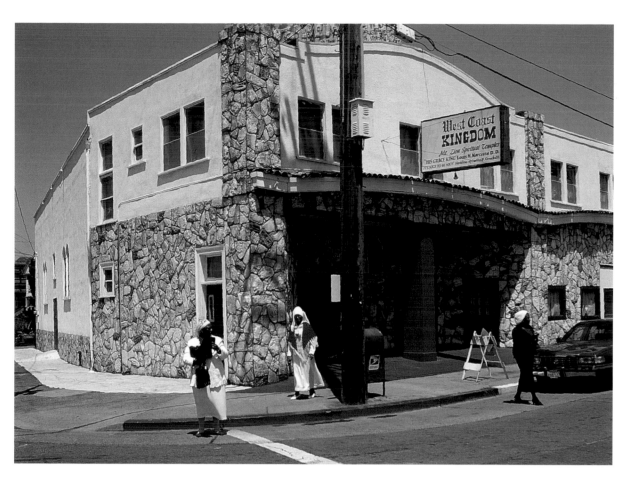

End of service,
Mount Zion
Spiritual Temple,
Fourteenth
Street, Oakland,
California, 2003

C.O.G.I.C., Church of God in Christ

The Church of God in Christ is the largest African American Pentecostal body. It is a well-established denomination that was first organized in 1967.

Our church is commonly known as being Holiness or Pentecostal in nature because of the importance ascribed to the Day of Pentecost, the fiftieth day after the Passover, or Easter.
 From "The Story of Our Church" (C.O.G.I.C. Web site)

I am incorporated with nine million people. They are all over the world. In Germany, they have twenty-four churches. They have churches in Jamaica; they have churches in Trinidad. It is one of the largest Pentecostal organizations in the world.
 Elder Robert Harris, Way of Holiness Church of God in Christ, Indiana Avenue, Chicago

Spiritual Churches:
Jesus Is the Light of the World

Two central, intertwined beliefs of Spiritual churches are the negation of death—spirit has no beginning and no end—and the ability of the living to communicate with the dead. The founders of these churches are remembered as charismatic figures and, typically, their flamboyant way of

dressing remains a vivid part of their reputations. Members address one another as king, queen, prince, or princess. These titles contribute to the special quality of belonging to the community. In addition, they bestow on the members identities truly distinct from those they bear every day as they perform essential, but low-status jobs such as day-care worker, school aide, and janitor. When asked, congregants proudly give the name of the official who conferred the title upon them and the date of that important event.

Spiritual churches use symbols to convey the sanctity of the place of worship. Religious objects are often scavenged from vacant churches and synagogues: Catholic statues, Jewish scrolls, Episcopal pews. Members of Spiritual churches are well along in age and their numbers diminishing, yet these congregations struggle to preserve their sanctuaries as they were in their heyday.

I enjoy my visits to Spiritual churches because in them I find solace from our stifling celebrity cult. I see these churches as a kind of authentic and decentralized outpost of the large, overly cautious "nation's attic," the Smithsonian Institution.

Spiritualist churches look like Christian churches; they have their Christian façades. African American spiritualists have merged with the Christian churches and justified practices

In order to see what distinguishes one house of worship from another, I have collected examples of how congregations present themselves. These include inscriptions on façades and sanctuaries, printed bulletins, calling cards, hymns that are sung, and greetings that are recorded on answering machines. I photographed many signs because of their striking graphics. To the visitor, the passerby, and the caller such manifestations of the church's public face tell in abbreviated form what the members find compelling: what they stand for, what they offer, and their beliefs, programs, and services. I include these texts as a resource for those interested in a more comprehensive interpretation of religious expressions among the ghetto poor, and as fragments with which to construct an alternative vision of the American spirit.

Texts and the Categories to Which They Belong

I found that most public messages conveyed by churches fall into the following categories: help/refuge, salvation, faith, permanence, family and fellowship, praising the Lord, and fear of hell. I have also included a category of additional miscellaneous messages. There are three main sources of texts. The first and largest of these consists of writings on the façades and walls of church buildings and in Sunday bulletins, followed by hymns that are sung during services, and, finally, I have selected messages from answering machines.

Examining more than four hundred texts and messages from houses of worship across the country, I discovered that salvation and help/refuge each account for about a quarter of all public messages. Another 20 percent make faith and family their most important themes. In decreasing order of frequency are references to permanence, praising the Lord, and fear of hell.

HELP/REFUGE

The church's purpose is to help people to live in Christ. The doors of the church are open to all. Walk in and find solace. God is there; you can feel Him. He listens; His

Stained-glass window designed by Kea Tawana, intended for the chapel on board Kea's Ark, a boat Tawana built in the Central Ward, Bergen Street, Newark, 1986

mercy is everlasting. He is a very real presence in times of trouble. Nothing is impossible for the Lord who made heaven and earth. God will take care of you. He will give you all the things that you pray for. He can heal the broken-hearted, and He can give peace, solitude, and rest. The Lord wants to help, to give strength to His people. In addition to religious services, churches frequently run food programs and have pastor's aid, an emergency fund often used to help families pay utility bills or rent.

SALVATION

Before we are saved, we are lost. We must seek the Lord, call His name, repent from our sins, and be baptized. We must be born again so that we can have life and have it more abundantly. We can all be saved in Christ. When a person turns to the Lord, he or she will be freely pardoned, will receive the gift of the Holy Ghost, and will have eternal life. The saved know that they are saved.

FAITH

People should follow their spiritual eyes, take God's word seriously, and read the Bible. The truth will make us free and will give eternal life. People who have faith can walk on water because we walk by faith and not by sight.

FAMILY AND FELLOWSHIP

Churches are places where congregants can come together to make plans, celebrate birthdays and graduations, find Christian mates, discuss job possibilities, and organize outings to beaches, resorts, casinos, and fishing spots. Most houses of worship own vans, and sometimes even buses, to take the congregation or the choir to visit with another church or to go on outings. This social aspect of church life is called "fellowshipping." Expressions of the family spirit are common: "All are welcome to the church with a big heart." "We are one in the spirit; we are one in the Lord." "They shall know we are Christians by our love."

PERMANENCE

In crumbling inner cities, churches are often the only functioning institution that remains. All around are vacant buildings and empty lots. The word "rock" is often part of the church's name, as in Double Rock Baptist Church, conveying a sense of timelessness. The Iglesia Evangelica

Pentecostes in Los Angeles, a simple building, has a façade inscribed with the message: "Built upon the foundation of the apostles and prophets, Christ Jesus is the cornerstone." A popular citation is from Matthew 16:18: "And I tell you, you are Peter, and on this rock I will build my church, and the powers of death shall not prevail against it."

PRAISING THE LORD

Bless His Name; God is a Good God. We are God's creatures. We are nobody, but in you, O God, we are somebody. We are placed on earth to praise God from whom all blessings flow. Nothing says it better than Psalm 100: "Make a joyful shout to the Lord, all the lands."

FEAR OF HELL

Where are you going to spend eternity? God's judgment is imminent. Repent; the cost of sin is death. Save yourselves by faith in Jesus Christ and by doing His will.

Texts Copied from Church Buildings and Sunday Bulletins

HELP/REFUGE

For I was hungered and ye gave me meat: I was thirsty, and ye gave me drink: I was a stranger, and ye took me in: Naked, and ye clothed me: I was in prison, and ye came into me. Mathew 25:35–36
> Chad T. Hinson, pastor and founder, New Strength
> Gospel Church, Roosevelt Plaza, Camden, New Jersey

God Loves You and Wants to Help You.
> Gethsemane Baptist Church, Morris Avenue, Newark

ALL ARE WELCOME TO THE CHURCH WITH A BIG HEART.
> First Zion Hope Missionary Baptist Church,
> Bergen Street, Newark

Personal Confession. I am under a Devine Decree of Increase. God has spoken Increase to me. I am destined to Increase, my anointing is Increasing, my wisdom is Increasing, my health is improving—EVERY DAY is a day of Increase for me and my family.
> Bishop Edward Peecher, New Heritage Cathedral,
> South Princeton Avenue, Chicago

From Vision to Reality:
> *A Beacon of Light in the Englewood Community.*
The Lord will perfect that which concerneth me: Thy mercy, O Lord, endureth forever; forsake not the works of thy own hands. Psalm 138:8
> Rev. C. C. Hatter, pastor, Saint John Evangelist
> M. B. Church, Sixty-third Street, Chicago

Helping Others to live in Christ, one day at the time.
> Maranatha Bible Fellowship, corner of Bloomingdale
> and Dennison, Baltimore

And let us not be weary in well doing; for in due season we shall reap, if we faint not. Galatians 6:9
> Elder Gregory A. Woods, pastor, Revival Temple Center
> of Deliverance, Sixteenth Avenue, Newark

I WAS GLAD WHEN THEY SAID UNTO ME, LET US GO INTO THE HOUSE OF THE LORD Psalm 122:1
> Ebenezer House of Prayer, South Side, Chicago

I asked Jesus, "How much do you love me?" "This much," He answered. Then He stretched out His hands and died.
[Text accompanying an illustration of a draped cross.]
> Bishop J. Davis, All Nations Healing Ministry,
> South Vermont Avenue, Los Angeles

In my distress I called upon the Lord and called out to my God, From His temple He heard my voice, and my cry to Him reached His ears. Psalm 18:16
> Elder Vessalene Williams, pastor,
> Prayer Warriors Deliverance Church,
> Frederick Douglass Boulevard, Harlem

Hear my voice, O God, in my prayer: preserve my life from fear of the enemy. PSA 64:1
> Jesus Only Apostolic Faith Church,
> Fourteenth Street, Newark

I will lift up my eyes unto the hills from whence cometh my help. My help comes from the Lord which made heaven and earth. Psalms
> New Silver Star Missionary Baptist Church,
> Gratiot Avenue, Detroit

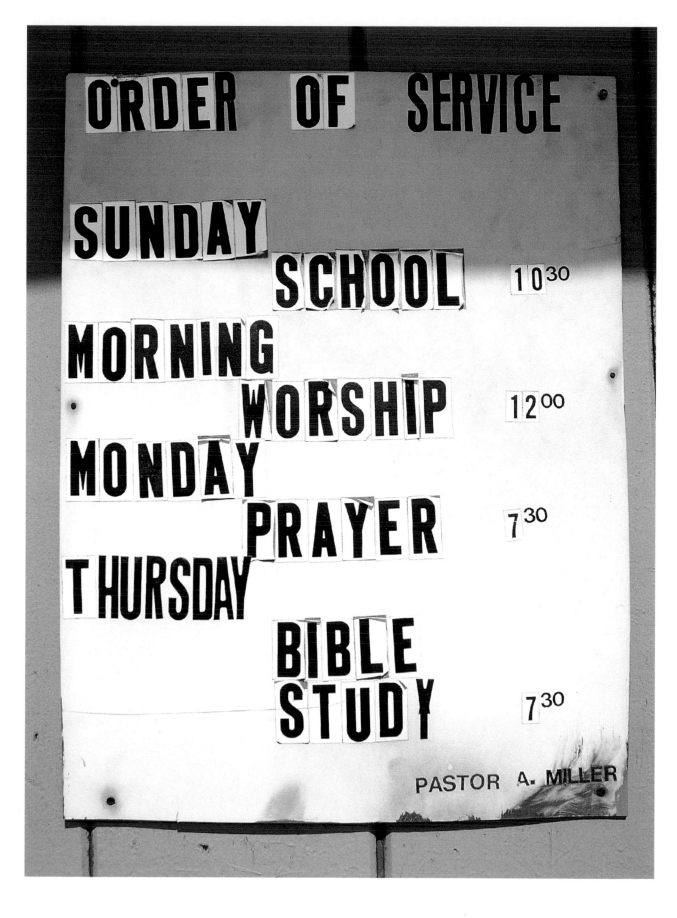

Sign left behind,
South Pedro Street, Los Angeles, 2002

I will seek what was lost and bring back what was driven away, build up the broken and strengthen what was sick.
Ezekiel 34:16
> God's Amazing Grace Fellowship Outreach Ministry,
> 1224 North Avenue, Baltimore

Come all ye that labor and are heavy laden, and I will give thee rest. Matt 11:28
> 1744 Gorsuch, Baltimore

Venid a mi todos los que estan trabajados y cargados que yo os hare descansar. Matt 11:28
> Iglesia de Cristo Jesus,
> West Vernon Avenue, Los Angeles

God will give strength to his people. Call upon him while he is near.
> Former Congregation Ahavath Zion, Holland Street, Newark

And all things whatsoever ye shall ask in prayer, believing, ye shall receive. Matt 21:22
> Pastor Johnson, Holy Defender C.O.G.I.C.,
> South Normandie Avenue, Los Angeles

THE CHURCH WHERE GOD MOVES FOR YOU.
> God's House of Deliverance Church Apostolic,
> South Figueroa Street, Los Angeles

THE JABEZ PRAYER
*Oh that you would bless me indeed, and enlarge my territory,
That your hand would be with me.
That you would keep me from evil, that I may not cause pain!
So God granted his request.* 1 Chron. 4:10
> Elder Nathaniel Burney, Holy Temple Baptist Church,
> South Eighteenth Street, Newark

No matter what may be the test, God will take care of you.
> Rev. Lucius Hall, pastor, First Church of Love & Faith,
> West Seventy-ninth Street, Chicago

God is our refuge and strength, an ever present help in trouble.
Psalm 46:1
> McKinley Green, pastor, Pentecostal House of Prayer of
> Deliverance, Weirfield Street, Brooklyn

FOOTPRINTS IN THE SAND
One night a man dreamed that he was walking along a beach and talking with the Lord. He said, "Lord, you promised that if I chose to follow You, You would always walk by my side and never leave me. Yet when I look back over the most difficult times in my life, I see only one set of footprints in the sand."

The Lord smiled and answered, "My precious child, I love you, and I am always with you. During your times of suffering, when you see only one set of footprints, it was then that I carried you." Anonymous
> Rev. Peter John, pastor, Gospel Mission Baptist Church
> of Newark, Ridgewood Avenue, Newark

Children brought up in Sunday School will seldom be brought up in court.
> Rev. Lonnie Dawson, founder and pastor,
> New Mount Calvary Baptist Church,
> El Segundo Boulevard, Los Angeles County

*Reaching the Lost at any cost.
In the name of Jesus, we have the victory.*
> Earthel Fleming, Jr., pastor, Christ Outreach Ministries,
> East Forty-third Street, Chicago

He sent His word and healed them and delivered them from their destructions. Psalm 107:20
> Pastor Wade, Mount Moriah Missionary Baptist Church,
> South Figueroa Street, Los Angeles

*Therefore I take pleasure in infirmities, in reproaches, in necessities, in persecutions, in distress for Christ's sake for when I am weak then I am STRONG. Corinthians 12:10.
I am a rope holder!*
> Pastor Randolph Ferdinand, Helping Hands Ministry
> (Recording Studio, GED Classes, Food, Clothing, Music
> Ministry, Barber/Beauty Shop), Junius Street, Brooklyn

ARE YOU EXPERIENCING OR SUFFERING FROM:
Unhappiness, Emotional turmoil, Being misunderstood, Hopelessness, Marital problems, Discouragement, Disobedient children, Personal difficulties, Employment/unemployment, Weak in spirit, Nervousness, Loneliness, Sadness, Not level,

THE ⬆ WAY
CHURCH OF CHRIST
PASTOR ELDER CATHERINE JACKSON
FOUNDER: JESUS CHRIST
CHIEF ADMINISTRATOR: HOLY GHOST

**Sign, The Up Way Church of Christ,
Pitkin Avenue, Brooklyn, 2003**

*Drugs/alcohol, Anger, Other problems. Visit the Divine
Spiritual University.*
 Church of Humanity & Divine Love,
 West Florence Avenue,
 Los Angeles

*If you are sick! If you are jobless! If you need healing! Come
and be prayed for by an anointed woman of God. Bring the
lame! Bring the ones in Wheelchairs! Bring a friend! Come
and be blessed! God does answer prayers.*
 Pastor Prophetess A. James,
 Holy Spirit Church of God in Jesus Holy Cross, Inc.,
 Rockaway Avenue, Brooklyn

*God has the answer to all our problems. God loves you very
much. He wants to help with your problems—whatever they
are, He can help. Come and let us help you to seek the Lord.
Love one another
Do to others as you would have them do to you.
We teach the Bible every service!
Spirit Controlled Scripturally correct.*
 True Faith Fellowship Born Again Baptist Church, Bronx

*A Message of Concern
My name is Mack and that is a fact
Clean up your act
And stay away from Crack.*
 Rev. Peter John, pastor, Gospel Mission Baptist Church
 of Newark, Ridgewood Avenue, Newark

*Helping Those in Need of a New Direction. Counseling,
Food, Clothing, Packages, Detox, Referrals.*
 Pastor Russell W. Seymour, New Creation Ministry,
 Sutter Avenue, Brooklyn

*Are you on crack, drugs, or a prostitute, homosexual,
lesbian, an alcoholic, a murderer! Are you tormented by
demons, do you want peace of mind, tired of sin, going to
jail, need a friend! Jesus can and will help.*
 Pastor Knight, Pentecostal Outreach Church of God in Christ,
 West Warren Avenue, Detroit

**Sign with lines from Psalm 91, The Living Vine
Apostolic Faith Church, Larchwood Avenue,
Philadelphia, 2002**

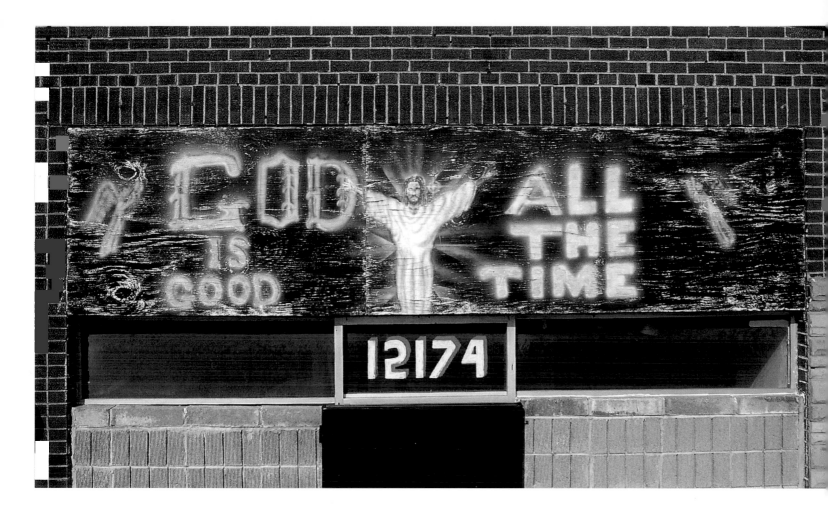

Sign, Dexter Avenue, Detroit, 2001

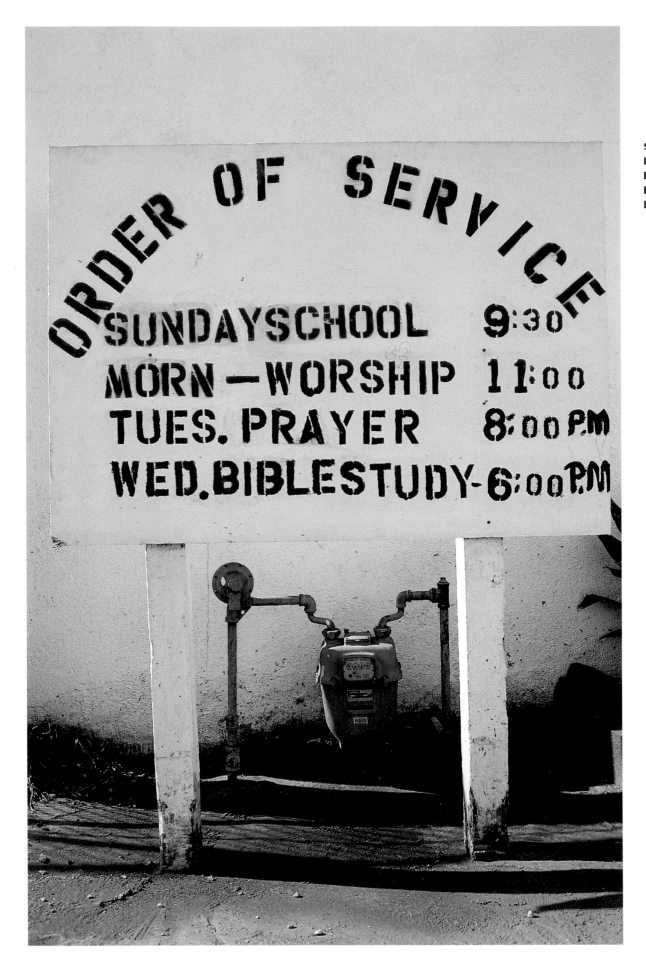

Sign, Jesus is the Light Missionary Baptist Church, East 109th Street, Los Angeles, 2003

Telling the world the answer to their problems is Jesus, that is a great thing, that is something the Bible tells us to do, that is part of evangelism and discipleship, that is a neighborhood that has all those things that he listed. A person who is at the end of his rope won't run away from the unadulterated truth.

> Pastor Victor Beauchamp (commenting on Pastor Knight's sign), Bibleway, Pentecostal Assembly of the Apostolic Faith, West Warren Avenue, Detroit

Total Recovery Is Possible.
Are you hooked on drugs?
Or know somebody who is?
First call on Jesus/ then call 1–866–730–6134.

> Royal L. Webster, Sr., pastor, Total Restoration Ministries, South Vermont Avenue, Los Angeles

FRIDAY OF MIRACLES
Now God worked unusual miracles by the hands of Paul, so that even handkerchiefs or aprons were brought from his body to the sick, and the diseases left them and the evil spirits went out of them. Acts 19:11, Friday at 7 p.m.

> Stop Suffering Universal Church of the Kingdom of God, Southern Boulevard, Bronx

Supernatural Healing & Victory Services Every Friday Night, 8 P.M. with Evang. Donald Womack, Bring the SICK, the SUFFERING, the DYING FOR A BLESSING FROM GOD.

> Faith Temple of Victory, Springfield Avenue, Newark

Do you feel there is NO HOPE?
Is Your MARRIAGE falling APART?
Have you been SEARCHING for something to fill that DEEP EMPTINESS in your heart, without finding anything that can SATISFY you?
Do you feel rejected by SOCIETY?
Have LONELINES, DEPRESSION and SICKNESS taken over your life?
Do you feel the NEED to be LOVED?
GOD LOVES YOU!

> Templo Jehovah Shammah, Southern Boulevard, Bronx

Come and Join the brethren in a 2 night Soul Stirring Revival, Oct. 9th and 10th, 8 p.m. nightly: House of Faith Church of Holiness Church of God in Christ, 401 Saratoga Avenue, Brooklyn, New York. Come and hear the Anointed Preaching of Elder C. Watts of Zion Tabernacle Holiness Church. Bring the Sick. Bring those who need Strength. Come and be Set Free. Come and get your Soul Recharged.

> House of Faith Church of Holiness Church of God in Christ, Brooklyn

OUR PASTOR
Who is it calls when we are ill
With cheerful words and right good will
And lingers gently then to pray
And soothe our care and fear away?
> Our Pastor!

Who is it comes when sorrow falls,
When death of friends our heart appalls,
And tells us of mansions fair,
And that sweet home, 'just over there'?
> Our Pastor!

Who is it shares our happiest hours,
When life is crowned with wedding flowers,
And to the scene lends added grace
By reverent voice and kindly face?
> Our Pastor!

Who is it on the Lord's Day
Points to Heaven and leads the way,
And brings a message from the Word,
Until our hearts within are stirred?
> Our Pastor!

For whom then shall we daily pray
And ask for him God's grace always,
And wish for him a glad new year,
With new-born souls his heart to cheer?
> Our Pastor!
> (Poem read on Sunday, October 26, 2003, on the occasion of Pastor's Day.)
> Elder Terrence L. Moore, founder and pastor, House of Prayer for All People, Church of God in Christ, Thirteenth Street, Philadelphia

SALVATION

SEEK THE LORD WHILE HE MAY BE FOUND CALL HIM WHILE HE IS NEAR LET THE WICKED FORSAKE HIS WAY AND THE EVIL MAN HIS THOUGHTS LET HIM TURN TO THE LORD, AND HE WILL HAVE MERCY ON HIM AND TO OUR GOD FOR HE WILL FREELY PARDON. Isaiah 55: 6–7

 Shiloh Apostolic Deliverance Church, Roosevelt Road, Chicago

But these are written that you may believe that Jesus is the Christ, the son of God, and that believing you may have life in his name. John 20:31

Jesus died for your sins. Repent of your sins. Accept what he did for you.

Live forever in eternal life.

I am the Vine, you are the branches, he that abideth in Me, and I in him the same bringeth forth much fruit, for without Me, you can do nothing.

 Pastors Sam and Tilly Giresi, the General Assembly Church/ House of Mercy Mission, Springfield Avenue, Newark

The head of this house is Christ, where we can all be saved. No loafers allowed in the hall.

 Elder I. Rapley, founder and pastor, Mount Zion Holiness Church, Inc., Glenmore Avenue, Brooklyn

Jesus Saves

The blood of Jesus can set you free.

This house is covered by the blood of Jesus.

No weapon turned against you shall prosper.

No cross, No crown.

 Pastor R. E. Sutton, The Church of Our Lord Jesus Christ, Prophetic Ministry, Dauphin Street, Philadelphia

WINNING SOULS, BEING A WITNESS

Questions to ask.

Are you saved; Are you a Christian? What is your relationship with God; Have you been born again; Are you a new creation in Christ; Have you accepted Christ as your Savior; Do you know your sins are forgiven and you are on your way to heaven; Do you believe in life after death; If you die, where will you go; Do you love Jesus; When is your next birthday and are you aware that you need a second birth to go to heaven?

 Rev. Cecil L. Lowe, pastor, Good News Evangelical Church, West 118th Street, Harlem

If ye keep my commandments, ye shall abide in my love. John 15:10

 Saint Luke M.B. Church, West Lake Street, Chicago

Jesus Wept . . . Jesus Saves

And behold. I Come Quickly and My Reward is With Me, to give every Man, according as His Work Shall be. Behold I Come Quickly: Blessed Is He that Keepeth the Sayings of the Prophecy of this Book. Revelations 22:7

 Pastor Susie M. Elliott, Mount Paran Baptist Church, Blake Avenue, Brownsville, Brooklyn

SEEK YE FIRST THE KINGDOM OF GOD AND ITS RIGHTEOUSNESS.

 Shining Star M.B. Church, Ogden Avenue, Chicago

Behold, I stand at the door, and knock: If any man hear my voice, and open the door, I will come in. Rev. 3:20

 Bishop T. D. Brown, New Freedom Full Gospel Church, Liberty Street, Camden, New Jersey

Our Motto: No man can sink so low that God can't lift him up. No man can be so lost that God can't find him.

 Though your sins be as scarlet, they shall be white as snow. IS. 1:18

 Rain or Shine Missionary Baptist Church, East Forty-third Street, Chicago

JESUS SAVES

Neither is there salvation in any other: for there is none other name under heaven given among men whereby we must be saved. Acts 4:12

 Pastor Hugh Simmons, New Testament Church, Orange Avenue, Newark

If my people, which are called by my name, shall humble themselves and pray, and seek my face, and turn from their wicked ways; then will I hear from heaven, and will forgive their sin, and will heal their land. II Chronicles 7:14

 Elder Michael Jackson, pastor, Antioch Church of Our Lord Jesus Christ, Inc., Bedford Avenue, Brooklyn

Sign, Stop Suffering Universal Church of the Kingdom of God, located in the former Art Theater, Southern Boulevard, Bronx, 2003

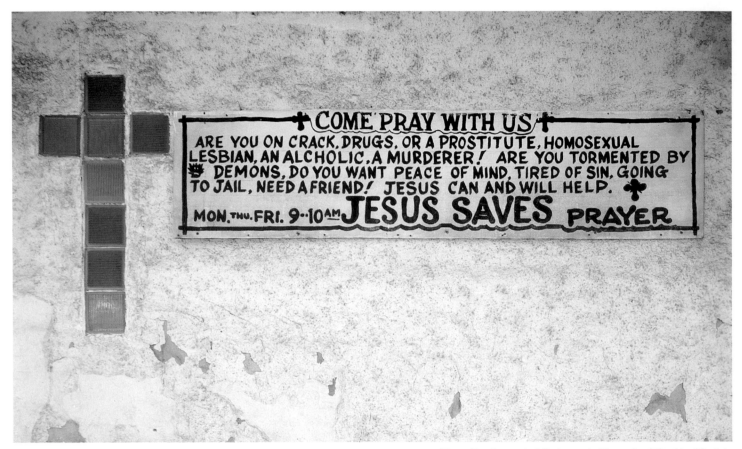

Sign, Pentecostal Outreach Church of God in Christ,
West Warren Avenue, Detroit, 2002

*This poor man cried unto the Lord, and the Lord heard him
and saved him out of all his troubles.* Psalm 34:6

> Pastor Connie Boatman, Deliverance Prayer Center,
> South Ashland Avenue, Chicago

*The field of battle is set, and the fight is on. Christians have
no need to take concern about wheres, hows, whats, whens,
whos, because God has given us every weapon, plan, map,
vehicle, and necessity imaginable to wage effective warfare
against the kingdom of darkness. We need only to remember
that 1) the battle is the Lord's, 2) the battle is not against
flesh and blood, 3) obey every instruction and command-
ment from God.*

> Doctor and Sister James Taylor, Saint Rest Congregation #2,
> South Vincennes Avenue, Chicago

There is still hope for you. Christ . . . is the answer.

> David Banco, founder and pastor, Divine Deliverance Center,
> North Philadelphia

*For whosoever shall call upon the name of the Lord
shall be saved. Romans 10:13*

> The Inner City Crossover Ministry,
> Cass Avenue, Detroit

We're pressing on the upward way.

> Chuck Rogers, pastor, Higher Ground Ministries,
> South Avalon Boulevard, Los Angeles

YOU MUST FIGHT TO LIVE RIGHT.

> Apostle Pam Hill, SPIRIT VISION,
> Livernois Avenue, Detroit

*REPENT, AND BE BAPTIZED IN JESUS NAME FOR THE
REMISSION OF SINS, AND YE SHALL RECEIVE THE GIFT OF*

THE HOLY GHOST ACTS 2:38, MARK 15, 16, 20, MATTHEW 26:19,
LUKE 21:47–49
> Calvary Healing and Deliverance Evangelistic Miracle
> Temple, Berryman Street, Brooklyn

CRISTO SANA Y SALVA. [CHRIST HEALS AND SAVES.]
> Sign at Iglesia Pentecostal los dos Olivos,
> Communipaw Avenue, Jersey City, New Jersey

Then Peter said unto them Repent and be baptized every one
of you in the name of Jesus Christ for the remission of sins
and ye shall receive the gifts of the Holy Ghost. Acts 2:38
> Elder Allan Fleet, Nazarene Temple, Hartford Road, Baltimore

When the Lord blesses you, it's then time for you to be
a blessing.
> Mount Bethel Baptist Church, South Pulaski Road, Chicago

I Was Glad When They Said Unto Me, Let Us Go
Into The House Of The Lord.
> Bishop McDonald Moses, D.D., pastor, Chester Street,
> Brownsville, Brooklyn

Our mission is to win the lost to Christ.
> Wiley Taylor, pastor, Thank God for Jesus Church,
> North Bond Street, Baltimore

GOD WANTS YOU!
> Rev. Al Rock, Gethsemane Baptist Church,
> Fulton Street, Brooklyn

Yo soy la puerta
El que por mi.
entrare.
Sera.
Salvo.
Juan 10:9

I am the door
the one that enters through me
will be
saved.
> La Iglesia de Dios Pentecostes Rios de Agua Viva,
> Thirty-second Street, San Diego

COME HEAR THE TRUTH THE LORD IS ABLE TO HEAL YOU
& SAVE YOU.
Everyone welcome! IF NO HINDERING.
> Apostle B. Darden, pastor,
> The Church of God the House of Prayer,
> Mount Elliot Avenue, Detroit

Babylon the great is fallen, is fallen, come out of her my peo-
ple that ye not be partaken of her sin, for her sin has reached
into heaven. God's judgement is coming. Acts 2:40
> *Save yourselves by faith in Jesus Christ and doing his will,*
for in one hour is she made desolate. Rev. 18:19
> Pastor Walter Jackson,
> The New Jerusalem Baptist Church, Peralta Street,
> Oakland, California

Marvel not that I said unto thee, ye must be born again.
St John 3:7
God is a Good God.
Yes he is!
> New Born Mission Church of God in Christ,
> Springfield Avenue, Newark

FAITH
Jesus is Coming.
> *Regardless of the rise in inflation, the wages of sin is the*
same.
> *Remember now thy creator in the days of thy youth while*
the evil days come not; nor the years draw nigh, when thou
shall say, I have no pleasure in them. Eccles 12:1
> *He healeth the broken in heart and bindeth up their*
wounds. Psalm 147:3

THE CHRISTIAN SURVIVAL KIT
A rubber band *to remind you to be flexible*
A teabag *to remind you to relax*
A toothpick *to remind you to pick out*
 the good qualities in others
A pencil *to remind you to list your blessings every day*
Most important your Bible *your basic instructions*
 before leaving earth.
The Church's Motto: "For we walk by faith and not by sight."
> Pastor Suzie Elliott, Mount Paran Baptist Church,
> Broadway, Brooklyn

Will you get out of the boat to walk on the water.
Matthew 14:22–23
> Joe Parker, pastor, Wayside Baptist Church,
> Broadway, Brooklyn

Bible Fed, Spirit Led.
> Jimmie Williams, pastor,
> Praise Temple Baptist Church, Boston Road, Bronx

Escrito esta: No solo de pan vive el hombre, sino de toda palabra que sale de la boca de Dios. [It is written, man shall not live by bread alone, but by every word that comes from the mouth of God.] Matt. 4:4
> Iglesia Pentecostal, Gates Avenue, Bushwick, Brooklyn

Weeping endures for a night, Joy cometh in the Morning. Have faith in the Lord Jesus Christ will shine in your life.
> Bishop Ronald Austin, pastor,
> Saint Paul Holiness Church,
> Broadway, Brooklyn

If you only believe.
> Pastor James Hartford, United Goodwill Temple Community
> Church, Broadway, Brooklyn

And Elisha prayed, and said LORD, I pray thee, open his eyes, that he may see. And the LORD opened the eyes of the young man; and he saw: and behold, the mountain was full of horses and chariots of fire round about.
> Wynford A. Williams, pastor,
> All Nations C.O.G.I.C.,
> York Street, North Richmond, California

We are a church built on Jesus Christ with a strong hold of faith controlled by the Holy Spirit.
> Robert Thomson, pastor, New Hope Church,
> Filbert Avenue, North Richmond, California

For the Vision is yet for an appointed time, but at the end it shall speak and not lie: Though it tarry, wait for it Because it will surely come, it will not tarry! Heb 2:3
> Dr. Gregory and Robin Dillard, pastors,
> Church of Christ for All Nations,
> East Eighth Place, Ford Heights, Illinois

Where there is no vision the people will perish. Prov. 29:18
> *Spirit-filled worship, Divine relationships, Abundant stewardship, Anointed discipleship.*
> Dr. Elliot Cuff, pastor, Mount Ararat Missionary Baptist Church,
> Howard Avenue, Brooklyn

ONE LORD, ONE FAITH, ONE BAPTISM.
> Greater Progressive Baptist Church, Broadway, Los Angeles

EF. 4:5
UN SENOR [ONE LORD]
UNA FE [ONE FAITH]
UN BAUTISMO [ONE BAPTISM]
> Iglesia Pentecostal Unida Int., Park Avenue, Bronx

If God Said It, That Settles It!!
> Anointed Gospel Christian Center,
> Martin Luther King Jr. Drive, Jersey City, New Jersey

GOD'S-WORD-IS-MADE PLAIN EVERY SATURDAY 4:30, COME AS YOU ARE.
> Apostle Point Nondenominational Church,
> North Pulaski Road, Chicago

Thy word is a lamp unto my feet and a light into my path.
> Bishop (prophet) Jerome R. Crawford, The New Morrisania Full
> Gospel F.B.C., Washington Avenue, Bronx

The word of God is taking us where we have not being before.
> Harold Frasier, pastor, Greater Mount Carmel Pentecostal
> Church, Schenectady Avenue, Brooklyn

REPENT, FOR THE KINGDOM OF GOD IS AT HAND.
If thou shall confess with thou mouth the Lord Jesus and shall believe in thy heart that God hath raised him from the dead, thou shall be saved. Romans.
> Deliverance Tabernacle Outreach Ministries,
> Avon Avenue, Newark

And it shall come to pass afterwards, that I will pour my spirit on all flesh; and all of your sons and daughters shall prophesy, your old men shall dream dreams, your young men shall see visions.
> Special Apostle Francis E. Ohikuare, Glorious Morning Star
> Cherubim and Seraphim Church, Saratoga Avenue, Brooklyn

Derelict sign with
marooned letters,
Erskine Street,
Detroit, 2000

Sign for
"Prophetic Ministry,"
Pastor R.E. Sutton,
Missionary L. D. Sutton,
Dauphin Street,
Philadelphia, 2003

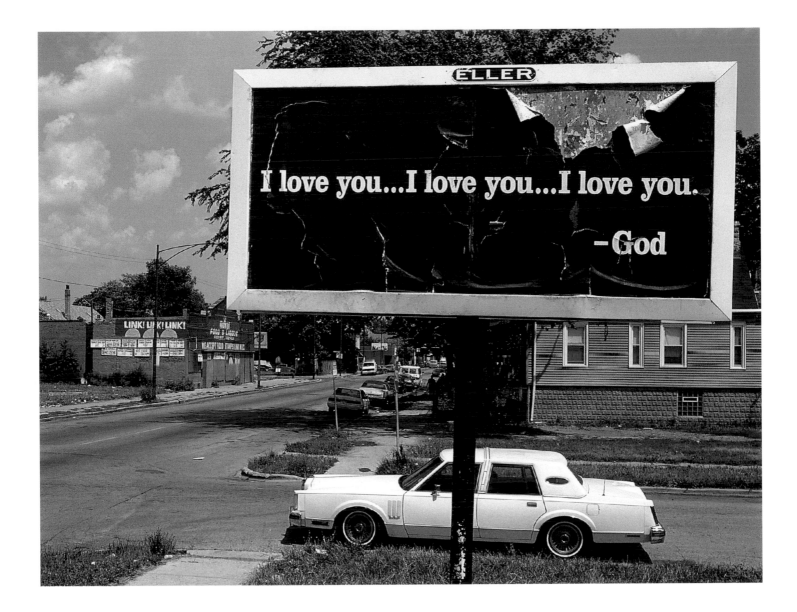

**Billboard, designed in 1998 by Andy Smith and Charlie Robb
of a Fort Lauderdale advertising agency for an anonymous
client, seen here on West Sixteenth Street, Chicago, 1999**

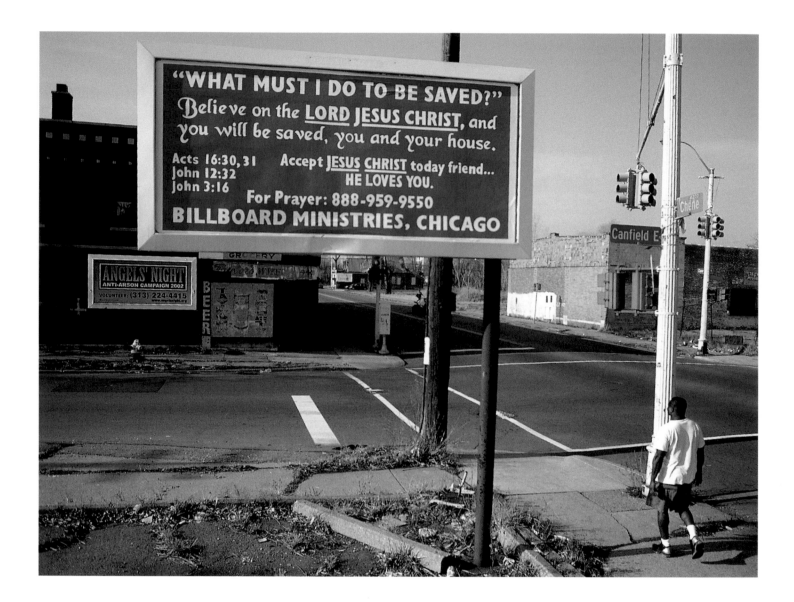

Sign, Chene Avenue, Detroit, 2003

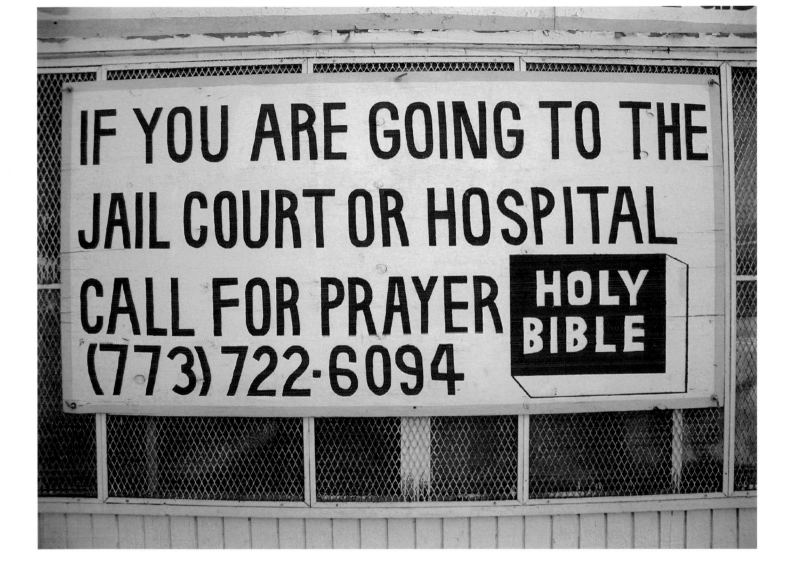

Pastors Bill and Annie Gibson's
Launch Out into the Deep Christian Center,
West Lake Street, Chicago, 2004

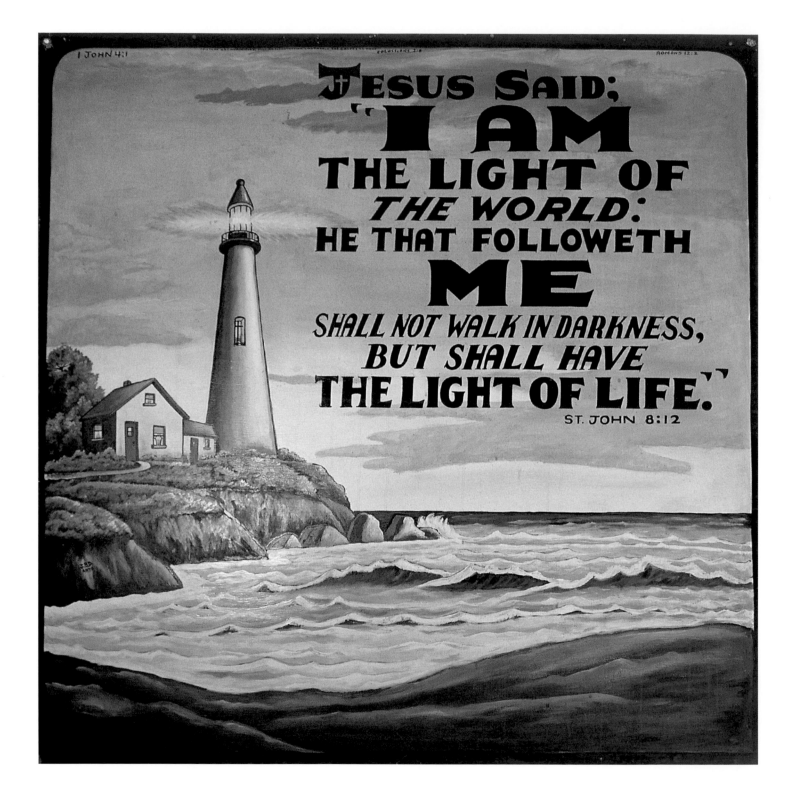

Painting by John B. Downey,
Emmanuel Baptist Rescue Mission,
Fifth Street, Los Angeles, 2004

*WHERE CHRIST IS OUR TEACHER AND THE WORD OF GOD
IS TAKEN SERIOUSLY.*
 Greater True Friendship Baptist Church,
 West Vernon Avenue, Los Angeles

*God is a spirit and they that worship Him must worship
Him in spirit and in truth.* John 4:24
 Pastor Claude Boone,
 True God's Tabernacle of Faith,
 South Hoover Avenue, Los Angeles

*Through faith we understand that the worlds were framed by
the word of God. So that things which are seen are not made
of things which do appear.* Hebrews 11:3
 Good Shepherd Church of Christ, Disciples of Christ, Inc.,
 Springfield Avenue, Newark

If you don't stand for something, you'll fall for anything.
 Rev. Charles Anderson, pastor, Providence Baptist Church,
 Madison Avenue, Harlem

FAMILY AND FELLOWSHIP

We are all one family under the same sky.
 Pastor Robert Moore, Rising Star Missionary Baptist Church #2,
 Eleventh Avenue, Gary, Indiana

*When you walked through our doors, you walked through
our hearts.*
 Pastor M. Barron, Higher Ground Temple C.O.G.I.C., Inc.,
 Pine Street, Camden, New Jersey

*WE WELCOME ALL TO OUR FRIENDSHIP AND LOVE
FELLOWSHIP DAY EVERY SUNDAY. Come feast at Jesus
Table and dine with us in love! Come as you are.*
 New Church of Christ Holiness unto the Lord,
 Ralph Avenue, Brownsville, Brooklyn

*God gave them tender hearts, to hold the hurts of others. He
gave them gentle hands to reach out with compassion and love.
Then with His own hand of blessing, He wrapped them up in
His mantle of love…and called them family and friends.*
 Rev. Frank Pelzer, pastor,
 New Ebenezer Baptist Church,
 Fifth Avenue, Harlem

*But if we walk in the light, as He is the light, we have
fellowship one with another and the blood of Jesus Christ
His Son cleanseth us from all sin.* John 1:7
 Rev. Leonard Rayam, Supernatural Deliverance Revival
 Tabernacle, First Street, Newark

*We are one in the spirit, we are one in the Lord, and we pray
that all unity may one day be restored, and they shall know
we are Christians by our love.*
 Pastor Amos F. Kemper III,
 Saint Samuel Cathedral C.O.G.I.C.,
 East 125th Street, Harlem

*Why am I here?
Somebody needs me
If I can help someone
As I pass along,
Then my living will not be in vain.*
 Pastor Benjamin Wright, Proverbs Church of God in Christ,
 Sutter Avenue, Brooklyn

Pray for all of our men and women who are incarcerated.
 Sunday Bulletin, Pastor G.T.M. Jones,
 Sr., Greater Zion Shiloh Baptist Church,
 Fulton Street, Brooklyn

*Tabernacle of Deliverance
2896 Eight Ave., (Cor 153rd St.)
Rev. Joseph T. Bright, Pastor
1ST ANNUAL FISHING OUTING
PORGIE TIME SEABASS TIME
DEEP SEA FISHING
Sailing from Onset Massachusetts
ABOARD THE ONSET CHIEF
Friday August 9, 2002
Round trip $85*
 Sign on Tabernacle of Deliverance,
 Eighth Avenue, Harlem

*Let's Go Deep Sea Fishing in Hyannis, Mass.,
for Porgie, June 21, 2003.*
 Pastor Dr. C. H. Evans,
 Smith Memorial Church of God in Christ,
 Clinton Avenue, Newark

Cruise 2004—August 21–28, 2004: *Sailing from New York to Florida & The Bahamas! All balances are due! Please see sisters Jaqui Lawrence & Carolyn Wade.*

 Mount Carmel Baptist Church, Prospect Avenue, Bronx

Bus trip to Dutch country Pennsylvania!! Sat. August 20, 1977. Sponsored By The Church of Jesus Christ, Buses leave Nostrand Ave. and Farragut Rd., Brooklyn. Adults $20.

"DRIVEN TO CLAIM THIS COMMUNITY FOR CHRIST— THROUGH CHRIST ONE CHILD, ONE FAMILY, ONE SITUATION AT THE TIME.

 Zion Hill Baptist Church, Georgia Avenue, Washington, D.C.

La Iglesia de la Comunidad Donde Nadie Se Siente Extraño [The Community Church Where Nobody Feels Out of Place]

 Pastor Rev. Montañez, Primera Iglesia de Dios Pentecostal
 Alpha y Omega, Pitkin Avenue, Brooklyn

PERMANENCE

Preaching the Word . . . Reaching the World. Upon this rock I will build my church and the gates of hell shall not prevail against it. Matt 16:18

 Revival Tabernacle, Woodward Avenue, Detroit

Now is the judgment of this world: Now shall the prince of this world be cast out and I, if I be lifted up from the earth will draw all men to me. John 12:31–32

 UPON THIS ROCK I WILL BUILD MY CHURCH; AND THE GATES OF HELL SHALL NOT PREVAIL AGAINST IT. MATT 16:18 New Rising Sun M. B. Church invites you to our annual DOWN HOME DINNER—Ham Hocks—Neck Bon—Ham— Rib Tips—Turkey and more, Saturday, August 18, 11 AM–2 PM, $9 Donation.

 Rev. O. D. Morris, pastor, New Rising Sun,
 West Sixteenth Street, Chicago

. . . built upon the foundation of the apostles and prophets, Christ Jesus himself being the cornerstone.

 Iglesia Evangelica Pentecostes, South Central Los Angeles

Jesucristo es el mismo ayer y hoy y por los siglos. [Jesus is the same yesterday, today, and for the centuries to come.]

 Juniper Street, South Central Los Angeles

I am the root and the offspring of David and the Bright and morning Star. Revelation 22:16

 Rev. James Taylor, pastor, Saint Rest #2,
 South Vincennes Avenue, Chicago

PRAISING THE LORD

PSALM 100

Make a joyful shout to the Lord, all you lands!
Serve the Lord with gladness: come before His presence with singing
Know that the Lord He is God, it is He who has made us, and not We ourselves; we are His people and the sheep of His pasture.
Enter into His gates with thanksgiving and into His courts with praise, be thankful to Him, and bless His name.
For the Lord is good, His mercy is everlasting
and His truth endures to all generations.

 Isac Lacy, Jr., pastor,
 God House M. B. Church,
 West Florence Avenue, Los Angeles

Genesis 12:3: And I will bless them that bless Thee, and curse him that curseth Thee: and in Thee shall all families of the earth be blessed.

 Lee T. Jones, pastor,
 San Jose Missionary Baptist Church,
 Saint James Street, San Jose, California

Bless the Lord!
I will praise the Lord!
I will thank the Lord!
I will love the Lord at all times, and His praises shall always be in my mouth, hands, body and soul. Psalm 34.

 Pastor M. Barron,
 Higher Ground Temple C.O.G.I.C., Inc.,
 Pine Street, Camden, New Jersey

The Lord is in His holy temple. Let all the earth be silent before Him.

 Pastor Calvin Kendrick,
 Victory Baptist Church,
 Union Avenue, Bronx

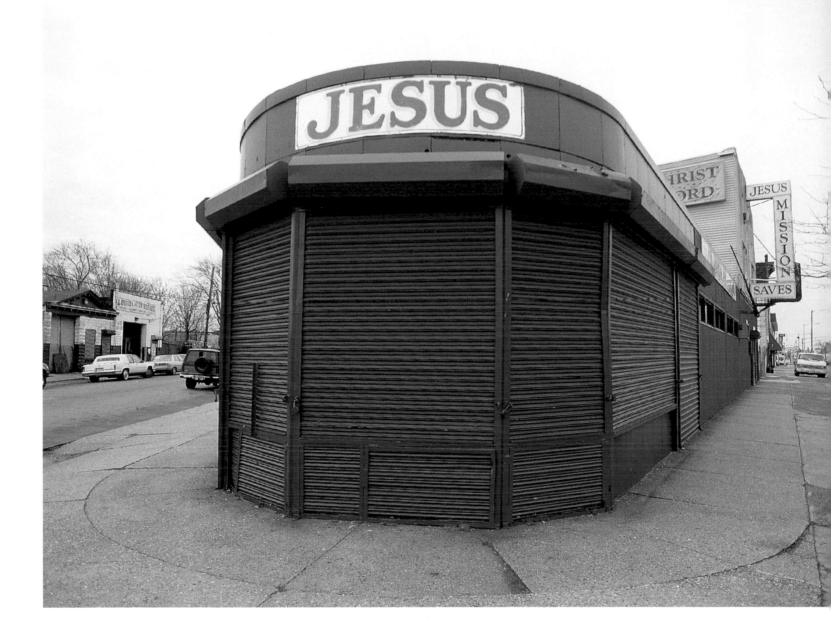

The General Assembly Church/House of Mercy Mission,
in a former furniture store,
Springfield Avenue, Newark, 2002

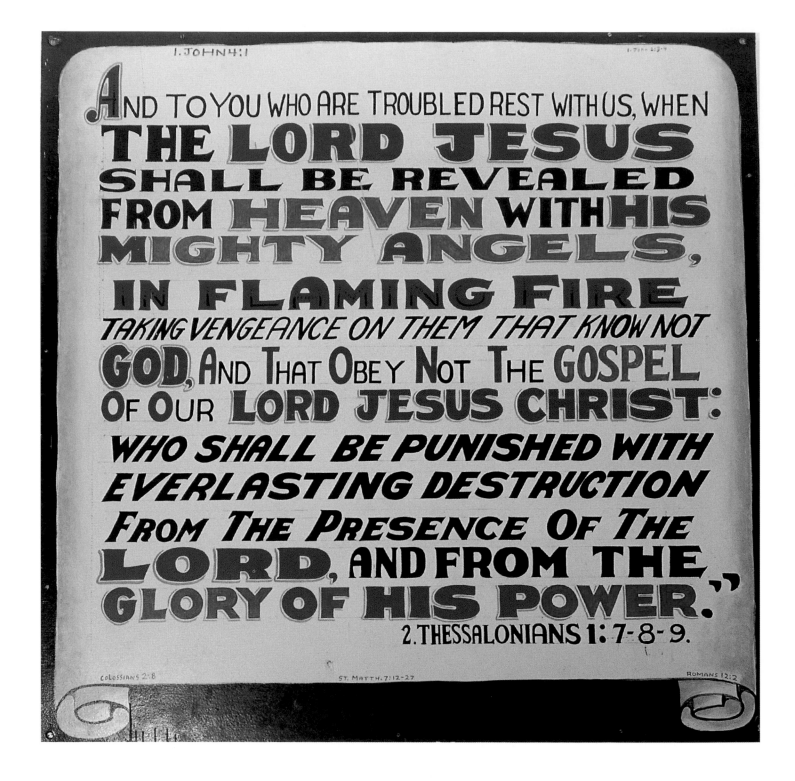

Sign by John B. Downey announcing fire and damnation,
and offering refuge, Emmanuel Baptist Rescue Mission,
Fifth Street, Los Angeles, 2003

Enter into His gates with thanksgiving and His courts
with praise. Psalm 100:4
 Holiness into the Lord.
 No eating, drinking or chewing gum in the church.
 Marriages performed. Babies dedicated.
 Bishop P. Rowe, pastor, Full Gospel Church #2,
 Aberdeen Street, Brooklyn

Entrad por sus puertas con accion de gracias, por sus atrios con
alabanza, alabadle, bendecid su nombre. Salmo 100:4 *[Enter*
into His gates with thanksgiving, and into His courts with praise;
be thankful unto Him, and bless His name. Psalm 100:4]
 Como el ciervo brama por las corrientes de las aguas, asi
clama por ti, O Dios el alma mia. Salmos 42:1 *[As the*
hart panteth after the water brooks, so panteth my soul after
thee, O God. Psalm 42:1]
 Iglesia Cristiana Camino al Cielo, Clay Avenue, Bronx

That they may be called trees of righteousness. The planting
of the Lord that He may be glorified.
 Clyde B. Smith, pastor, Isaiah 61:3 Prayer House
 of Deliverance Temple, Fifth Avenue, Gary, Indiana

SPLENDOR AND MAJESTY ARE BEFORE HIM, STRENGTH
AND BEAUTY ARE IN HIS SANCTUARY.
 Pastor Calvin L. Bryant,
 New Mount Zion M.B. Church,
 Kedvale Avenue, Chicago

Whatsoever things are true,
Whatsoever things are honest,
Whatsoever things are just
Whatsoever things are pure
Whatsoever things are lovely
Whatsoever things are of good report
If there is any virtue, and if there is any praise
Thank on these things.
 Bishop H. Vaden, pastor, Saint Peter's Angelic Church of God,
 Eleventh Street, Newark

When praises go up blessings come down.
 Bishop J. Davis,
 All Nations Healing Ministries,
 South Vermont Avenue, Los Angeles

FEAR OF HELL

Wonder what hell is going to look like. Isaiah 13:14
 Graffiti written on the back of the Apostolic Faith Church,
 South Indiana Avenue, Chicago

Where Will You Spend Eternity? The wicked shall be turned
into hell and all nations that forget God. Psalm 9:17
 Bishop Wallace Furrs,
 America Comes Back to God Evangelistic Church,
 Tent Crusade Services, Rockaway Avenue, Brooklyn

Stop, read, & take action
Are you sick enough yet?
Give God a chance and see the difference He shall make
in your life.
Do it now!!!
 Pastor E. M. Barron, Higher Ground Temple Church
 of God in Christ, Pine Street, Camden, New Jersey

Come Now, Don't Let It Be Said: Too Late.
 Rev. Bobby Wright, Pastor, Last Day Baptist Church,
 South Tenth Street, Newark

The Wages of Sin Is Death. Repent Before Payday.
 G. T. Hairston, pastor,
 First Refuge Baptist Church,
 Kaighns Avenue, Camden, New Jersey

MISCELLANEOUS

No Hill is too High to Climb.
 Dr. Ralph E. Loeb, pastor, Day Star Baptist Church,
 Prospect Avenue, Bronx

REMEMBER LOT'S WIFE.
 Risen Valley Church of God in Christ,
 West Harrison Street, Chicago

A Ministry with a Purpose.
 Faith in Christ Ministries, South Western Avenue,
 South Central Los Angeles

Let the Power Work.
 Greater Works Anointed Church Ministries,
 Outer Drive East, Detroit

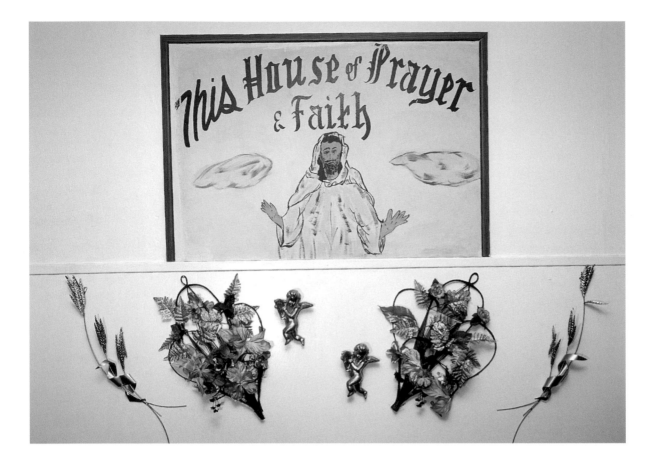

The fear of the Lord is the beginning of wisdom: and the knowledge of the holy is understanding. Proverbs 9:10
> Bishop William D. Broughton,
> New Light Holy Church,
> Livingstone Street, Newark

Our Motto: If my mind can believe it and my heart can receive it, I know I can achieve it, because I am somebody.
> House of Faith,
> Saratoga Avenue, Brownsville, Brooklyn

Moving from Traditions to Changing Conditions.
> Rev. Darryl Stephens, pastor, Saint Stephen's Missionary Baptist Church, East Monument Street, Baltimore

22nd chapter of Deuteronomy, verse 5, God said: that Women shouldn't wear pants in the church.
> Rev. Dan Simmons, pastor,
> Greater Peter's Rock M.B. Church, South State Street, Chicago

And from the days of John the Baptist until now the kingdom of heaven suffereth violence and the violent take it by force. Matthew 11:12
> D. Parker, pastor, Berean Christian Center, Broadway, Brooklyn

Please brothers don't urinate here, this is a church. We won't hurt you this way EVER. God bless you.
> Iglesia Pentecostal Casa de Oracion, Broadway, Brooklyn

Help Wanted: Jesus is Hiring.
> Rev. S. L. Rice, pastor, The New Upper Room Missionary Baptist Church, Chicago

The church alive is worth the drive.
> Pastor A. Richardson, Holy Ghost Deliverance Church, Arctic Avenue, Bridgeport, Connecticut

The Lord's Voice Cries Out to the City. Micah 6:9
> Calvary Christian Fellowship, West 116th Street, New York

And Jesus, when He was baptized went up straightway out of the water, and lo the heavens were opened unto Him, and He saw the Spirit of God descending like a dove and lightning upon him.
> Matt Harris Temple C.O.G.I.C.,
> South Michigan Avenue, Chicago

TELL THE TRUTH AND SHAME THE DEVIL!
> *IT'S A SET UP BY THE HOLY GHOST!*
> *JESUS IS LORD AND THAT IS FOR REAL, FOR REAL!*
> *THE DEVIL IS A DEFEATED FOE Col. 2:15*
> *GO WITH GOD*

Tabernacle of Faith,
South Hoover Street, Los Angeles, 2002

The Past is Past
The New Is Now!
Five signs on the walls of Miracle Temple Church,
Carol Ann Thomas, pastor, South Twentieth Street, Newark

You don't have to take the devil's Junk because Jesus is Lord.
Apostle Ernest Leonard, Sr., pastor, Provision of Promise
Ministries, Clinton Avenue, Newark

Our enemies haven't seen nothing yet!
No weapon formed against this ministry shall prosper,
we are highly favored.
Overseer Clarence L. Smith, Chosen Generation
Outreach Ministry, South Eighteenth Street, Newark

And whatsoever you do, do it heartily as to the Lord
and not unto man. Col 3:23
The Lord gave the pastor this passage from the Bible
before she started the church.
Grace Chapel Church of the Living God P.G.T.,
Dixwell Avenue, New Haven, Connecticut

The Truth, The Whole Truth, and Nothing But the Truth,
So Help Us God.
Rev. Harvey L. Richardson, pastor, The Kingdom
of Christ Baptist Church, South Union Avenue, Chicago

Believe in yourself
Success is failure turned upside down
The silver tint of the clouds
You can't never tell how close you are.
It maybe nearer when it seems so far;
Stick to the fight when you are hardest hit.
It is when things seem worst
That you must not quit.
Bradley Tyler
Framed sign on wall of Apostolic Gospel Church of Christ,
Pastor Thomas Nesbitt, Chester Avenue, Brooklyn

Whereas ye know not what shall be on the morrow. For what
is your life? It is even a vapour, that appeareth for a little
time and then vanisheth away. James 5:14
Pastor Davis, Bible Fellowship House,
Broadway, Camden, New Jersey

Be a practitioner, Earn while you learn.
Unity Temple of Scriptural Sermons, Academy of Theological
Writers, A Chartered Institution in the State of Illinois.
Primate Clarence Rodney, Ph.D., Th.D.,
South Side, Chicago

What makes a good church
If all the lazy folks will get up,
And all the sleeping folks will wake up,
And all the discouraged folks will cheer up,
And all the gossiping folks will shut up,
And all the dishonest folks will confess up,
And all the estranged folks will make up,
And all the depressed folks will look up,
And all the disgusted folks will sweeten up,
And all the lukewarm folks will fire up,
And all the dry bones will shake up,
And all the sanctified folks will show up,
And all the leading folks will live up,
And all the vowing folks will pay up,
And all the true soldiers will stand up,
Then, yes, we can have a good church.
We're going to wake up ... Pray up ...
Sing up ... Teach up ... Stay up ... Pay up ...
And never give up, Back up or shut up,
Until the cause of Christ is built up.
Greater Antioch Missionary Baptist Church,
Compton Avenue, South Central Los Angeles

So He drove out the man; and He placed a cherubim at
the east of the garden of Eden and a flaming sword which
turned every way, to guard the way to the tree of life.
Genesis 3:24
Saint Rest Missionary Baptist Church,
West Manchester Avenue, Los Angeles

Devil the blood of Jesus is against you! Cash reward to the
person God brings to me and tell who broke in this house
and stole my church's clothes, radio. I am praying for God
to expose you. I believe he will.
Storefront church sign,
South Halsted Street, Chicago

Vandalized window at former City Methodist Church,
Washington Street, Gary, Indiana, 2004

"Make a Joyful Noise unto the Lord":
Church Hymns and Songs

I asked pastors and choir leaders why people sing in churches, and also how they select their songs. Several replied, "Because it is in the Bible, and because singing makes them rejoice." They choose whatever the spirit tells them. They explained that songs may come straight from a person's soul as a result of a profound experience. In answer to my question about what distinguishes hymns from songs, I was told that hymns are a specific kind of song, akin to a psalm. When singing hymns, according to Pastor Jack Walker of the Bronx, "You sing verses, and after each verse, you sing the refrain. Songs, on the other hand, are just different words that keep going along continuously."

Most church officials with whom I spoke had a favorite hymn that they readily sang when asked. I tried to transcribe accurately the lyrics I heard during phone interviews and church services. Searching the Internet for titles of hymns, hymnals, and church bulletins, I found composers, dates, and sometimes more standard titles. I also realized that my transcriptions were often variations.

Many hymns that I heard were personalized versions of those in books, with alterations, new lines, and different beats. Even the same church choir might never sing a song twice in the same way. Choristers, who add lines of personal testimony, make it hard to recognize the original hymn easily. And the minister of music (the choir director) is sometimes free to insert parts of one song in the middle of another being sung, a practice referred to as "morphing." In order to enhance a sermon, pastors sometimes recite a few verses from a hymn because, as one explained, "These songs are very meaningful; people have them in their hearts."

European and American composers of the nineteenth and early twentieth centuries wrote most of the church music I heard. African American and Latino traditions were relatively scarce. Certain songs, such as "Amazing Grace," "A Mighty Fortress Is Our God," and "We Shall Overcome" are sung in rich and poor churches alike. Johnson Oatman, Jr., a Methodist minister who died in Norman, Oklahoma, in 1922, is credited with having written some five thousand gospel songs. His most popular works include "Lift Him Up," "The Last Mile of the Way," and

"Not, Not One." Bishop B. J. Luckett, of South Central Los Angeles, feels certain that much was stolen from African Americans; so do many church officials from neighborhoods like his. He explained to me, "If whites heard a song in a black church and they liked it, they just took it." At the same time, he accepts that hymns attributed to Martin Luther are indeed by him, and that Salvation Army members wrote music for their organization.

Many of the songs I heard I could not find written down, such as "Just Like Fire," "I Thank God for Keeping Me," "I Got to Make It to That City," "Jesus Is My Lord and Master and My Savior Now and Forever More, Hallelujah," "Send Down the Rain," "Elevator Man, Let's Go Higher," and "Drinking of the Wine," an old Baptist hymn for Communion. Some of these songs exist in renditions by such well-known musicians as Aerosmith, Sam Cook, Nina Simone, and Ry Cooder. And, not surprisingly, in Latino churches one hears folk tunes from the congregations' places of origin. One such song is "El Orgullo y la Soberbia," a Dominican song about the downfall of a powerful king due to an overabundance of pride, and later his rise through humility; another is "Me Hirio el Pecado [I was hurt by sin]."

I pick the songs based on the action of the spirit that guides me, and based upon the type of service on that Sunday. You can hear what you want on radio and television, but in church we speak truth, and truth is there in the Bible. I don't pick a new hymn for the service unless it passes the Bible test.

Pastor E. Holland, New Nazarene Missionary Baptist Church, B Street, Richmond, California

Sometimes you pick a song because of what you are going through. Sometimes during service, the Holy Spirit give people a song and that set the tone for the service. Some may sing it fast; some may sing it slow; some may add a word to it. Usually they may sing it the way they feel like singing it, and it may catch so it may become the way they sing that song at that church. Music a lot of times expresses what you feel, what you are going through. Also, there are Scriptures in the Bible that say so. "Is any among you afflicted, let him pray. Is any merry, let him sing psalms." There is another, Colossians the 3rd chapter, verse 16: "Let the word of Christ dwell in you richly in all wisdom, teaching and admonishing

one another in psalms and hymns and spiritual songs, singing with grace to the Lord."
 Pastor Sarah Daniels,
 Whole Truth Gospel Church of Faith, Gary, Indiana

We usually have a hymn of the month; I pick it with the assistance of the Holy Spirit, through meditation.
 Rev. William Pinkney, pastor, New Greater Straightway Baptist
 Church, North Seventh Street, Philadelphia

My organist and the one encharged to direct the choir select the hymns we sing; they be led by the Holy Spirit to do it.
 Pastor Wallace Farrs,
 America Come Back to God Evangelistic Service,
 Rockaway Avenue, Brooklyn

You take one song and you go to five churches, and they all sing the same basic song but they add different verses and lines. During service we sing a worship song and two prayer songs,

and we end up with an upbeat worship and prayer song, but I change the program if the Lord suggest a different one.
 Elder Higgenbottom, worship leader, New Hope
 Pentecostal Church, Ralph Avenue, Brooklyn

Hymns are only changed because of how you feel, and because of the depth of the song. Some sing hymns the metered way—it is more baritone—but I sing them with joy, very energetic, with a soulful singing. White folks sing hymns straight; we sing it from the heart.
 Pastor Margaret Lucas, The Mount Calvary Church of God
 United in Christ, Holland Street, Newark

God's music is special and has a very special place in His house. This area [of the church] is sacred and all the instruments are dedicated for that purpose.
 All musicians please pray before you play.
 Sign near the altar, Church of the Living God,
 Poplar Street, Philadelphia

My favorite hymn is "What a Friend We Have in Jesus." My late pastor, Ben Hedgebeth, added a verse or two to the text

Stylized wall mural depicting a choir, parking lot, Hays Tabernacle C.M.E., South Central Avenue, Los Angeles, 2003. The image is taken from a fan very popular in African American churches.

because singing a song may be a way to testify. He may have added, "Through His words He comforted me when my brother died."

> Rev. Malcolm J. Williams, Ben Hedgebeth Temple, Twelfth Street, Newark

It is all biblical. In the Psalms, David instituted singing. People sing to rejoice in the Lord, to "come before His gates with praise." When you sing, it releases you of a lot of stuff. You can hymn all you want, but if you don't have Jesus, the hymn won't do it by itself.

> Bishop B. J. Luckett, Plain Truth Mission, South Avalon Boulevard, Los Angeles

These songs rejuvenate us, and some give us that power that you need to make it.

> Pastor Robert Durr, God's House of Prayer, East Sixty-seventh Street, Chicago

Jesus is a rock in a weary land. Jesus is my rock. He is the chief cornerstone. He won't let you down. I am so glad that Jesus is a rock in a weary land, shelter in a time of storm. Who else do you know that would hang from a tree and die for you?

> Rev. Walter Washington, Jr., pastor, Greater New Light Baptist Church, Ninety-second Street, Los Angeles (During a Sunday sermon in 2003, Reverend Washington enhanced his sermon by reciting verses from the famous spiritual "Jesus Is a Rock in a Weary Land.")

People come to service for the food, or they are just there hanging out. There are few, in skid row, that come for the service. Ninety percent of the people there were raised by parents who were involved in church life. We sing songs that bring a remembrance of church life before they got to skid row. When you sing "That River of Life" in an environment that has alcoholics and drug addicts, it brings them back to reality.

> Elder James Culpeper, skid row, Los Angeles

I let the piano player pick the songs. We sing "At Calvary" almost all the time. We also sing "Nothing but the Blood of Jesus."

> Pastor Philip N. Bates, Fellowship Baptist Mission (speaking about the services he offers at Emmanuel Baptist Rescue Mission), skid row, Los Angeles

I hear songs being sung along the roads I have walked through, and I sing them. I like to sing things that are solemn, that are old, that please the Lord. The Lord told His followers that He does not like for His hymns to be made into huarachas, merengues, or salsa.

> Pura Martinez (objecting to the making of religious hymns into ballroom music in some churches), Senda de Bendicion, Brook Avenue, Bronx

HELP/REFUGE

"LEANING ON THE EVERLASTING ARMS"
BY ELISHA A. HOFFMAN, 1887
Leaning on Jesus
Trusting in my savior
Leaning on the everlasting arms.

Chorus
Leaning, leaning
Safe and secure from all alarms
Leaning, leaning, leaning on the everlasting arms.

> Pastor Philip N. Bates, Emmanuel Baptist Rescue Mission, Fifth Street, skid row, Los Angeles

"THERE IS A BALM IN GILEAD,"
AFRICAN AMERICAN SPIRITUAL
There is a balm in Gilead
To make the wounded whole;
There is a balm in Gilead
To heal the sin-sick soul.

Sometimes I feel discouraged,
And think my work's in vain,
But then the Holy Spirit
Revives my soul again.

Refrain
If you can't preach like Peter,
If you can't pray like Paul,
Just tell the love of Jesus,
And say He died for all.

> Pastor John Grier, House of God Apostolic Church, Inc., South Western Avenue, Los Angeles

**Rochelle Johnson at the organ
during a Friday night service,
Church of Our Lord Jesus Christ Ark of Deliverance,
Dauphin Street, Philadelphia, 2004**

"BLESSED ASSURANCE," WORDS BY FANNIE CROSBY, 1873

What a friend we have in Jesus
All of our sins and griefs to bear
What a privilege it is to carry
Everything to God in prayer

Oh, what peace we often forfeit
Oh, what needless pains we bear
All because we do not carry
Everything to God in prayer.
 Elder Higgenbottom, worship leader, New Hope
 Pentecostal Church, Ralph Avenue, Brooklyn

"THE JORD WILL PROVIDE,"

WORDS BY MRS. A. W. COOK, 1894

In some way or other the Lord will provide
It may not be my way,
It may not be thy way;
The Lord will provide

Refrain
Then, we'll trust in the Lord,
And He will provide
Yes, we'll trust in the Lord,
And He will provide.

At some time or other, the Lord will provide;
It may not be my time,
It may not be thy time;
And yet, in His own time,
The Lord will provide.
 Rev. Marva M. Edmonds,
 Truth Center of Divine Awareness,
 Ralph Avenue, Brooklyn

"JESUS LOVES ME," WORDS BY ANNA B. WARNER, 1860
Jesus loves me! this I know,
'Cause the Bible tells me so.
Little ones to Him belong,
They are weak but He is strong.
Yes, Jesus loves me!
'Cause He tells me so.
Will the Lord remember me
When I am called to go?
> Pastor Walter Willis, Love Thy Neighbor M.B. Church,
> East Twenty-first Street, Gary, Indiana

"JESUS IS ON THE MAINLINE"
Jesus is on the mainline; tell Him what you want
Jesus is on the mainline; tell Him what you want
Just call Him and tell Him what you want.

Variations:
If you need your souls saved, tell Him what you want
If you need deliverance, tell Him what you want
If you need the Holy Ghost, tell Him what you want
If you need forgiveness, tell Him what you want
If you need a miracle, tell Him what you want.
> Associate Minister Russell Yancey, Leadership Missionary
> Baptist Church, Martin Luther King Jr. Boulevard, Milwaukee

"CAN'T NOBODY DO ME LIKE JESUS"
There is nobody healing me like Jesus
Nobody, nobody, nobody, nobody,
Nobody, nobody
There is nobody saving, saving like Jesus
Nobody, nobody, nobody, nobody,
Nobody, nobody
Nobody, father can't, mother can't, nobody can but Jesus
I am glad I serve Him.
> Rev. James Clark Pastor, Christian Home Baptist Church,
> West Barrett Street, Richmond, California

"WHAT IS HIS NAME: JESUS"
What is His name: Jesus
Who do you love: Jesus
Who saved you: Jesus
Who heals you: Jesus.
> ("It gives you peace."), Pastor Inez Ashford,
> Third Street, North Richmond, California

"WHATEVER YOU NEED, GOD'S GOT IT"
If you need more love, God's got it
If you need joy, God's got it
If you need more peace, God's got it
If you need a husband, God's got it
Whatever you need, God's got it.
> Pastor Inez Ashford,
> Third Street, North Richmond, California

"JESUS, I'LL NEVER FORGET
WHAT YOU HAVE DONE FOR ME"
Jesus, I'll never forget what you have done for me
Jesus, I'll never forget how you turned me free
Jesus, I'll never forget how you died for me
Jesus, I'll never forget how you brought me out.
> Pastor Virginia Shaw, Shiloh Temple of God in Christ Jesus,
> Nineteenth Street, Newark

"SEND DOWN THE RAIN"
Send down your rain
Lord, send down your rain
We need a lot of rain
We need your rain
There is healing in your rain
There is healing in your rain
There is a lot of healing in your rain
There is peace in your rain
There is love in your rain
There is joy in your rain.
> ("This is an old Pentecostal song to ask the Lord to send the
> spirit and blessings. There are a lot of songs like this that are
> not in the books; they sung them when I was a child."),
> Pastor Edward E. Young,
> Mount Zion Holiness Church of Christ,
> Chestnut Street, Camden, New Jersey

"OH SATAN, THE BLOOD OF JESUS IS AGAINST YOU"
Oh Satan, the blood of Jesus is against you.
The blood of Jesus is against you right now.
I am talking about the blood.
The blood of Jesus is against you.
They hung Him on the cross.
Oh Satan, the blood of Jesus is against you.
I am talking about the blood
The blood of Jesus is against you.

Hallelujah, the blood of Jesus is against you.
What a mighty Lord we serve.
> Rev. Charles Anderson, pastor,
> The Providence Baptist Church,
> Madison Avenue, Harlem

SALVATION

"AMAZING GRACE," WORDS BY JOHN NEWTON, 1829
Amazing grace! How sweet the sound
That saved a wretch like me.
I once was lost, but now I am found;
Was blind, but now I see.

'Twas grace that taught my heart to fear,
And grace my fears relieved;
How precious did that grace appear
The hour I first believed.
> ("Praise God, Praise God, Praise God."), Bishop (prophet)
> Jerome R. Crawford, The New Morrisania Full Gospel
> F.B.C. Church, Washington Avenue, Bronx

A member of The Providence Baptist Church, in Harlem, commented, "When I don't have a friend in the world, I can sing 'Amazing Grace.'"

"LIFT HIM UP," WORDS BY JOHNSON OATMAN, JR.
(1856–1926)
How to reach the masses, men of every birth,
For an answer Jesus gave the key:
And I, if I be lifted up from the earth,
will draw all men unto Me.

Refrain
Lift Him up,
Lift Him up
Still He speaks from eternity:
And I, if I be lifted up from the earth,
Will draw all men unto Me.
> Pastor Jackson, New Mount Hebron Baptist Church,
> North Avenue, Baltimore

"THE LAST MILE OF THE WAY,"
WORDS BY JOHNSON OATMAN, JR., 1908
If I walk in the pathway of duty.

If I work till the close of the day,
I shall see the great King in His beauty,
When I've gone the last mile of the way.

Refrain
When I've gone the last mile of the way,
I will rest at the close of the day,
And I know there are joys that await me
When I've gone the last mile of the way.

If for Christ I proclaim the glad story,
If I seek for His sheep gone astray,
I am sure He will show me His glory,
When I've gone the last mile of the way.
> Rev. Bobby Wright, pastor,
> Last Day Baptist Church,
> South Tenth Street, Newark

"PASS ME NOT, O GENTLE SAVIOR,"
WORDS BY FANNY CROSBY, 1868
Pass me not, O gentle Savior,
Hear my humble cry;
While on others Thou art calling,
Do not pass me by.

Refrain
Savior, Savior,
Hear my humble cry;
While on others Thou art calling,
Do not pass me by.
> Rev. Anthony Lowe, pastor,
> Mount Carmel Baptist Church,
> Prospect Avenue, Bronx

"THE OLD RUGGED CROSS,"
WORDS BY GEORGE BENNARD, 1913
On a hill far away stood an old rugged cross,
The emblem of suffering and shame;
And I love that old cross where the dearest and the best
For a world of lost sinners was slain.

Refrain
So I'll cherish the old rugged cross,
Till my trophies at last I lay down;

Roger Valdez, originally from Peru,
organist at Beautiful Gate
Deliverance C.O.G.I.C., South
Compton Avenue,
Los Angeles, 2002

I will cling to the old rugged cross, the old rugged cross,
And exchange it some day for a crown.

> Rev. H. Grady James, Jr., pastor,
> First Bethel Baptist Church,
> Nineteenth Avenue, Newark

"MY FAITH HAS FOUND A RESTING PLACE," WORDS BY
LIDIE H. EDMUNDS, 1891
My faith has found a resting place—Not in device or creed:
Enough for me that Jesus saves—This ends my fear and doubt;
My heart is leaning on the Word—The written word of God:
My great Physician heals the sick, The lost He came to save;
I trust the Ever living One—His wounds for me shall plead.
A sinful soul I came to Him—He shall never cast me out.
Salvation by my Savior's name—Salvation through His
blood
For me His precious blood He shed, For me His life He gave.
It is enough that Jesus died, And that He died for me.
I need no other argument, I need no other plea.

> Rev. William Pinkney, pastor, New Greater Straightaway
> Baptist Church, North Seventh Street, Philadelphia

"HE WILL REMEMBER ME," WORDS BY E. M. BARTLETT, 1924
Verse 1
When on the cross of Cal-vry The Lord was cru-ci-fied;
The mob stood round about Him And mocked un-til He died.
Two thieves were nailed beside Him To share the a-go-ny,
But one of them cried out to Him, O Lord remember me.

Verse 2
O, what a shame to kill Him There on the rug-ged cross;
But such a death was need-ed To rescue all the lost.
His blood was made a ran-som To set the captives free,
I know that I'm in-clud-ed, And he will remember me.

Verse 3
At His dear feet I am knee-ling, My sins I now confess;
I bow in deep repentance, My soul He'll sure-ly bless,
My blind-ed eyes He opens So that the light I see,
And when I reach the pearl-y gates, He will remember me.

Chorus
Will the Lord remember me, When I am called to go?
When I have crossed Death's chil-ly sea, Will He His love
* there show?*
Oh, yes, He heard my feeble Cries, From bondage set me free,
And when I reach the pear-ly gates He will Remember me.

> E. Holland, pastor,
> New Nazarene Missionary Baptist Church,
> B Street, Richmond, California

"COME TO JESUS,"
WORDS BY EDEN REEDER LATTA (1838–1907)
Come to Jesus, He will save you,
Though your sins as crimson glow,
If you give your heart to Jesus,
He will make it white as snow.

Refrain
Come to Jesus! Come to Jesus!
Come to Jesus! Come today!
Come to Jesus! Come to Jesus!
Come to Jesus! Come today!
> (Sung at the end of the service), Rev. Amir Ballard, pastor,
> Allen African Methodist Episcopal Church,
> Nineteenth Avenue, Newark

"DON'T BE UNEASY, I AM GOING TO RISE"
Don't be uneasy, I am going to rise
When that first trumpet sounds
I am going to get out of the ground
Help me, Holy Ghost.
> Bishop Wallace Furrs, pastor,
> America Come Back to God Evangelistic Church,
> Rockaway Boulevard, Brooklyn

"LORD, I HEAR OF SHOWERS OF BLESSING,"
WORDS BY ELIZABETH CODNER, 1860
Lord, I hear of showers of blessing
Thou art scattering full and free;
Showers the thirsty land refreshing;
Let some drops now fall on me.
> Grady James, Jr., pastor,
> First Bethel Missionary Baptist Church,
> Nineteenth Avenue, Newark

(One Sunday Pastor James encouraged his congregation to sing "Bread of Heaven," saying, "Come on church, sing the song if you want God to bless you. Anybody here wants the bread of heaven?")

"GOD'S GRACE AND MERCY"
God's grace and mercy has brought me through
I am standing here today because of you
Grace and mercy woke me up. Started me on my way.
> Pastor Wallace Farrs, America Come Back to God
> Evangelistic Service, Rockaway Avenue, Brooklyn

"I GOT A RIVER OF LIFE"
I have a river of life that's flowing out of me
It makes the lame walk, and makes the blind to see
It opens prison doors; it sets the captives free

I got this river of life flowing out of me
Spring up the well that is in my soul
Bring up the well that makes whole
Bring up the well that gives to me new life abundantly.
> (About the Holy Ghost, this is "one of the old standard songs
> of Christianity."), Pastor Russell W. Seymour, New Creation
> Ministry, Sutter Avenue, Brooklyn

"IF YOU LIVE RIGHT," TRADITIONAL
If you live right, heaven belongs to you
If you pray right, heaven belongs to you
If you treat your neighbors right, heaven belongs to you
If you shout right, heaven belongs to you
You have to live right, pray right, walk right, and shout right
Hallelujah!

Variations:
If you love Him, heaven belongs to you
If you serve Him, heaven belongs to you
If you grow in Grace, heaven belongs to you
If you run the race, heaven belongs to you
If you are born again, heaven belongs to you
If you die in Him, heaven belongs to you.
> (Song sung in the slave fields), Bishop (prophet) Jerome R.
> Crawford, The New Morrisania Full Gospel F.B.C. Church,
> Washington Avenue, Bronx

People look at me and say, say, say
There goes Miss Nobody going down
People look at me and say, say, say
There goes Nobody
When I get there [Heaven], I will need no shoes
Hallelujah
> (Probably a song Dena made up), Dena, All Nations Healing
> Ministry, South Vermont Avenue, Los Angeles

"WHAT MORE CAN HE DO"
Tell me what more, what more can Jesus do
He has laid the foundation and open wide the door
Tell me what more, what more can Jesus do.
Tell me what more, what more can Jesus do.
> ("It is up to us now."),
> Overseer Bishop Leon Golding, United Holy Church of God,
> South Fourteenth Street, Newark

Deacon William Leonard singing at a gospel festival for groups from the Chicago metropolitan area, organized by The Gospelettes, Saint Rest #2, South Vincennes Avenue, Chicago, 2002

"I SHALL FLY AWAY,"

WORDS BY ALFRED E. BRUMLEY, 1932

Some glad morning when this life is over
I shall fly away
To a place where joy shall never end
I shall fly away, oh glory, I shall fly away
On God's celestial shore
I shall fly away
Some glad morning when this life is over
I shall fly away
When I die, Hallelujah, Bye and bye
I shall fly away.
 (Sung at funerals), Ebenezer Evangelical Lutheran Church,
 Harding Avenue, Chicago

"SOLAMENTE EN CRISTO" ["ONLY IN CHRIST"]

Solamente en Cristo
Solamente en El
La Salvacion se encuentra en El
No hay otro nombre

Dado a los hombres
Solamente en Cristo
Solamente en El.

[Only in Christ
Only in Him
Salvation is found in Him
There is no other name
Given to mankind
Only in Christ
Only in Him.]
 Pastor Felix,
 Iglesia Evangelistica Discipulos de Cristo,
 Union Avenue, Bronx

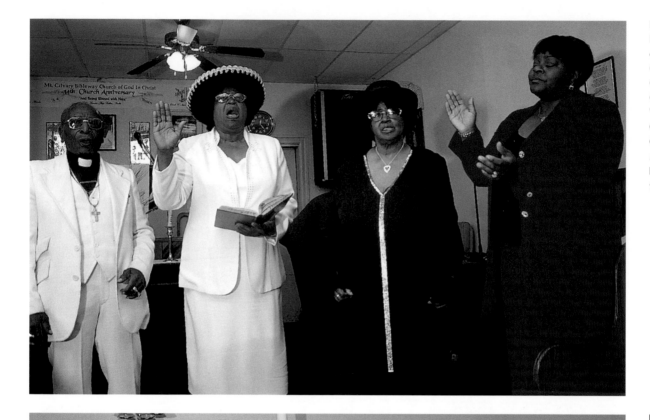

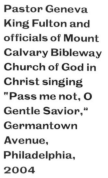

Pastor Geneva King Fulton and officials of Mount Calvary Bibleway Church of God in Christ singing "Pass me not, O Gentle Savior," Germantown Avenue, Philadelphia, 2004

From left to right, Evangelist McNeill, Mother Wilder, and Sister Elvira, Full Life Gospel Assembly Church, Prospect Avenue, Bronx, 2001

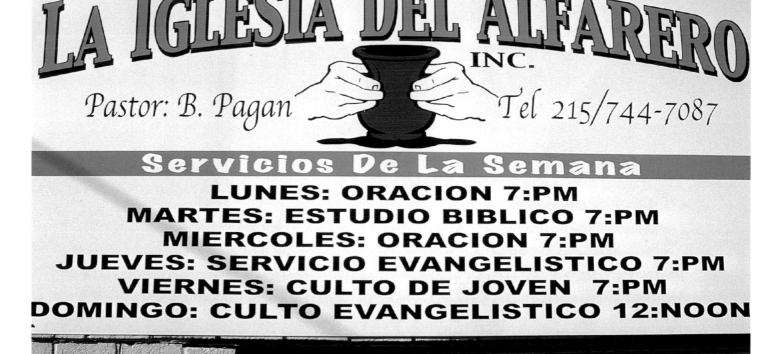

Sign for Iglesia Del Alfarero,
Germantown Avenue,
Philadelphia, 2004

"HAVE THINE OWN WAY, LORD,"
BY ADELAIDE A. POLLARD, 1907

Have Thine own way, Lord! Have Thine own way!
Thou are the potter, I am the clay:
Mould me and make me after Thy will,
While I am waiting, yielded and still.

Have Thine own way, Lord! Have Thine own way!
Search me and try me, master, today!
Whiter than snow, Lord, wash me just now,
As in Thy presence humbly I bow.

Have Thine own way, Lord! Have Thine own way!
Wounded and weary, help me, I pray!
Power, all power, surely is Thine!
Touch me and heal me, savior divine!
 Pastor Charles Jenkins, Fellowship Missionary
 Baptist Church, Princeton Avenue, Chicago

"EL ALFARERO" ["THE POTTER"]

Un dia orando le dije a mi senor
Tu el alfarero, yo el barro soy
Modela mi vida a tu parecer
Haz como tu quieras, hazme un Nuevo ser.
Me dijo no me gustas, te voy a quebrantar
Y en un vaso Nuevo te voy a transformar

Pero en el proceso te voy a hacer llorar
Porque por las pruebas te voy a hacer pasar
Quiero una sonrisa cuando todo va mal
Quiero una alabanza en lugar de lo quejar
Quiero tu confianza en la tempestad
Y quiero que aprendas tambien a perdonar.

[One day, praying, I told my Lord
You are the potter, I am the clay
Shape my life as you want
Do as You wish, make me a new person.
He told me, I don't like you; I am going to break you
And into a new vessel, I will make you
But in the process, you will cry
Because I am going to test you
I want a smile when everything goes wrong
I want your praises instead of complaints
I want your trust in the storm
And I want you to learn to forgive.]
 Pastor Orlando Amaya, Iglesia Torre Fuerte,
 South Avalon Boulevard, Los Angeles

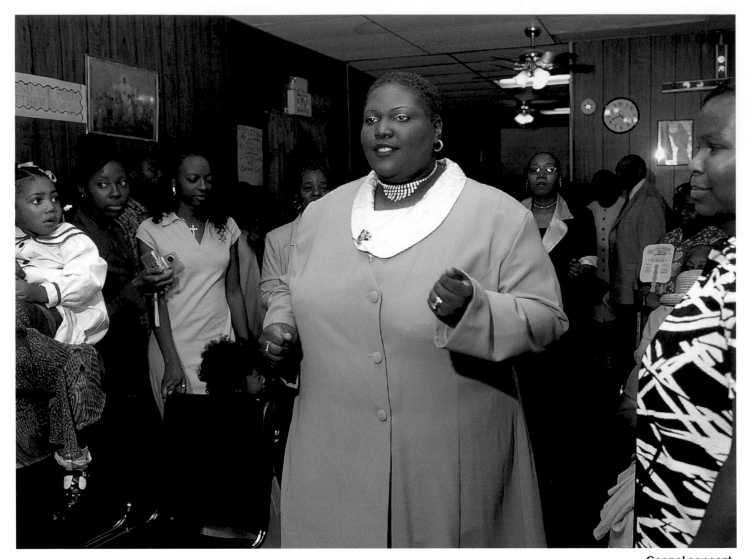

**Gospel concert,
Supernatural Deliverance Revival Tabernacle,
First Street, Newark, 2003**

"EN LA CRUZ" ["IN THE CROSS," WORDS BY ISAAC WATTS,
1707, TRANS. PEDRO GRADO VALDÉS]

En la cruz
Do primero vi la luz
Y las manchas de mi alma
Yo lavé
Fue allí por fe do vi a Jesús
Y siempre feliz
Con El seré

[In the cross
I first saw the light
And the stains of my soul
I cleaned
There by faith, I saw God
And always happy
With Him I will be]
 Pastor Monserrate Guzman,
 Iglesia Cristiana la Nueva Gethsemani,
 East 104th Street, Harlem

FAITH

En el altar de Dios, en el altar the Dios, el fuego esta
 encendido.
En el altar the Dios, el fuego esta encendido.
Nadie lo podra apagar, porque el fuego del señor en mi
 corazon esta.
Nadie lo podra apagar.

[In God's altar, in God's altar, the fire is burning.
In God's altar the fire is burning.
Nobody will be able to put it out because God's fire is
 in my heart.
Nobody will be able to put it out.]
 Pastor Candido Berrios,
 Roca de Salvacion, Home Street, Bronx

**Nelson Torres singing
at Una Voz de Alerta,
Third Avenue, Bronx, 2004**

"WHERE HE LEADS ME," WORDS BY
ERNEST W. BLANDY, 1890
*Where he leads me, I will follow
I go with him all the way
Where he leads me, I will follow
I go with him all the way
I go with him through the valleys
I go with him all the way.*
> Apostle J. Douglas, pastor, United House of Prayer
> for All People of the Church on the Rock of the Apostolic Faith,
> Broadway, Camden, New Jersey

"MY FAITH LOOKS UP TO THEE,"
WORDS BY RAY PALMER, 1830
*My faith looks up to Thee,
Thou Lamb of Calvary, Savior divine!
Now hear me while I pray, take all my guilt away,
O let me from this day be wholly Thine!
May Thy rich grace impart
Strength to my fainting heart, my zeal inspire!
As Thou has died for me, O may my love to Thee,
Pure warm, and changeless be, a living fire!*
> Rev. Dr. M. William Howard, Jr.,
> Bethany Baptist Church,
> West Market Street, Newark

"GOD'S UNCHANGING HANDS," TRADITIONAL HYMN
*You better hold on to his hands
Children hold on to his hands*

"DRINKING OF THE
FOLK SONG FROM T
*Drinking of the win
Drinking of the win
Wine, wine, wine, h
Wine, wine, wine, h
It has been a thouso*
> Rev. Charles White
> Smith Chapel Bap
> Germantown Ave

"I AM GOING TO I
*Darkness is around
I am going to live i
I am going to live i*

*Hold on to God's unchanging hands
You better hold on to his hands
You better hold on to some things unchanging.*
> United House of Prayer for All People,
> Fulton Street, Brooklyn

PRAISING THE LORD
*Singing, praising and rejoicing creates great spiritual rhythms
in the inner man. Singing restores and heals the nerve endings
in the body by creating vibrations of life and action.*
> Lesson 26, June 29, 2003, "Challenger,
> The advance schools of wisdom," Biannual Volume 3,
> *Triumph the Church and Kingdom of God in Christ*
> (Birmingham, AL: Hall Printing)

"WHAT A MIGHTY GOD WE SERVE," TRADITIONAL HYMN
*What a mighty God we serve
Angels bow before Him
Heavens and earth adore Him
What a mighty God we serve
We serve
We serve
We serve.*
> Emma L. Barr, pastor, Greater Concord M.B.C.,
> Bergen Street, Newark

"STAND UP AND

TRADITIONAL JA

Stand up and tel

I want to know,

I want to know i

 Testimony, Chu

 Schenectady A

"GLORY TO HIS

WORDS BY ELIS

Down at the cro

Down where for

There to my hea

Glory to His na

Chorus

Glory to His na

Glory to His na

There to my hea

Glory to His na

 Pastor Marga

 The Mount C

 Holland Stree

Creating an Atmosphere of Reverence and Devotion

I imagined that somewhere in america there was a department store—like a Macy's, L. L. Bean, or, perhaps, a Home Depot—stocked with religious goods. But when I asked church officials if there was a department store devoted to religious articles, they said they did not know of one. Churches buy their supplies mostly in local Christian stores, through mail-order catalogues, and from businesses on the Internet.

In my imagination, God's Megastore is a place where one can find experts in Pentecostal worship, Catholic theology, Baptist and Lutheran religions, and other branches of Christianity. Religious salespeople could recommend the most appropriate items to buy, ranging from a selection of ready-made steeples and church signs to varieties of contact paper, used to turn ordinary commercial windows into stained-glass windows. There would be dozens of Bibles under one roof, including that rare one, *Bible of the Prophecy*.

Among the garments offered for sale there would be a wide selection of robes for ushers, choir members, and pastors, including those worn by Catholic priests and bishops half a century ago. Visitors would come to the Megastore for religious fashion shows. There would be monsignor hats with pompoms on top, stoles made of kente cloth. There would be photographers showing inventive ways to portray "Our Man of God" with or without the First Lady. Some would be depicted as Moses, others dressed in bankers' attire. Female pastors would be represented as a lady, as the queen of Sheba, or the queen of England.

I imagine what a thrill it would be to visit a special section dedicated to Clear Vision Studies and there in a dark room admire Reverend Gosey's rendition of "The Satanic Trilogy," taken from Clarence Larkin's "The Book of Revelation." There would be a floor full of supplies for houses of worship, including Gothic-style chairs with high backs for the elders of the church, Plexiglas pulpits, wooden altars with the words "This Do in Remembrance of Me" carved on them, and small items such as usher badges from the well-known firm R. H. Boyd, of Nashville. And there would be large numbers of multiracial, multiethnic images of Christ in print, stained glass, and statuary. One would find images as strong, masculine Christs, multiracial Christs, and the feminized Jesus. The store would stock perfumes and olive oil for anointing. West Indians would find Eau de Cologne 4711, and bronze cobras for their Spiritual Baptist churches.

A stream of religious figures would make live appearances at God's Megastore, celebrity evangelists like T. D. Jackes, Creflo Dollar, and Benny Hin. These men of God would get the same billing as the unknown fiery, paralytic prophet I saw at the First Home of God in Robbins, Illinois, or as the incomparable Mother Duckett of the Holy Revival Baptist Church in Compton, California.

Music in God's Megastore would include the brass ensemble of the Washington, D.C., United House of Prayer for All People and recordings by the little old lady who puts her head down and sings and plays the ukulele so movingly at Greater Concord M.B.C. in Newark. Dena, from Los Angeles, would put a lump in my throat with her rendition of "Miss Nobody."

It is our doctrine to secure blessed articles every week. We use candles, oil, and incense for our protection. We use oil for anointing of our body for conditions. We use incense as in Revelation 8:4, which declares that the smoke of the incense, which came with the prayers of the saints, ascended up before God out the angel's hand. For we know that, through this, God will answer our prayer.

West Coast Kingdom, Mount Zion Spiritual Temples, Inc., Fourteenth Street, Oakland, California

We know you prepare carefully for every aspect of your worship service. From sermon to special music, from sanctuary design to décor, each element is thoughtfully chosen to enhance the worship experience. At Murphy we give the same attention to our products. Years of experience have reinforced our conviction that quality contributes to an atmosphere of reverence and devotion. As you look through this catalog, you'll find items that are suitable for a wide range of pastors and churches.

Church Wear, Murphy Robes, Saint Petersburg, Florida, 2001

Contact paper, Antioch Temple, Independent Church of Christ in Jesus, Nineteenth Street, Newark, 2004

Plastic columns designed to hold flower pots and urns are popular objects used to decorate sanctuaries, Pedro Zendejas y Rodriguez, Import Wholesale, South San Pedro Street, Los Angeles, 2003

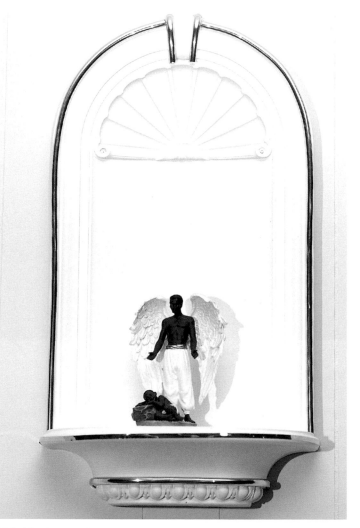

This black guardian angel and sleeping child were bought in a gift shop in Plymouth, Massachusetts, for about fifty dollars by Pastor Washington, Bibleway House of Blessing, Franklin Avenue, Brooklyn, 2003

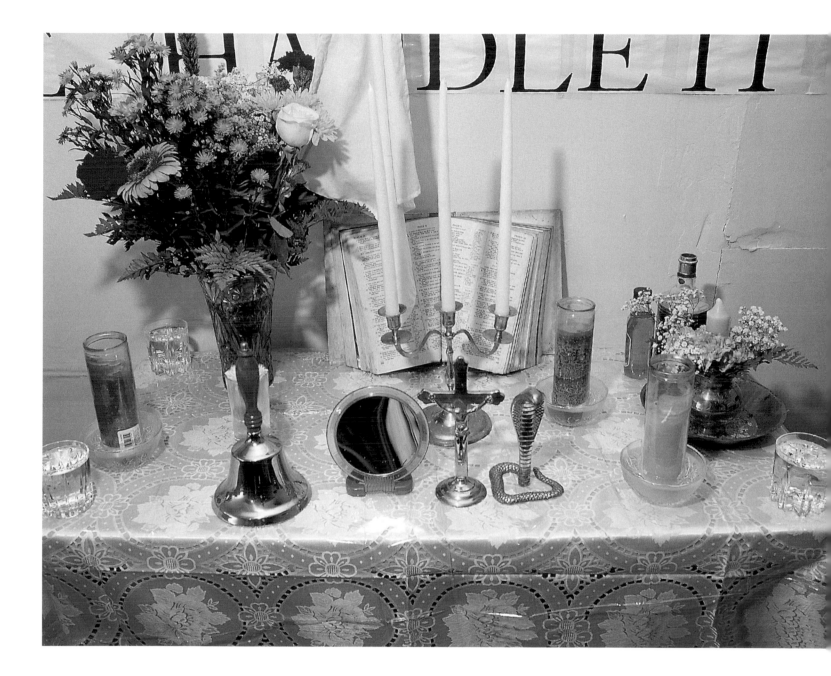

Olive oil, cologne, and a bronze cobra snake are some of the objects used to decorate the altar of Temple Arch Spiritual Baptist Church, Sutter Avenue, Brooklyn, 2004

Dickson New Analytical Study Bible. Iowa Falls, IA: World Bible Publishing, 1984.

The First Scofield Study Bible. Iowa Falls, IA: World Bible Publishing, 1986.

Good News Bible. Today's English version. New York: American Bible Society, 1976.

Holy Bible. Wichita, KS: Heirloom Bible Publishers, 1964.

Holy Bible. Nashville: Thomas Nelson Publishers, 1984.

Holy Bible. Reference edition. Fort Worth, TX: Kenneth Copeland, 1991.

Holy Bible. Nashville: Holman Bible Publishers, 1973.

Holy Bible. Plantation, FL: Paradise Press, Inc., 1997.

Holy Bible, Containing the Old and New Testaments. Uhrichsville, OH: Barbour Publishing Co., 2001.

The Holy Bible, Containing the Old and New Testaments. Authorized. Iowa Falls, IA: Bible Publishers, Inc., 1989.

The Holy Bible, Containing the Old and New Testaments. Nashville: Thomas Nelson Publishers, 1984.

Holy Bible Dictionary–Study Help. Nashville: Broadman and Holman, 1979.

Holy Bible. New international version; reference edition. Nashville: International Bible Society, Royal Publishers, 1977.

Holy Bible. People's parallel edition. Wheaton, IL: Tyndale House Publishers, 1977.

Holy Bible. Teachers' reference edition. Philadelphia: National Publishing Company, 1959.

Holy Bible. Woman Thou Art Loosed! edition. Ed. T. D. Jakes. Nashville: Thomas Nelson Publishers, 1998.

The Layman's Parallel Bible. Grand Rapids, MI: Zondervan Publishing House, 1991.

Life Application Bible. Wheaton, IL: Tyndale House Publishers, 1993.

Men of Color Study Bible. Created by and for contemporary men of African descent. Iowa Falls, IA: World Bible Publishers, 2002.

The Nelson Study Bible. New edition. Nashville: Thomas Nelson Publishers, 1997.

The Prophecy Bible. Morris Cerullo. N.p., n.d.

Teen Study Bible. New international version. Grand Rapids, MI: Zondervan, 1998.

Touch Point Bible. New living translation. Wheaton, IL: Tyndale House Publishers, 1996.

BIBLES IN SPANISH

Biblia de Estudio Pentecostal. Version Reina-Valera. Deerfield, FL: La Vida Publishers, 1993.

Biblia de Referencia Thompson. Version Reina-Valera. Deerfield, FL: La Vida Publishers, 1966.

El Nuevo Testamento. New international edition. New York: Sociedad Biblica Internacional, 1979.

La Santa Biblia. Kissimee, FL: Editorial Publicaciones Españolas, 1960.

La Santa Biblia. Edicion Cristiana familiar, Antiguo y Nuevo Testamento. Charlotte, NC: C. D. Stamply Enterprises, 1977.

La Santa Biblia. Version Reina-Valera. New York: American Bible Society, 1999.

La Santa Biblia. Version Reina-Valera, revision 1960. Nashville: Broadman and Holman Publishers, 1997.

Traduccion del Nuevo Mundo de las Santas Escrituras. Brooklyn, NY: Watch Tower Bible and Tract Society of Pennsylvania, 1987.

HYMNALS FOUND IN GHETTO CHURCHES

Favorite Hymns of Praise. Harlem, NY: The Abyssinian Baptist Church, n.d.

Himnos de Gloria y Triunfo. Miami, Deerfield, FL: Editorial Vida, 1980.

The National Baptist Hymnal. Nashville: National Baptist Publishing Board, 2000.

Pentecostal Hymnal. Revised. Hazelwood, MO: Pentecostal Publishing House, 1953.

Seventh Day Adventist Hymnal. Hagerstown, MD: Review and Herald Publishing Association, 1985.

West Indian United Spiritual Baptist Sacred Order, Inc., Popular Hymns and Choruses. N.p., n.d.

Worship Songs. Kansas City: Lillenas Publishing Company, n.d.

Yes Lord, Church of God in Christ Hymnal. Memphis: Church of God in Christ, 1982.

OTHER RELIGIOUS BOOKS AND BOOKLETS

Adult Christian Life, a quarterly publication. Nashville: R. H. Boyd Publishers.

Discipline of the Primitive Baptist Church. 4th rev. ed. Tallahassee, FL: National Primitive Publishing Board, 1966.

Produce arranged on the altar of Family and Friends Christian Center, Powell Street, Brooklyn, 2004. "This is harvest time, when we give thanks to God for the harvest being so plentiful, then we present it to God with thanksgiving, and then we enjoy the fruit of the harvest," explained Lady Mary Freeland, the pastor's wife.

Moravian Book of Worship. Bethlehem, PA: Moravian
 Church of America, 1995.
Power for Living. Memphis: Church of God in Christ, 2004.
Precepts for Living. Ed. A. Okechuckwu Ogbonnaya.
 Chicago: Urban Ministries, Inc., 2004.
Primary Bible Lessons. Nashville: Sunday School Publishing
 Board, n.d.

Christian Stores

Christian stores are businesses that sell religious objects,
including books, greeting cards, music, crosses, Bibles,
charts, ties, robes, and ecclesiastical shirts that are an
important part of religious worship. The managers of these
stores are often pastors with an excellent knowledge of the
local churches.

Bible Book Center, Inc., Broadway, Gary, Indiana
Book of Life Bookstore, Florence Avenue and South Main
 Street, Los Angeles
CLC Bookstore, Crittenden Street, Philadelphia
Cross Roads, East Orange, New Jersey
Ebenezer Libreria Cristiana ("Watch Out God Sees
 Everything. The cure for crime is Jesus Christ"),
 Eighth Street, Los Angeles
Fountain of Living Water, West Madison Street, Chicago
God's Armor, Hillside, New Jersey
Libreria Cristiana Bethel, Broadway, Brooklyn
Will-Mar Gifts, Christian Supplies, Market Street, Camden,
 New Jersey

Custom Pulpit Robes,
Choir Robes, Usher Uniforms

*Jesus himself was wrapped around and swaddled with
clothes. This is how organizations visualize it. Each
organization has its own concept for garments. The
Scriptures speak about different colors or garments. What
is written is what we are to go by.*
 Mr. Clayburn, South Broadway, Los Angeles

*A lot of preachers don't wear robes. The robe is a show; the
average price of a robe is two hundred ninety dollars. I*

*have women come here and buy a robe for their pastor,
usually his wife. When a person comes in, they come in
with something in their minds. Robes are often designed to
match the carpeting and the pews; you want your choir to
look good.*
 Saleswoman, Praise Choir Robes,
 South Crenshaw Boulevard, Los Angeles

*Our products are developed by seasoned Christian educators
who have experienced the African and African American
worldview.*
 Jacob and Associates Pulpit Robes,
 www.urbanministries.com.

*It seems that the pastor asked the ladies of the congregation
what was their favorite color, and they answered that they
preferred yellow.*
 Richard, explaining how yellow was chosen
 for the jackets of ushers at the Templo De
 Renovacion Espiritual, 149th Street, Bronx

POPULAR BRANDS OF RELIGIOUS VESTMENTS
Bob Siemon Designs ("To create, manufacture, and
 distribute creative, quality, inspirational products
 worldwide," statement on their website), Santa Ana,
 California
Free Man Apparel, A Swanson Company, Tennessee
Friar Tuck shirts
Murphy robes

Mail Order Catalogues with Church Supplies

A pastor in Newark explained that these are "books
they send to the church with things like Baptism pools,
windows, and church signs."

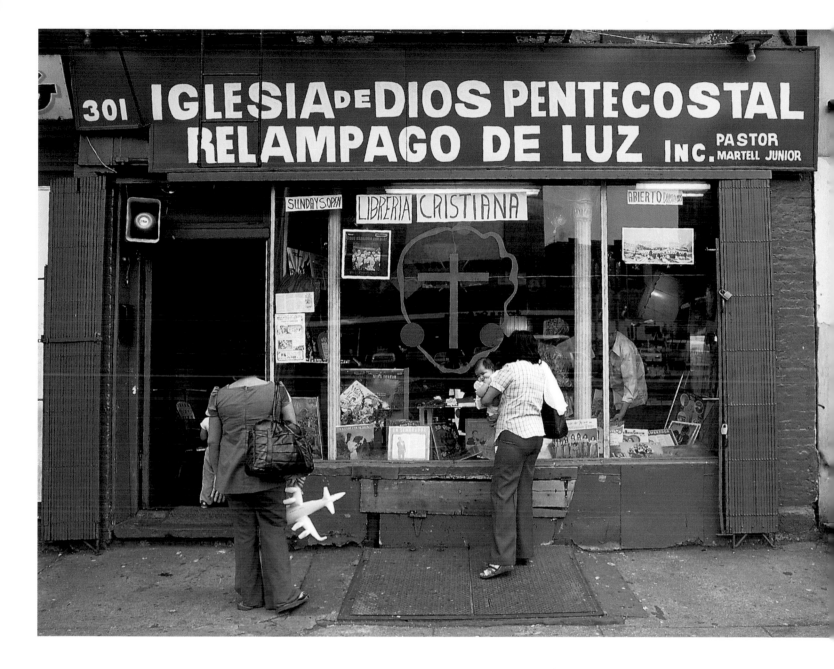

**Libreria Cristiana, Iglesia de Dios
Pentecostal Relampago de Luz Inc.,
East Houston Street, Manhattan, 1977**

**Fine stone head of a saint or a prophet,
Christ Temple Interdenominational Church,
formerly Girard Avenue Presbyterian Church,
West Girard Avenue, Philadelphia, 2003**

I collected the bulk of the information for this book by visiting houses of worship, speaking to church officials, and reading their publications. I searched through the World Wide Web to find names of churches, pastors' phone numbers, and titles of hymns and composers. During conversations with scholars, I was advised to document and report. I gathered imagery, interviews, songs, and stories as I found them because much of what I was hearing was part of a rich and disappearing oral tradition.

In order to familiarize myself with the history and the concepts of Christianity, I read a number of basic texts written by reformers, mystics, and founders of religious orders. I read about religion, faith healing, and witchcraft in Haiti, Colombia, and South Africa. I inquired about the connection between inner-city religious leaders and prominent historical figures like Martin Luther, Saint Francis of Assisi, Saint Paul, Saint Augustine, and Saint John of the Cross. I observed expressions of asceticism and mysticism in movies, music, and art. Although only a small part of my data came from movies and newspapers, and an even smaller part came directly from books and scholarly articles, these materials were important guides to the core issues of Christianity and were helpful to me as I formulated questions. In addition, these texts provided me with a context for understanding the buildings that churches occupied, their symbolism, and their religious practices.

With the notable exception of works by Karen McCarthy Brown, Hans Baer, and Robert Orsi, the vast subject of religion in America's ghettos remains largely unexplored. There are studies of churches in the ghettos of Boston, and of houses of worship during the WPA in Bronzeville, Chicago, but these social-science monographs deal with small numbers of urban areas.

Printed Sources

Archdiocese of Detroit. *Make Straight the Path: A 300-Year Pilgrimage*. Strasburg: Editions du Signe, 2000.

Ashforth, Adam. *Madumo: A Man Bewitched*. Chicago: University of Chicago Press, 2000.

Baer, Hans. *The Black Spiritual Movement: A Religious Response to Racism*. Knoxville: University of Tennessee Press, 1986.

Baldwin, James. *Notes of a Native Son*. New York: Bantam, 1964.

Benedict, Saint. *The Rule of Saint Benedict*. New York: Vintage, 1998.

Bowden, Henry Warner, and P. C. Kemeny, eds. *American Church History: A Reader*. Nashville: Abingdon Press, 1998.

Caillois, Roger. *L'homme et le Sacre*. 1950. Reprint. Paris: Gallimard, 1994.

Campell, Karen, ed. *German Mystical Writings: Hildegard of Bingen, Meister Eckhart, Jacob Boehme, and Others*. New York: Continuum, 1991.

Castillo, Ana. *Goddess of the Americas: Writings on the Virgin of Guadalupe*. New York: Riverhead Books, 1996.

Chadwick, Henry. *Augustine: A Very Short Introduction*. Oxford: Oxford University Press, 1986.

Chesterton, G. K. *Saint Francis of Assisi*. New York: Doubleday, 2001.

Cone, James H. *The Spirituals and the Blues: An Interpretation*. Maryknoll, NY: Orbis Books, 1992.

De Bary, William Theodore. *The Buddhist Tradition in India, China, and Japan*. New York: Vintage Books, 1972.

De Vries, Hent, and Samuel Weber, eds. *Religion and Media*. Stanford: Stanford University Press, 2001.

Dionne, E. J., Jr., and John J. DiIulio, Jr., "What's God Got to Do With the American Experiment?" *Brookings Review* (Spring 1999).

Du Bois, W.E.B. *The Souls of Black Folk*. New York: Norton, 1999.

Edwards, Jonathan. *A Jonathan Edwards Reader*. Ed. John E. Smith, Harry S. Stout, and Kenneth P. Minkema. New Haven: Yale University Press, 1995.

Encyclopedia of Religion and Society Ed. William H. Swatos, Jr. Hartford Institute for Religious Research, Hartford Seminary. Walnut Creek, CA: Altamira Press, 1998.

Ford, David F. *Theology: A Very Short Introduction*. Oxford: Oxford University Press, 1999.

Gardiner, Patrick L. *Kierkegaard: A Very Short Introduction*. New York: Oxford University Press, 2002.

Hillerbrand, Hans J., ed. *The Protestant Reformation*. New York: Harper Torchbooks, 1968.

Hudnut-Beumler, James. "The Many Mansions of God's House: The Religious Built Environment as Assimilation and Differentiation." www.material religion.org/journal/mansions/mansions.html, 2002.

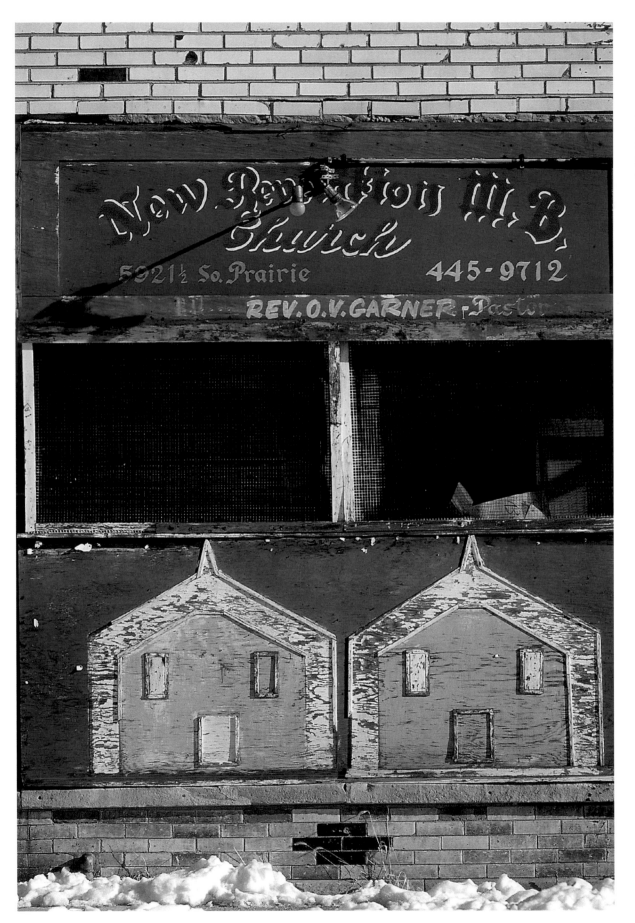

Sign, New Revelation M.B. Church, South Prarie Avenue, Chicago, 1987

R eligious leaders and congregants opened the doors to their sanctuaries for me to photograph and take notes, took time to answer my questions, and even asked me where to buy copies of the *How the Other Half Worships*. Many of those interviewed were surprised by my "carnal" questions. Didn't I know that religious objects, pictures, names, buildings, and fundraising were secondary to saving souls? Officials still collaborated, and for this I am grateful. Their names and those of their houses of worship, too numerous to list here, are found throughout this book.

Timothy J. Samuelson, the cultural historian of Chicago whose name appears frequently throughout this book, was a fountain of ideas and enthusiasm and even gave me hospitality. Tim and I drove through Chicago and New York in tours of houses of worship. Tim's rich commentary often centered in experiencing buildings; he was constantly asking: Did you see this, did you see that, Camilo? Little escaped his eye: signs, obscure building details such as the odd placement of air conditioners. I played Boswell to his Doctor Samuel Johnson. I listened to his commentary, asked for his opinions, and took copious notes. Knowing that Tim was there or that I was going to describe a church visit to him made me ask questions I would have been hesitant to ask if I had been alone.

I was apprehensive about approaching religious specialists in academia, those true scholars, who know Greek and Latin and read old parchments. I imagined them asking what was the purpose of documenting unimportant, "backward," and often misguided expressions of Christianity. Yet my first contact with a religion scholar was with David Morgan, professor of Christianity at Valparaiso University, who read my early drafts, encouraged my documentary zeal, and generously advised me for more than two years. Professor Timothy Trask of Massasoit Community College, himself the son of a Nazarene minister and an old friend, told me that he wanted to help me shape this book. He read several versions of the work, suggested a reordering of the sections, and came up the title *How the Other Half Worships*. Paul Gutjahr, professor of English and American Studies at Indiana University, read the manuscript and sent extensive notes including additions and deletions of categories and a reorganization of the contents. His enthusiasm for the work helped give me the strength and the resolve I needed to complete it and to safeguard its integrity. James Dickinson, a professor of sociology at Rider University, made sure I did not neglect the Philadelphia metropolitan area. He suggested places to visit, sent me numerous clippings from local newspapers, and read two versions of the manuscript, improving them considerably. Dr. Tricia Pongracz, of the Museum of Biblical Art in New York City, read a late version of the manuscript and studied the images. Her comments contributed much to make descriptions more elegant and arguments clearer.

Art historian Lisa Vergara of Hunter College and Julie Lasky of *I.D. Magazine* revised some of the texts included in this book. Lisa Thackaberry, a well-known photo editor, helped with the selection of images, and Evan Schoninger, a freelance art director, was a design consultant for this book.

Without the generous support from the MacArthur Foundation *How the Other Half Worships* would have been a less ambitious book, its images and text would have dealt mainly with the forms associated with Christianity in the ghetto and only briefly touch on its meaning. The Architecture and Design Program of the New York State Council of the Art gave a crucial initial grant to start this book.

At Rutgers University Press, Marlie Wasserman and Marilyn Campbell allowed me the time I needed to complete the manuscript to my satisfaction, and to revise the work as it went through two editors, and to work closely with a designer of my choice, Tom Whitridge. I am grateful to Rutgers University Press for their confidence in this book.

Angel, Mount Zion Baptist Church,
East 126th Street, Harlem, 2002

ABOUT THE AUTHOR

Since 1977, Camilo José Vergara has documented the transformation of urban landscapes throughout the United States. Trained as a sociologist, he reaches into the disciplines of architecture, photography, urban planning, history, and anthropology for tools to present the gradual erosion of the late nineteenth- and early twentieth-century architectural grandeur in urban neighborhoods, their subsequent neglect and abandonment, and scattered efforts at rehabilitation. Repeatedly photographing, sometimes over the course of decades, the same structures and neighborhoods, Vergara records both large-scale and subtle changes in the visual landscape of cities and inner cities in the United States. Over the years, Vergara has amassed a rich archive of several thousand photographs that are a rare and important cache of American history. These images, monuments to survival and reformation of American cities, are a unique visual study; they also inform the process of city planning by highlighting the constant remodeling of urban space. His photographs have been exhibited widely and acquired by institutions such as the New York Public Library, the New Museum of Contemporary Art in New York, and the Getty Research Institute in Los Angeles. In collaboration with historian Howard Gillete, under the sponsorship of Rutgers University in Camden and with support from the Ford Foundation, Vergara is creating a documentary record for Camden, New Jersey, and Richmond, California. The work in progress, in the form of an interactive Website, can be seen at www.camden.rutgers.edu/~hfcy. His books include *Silent Cities: The Evolution of the American Cemetery* (1989, with Kenneth Jackson), *The New American Ghetto* (1995), *American Ruins* (1999), *Unexpected Chicagoland* (2001), *Twin Towers Remembered* (2001), and *Subway Memories* (2004). Vergara has received numerous awards and fellowships, among them a MacArthur "genius" grant in 2002.

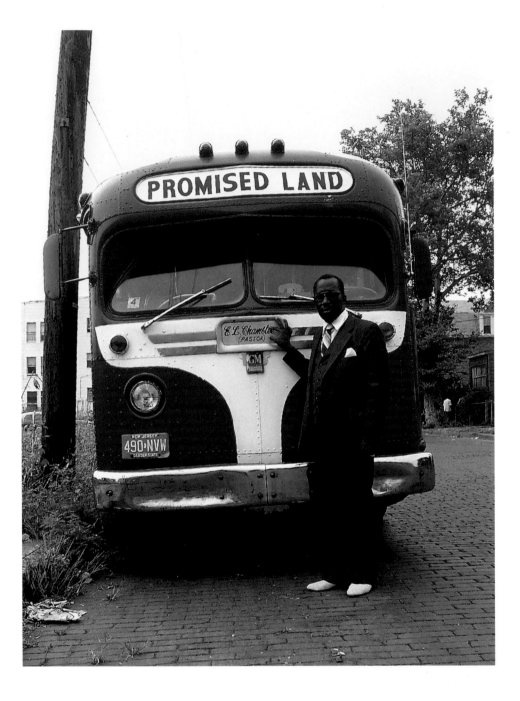

**The Reverend E.L. Chamblee,
Promised Land Baptist Church,
Madison Avenue, Newark, 1982**

277.3009
V494

LINCOLN CHRISTIAN COLLEGE AND SEMINARY

115184

3 4711 00186 4208